Rivers of America

Scale of miles

0 200

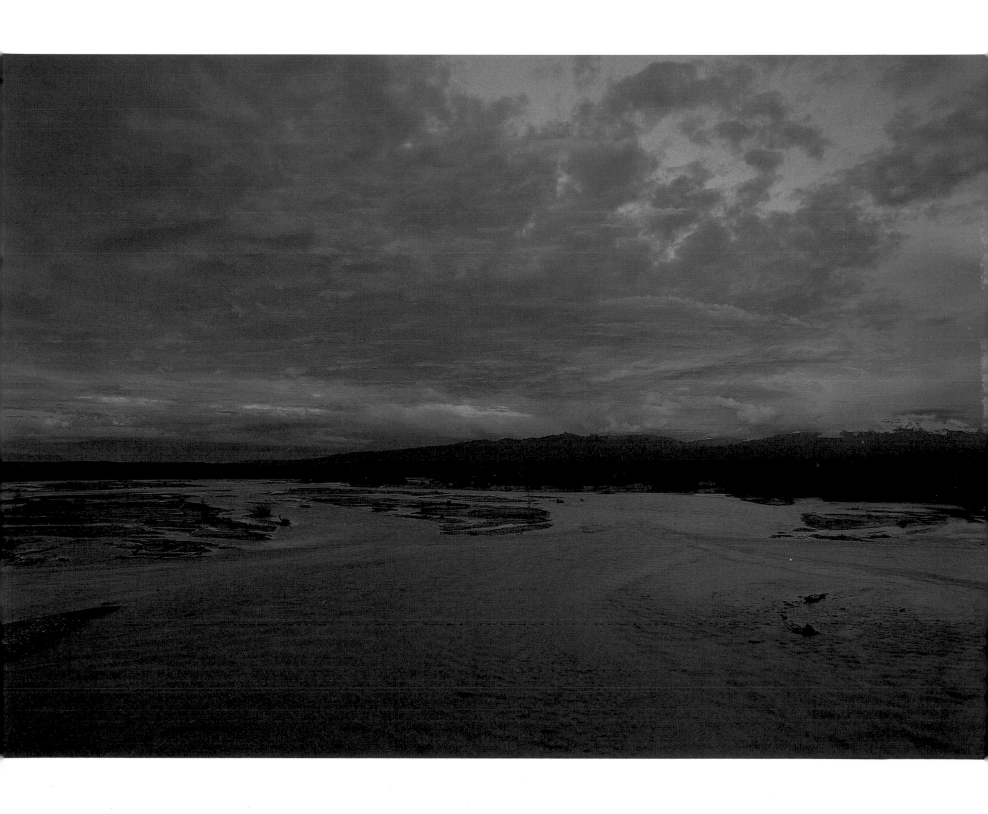

Rivers of America

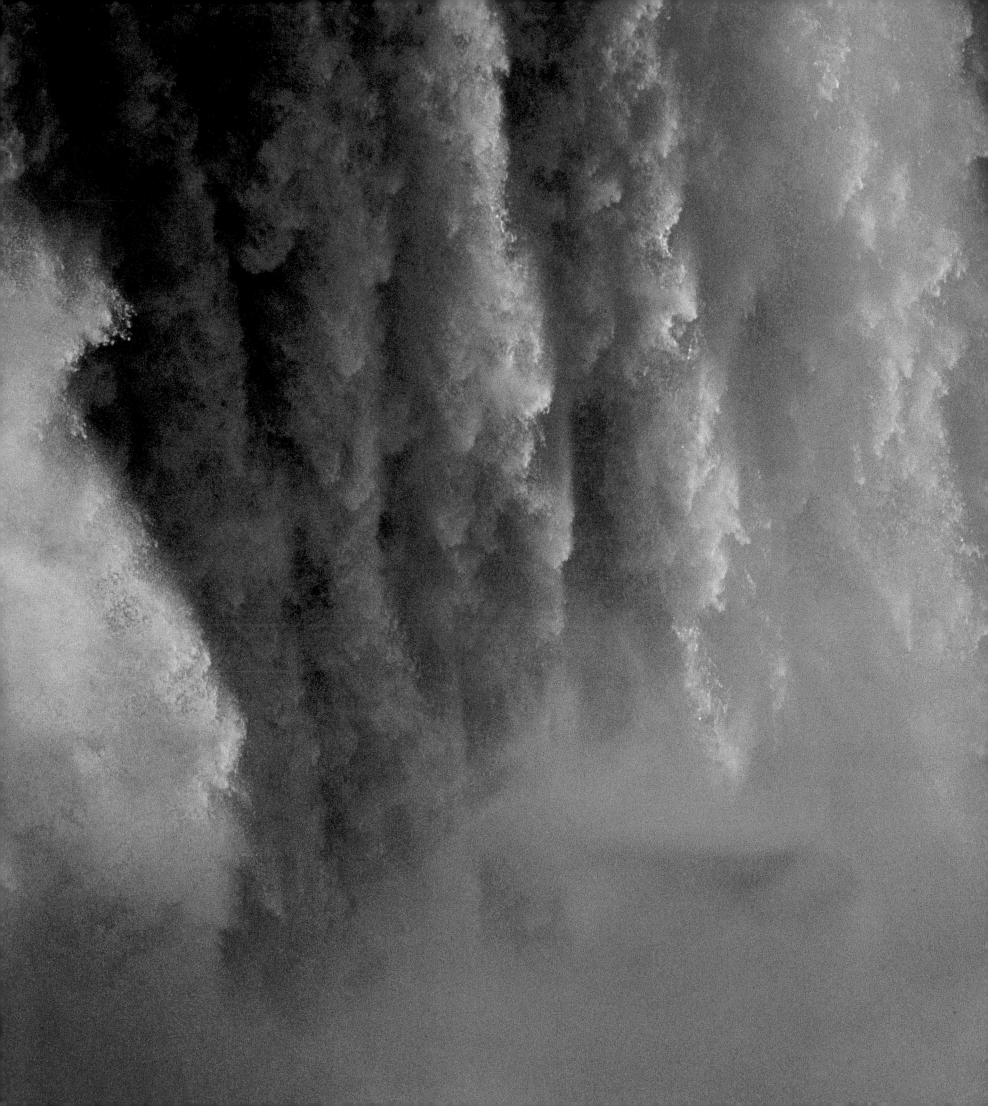

EDITOR

Charles Kochman

DESIGNER

Brady McNamara

LAYOUT AND COMPOSITION

Neil Egan

PRODUCTION MANAGER

Jane Searle

LIBRARY OF CONGRESS CATALOGING-IN-PUBLICATION DATA

Palmer, Tim, 1948–

 Rivers of America / photographs and text by Tim Palmer.

 p. cm.

 Includes bibliographical references and index.

 ISBN 10: 0–8109–5485–0 (hardcover with jacket)

 ISBN 13: 978–0–8109–5485–4

 1. Rivers—United States. 2. Rivers—United States—Pictorial works. I. Title.

 GB1215.P286 2006

 551.48'30973—dc22

 2006005710

Map by Steven Gordon, Cartagram

Printed and bound in China

10 9 8 7 6 5 4 3 2 1

HNA

harry n. abrams, inc.

a subsidiary of La Martinière Groupe

115 West 18th Street

New York, NY 10011

www.hnabooks.com

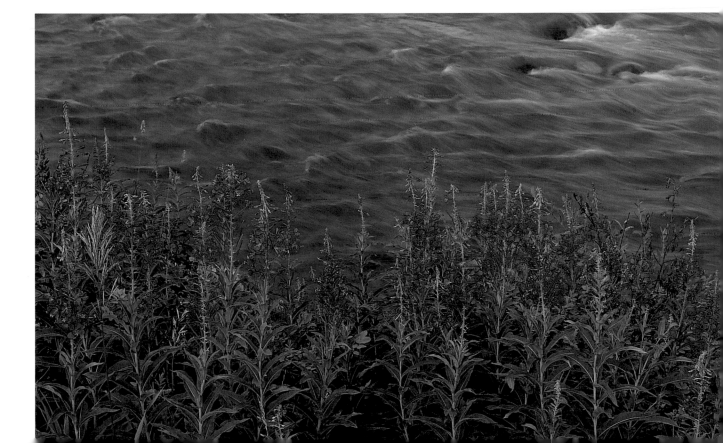

Index

Page numbers in *italics* refer to photographs.

221

About the Author

TIM PALMER has been involved with rivers since 1970 as a writer, photographer, planner, conservationist, speaker, and consultant to citizen organizations. He has written seventeen books about rivers, conservation, adventure travel, and the American landscape.

His book of text and color photos, *California Wild*, won the Benjamin Franklin Award as the best American book on nature and the environment in 2005. *The Heart of America: Our Landscape, Our Future* won the Independent Publisher's Book Award as the best essay and travel book in 2000. *The Columbia* won the National Outdoor Book Award in 1998. *Yosemite: The Promise of Wildness* received the Director's Award from the Director of the National Park Service for the best book about a national park in 1997.

For his accumulated writing work, Palmer received the first Lifetime Achievement Award from the nonprofit conservation organization American Rivers in 1988. Perception, Inc. honored him as the River Conservationist of the Year in 2000, and in 2002 California's Friends of the River gave him its highest honor, the Peter Behr Award. *Paddler* magazine named him one of the ten greatest river conservationists of our time, and in January 2000 the editors of that publication included him as one of the "hundred greatest paddlers of the century." In 2005 Palmer received the Distinguished Alumni Award from the College of Arts and Architecture at Pennsylvania State University.

Tim Palmer has canoed or rafted on nearly three hundred different rivers in the United States and Canada, and his collection of river photographs is one of the most complete in existence. He frequently speaks and gives slide shows at colleges, universities, workshops, and conferences nationwide. For more information, see *www.timpalmer.org*

Acknowledgments

ANN VILEISIS'S BOUNDLESS LOVE of rivers made every part of this book better and the writing of it more fun. I credit the best days of my life to her companionship with me on the water. She was a perceptive editor and an endless font of undeniably good ideas. Ann encouraged me to do all that was needed, even when it meant extended photographic journeys alone. For all this and more, thank you my dear wife.

Editor Charlie Kochman at Harry N. Abrams tended to this book's production with skill, vision, and wonderful enthusiasm. His respect for the choices I made would be the envy of any author or photographer. To keep this short, let me just say that I could not have been more fortunate than to have had my work land on Charlie's desk and to have him as an editor and a friend.

Christopher Sweet, formerly at Abrams, valued my idea from the start and championed my book in the rigorous approval process there. I deeply appreciate Carol Morgan for introducing my proposal to the editors at Abrams. Brady McNamara designed the book with talent I hadn't even imagined.

None of this would have happened if it weren't for Marc Taylor. Among my finest of friends, Marc initially recommended that I look to Abrams. But long before that he provided me with wisdom, an appreciation for all that is vital in the world, and a model for good living that goes far beyond what anyone could reasonably expect from a father-in-law. Of course I appreciate Janet Taylor no less, and their combined hospitality made my New England photo tour a pleasure.

Yvon Chouinard and his company, Patagonia, supported my work financially. Yvon's credentials regarding rivers go back decades and include the first kayak descents of extremely difficult and extremely beautiful rivers such as the upper San Joaquin, Kings, and Kern. Thanks also to Lisa Pike and Lisa Myers at that fine company. Patagonia's commitment to protecting rivers and the environment has helped me and many others.

Nat Hart reviewed my copy as only a veteran English professor can do, but even more as a friend of great spirit who is trusted and valued by me beyond words. Professor Vicki Graham likewise offered insightful comments as a friend and a real pro when it comes to manuscripts. Biologist, author, and one of America's preeminent river scientists, J. David Allan at the University of Michigan's School of Natural Resources reviewed Chapter 2 with a sharp eye toward his discipline.

John Clark of North Bend, Oregon, expertly repaired my classic but aging camera gear when needed. Cristina Morales at the Fuji Photo Lab went the extra mile to make sure my film was processed with care. Roger Poe at Tower Ford in Coos Bay, Oregon, took the interest that only the most professional of salesmen do when he found the new van I needed for my expeditions.

Navigating my way to scores of remote river sites would have been far more difficult without the DeLorme atlases—superb map books that I used in every state. I take these with me wherever I travel—even to watch my route from airplanes. For one who used to run rivers with only state road maps and who indulged himself only occasionally with the treasured USGS topo sheet, it's quite amazing to now have great maps for all of America at my fingertips.

In my most recent photo expeditions I enjoyed the support of Beth Manor Young on the Cahaba River, Sally Bethea on the Chattahoochee, Charlie Zemp on the Ashepoo, Sally Paar on the French Broad River, John Helland on the Saint Croix, Vibeke Wilberg on the Rio Grande, Chris Brown on the Potomac, Glenn Oakley on the Kongakut, and Bill Trail on the Clinch. When I was gone for months at a time, Jim Rogers—an accomplished river conservationist in his own right—split my winter's supply of firewood even though I told him to just dump it in a pile for me to deal with later. Thanks also to my neighbor, Jeff Peabody, who expertly weed-whacked the lawn, such as it is.

I appreciate the help of many others through the years, especially my mother, Jane Palmer May, for her limitless amount of love. More than once my older brother, Jim, pulled me out of rivers we were joyfully paddling together. My sisters, Becky and Brenda, both stored my books, files, and tools while I was on the road for decades. This chain of dependencies has no end; for example, Becky's husband, Steve Schmitz, bought my first good camera for me many years ago and wisely chose a Canon. I wish my father, Jim Palmer, could see this book, as he was the first to take me to the Youghiogheny and show me a magnificent river.

A whole library of guidebooks and literature informed my search for river beauty across the country; see the Sources section for a short list of documents that were helpful to me. Payson Kennedy of the Nantahala Outdoor Center generously shared a package of guidebooks that he sells at his store.

Don Elder of River Network and Rebecca Wodder of American Rivers championed my efforts with uncommon interest and support, as did the highly competent staffs of those organizations. Working in the same fruitful but challenging fields, hundreds of people all over America show unwavering commitment for better stewardship of their rivers, and I thank them all for taking care of the places I photographed and for saving the rivers that we all need and enjoy.

Organizations Engaged in River Conservation

For a comprehensive list of organizations, including local groups, see the *River Conservation Directory*, available through River Network.

AMERICAN CANOE ASSOCIATION

7432 Alban Station Boulevard, Suite B-32, Springfield, VA 22150, (703) 451-0141, *www.acanet.org*

AMERICAN FISHERIES SOCIETY

5410 Grosvenor Lane, Suite 110, Bethesda, MD 20814, (301) 897-8616, *www.fisheries.org*

AMERICAN RIVERS

1101 14th Street NW, Suite 1400, Washington, DC 20005, (800) 296-6900, *www.americanrivers.org*

AMERICAN WHITEWATER AFFILIATION

P.O. Box 1540, Cullowhee, NC 28723, (800) 262-8429, *www.americanwhitewater.org*

CLEAN WATER ACTION

4455 Connecticut Avenue NW, Suite 300, Washington, DC 20008, (202) 895-0420, *www.cleanwateraction.org*

FRIENDS OF THE RIVER

915 Twentieth Street, Sacramento, CA 95814, (916) 442-3155, *www.friendsoftheriver.org*

IZAAK WALTON LEAGUE OF AMERICA

707 Conservation Lane, Gaithersburg, MD 20878, (800) 284-4952, *www.iwla.org*

NATIONAL PARK SERVICE, RIVERS AND TRAILS ASSISTANCE PROGRAM

1849 C Street NW, Washington, DC 20240, (202) 354-6900, *www.nps.gov/rtca*

NATIONAL WILDLIFE FEDERATION

11100 Wildlife Center Drive, Reston, VA 20190, (800) 822-9919, *www.nwf.org*

THE NATURE CONSERVANCY

4245 North Fairfax Drive, Suite 100, Arlington, VA 22203, (703) 841-5300, *www.nature.org*

RIVER NETWORK

P.O. Box 8787, Portland, OR 97207, (800) 423-6747, *www.rivernetwork.org*

SIERRA CLUB

85 Second Street, 2nd Floor, San Francisco, CA 94105 , (415) 977-5500, *www.sierraclub.org*

TROUT UNLIMITED

1300 North Seventeenth Street, Suite 500, Arlington, VA 22209, (800) 834-2419, *www.tu.org*

WATERKEEPER ALLIANCE

828 South Broadway, Suite 100, Tarrytown, NY, 10591, (914) 674-0622, *info@waterkeeper.org*

Williams, Garnett P. and M. Gordon Wolman, "Effects of Dams and Reservoirs on Surface-Water Hydrology—Changes in Rivers Downstream from Dams," *National Water Summary*, Washington, DC: U.S. Geological Survey, 1985.

Worster, Donald. *Rivers of Empire*. New York: Pantheon Books, 1985. Historical basis of water diversions in the West.

Young, Beth Manor, and John C. Hall. *Headwaters: Descending the Rivers of Alabama*. Athens: University of Georgia Press. To be published in 2007. Text and fine photos.

This page
Middle Fork Smith River, Californina

Pages 218–219
Rogue River, Oregon

Page 220
Klamath River, California

Page 224
Granite Creek, Wyoming

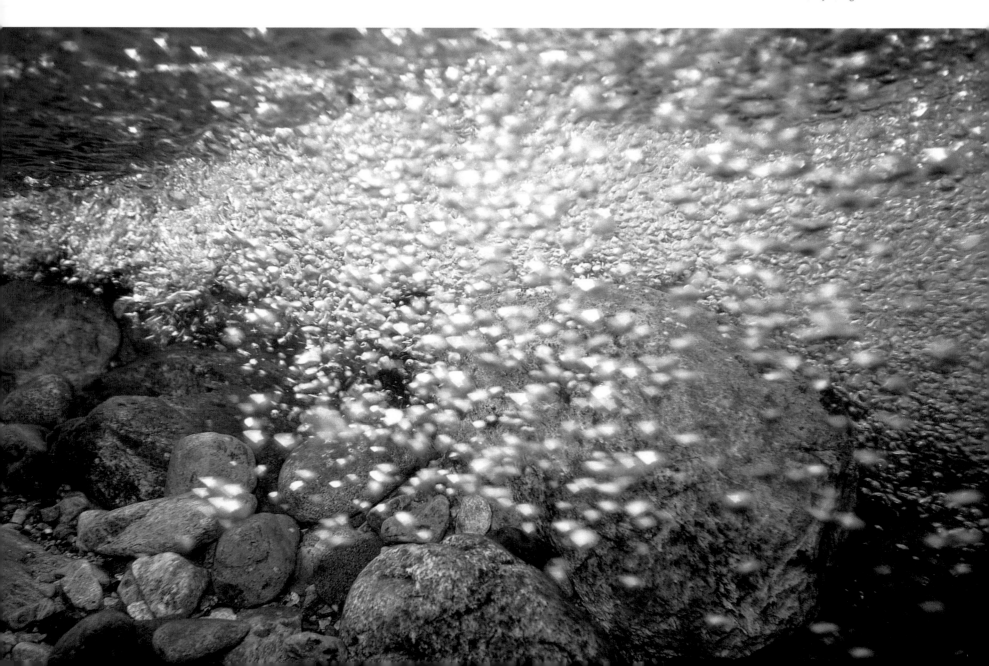

——. "Social Security and the Fear of Aging," *NPG Forum*, August 2005. Projections of immigration as a percentage of U.S. population growth.

Hundley , Norris. *The Great Thirst, California and Water, 1770s–1990s*. Berkeley: University of California Press, 1992. History of water development.

Karr, James R., and Ellen W. Chu. *Restoring Life in Running Waters*. Washington, DC: Island Press, 1999. Biological criteria for water quality.

Kauffmann, John M. *Flow East*. New York: McGraw-Hill, 1973. Rivers of the Northeast.

Kolankiewicz, Leon, and Roy Beck. *Forsaking Fundamentals: The Environmental Establishment Abandons U.S. Population Stabilization*. Washington, DC: Center for Immigration Studies, 2001. Information on population growth, covered in Chapter 4.

MacBroom, James Grant. *The River Book*. Hartford, CT: Connecticut Department of Environmental Protection, 1998. The ecology and hydrology of New England rivers.

Marston, Ed, ed. *Western Water Made Simple*. Washington, DC: Island Press, 1987. Diversion problems and water rights.

Master, Larry, "The Imperiled Status of North American Aquatic Animals," *Biodiversity Network News* 3, no. 3 (1990). Source for "30 percent of fish species imperiled," Chapter 4.

McNamee, Gregory. *Gila: The Life and Death of an American River*. New York: Orion, 1994.

McNulty, Tim, and Pat O'Hara. *Washington's Wild Rivers*. Seattle: The Mountaineers, 1990. Text and photos.

Morisawa, Marie. *Streams: Their Dynamics and Morphology*. New York: McGraw-Hill, 1968. Stream hydrology and morphology.

Mount, Jeffrey F. *California Rivers and Streams: The Conflict Between Fluvial Process and Land Use*. Berkeley: University of California Press, 1995. Hydrology, morphology, and effects of development.

Moyle, Peter B. *Fish: An Enthusiast's Guide*. Berkeley: University of California Press, 1993. The natural history of fish.

National Research Council. *Restoring Aquatic Ecosystems*. Washington, DC: National Academy Press, 1992. Overview of river problems.

Nehlsen, Willa, Jack E. Williams, and James A. Lichatowich, "Pacific Salmon at the Crossroads: Stocks at Risk from California, Oregon, Idaho and Washington," *Fisheries*, March/April, 1991.

Noss, Reed F., and Allen Y. Cooperrider. *Saving Nature's Legacy*. Washington, DC: Island Press, 1994. Source for "half of all our land must be protected," Chapter 4.

Olson, Larry N., and John Daniel. *Oregon Rivers*. Englewood, CO: Westcliffe, 1997. Text and photos.

Pacific Rivers Council. *Entering the Watershed*. Washington, DC: Island Press, 1993. Overview of ecosystem problems.

Palmer, Tim. *America by Rivers*. Washington, DC: Island Press, 1996. A popularized river geography; see this book for additional detail about concepts raised here in Chapter 3.

——. *Endangered Rivers and the Conservation Movement*. Lanham, MD: Rowman and Littlefield, 2nd ed., 2004. The history of river conservation.

——. *Lifelines: The Case for River Conservation*. Lanham, MD: Rowman and Littlefield, 2nd ed., 2004. The modern problems affecting rivers; see this book for more details about concepts raised here in Chapters 2 and 4.

——. *Rivers of Pennsylvania*. University Park, PA: Pennsylvania State University Press, 1980.

——. *Stanislaus: The Struggle for a River*. Berkeley: University of California Press, 1982. Friends of the River's attempt to save the Stanislaus.

——. *The Columbia*. Seattle: The Mountaineers, 1997. Environmental issues of the Columbia River basin, with color photos.

——. *The Snake River, Window to the West*. Washington, DC: Island Press, 1991. A profile of this river, including details about subsidies for irrigation in the west.

——. *The Wild and Scenic Rivers of America*. Washington, DC: Island Press, 1993. The National Wild and Scenic Rivers system.

Postel, Sandra, and Brian Richter. *Rivers for Life: Managing Water for People and Nature*. Washington, DC: Island Press, 2003. The problems of instream flow, water quantity, and the biological importance of floods.

Powledge, Fred. *Water*. New York: Farrer, Straus and Giroux, 1982. Overview of water issues.

Reisner, Marc. *Cadillac Desert: The American West and Its Disappearing Water*. New York: Viking, 1986. The classic history of water development in the West.

River Network. *The Clean Water Act: An Owner's Manual*. Portland: River Network, 2005. A guide for using the Clean Water Act to improve streams.

Steingraber, Sandra. *Living Downstream: A Scientist's Personal Investigation of Cancer and the Environment*. New York: Vintage Books, 1998. Coverage of toxins, discussed in Chapter 4.

The Conservation Fund. *Greenways: A Guide to Planning, Design, and Development*. Washington, DC: Island Press, 1993.

U.S. Census Bureau. *www.census.gov/* This Web Site was used for the population and population projection data in Chapter 4.

U.S. Department of the Interior, Geological Survey. *National Water Summary*. Washington, DC, 1985. Water use data.

U.S. Department of the Interior, National Park Service, Rivers and Trails Conservation Assistance. *Economic Impacts of Protecting Rivers, Trails, and Greenway Corridors*. Washington, DC, 1990. Economic values of natural rivers.

U.S. Environmental Protection Agency. *National Water Quality Inventory, 2000*. Washington, DC, 2002. Water quality status.

Vileisis, Ann. *Discovering the Unknown Landscape. A History of America's Wetlands*. Washington, DC: Island Press, 1997. A subject closely linked to rivers.

Waters, Thomas F. *The Streams and Rivers of Minnesota*. Minneapolis: University of Minnesota Press, 1997.

——. *Wildstream: A Natural History of the Free Flowing River*. Saint Paul, MN: Riparian Press, 2000. River ecology in the upper Midwest.

Sources

FOR THE TEXT I drew heavily from a wealth of river-related articles and literature, including books, journals, and technical reports. Many of the questions regarding rivers' health and ecology are covered in more depth in other books that I have written (see page 216). Each includes an extensive list of its own sources. See especially my book *Lifelines: The Case for River Conservation* for the ideas and information covered in Chapters 2 and 4. Newsletters and online publications of *American Rivers* and *River Network* were helpful in keeping me up-to-date with current trends and events in river conservation.

My fieldwork photographing rivers was informed by many years of travel, by canoe and raft trips on nearly three hundred different streams, and by guidebooks, which readily can be found in bookstores or on the Internet.

Below I list books that are generally available, along with a few landmark scientific articles and technical documents. Some of these appear here because I drew information from them; others round out this reading list for people who want to learn more.

Regarding natural history and ecology, see especially the books by Cushing, Amos, Waters, MacBroom, and Moyle. For environmental issues, see my book *Lifelines: The Case for River Conservation* and the work of Postel, Adler, Coffel, Echeverria, and River Network. For river geography, see my book *America by Rivers*, Benke and Cushing's *Rivers of North America*, Kauffmann's *Flow East*, and books that address specific rivers. For other fine picture books covering specific states, see Young, Olson, McNulty, Blagden, Fielder, and Cook.

Adler, Robert W., Jessica C. Landman, and Diane M. Cameron. *The Clean Water Act 20 Years Later*. Washington, DC: Island Press, 1993.

Amos, William H. *The Infinite River*. New York: Ballantine, 1970. The ecology of natural rivers in a narrative style.

Bachman, Ben. *Upstream: A Voyage on the Connecticut River*. Chester, CT: Globe Peaquot, 1988.

Barker, Rodney. *And the Waters Turned to Blood*. New York: Simon and Schuster, 1997. The story of *Pfiesteria* and pollution in the Southeast.

Belleville, Bill. *River of Lakes: A Journey On Florida's St. Johns River*. Athens, GA: University of Georgia Press, 2000.

Benke, Arthur C., and Colbert E. Cushing, eds. *Rivers of North America*. San Diego: Academic Press, 2005. An encyclopedia with information on all major river systems in North America.

Benke, Arthur C., "A perspective on America's Vanishing Streams," *Journal of the American Benthological Society*, March 1990.

Blagden, Tom, Jr., and Barry Beasley. *The Rivers of South Carolina*. Englewood, CO: Westcliffe, 1999. Text and photos.

Bolling, David. *How to Save a River*. Washington, DC: Island Press, Prepared for River Network, 1994. Excellent handbook for river activists.

Brown, Bruce. *Mountain in the Clouds*. New York: Simon and Schuster, 1982. The salmon of Washington State.

Brubaker, Jack. *Down the Susquehanna to the Chesapeake*. University Park, PA: Pennsylvania State University Press, 2002.

Coffel, Steve. *The Lifesaving Guide to Good Water*. New York: Ivy Books, 1989. Water pollution.

Collier, Michael. *Water, Earth, and Sky: The Colorado River Basin*. Salt Lake City: University of Utah Press, 1999. Text about flow problems, with striking aerial photographs.

Cook, Joe, and Monica Cook. *River Song: A Journey Down the Chattahoochee and Apalachicola Rivers*. Tuscaloosa, AL: University of Alabama Press, 2000. Text and photos.

Cronin, John, and Robert F. Kennedy, Jr. *The Riverkeepers*. New York: Scribner, 1997. The story of Riverkeeper and its efforts to clean up the Hudson.

Cushing, Colbert E., and J. David Allan. *Streams: Their Ecology and Life*. San Diego: Academic Press, 2001. A fine and accessible introductory textbook.

Davis, Norah Deakin, and Joseph Holmes. *The Father of Waters: A Mississippi River Chronicle*. San Francisco: Sierra Club Books, 1982.

Echeverria, John D., Pope Barrow, and Richard Roos-Collins. *Rivers at Risk*. Washington, DC: Island Press, 1989. Overview of hydropower and how citizens can intervene.

Fielder, John, and Mark Pearson. *Colorado: Rivers of the Rockies*. Englewood, CO: Westcliffe, 1990. Text and photos.

Fradkin, Philip L. *A River No More*. New York: Knopf, 1981. The Colorado River.

Grant, Lindsey. *Juggernaut: Growth on a Finite Planet*. Santa Ana, CA: Seven Locks Press, 1996. The effects of population growth.

215

ROGUE RIVER, OREGON
The Rogue River of southern Oregon reflects the colors of its shoreline at sunset.

Rivers

of America

Photographs and text by TIM PALMER

Abrams, New York

To Ann . . . always

Contents

Page 1
Chistochina River, Alaska

Pages 2–3
Niagara Falls, New York

Pages 4–5
Rogue River, Oregon

Left
Hoback River, Wyoming

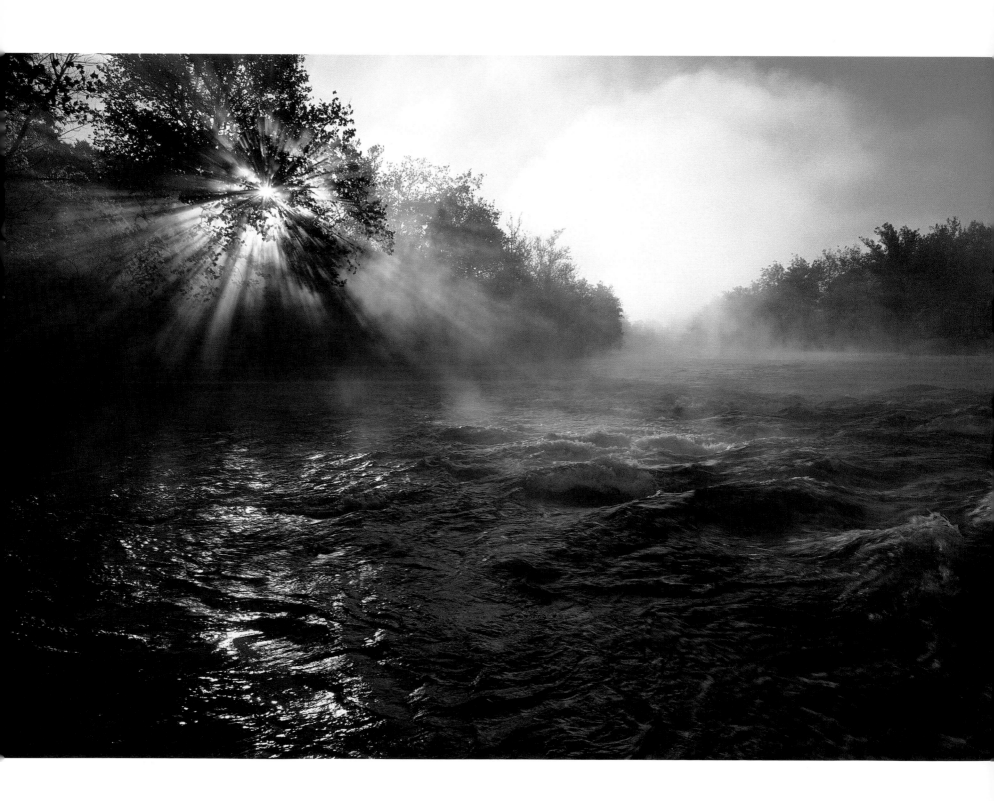

THIS BOOK BEGAN MANY YEARS AGO, when I realized that rivers had become a central theme of my life, that I loved to photograph flowing water, and that no comparable book existed.

While watery scenes from all parts of the country percolated in my brain, I was busy writing other books, many of them with specific slants on rivers. These include a history of river conservation—*Endangered Rivers and the Conservation Movement*; a book about the current problems of rivers—*Lifelines: The Case for River Conservation*; a book covering the National Wild and Scenic Rivers system—*The Wild and Scenic Rivers of America*; and a river geography—*America by Rivers*. I also wrote books about specific rivers—the Columbia, Snake, Stanislaus, and Youghiogheny—plus magazine articles and reports for conservation groups.

Throughout this time, whether exploring rivers for work or for pleasure, I took photos, amassing a collection that I used for my writing projects, for slide shows, and for the book I most dreamed of—the one now in your hands. To supplement the pictures I had been shooting for years, I launched new photo expeditions to Alaska, New England, the South, the Midwest, and the Great Plains, and I revisited all other regions as well.

While I had the option of making the book a documentary of American rivers in all their various conditions, I chose instead to regard this as a river art book showing my most beautiful and interesting scenes of unspoiled waterways. Foremost, I wanted the book to be a celebration of natural rivers and an account of their importance.

I photographed with Canon 35-millimeter cameras and fixed-focal-length lenses from 28 to 200 millimeters. I shot almost all scenes except action and wildlife from a tripod for the greatest depth of field. This requires a slow shutter speed, which also gives moving water the fluid look you will see in many of the pictures. I used Fuji Velvia film, though my older slides are Kodachrome. Many of the scenes were photographed at the sunrise or sunset hours; during those times the angle of light is low, the colors are warm and vivid, the shadows are sharp. The only filter I used—and sparingly—was a graduated gray overlay to slightly darken a white sky that can otherwise underexpose the rest of the view. After toying for awhile with artificial light, I used none of it for this book.

I did no manipulation of the photos by computer or digital means, other than for the printer removing occasional specks of dust or scratches from my older slides while preparing them for reproduction, and minor aperture corrections for lightness or darkness. I did nothing to change the color or content of any picture. In other words, these photos are honest illustrations of what I found where rivers flow. If you don't mind getting up early, or maybe missing dinner now and then, you can go to the water and see these scenes yourself—which, after all, is the only way to fully know, appreciate, and enjoy the nature and the magic of these special places.

I wanted to capture rivers in their every mood. I shot from the shore, occasionally from a canoe or raft, from a ladder above the brush, from my skis on top of the ice, from mountains to which I sometimes hiked or ran for hours, from airplanes at 35,000 feet, and from the rivers themselves by wading up to my ankles, knees, and waist; some pictures were taken with my chin in the water. I enjoyed going out in all kinds of weather—the worse the better—and in all seasons.

My hope is that this book will offer some inspiration for readers to get out and learn more about a stream near home, to notice the beauty of rivers while traveling, to cast aside all inhibitions and take the plunge for physical or emotional refreshment, or to paddle along with the tug of the current for a better look at everything that is touched by flowing water.

HOUSATONIC RIVER, CONNECTICUT
The sun rises on the Housatonic River downstream from the town of Kent.

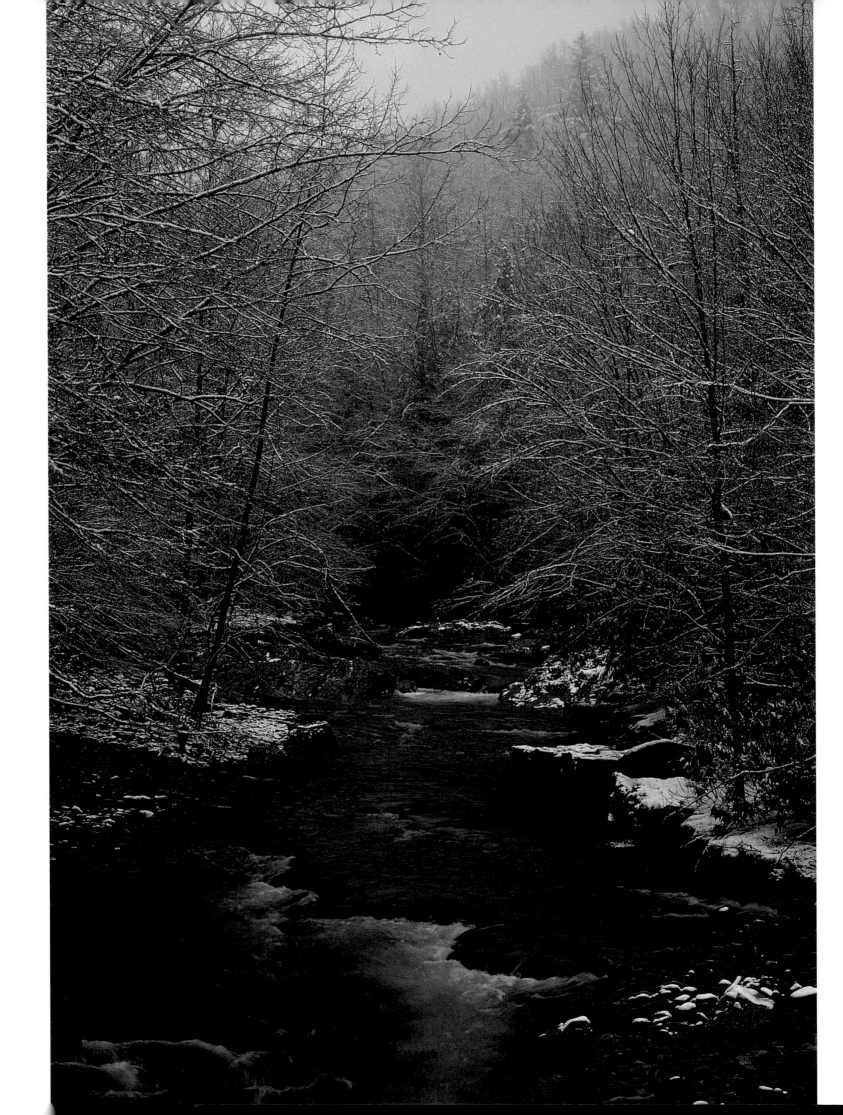

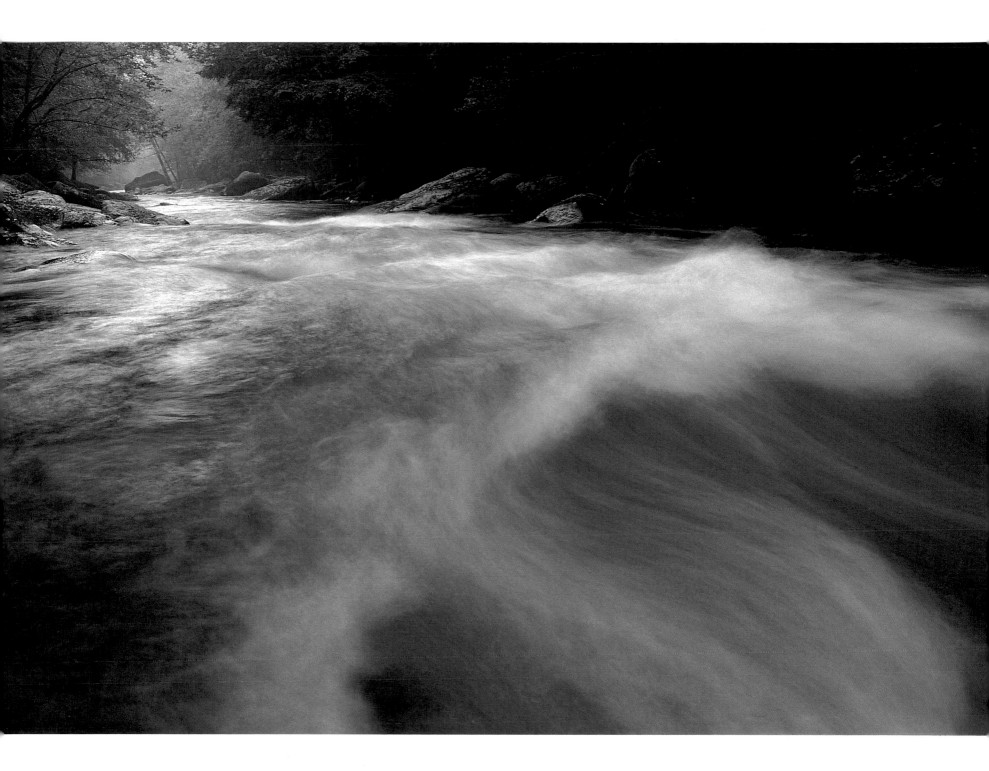

SLIPPERY ROCK CREEK, PENNSYLVANIA
Slippery Rock Creek churns through a hemlock-shaded gorge in the Beaver River basin
of western Pennsylvania.

OCONALUFTEE RIVER, NORTH CAROLINA
South of Great Smoky Mountains National Park, a winter storm has frosted the trees
over the Oconaluftee River.

MISSISSIPPI RIVER, ARKANSAS AND MISSISSIPPI
As the central artery of the continent, the Mississippi stretches a mile wide at the border of Arkansas and Mississippi.
This river carries one-and-a-half times more water than the next-largest river in America.

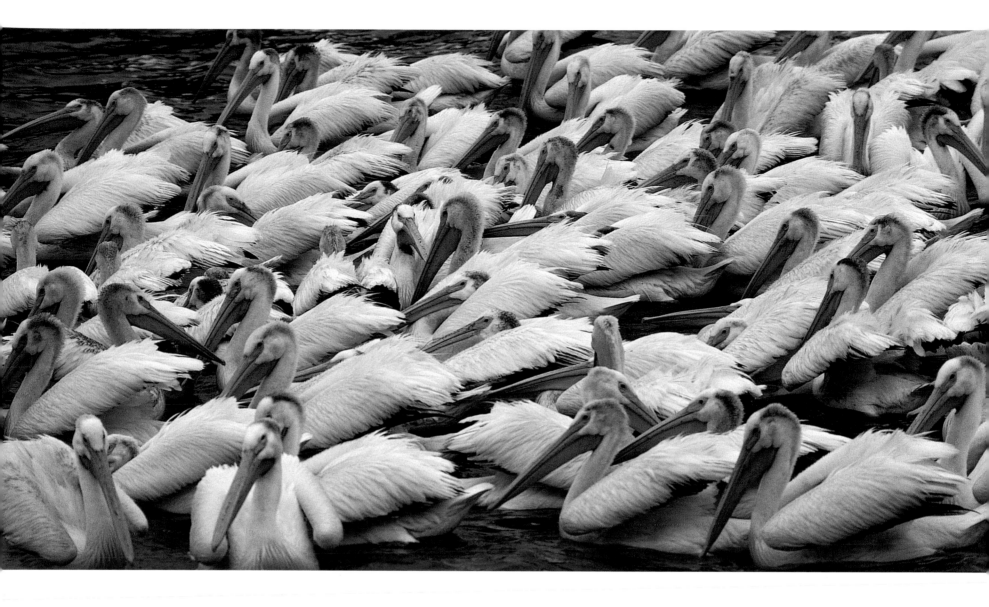

MINNESOTA RIVER, MINNESOTA
On the Minnesota River below Granite Falls, white pelicans flock together catching fish that migrate upriver during floods.

Overleaf YELLOWSTONE RIVER, WYOMING
Thundering over its tallest waterfall, the Yellowstone River enters an impassable canyon of tawny igneous rock that gave our first national park its name.

TUOLUMNE RIVER, CALIFORNIA
A gem of California, the Tuolumne River downstream from Yosemite National Park entices river travelers through a rugged foothills canyon in the Sierra Nevada

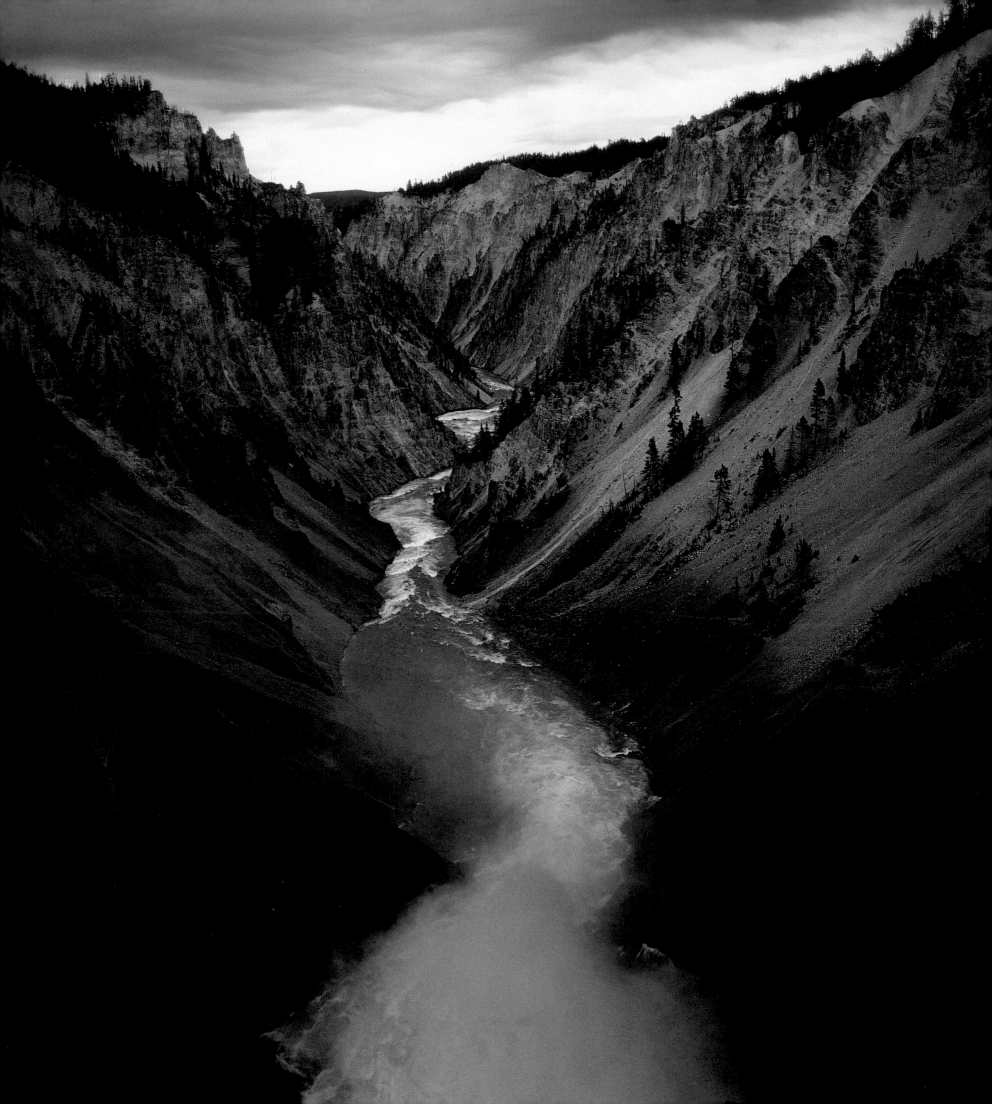

GREEN RIVER, UTAH
Virid only at its headwaters, the silty water of the Green River reflects golden sandstone cliffs
at the end of the day.

HUGHES RIVER, VIRGINIA
In the misty green world of the Appalachian Mountains, the Hughes River riffles through Shenandoah National Park
on its way to the Rappahannock River and Chesapeake Bay.

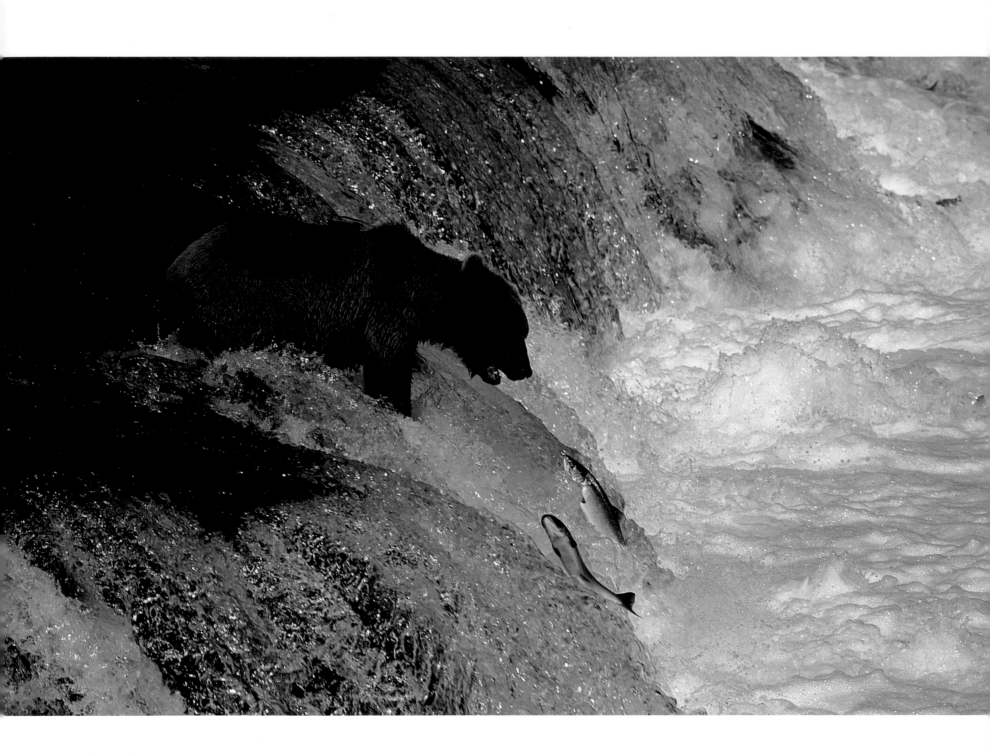

BROOKS RIVER, ALASKA
In southwestern Alaska, brown bears come to the Brooks River to feed on sockeye salmon,
which migrate upstream in astonishing numbers every July.

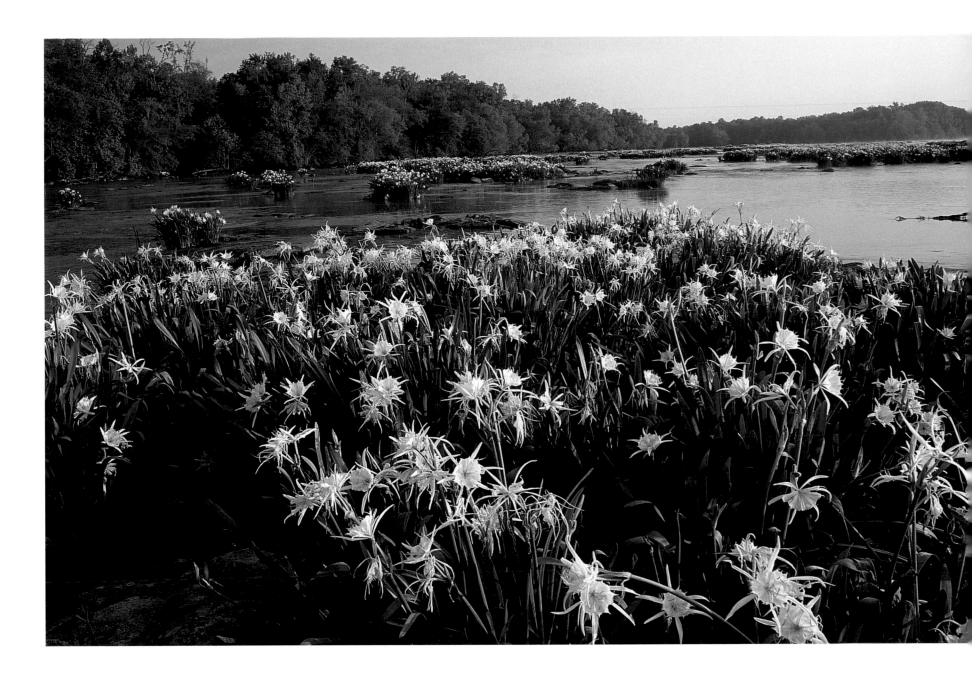

CATAWBA RIVER, SOUTH CAROLINA

The rocky shoals spider lily grows only at rapids where rivers of the South drop over the Fall Line to the Coastal Plain. Because hydropower dams were built at most of these locations, few sites with lilies still exist. This is the world's largest colony on the Catawba River at Landsford Canal State Park.

Overleaf **ROGUE RIVER, OREGON**
Famous in the lore of western rivers, the Rogue crosscuts through the coastal mountains as it wends its way to the Pacific.

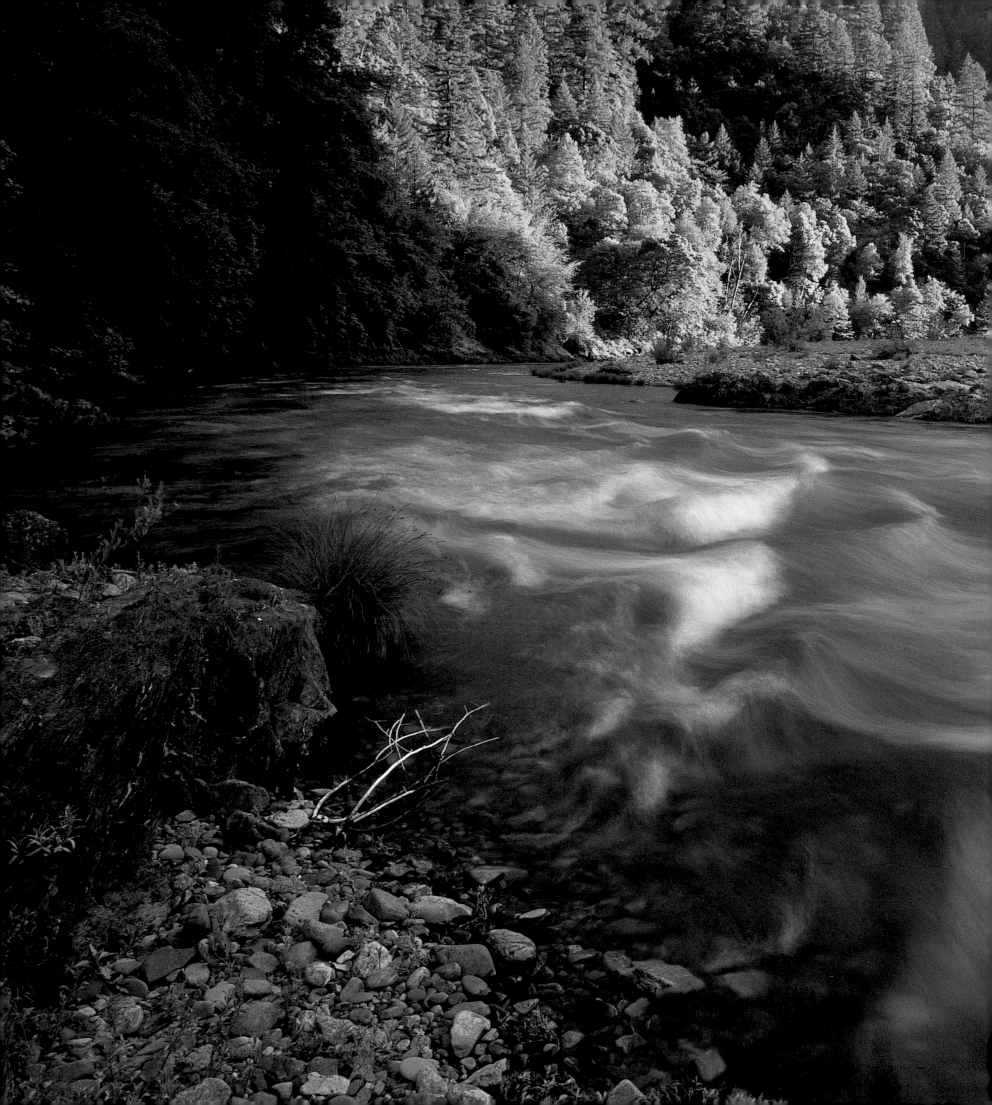

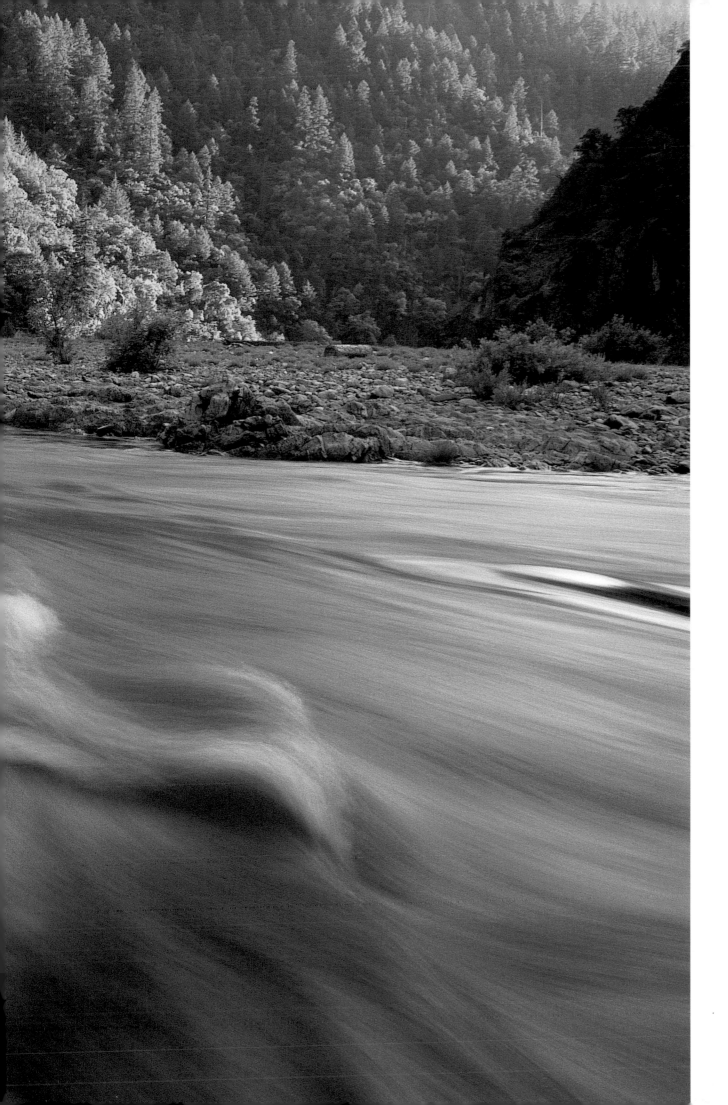

Growing up with Rivers

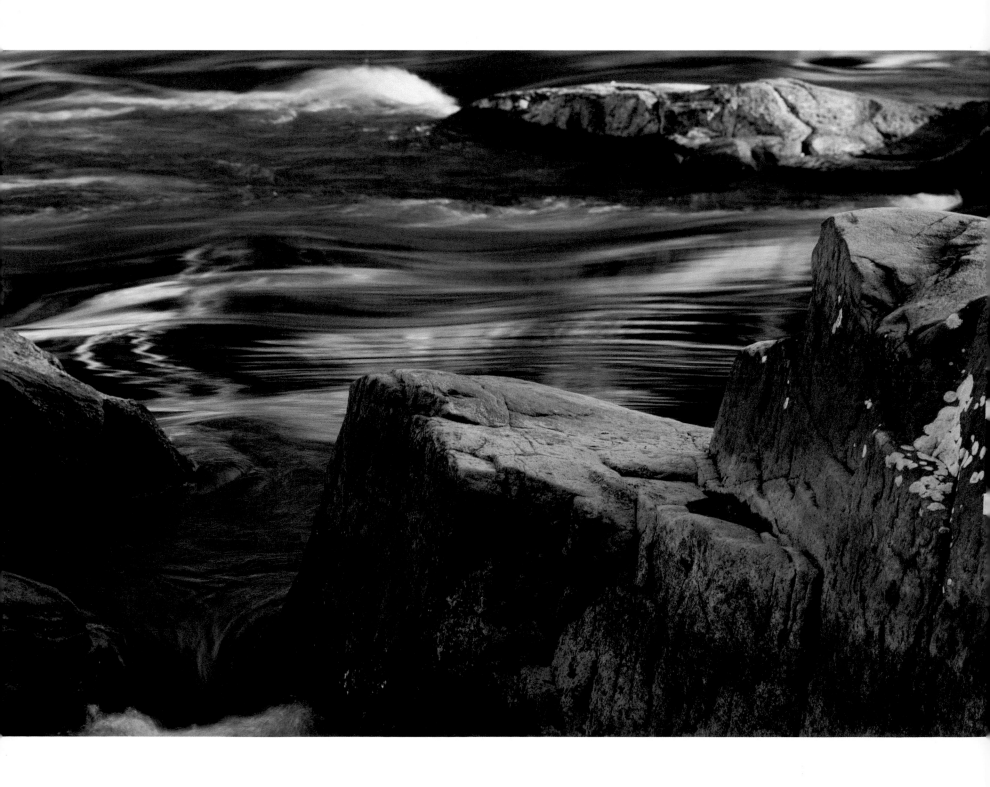

Home lay on a broad ridge where the river began. You couldn't see the flashing bends, the rippling pools, the waterfalls, the rapids. In fact, you couldn't even see water at all unless you looked carefully.

Our land was the uppermost ground. It wasn't much different from millions of other rural home sites across America. But when raindrops and snowflakes fell on our family soil, they began their journey downhill, bound inevitably for the Gulf of Mexico, fifteen hundred miles away, by river.

Knowing how I feel about rivers today, I might easily imagine myself being born on the banks of some powerful freshwater artery or at least along a tributary large enough for catching a fish. But maybe that humble beginning—high in the watershed, stitched into the fabric of Appalachian foothills—maybe that is what made me who I am. I do know that this book began there.

Kids never think about where the water in the driveway puddles comes from, and where it goes, and I didn't either. But gradually I pieced together the logic that the puddles and the low swale alongside the garden were somehow connected to the spring, which lay downhill from them, at the other end of a field.

The spring was the Source—one of the first sources of anything that I knew and identified as such in my life. When I picture this scene from many years ago, or think about drawing a schematic of our property, I now envision the spring as a brilliantly fluid core at the center, colored in deep reflective blue while even the house sits at the periphery in subdued gray. Because of wet ground in the lowlands where the spring appeared, a lot of shrubs and high weeds surrounded it. But a path led to the water, and even at a very young age I followed every path I could find.

My great uncle, who lived just up the hill with my beloved grandfather, had shored up the walls of the spring with blocks of sandstone, giving the water more depth than it otherwise would have had. We didn't drink this water, but during the dry weeks of late summer, when our well couldn't stand the strain of extra pumping, my grandfather and I dipped buckets of water from the spring and carried them to our gardens. Walking down the cultivated rows, we poured the water into bowls molded by dirt we had carefully pushed

up around tomato plants and cantaloupe vines. Without being told, I knew that the spring water was a life-force of great importance.

It seemed not only important, but almost magical. No matter how much water we took out—keep in mind we were just an old man and a young boy hefting buckets by hand—the spring never dried up.

In the winter I learned that it never froze, either—even though all the other surface water did, and even though the ground near the spring turned rock-hard. After the snow melted, the spring flowed stronger, pouring liberally over its outlet. The water ran down through a field to a deepening woods. Then it disappeared into the unknown.

Where did it go?

As I grew older, I could count my years by how far downstream I had explored. Our creek soon penetrated a forest of oak and hickory, darkened here and there by an eastern hemlock growing in the shade of steep hillsides that the stream had shaped like a sculptor molding an outsized pile of clay, in this case the entire Appalachian Plateau.

Every bend opened new wonders to me. I spotted woodpeckers drumming on dead elms. I sneaked up on an agitated flock of crows until they scattered, leaving a great horned owl sternly staring down at me from a hollowed-out sycamore high above the creek. At the widest ponded place in my stream I flushed a duck. Being an upland boy, I had never seen waterfowl of any kind. It was only a mallard—the kind of duck that city kids tossed bread crumbs to all the time. But thrilled at the iridescent green of its head, I ran home with the news. "Mom, you won't believe what I saw!"

During my high school years, these Saturday-morning outings expanded to daylong expeditions. I packed lunch and hiked downstream as far as I could, my increasing endurance now a match for my curiosity. My stream grew in volume and the riffles gained some force while the flow dropped off sandstone ledges and then filtered into wetlands and later trickled out. The water pooled up in places big enough for me to jump in. The stream and its valley were amazingly wild for being only forty miles from Pittsburgh.

Then one day I heard the incongruous rumble of truck noise ahead of me. Approaching cautiously, almost afraid of what I would find, I saw that my wild stream tunneled into the darkness of a culvert beneath a trash-littered, four-lane highway. Then, with all its distance covered, with its own life of intimacy past, my little stream entered the Ohio River.

At that time the Ohio was the largest barge-floating cesspool in America. In a few short feet my family waters mixed and then

23

YOUGHIOGHENY RIVER, PENNSYLVANIA
The warm glow of sunset illumines rocky rapids in the Youghiogheny River's alluring course below the town of Ohiopyle.

disappeared into the rainbow-swirled, oily flow of that eastern behemoth, once the biologically richest river in America, but for generations dedicated to industrial barging.

In one culminating instant I understood what a stream should be and what it shouldn't. I sensed something tragic in what happens to the unfortunate raindrops and headwater rivulets that flow into the wrong river. This awareness came solely from what I *saw*—simply the way it *looked* to me. I wanted to capture it all in a picture, but couldn't. I didn't even own a camera.

The Ohio was huge: it stretched a quarter mile across, its abuses embedded in the aging steel mills rusting along its edge, in the traffic pounding its banks, and in railroad tracks that cordoned off the water. Furthermore, it stunk. What had once been the ultimate life force had become a conduit for waste in volumes and concentrations that defined the term "public health hazard."

The combined effect assaulted my senses completely, but something else troubled me even more. Dirty water, after all, could be cleaned up. The highway and railroad tracks had to run through the valley in one place or another. Something else, I knew, was even more amiss with the Ohio River.

Then I realized: it had no flow. It didn't *move*. Later I would learn that the Ohio is dammed back-to-back twenty-six times in 981 miles, scarcely a hundred yards of free-flowing river to be found in its entire length.

The Ohio showed me what could happen to streams when they became rivers. At the time, I took my stream's dammed and polluted outcome simply as a lesson in the way the world is. An accompanying sense of fatalism took years to shed. What I saw, of course, doesn't happen to every stream, and even where it does, there's no reason it must stay that way forever. But these realizations would come later. Before I could imagine better possibilities, I had to live more, see more, and learn more about other streams.

24 **DURING THOSE SAME YEARS,** another river flowed into my life and affected me even more deeply. The Youghiogheny (yock-a-GEN-ee) cut through the mountain town of Ohiopyle, Pennsylvania. This sleepy, two-block burg in Appalachia clung with a time-tested grip to a hillside above the banks of the river. Ancestors of mine had settled there nearly three hundred years earlier. Some hearty relatives remained, and once each summer my family journeyed back to visit my great aunt and uncle and to stay for a while at a white-frame house owned by my grandmother.

A formidable set of creaking steps led up to a full-length porch where a two-person wicker swing hung by chains from the rafters. This comfortable slice of Americana lay deeply shaded under the leggy limbs of sugar maples. Most important, the porch looked down to the river.

Right there in town, just a couple of stone's-throws below the house, the Youghiogheny plunged over one of the largest waterfalls in the East. Then it ripped into rock-ribbed rapids and curled around bends overhung by sandstone crags and the silhouettes of gnarly hemlocks that had been pruned and scarred by storms and by the picturesque rot that inevitably comes with time.

As a boy I gloried in Ohiopyle because it was so easy to make believe that I lived in another era. I could imagine the Iroquois of James Fenimore Cooper stories appearing on the jagged outcrops of sandstone, and meeting them, joining them. More important, the Youghiogheny flowed wide enough that I could imagine traveling on it. In this consummate adventure, I would launch a log raft in the big eddy below the falls. After kicking off from shore, I would brave the rapids, one by one. I wanted to do this so badly that I had to be careful not to think too much about it. But the fantasy returned again and again: I would kiss security and boyhood good-bye and face the great unknown as the river swept me mercilessly away from all that I had known in order to learn what I needed to know.

Where did the river go? I wondered.

What would I see if I went there?

Then one day I spotted three older boys inflating a yellow raft and carrying it into the river. They cinched their army-surplus life jackets and paddled without hesitation into the non-negotiable suck of the current.

They were living out my dream. As I did when I saw my first duck, I ran back to my grandmother's house with the news. Envious of what those older kids were doing, I knew that to navigate the Youghiogheny still lay beyond me. But I couldn't help wondering if someday, maybe someday I could take the plunge downriver myself.

On a quieter hike a few years later—all alone, as usual—I climbed over big stacks of Youghiogheny rocks and emerged on a flat ledge above a whitewashed rapid. I sat down to rest, and to look, and to listen.

Warm, moist evening air scented with July's rhododendron flowers filled my head, but nothing was on my mind, absolutely nothing. I just leaned against a timeless rocky backrest and watched

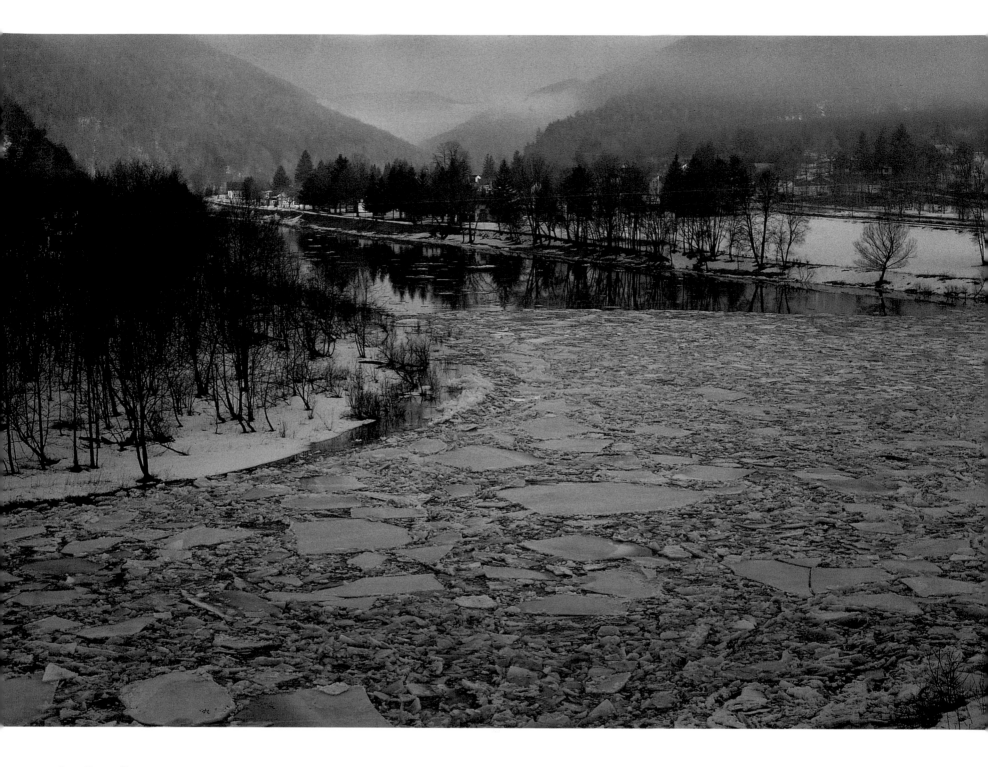

PINE CREEK, PENNSYLVANIA
On Pine Creek, at the village of Cammal, a whole winter's accumulation of ice breaks up and begins to
flow downriver as the water rises with the onset of spring.

the water flow. The sun set toward the steamy profile of Appalachian forest, and the last yellow rays of light glinted through the branches and made sparkles on the water, which after a while began to play tricks on my eyes. Spray shot off like fireworks, and the constant movement now and then seemed to stop while the rest of my world launched into dizzying upstream motion.

I was entranced.

The sound filled me up as well, and the rest of the world could have been a thousand miles away.

Then, suddenly, it occurred to me: "This place is perfect."

All this happened after I had followed my own home stream the whole way to the Ohio River, and so I knew why this place on the Youghiogheny was perfect. Quite simply, it had been left alone. It was natural. Like my Ohio River revelation, this one derived solely from what I saw. At the time I hardly knew anything about rivers.

When it got dark I had to go home, and this time I couldn't tell anybody what I had seen or what had happened, because nothing had really happened at all. Yet somehow my world had changed. I now knew something that I hadn't known before.

I didn't realize that this had been a defining moment for me, and I was certainly not aware that it marked a step toward a lifetime of knowing rivers. But there beside the Youghiogheny, on a warm summer night, I had somehow bonded with the flow of water. I loved it. And I wanted more.

But the time for rivers had not yet come in my life. With adventurous dreams shelved way back where it wasn't evident if I'd ever live them out, I left for college. Eventually I found my way to the field of landscape architecture. I embraced the basic premise of that fine profession: both art and the beauty of nature can be integrated while designing outdoor spaces for practical use. However, I was troubled by the mandate that put development first. This, I soon realized, owed to who paid the landscape architects for their services.

Our professors at Penn State assigned realistic projects: say, arrange fifty condominiums on five acres being split from a local farm at the edge of town. I enjoyed the game of shuffling blocks on models and shaping contours, of curving entrance roads and planting borders so they looked like the real woods where I had grown up. But I always wondered: were condominiums the best use of that property? Siting fifty of them while incorporating usable and attractive open space was a worthwhile challenge, but I still had to ask, should anything be built there at all? The land might better be

left as a farm. Following this line of thought, it seemed to me that riverfronts might better be left to the forces of floods, the work of beavers, and the rule of natural law.

Near the end of my junior year an opportunity to confront these kinds of questions came my way. I had drawn up a plan for a bicycle trail in the town that surrounded Penn State University. I designed a type of plan that would later be called a "greenway." After I showed my drawings to a group of local residents, a tall, gray-haired man approached me and asked if I'd be interested in working on a watershed-based plan for a large stream called Pine Creek.

"What's a watershed?" I asked.

He patiently answered that it was all the land that drains into a particular stream. I immediately thought of my home ground, where I had grown up at the top of the ridge, which drained toward the spring, and then into the stream, and later into the Ohio River. A forester by profession, Dr. Peter Fletcher wanted me to see what a nature-based planning approach might suggest for how the Pine Creek watershed of northern Pennsylvania could best be used and protected.

I jumped at the opportunity. The first task was to canoe the river and inventory everything I saw.

Through a whole year of mapping the floodplains and the wetlands, of plotting the steep slopes and the wildlands, of checking in the field for the most beautiful views, the essential wildlife habitat, and the nuggets of local character such as giant trees or big rock outcrops, I fell deeply in love with that elegant river on the eastern incline of the Appalachian Mountains. I went there often—fall, winter, and spring. I never wanted to leave. It was the place of my dreams.

Learning about rivers and how they work, I realized that my early childhood impressions had hit the mark, two bull's-eyes. The Ohio River was ugly because it had been damaged, poisoned, ruined. The Youghiogheny was beautiful because it was intact, its natural cycles still functioning.

As a designer and then a planner, I learned that the most important thing in caring for a river was to protect the land that floods. Cleaning up the pollution from towns and thousands of septic tanks was also necessary, and proper stewardship was needed for the headwaters where the runoff began. I learned that the quantity as well as the quality of water in the river spelled success or failure to all the life around it. I learned that river life included everything from algae to sycamores, everything from mayflies that

were snatched up by rainbow trout to beavers that checked erosion on tributary streams. All the pieces had to be handled carefully or the whole wouldn't add up to a healthy system.

Armed with new knowledge and a lot of enthusiasm, but clueless about the scope of political difficulties lurking ahead in my path, I wanted my work to make a difference. So, after graduation, rather than taking a job designing real condo complexes on farms at the edges of towns, I decided to put my Pine Creek plans to work.

A fishermen's group called Trout Unlimited pitched in money to get me started, and I dove headfirst into the whirlpool of politics that surrounds every question about the future of every river in America. I persuaded the State Bureau of Forestry to set aside a few of the finest tributary streams as Wild or Natural Areas—the highest form of watershed protection. I tried to get local governments to zone their floodplains to prevent development that would otherwise eliminate the best habitat and cost millions of dollars in damage when the flood inevitably came. A few years later, after the greatest deluge in history scoured the valley, the floodplain zoning approach succeeded. I also persuaded the Nature Conservancy and the state to buy some of the most important stream frontage for open space. And every day I paddled a canoe.

I canoed every day because I lived in a cabin on the other side of the creek from the road. At first I borrowed a boat from a friend. Later I bought my own. I paddled across Pine Creek to the village of Cammal to pick up my mail, to buy groceries, and to drive out to anywhere I had to go.

Whenever I got the chance, I slipped the canoe into the water for a longer trip. Enduring my share of mistakes, I eventually learned how to read the rapids. I learned when to go ahead, when to stop and look, and when to carry the canoe around. I learned how to angle into big waves and how to push through holes that could otherwise completely swamp the boat.

My Pine Creek work led to a job with the local county as a land-use planner, a career that lasted eight years and required that I consider all aspects of rivers and their uses. I worked with streams as small as Trout Run, where I dipped a bucket to get drinking water just outside my cabin, and as wide as the Susquehanna—the largest river on the East Coast of the United States.

To truly know that great waterway, which ran down the centerline of our county, I decided to spend my vacation canoeing from the uppermost point where I could float my boat all the way to the

Chesapeake Bay. For eight days and 230 miles, with my friend Bob Banks, I thrilled at the vastness of a long river and at the epic nature of its journey, mountains to sea. Every bend brought another view—another perspective on the world. Camping on islands, I felt as wild and adventurous as Huckleberry Finn.

Each day was different from any that I had ever lived, yet each was also the same in its free-flowing routine of breaking camp, dipping our paddles into glassy pools or agitated riffles, swimming alongside the boat in the heat of the afternoon, and sleeping under a dome of sycamores. I entered the realm of river time, when life moves with the cycles of season and sun, wind and current. Morning mist burns off as the day warms; the wind blusters as the heat on the land intensifies; the speed of the current ebbs and accelerates in a sequence of pool, riffle, pool, riffle.

As I lived out these moments, hours, and days with intense awareness of my environment, the Susquehanna took a stronger and stronger hold on me. I realized that, along a river, I could search endlessly for beauty—and find it—a practice that increasingly motivated me. I started taking pictures and became fascinated with the challenge of capturing the kaleidoscope of scenes and the ever-changing moods of flowing water.

I learned a lot on that trip. Floating along for miles and miles, I gained a greater understanding of the wholeness of a river. The many parts that I had seen separately and that appeared with their own place-names on the map all began to link together as one. With this awareness of connections, I better grasped the value of the entire river. Instead of separate parts, which can easily be split off and then commodified, I saw the river altogether, each part critical to the rest, the whole stream like one big organism, elegant and complex. Knowing the river in this way, I could better understand the damage of a strip mine here, a feedlot there, a clearcut here, a highway encroachment there.

In all this I sensed the close ties between forest and fish, between mountaintop and sandbar, between flood flows and groundwater surfacing far from the Susquehanna itself. It all seemed evident, but I wanted to know more about all these things and to be able to show the connections and the beauty of the river's wholeness to other people.

Out there overnight, one thing I knew for sure was that rivers offered the best way to travel. Everything I saw and did—watching a mink scrambling along the shore, cooking over a fire, dodging rocks

in rapids—all of it was just fine, but the river as a means of going somewhere was the main thing. The Susquehanna had become my way of seeing America.

Deeply satisfied after that trip, yet highly motivated as well, I wanted to see the other great rivers of the East. Even more, I wanted to see the streams that flowed off the steep slopes of the Rockies, the Cascades, and, most of all, the magnificent granite rise of the Sierra Nevada.

Then, through a friend I had met at a river planning conference, I heard about the Stanislaus in California. This Sierra river splashed down from snowy mountains, into a green belt of cedar and Sequoia trees, and then past rugged foothills. It churned through the deepest limestone canyon on the Pacific Coast, where more people went whitewater rafting than anywhere else in the West. This canyon was also the most contested dam site in American history. In 1979 the river remained a paradise, but it was soon to be lost, forever, and for no good reason other than the lingering momentum to dam every wild river in a state whose official animal was the grizzly bear—long extinct.

I quit my planning job to write a book about a band of Stanislaus activists who called themselves Friends of the River. With them I floated the rapids, camped on sunny beaches, swam in lucid pools at twilight, and labored day and night writing about our river, weighing arguments for its use and protection, and persuading people from local officials on up to the governor and president to try to spare one of the most extraordinary places I had ever known, and ever will know.

We lost that fight. The flatwater of New Melones Reservoir entombed the Stanislaus River canyon and all the sandy beaches, the bubbling rapids, the riverfront caves, and the village sites that Miwok Indians had occupied for millennia. Each scene of artistic splendor disappeared, inch by agonizing inch, foot by excruciating foot, until it was gone, utterly gone under a muddy gloam six hundred feet deep. For me and for thousands of other people who had come to know and love the place, the death of the Stanislaus brought a wave of despair, but more important, it triggered a resolve that nothing so precious should ever be lost again.

With this great river gone, and a great emptiness where the Stanislaus had lived so briefly but vitally in my heart, I returned to write a book about my own river, the Youghiogheny, which survived as I had known it. The river had actually improved with the treatment

of coal-mine drainage that earlier stained many tributaries orange with iron and acid.

While I had been away, the secluded Appalachian enclave of my youth had become the most popular whitewater run in America. The family homestead had been sold for a state park in Ohiopyle, so I could no longer use my grandmother's house. But wanting no encumbrances, I lived happily out of my van and worked on my book above the banks of that long-familiar stream.

I reasoned that to tell the story of a river, I had to start at the beginning. Therefore my first task was to seek out the headwaters, high on the Youghiogheny–Potomac divide. No path led to this special place. But beyond a thicket of rhododendron and greenbrier I found a diminutive trace of water that flowed just like the spring of my childhood, though this spring was fully wild, untended by anyone's great uncle. From this new Source in my life, I followed the tumbling route downstream. Ironically, like the first stream of my

SUSQUEHANNA RIVER, PENNSYLVANIA
Upstream from Harrisburg, the sun rises on the Susquehanna, the largest
East Coast river south of the Saint Lawrence.

youth, Youghiogheny waters ended up taking me the whole way to the Ohio River.

After living for months by the Youghiogheny, I finally set my canoe alongside the pool below the Ohiopyle Falls. I drew in a deep breath as I cinched my own life jacket. Then I kicked off from shore the way I had dreamed of doing so many years before.

The rapids of the Youghiogheny were larger, rockier, and whiter than anything I had ever run, but I had learned the finer points of leaning the bottom of the boat away from the jets of crosscurrent, of catching eddies and stopping in the middle of swift flows, of surfing on the slick green waves. Doing all this on the river of my youth now exhilarated me, and the airy lightness of bubbles beneath the boat lightened my spirit as well. I couldn't help laughing out loud at my good fortune—being in a boat, on a river—a natural river. Nothing could be finer.

I learned to identify real danger compared to the usual whitewater rush. I learned to use the flow of the river rather than to fight it. Except, sometimes I had to fight as well: the Youghiogheny pounded into the face of an ominous boulder. I had to move to the left. I *had* to! Paddle harder! *Harder!*

I learned about total engagement—being so focused on the complexities of the river ahead that the rest of the world completely disappears. Then, when I returned, the rest of the world looked fresher and brighter.

In seeing the whole river, from beginning to end, I found that it offered values that are practical, ecological, social, and economic. Furthermore, it served up important lessons, along with metaphors of many kinds. One of these has survived the ages because it fits so well: the source and headwaters symbolize youth. The small but increasing flow offers promises of many kinds. Growing larger, the river reflects adolescence, and the rapids are chaotic, risky, exciting. Then the widening waters signify maturity. Some rapids here are huge, and in other places headwinds blow upriver through miles of flatwater. Finally, with a broad and gentle current, the lower river denotes old age, the mysterious and infinite ocean ahead. For anyone floating on those waters, the approach to the sea is inevitable, unstoppable with the force of the whole river pushing from behind.

Like the rest of life, rivers flow unceasingly—forever different, yet forever the same. They bring life to the land around them, and at the same time they reflect everything that we do to the land that lies upstream. Traveling on rivers, I always had to accommodate changes, surprises, new impressions, greater meanings. Rivers are lifelines in so many ways.

These early experiences on waterways led me to an unending pursuit of knowing, writing about, and photographing rivers. When I later lived along the Salmon River of Idaho, and rafted its four-hundred-mile length, I learned about the wild chinook and sockeye that gave the river its name. I realized that these charismatic fish were endangered and would likely go extinct unless changes were made to the dams blocking their path downstream in the lower Snake River. For me, the salmon came to symbolize the importance of all life connected to the rivers—a community of creatures unmatched, irreplaceable, essential.

Later, in the southern Sierra, I worked with a group of fishermen to defeat a plan to dam the Kings River, which flows through the deepest canyon in America. There and along other streams, the momentum of destruction that had tragically sealed the fate of the Stanislaus was stopped. But what happens now in the twenty-first century—in a new era of runaway population growth and the abandonment of political responsibilities—remains to be seen.

I never returned to Sixmile Run—the stream that our family spring water joined on its way to the Ohio River. But I've been back many times to the Youghiogheny, where that showcase of whitewater was included in a state park, and protected. I still go down and sit on the rocks whenever I can, and when I relax with a timeless sandstone boulder as a backrest on a warm and sultry summer evening—especially when rhododendron flowers scent the air—the power of it all is so strong that the years evaporate and disappear, leaving me right where I was the very first time. I'm back there again, seeing a wondrous river as a new and vital force in my life.

Since I first sat there, bonding to the flow of water, I've canoed or rafted on nearly three hundred different rivers. I've written books, worked for groups trying to save their rivers, and spent months at a time along dozens of different streams. Living out my lotic dreams, I've learned all I could about everything that rivers touch.

Hundreds of rivers in every part of the country have drawn me to their edges and their centers, to sunrises, sunsets, and moonlit nights along watery green shores from one ocean to another. Now I'd like to show you what I have seen.

29

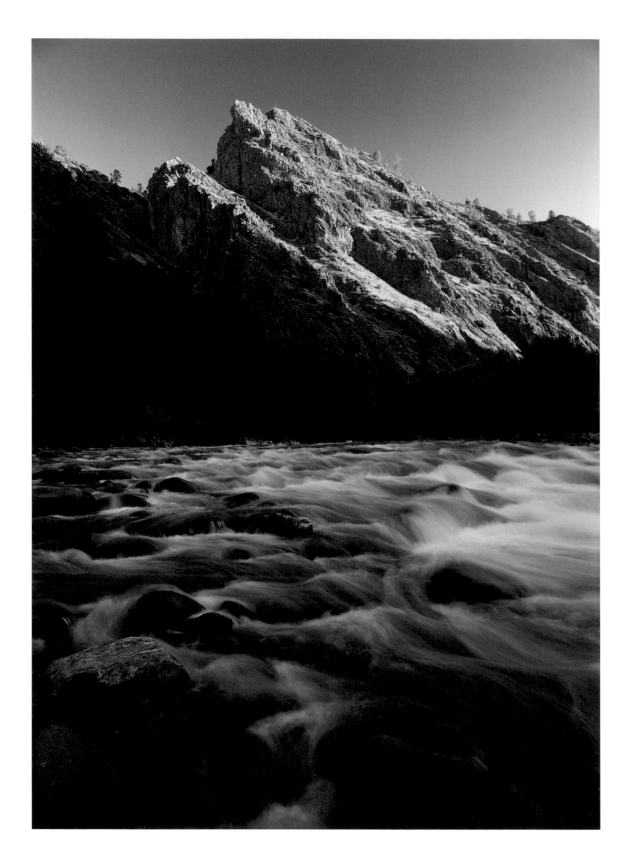

STANISLAUS RIVER, CALIFORNIA
With the deepest limestone canyon on the Pacific Coast, the Stanislaus of California was once the West's most popular whitewater river. It is now flooded 600 feet deep by a reservoir behind New Melones Dam.

SALMON RIVER, IDAHO
One of the great free-flowing rivers of America, the Salmon collects its water from the Sawtooth Mountains after a summer thunderstorm near the town of Stanley.

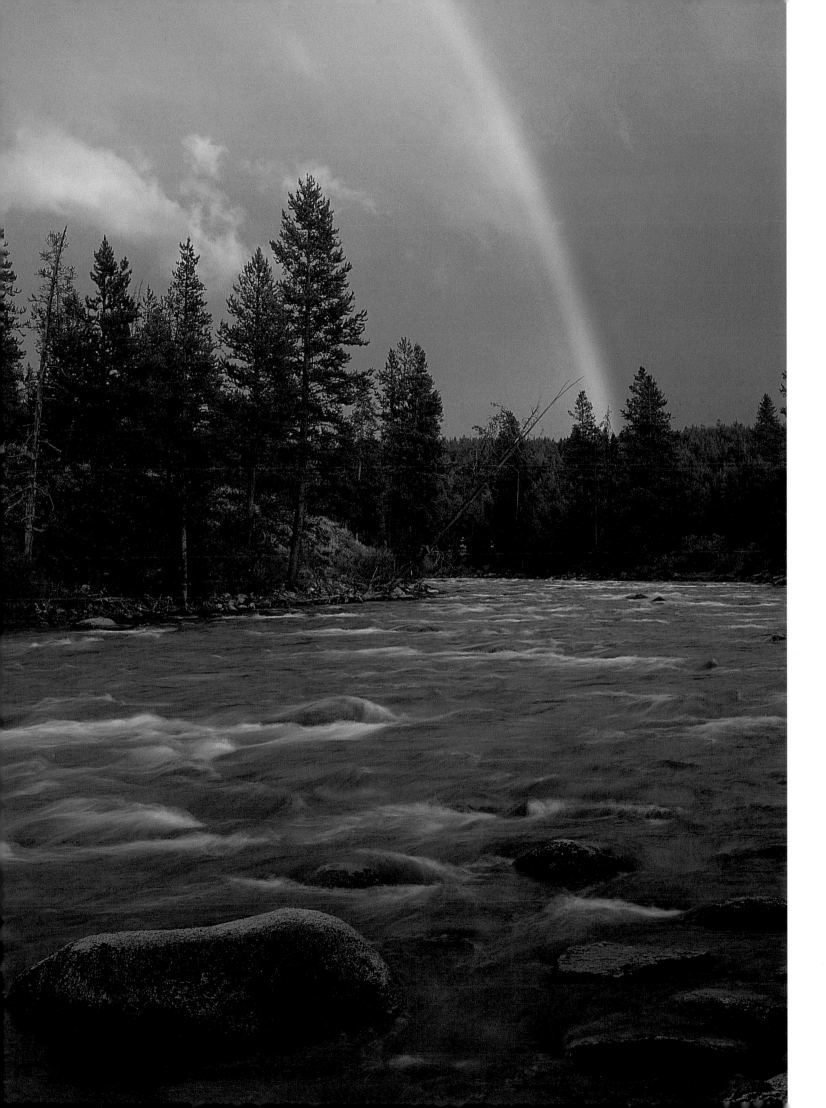

32 KINGS RIVER, CALIFORNIA
Suffused in the green of fresh grass and oak trees, the Kings River winds through its foothills canyon in the Sierra Nevada. A group of local anglers
defeated a proposal to dam this section of the river in the 1980s.

MISSISSIPPI RIVER, MINNESOTA
The upper Mississippi drifts past islands shaded by silver maples and
ash trees near the town of Royalton.

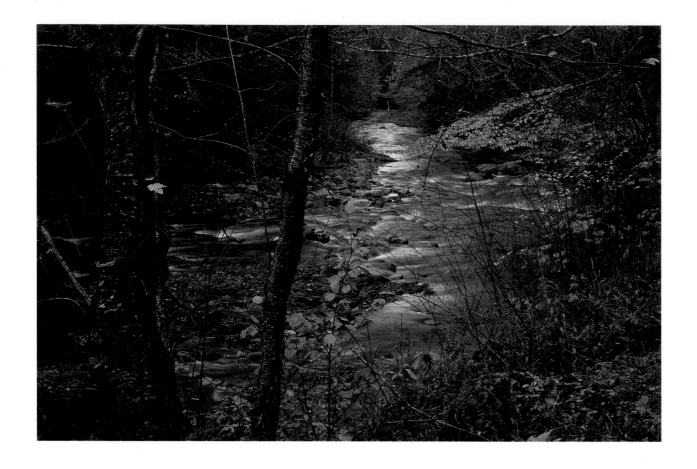

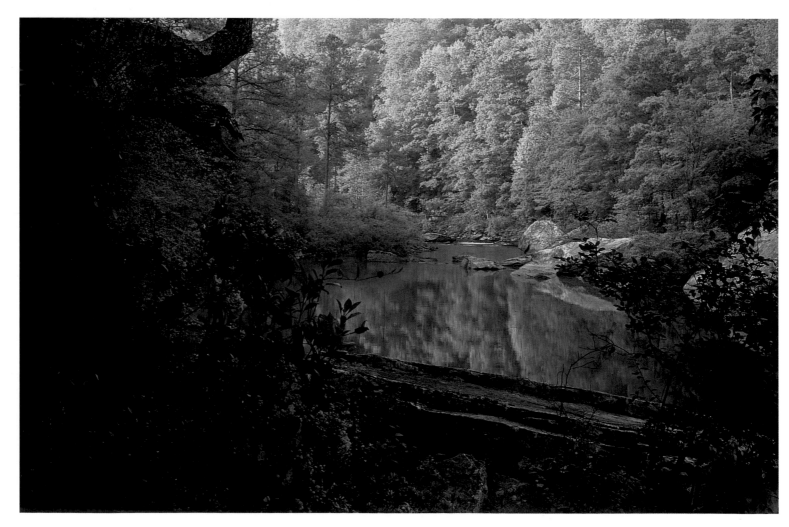

34

MISSISSIPPI RIVER, WISCONSIN
Raindrops fall on the Mississippi as the sun sets near La Crosse.

MIDDLE BRANCH WESTFIELD RIVER, MASSACHUSETTS
Autumn brightens the Middle Branch of the Westfield, a tributary to the Connecticut River.

LITTLE RIVER, ALABAMA
One of the southernmost Appalachian streams, the Little River cuts through a deep canyon in
northern Alabama before it joins the Coosa River.

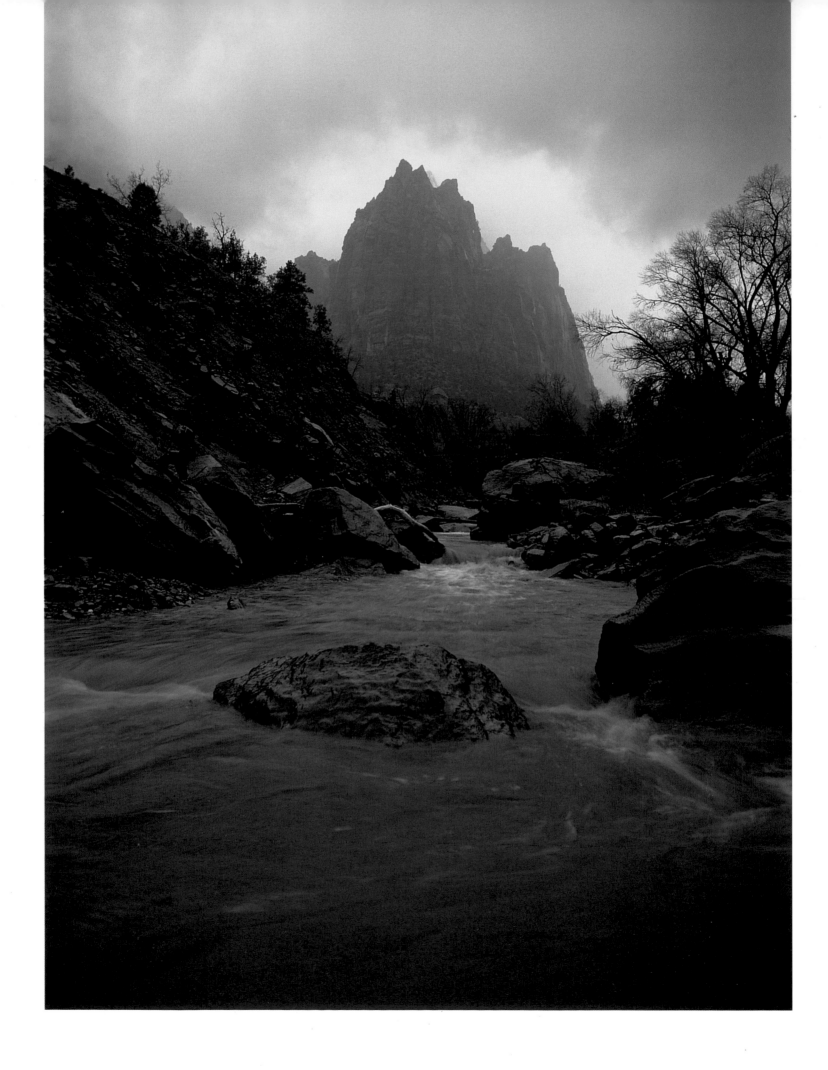

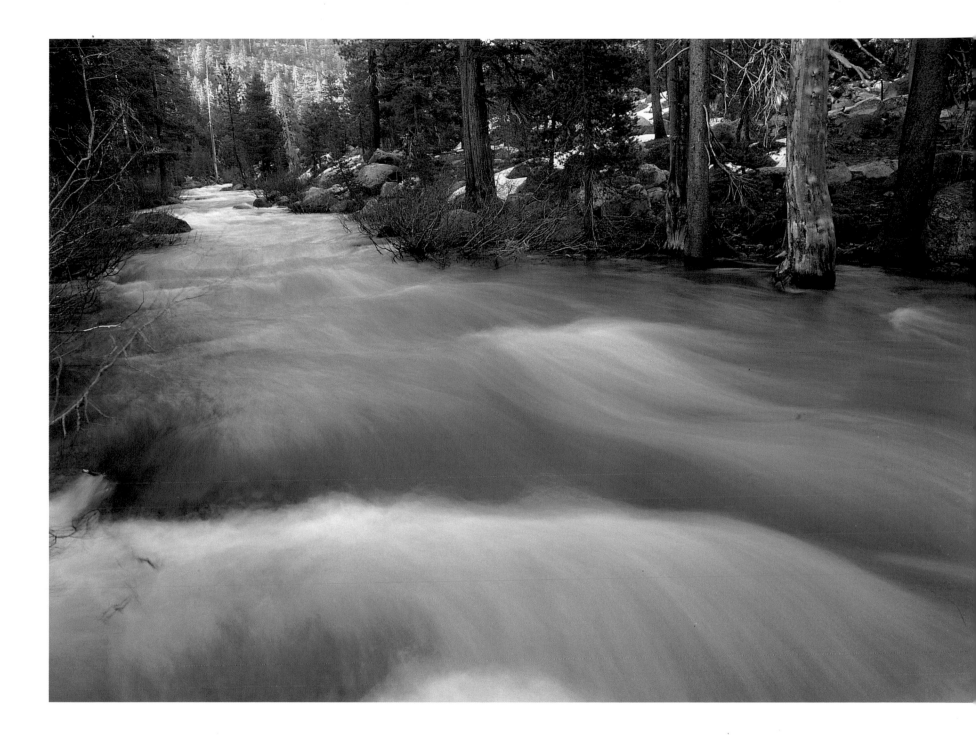

NORTH FORK MOKELUMNE RIVER, CALIFORNIA
Running high in springtime, the North Fork Mokelumne rushes through Sierra high country before disappearing
into a remote and forbidding canyon.

VIRGIN RIVER, UTAH
Incised among monoliths of desert sandstone in Zion National Park, the Virgin River is
darkened by capricious storm clouds and rain.

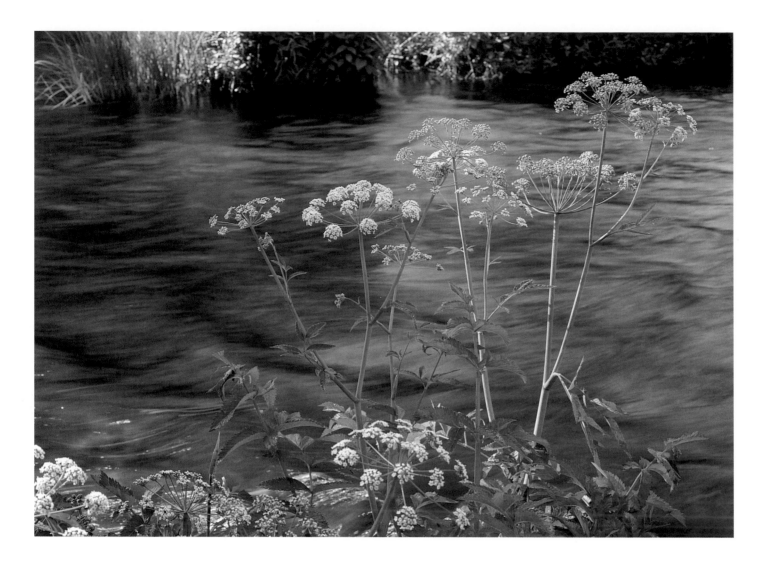

METOLIUS RIVER, OREGON
Bubbling up from a steady plume of springwater, the Metolius River in central Oregon has a remarkably
stable flow, allowing water hemlock to grow without disturbance at its edge.

ALSEK RIVER, ALASKA
Obscured by fog, rain, and clouds, the glaciated country surrounding the Alsek River
rises to staggering heights above the massive Alaskan waterway.

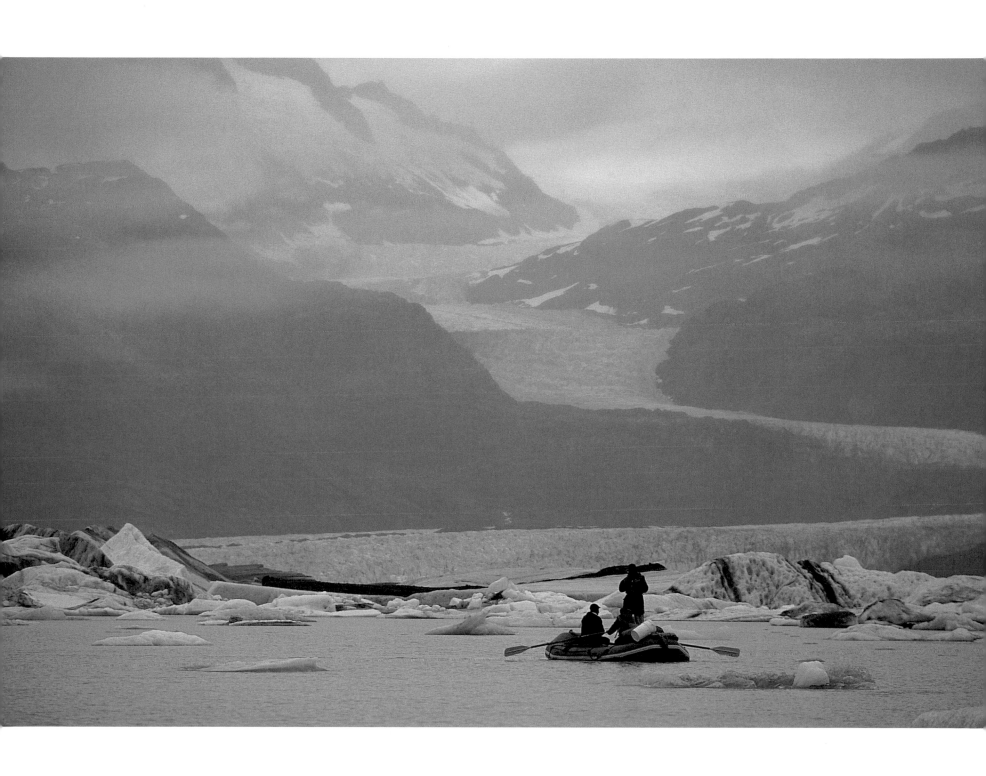

The Flow of Life

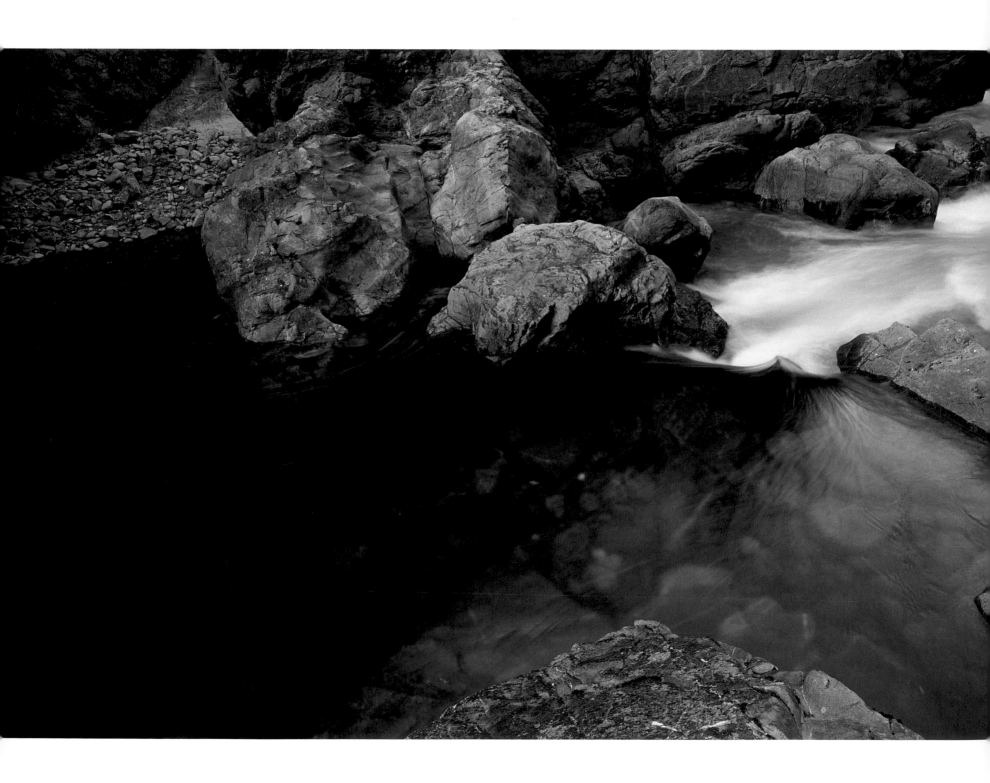

THE EYE IS ALWAYS DRAWN to motion, and the river moves all the time. Though I can find beauty in almost any natural landscape, the rest of the planet looks like a still life compared to a river. Flowing water is the great animator of the earth.

The eye is also drawn to life, and life thrives at the river—in it, on it, next to it, under it, over it—suffused.

All this life is well served in crucial and connected ways by the same qualities that make a river beautiful—its motion, color, seasons, shoreline, trees, rocks, geologic setting, wetness, weather, and full complement of native wild creatures.

I don't think about why I love rivers. I just do. And when I take pictures of the rivers' liveliness and moods, I don't think about why the stream is beautiful. It just is. But when I write about rivers, all kinds of relationships cross my mind, some as obvious as the effects of gravity and thirst, some as abstract as a hydrograph of the flow or a chart showing how the water's oxygen content peaks and dips each day and night.

If I were not the writer but only the photographer for this book, I might be satisfied not to pursue my thoughts about rivers any further than this. The camera, after all, offers a distinct advantage over the pen. As the saying goes, each picture is worth a thousand words. I have no intention of trying to catch up in this book by writing a thousand words for each photo I've shot, but I also know that even the best of pictures alludes to only certain truths about rivers. Plus, I'm drawn to questions that are not answered by photos alone. Rivers are beautiful, yes, but why else are they so important? How do they function within the greater cycles and overarching schemes of nature?

Camera in hand, I'm lured to the beauty of river places, but each river also reveals a story that goes to the core of how life on earth really works. Searching for that story when I write, I pursue underlying meanings of the shapes, the colors, and the movements that I see and that I capture for others to see with each click of the shutter.

My intuition along the Ohio and Youghiogheny Rivers years ago told me that beauty is good and ugliness bad. An easy stepping-stone from there took me to a corollary: beauty works in the ways of nature but ugliness does not.

Set up for this truth by my own experience, I was deeply gratified when I first read *A Sand County Almanac*, written by one of America's greatest conservationists, Aldo Leopold. A forester and ethicist with vision, and a master of his field, he wrote, "A thing is right when it tends to preserve the integrity, stability, and beauty of the biotic community. It is wrong when it tends otherwise." Few others have had the courage to say forthrightly that beauty can be a useful guide for discerning right and wrong in what we do to the earth.

Now, years later, when I wade waist-deep into rivers to photograph them, I'm also immersed in this relationship between beauty and purpose, between scenery and ecology, between the pictures I shoot and the knowledge of what is actually happening in the water. The photographer in me wants to see it all, and the writer in me wants to understand it all, the combined effect taking me to many places and many ideas. So let me start at the beginning.

IF IT WEREN'T FOR WATER, there wouldn't be life. Everything that lives needs water, and rivers are the water supply of the world.

Even more fundamentally—if that's possible—without rivers there wouldn't be a hydrologic cycle. In this essential operating system of nature, water circulates from the oceans to the clouds, then to the rivers, and finally back to the oceans. Rivers are what carry the rainfall and snowmelt back to the sea. Put another way, the streams form the connecting link between the atmosphere, which delivers water to the land, and the ocean, which is both the water's source and its destination. Without this cycle, the earth would be a dead planet.

While carrying out this vital linkage, rivers do no less than shape the earth and give it the forms we live with and depend upon every day. Tectonic and volcanic forces have built the land up; now rivers wear it down and sculpt it into the usable places we know. One might think of rivers as the great refiners of our landscapes, or perhaps as the benevolent interveners that make the blackened cinder cones of volcanoes and the sawtoothed scarps of seismic upheaval inhabitable to us. Valleys, canyons, flat floodplains, open basins as large as Los Angeles, and the incised fingers of erosion clawing into plateaus and mountain ranges everywhere owe their existence to the work of rivers. Even the continental scale of relief in dry and seemingly flat regions such as the Great Plains, which tilt gently from the base of the Rockies toward the banks of the Mississippi, follows

SMITH RIVER, CALIFORNIA
The lucid clarity of the Smith River reflects the condition of its watershed—all the land that drains into the river. Percolating through the spongy soil of wild, uncut forests, the runoff here is silt-free and prime for salmon and steelhead that spawn in gravel beds rinsed by flowing water.

from the earth-moving power of rivers. This great force, sometimes chiseling, sometimes aggregating, includes the glaciers as rivers of ice—the geographic master builders that so artfully rearranged North America in Pleistocene times.

The rivers' landscaping power appears evident in the intricate, carved-out maze of the Grand Canyon, the idyllic repose of the Connecticut River Valley, and the swampy bottomlands of the Mississippi, Waccamaw, and Altamaha. Rivers and their tributaries have created our deepest canyon: the South Fork of the Kings in the Sierra Nevada, which flows eight thousand feet beneath the peaks around it. No less important, rivers have bequeathed us with the tiniest ravines where water collects behind our houses and along our roads.

Rivers complete the hydrologic cycle, they shape the earth into the landscapes we know, and then they make our own lives possible. Water constitutes 70 percent of our bodies. In a hydrocentric spin on the creation story, God invented people so that water could walk from place to place. We *are* the river that flows nearby. Tonight, pick up a child you love and realize that most of his or her weight came from a river. Step on the bathroom scales for an even more personal version of the same lesson. Perhaps the deep-seated fascination that people have with water has something to do with this most ancient of dependencies: the rivers flow in our veins.

Without pipes plumbed to sinks and toilets, Americans know that their lives would be quite different. Yet we ignore the fact that water gushes out of the kitchen tap only because the other end of the pipe is connected to a river, or at least to groundwater that is linked to the surface flow. Whole cities would dry up and blow away if it were not for a river nourishing them every day of the year.

Beyond pipes and plumbing, rivers are important to our communities in many ways. We go to the waterfront for recreation, and this is more than frivolous amusement. *Recreation* means re-creation in the most vital sense as we restore our spirits, balance our psyches, and put our bodies to work breathing hard, having fun, staying healthy. River recreation is also an economic boon. Forty-four million anglers generate $116 billion a year in the national economy. Twenty-four million people each year go canoeing, kayaking, or rafting in the United States, according to the American Canoe Association and the Forest Service.

Even more important, rivers support a fabulous diversity of life and they host a web of interactions that benefit people in myriad ways. Like arteries feeding the organs and limbs of the body, rivers feed the greater organism of life on earth, each piece depending on other pieces, all of them connected by water. The functioning of this metasystem of life requires not just rivers, but healthy rivers.

As both a photographer and writer, I'm interested in the connections between what I see at the river and what the river does for all of life, and so for awhile I'd like to pursue the ways rivers actually work in the natural world. I'd like to consider how that work is evident in what we see at the water's edge or when we simply turn the pages of this book and look at pictures of wild streams.

More than two out of three wildlife species depend directly on rivers and riverfront land at some stage of their lives. Microscopic creatures need clean flows; in turn, insects and invertebrates need the microscopic life; small fish need the insects and invertebrates; large fish need the small fish; bears, eagles, and people need the large fish.

This sequence describes the food chain, and its entire cast amazes anyone who takes the time to see. Down at the river, a tiny minnow scurries, sometimes moving many pounds of gravel to prepare her spawning bed. At the top of the food chain, snapping turtles grow to ninety pounds (and do not make good swimming partners). Whirligig beetles sport double sets of eyes—bifocals, so they can see both underwater and on top. Sturgeon in the Columbia River have grown to sixteen feet long, real lunkers with cartilage-spiked backs dating to the dinosaur age. Loons, larger than ducks, hold their breath for five minutes while diving to snatch fish in their beaks. Dippers walk on the bottom of the river with bird-feet grippers made for underwater use and with special membranes as windshield wipers for eyeballs. Fisher spiders carry bubbles of air with them so they can breathe when submerged. Moose—the largest member of the deer family—wade five feet deep and browse on riverfront willows for much of their diet. In an extravaganza of acrobatic flight, ospreys swoop out of the sky to pluck fish from beneath the surface with their talons. Caddisflies build tiny tubes of sand and live encased in these gritty sheaths until they are ready to brave the outside world, where many are promptly eaten by fish. More than six hundred North American species of mayflies—each delicate and exquisite— make gourmet meals for trout. Frogs respire through their skin while estivating in riverfront mud during the dry months. Otters slide in mud just for fun.

Rivers also contain clams, sponges, snails, rotifers, protozoa, diatoms, crayfish, muskrats, sandpipers, and catfish weighing up

EDISTO RIVER, SOUTH CAROLINA

On the East Coast, the Edisto River crosses the flattened expanse of South Carolina's Coastal Plain and makes its final bends through salt marshes before easing into the warm waters of the Atlantic.

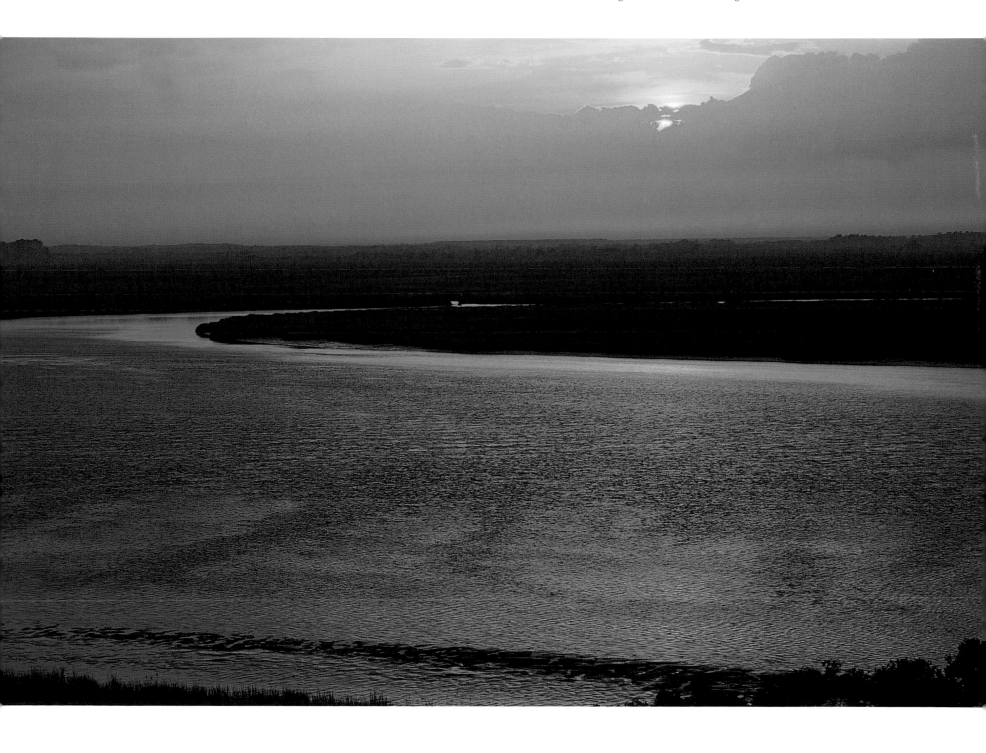

to three hundred pounds with whiskers you don't want to even get near. Early explorers on the upper Mississippi, including Père Marquette, thought these thick-skinned bottom dwellers were sunken logs when they ran into them with their boats. More than half of America's bird species nest near waterways, and the other half would surely not be indifferent to the basic services that rivers provide for all of life.

Take rivers and streams out of almost any ecosystem, and not much would be left. This is true of watersheds as small as the one where I live on the coast of Oregon—a tiny creek draining a couple of square miles into an estuary—and it's true for any one of America's fourteen largest rivers, each disgorging 50,000 cubic feet of water per second (cfs) or more. (The Mississippi is the largest at 593,000 average cfs, followed by the Saint Lawrence, Ohio, Columbia, and Yukon. I somehow feel the urge to continue: the Missouri, Tennessee, Mobile, Kuskokwim, Copper, Atchafalaya, Snake, Stikine, and Susitna.)

Beyond the entourage of individual creatures and happy couples paired up for breeding, whole systems of life depend on natural rivers. Consider the floodplain forests. These are some of the most magnificent and valuable woodlands on earth. Without adequate flows, including occasional floods, the forests dry out because the groundwater at their root tips recedes. Cottonwoods, for example, are tied directly to the flood cycle. Each tree produces millions of seeds immediately after the high water of springtime subsides. Timing is of the essence because cottonwood seeds require a freshly scoured beach or a new deposit of silt in order to germinate. When dams prevent periodic flooding, however, the scouring and silting don't happen. New trees fail to germinate, and being short-lived, the old ones die off. Cottonwoods are keystone species, meaning that many animals depend on them for shelter, nesting, and food, especially in the West. When the cottonwoods disappear, a host of other creatures disappears with them and are gone, simply gone.

The same flood-deposited alluvium of silt and sand that cottonwoods depend upon also holds moisture long after the high water recedes. These flood-borne soils are the deepest and often the most fertile. For this reason, many towering forests grow on floodplains. The tallest groves of coast redwoods thrive along Redwood Creek, the Smith River, and the South Fork of the Eel in California. As the largest tree in the East, the sycamore likewise grows best on floodplain soils. The baldcypress literally stands in water, the king of the southern forest and the oldest tree east of the Rocky Mountains.

The interdependence of forests and rivers is pivotal to life in many ways. Trees cast shade indispensable for keeping the water cool in summer. Furthermore, forests build soil that is full of organic detritus—leaves, needles, twigs, cones, seeds, bark—altogether a rich and porous humus. This soil acts like a sponge when it rains, soaking up the water, retarding its immediate runoff, and releasing the chilled groundwater gradually. The carefully buffered temperatures are important to many creatures such as native trout, which cannot survive if water is heated above seventy degrees. If the trees are all cut down, both the shade that controls the stream temperature and the spongy soil that controls the rate of runoff are diminished.

Trees growing along streams ultimately die, and when they do, a whole new purpose in their lives is born. Some fall directly into the water, where they might remain for years providing cover for fish that hide beneath flooded limbs, trunks, and root balls. The river's flow swishes around the downed trees and forms eddies—slackwater that offers fish a place to rest. They wait there for food, which is always drifting downstream as if carried by a giant conveyor belt in the grandest of all food factories—a natural river running from its headwaters to the sea.

The dead, fallen trees eventually wash loose, float for awhile, then get stuck as logjams on tight bends or run aground on the upstream tips of islands. Not just piles of errant trees misplaced in water, logjams serve essential functions in the anatomy of the river. They cause the current to slow down and pond in some areas and to speed up or riffle in others, depending on how the flow is trapped or deflected.

The logjams also make excellent habitat for fish and for other riverine wildlife, such as otters, because the wood piles are full of cavities—whole apartment complexes for the residents of the stream, some below the water line on the logjam and some above it. Insects feed on the cellulose and make food for larger animals and for birds. Bacteria digesting the wood enrich the aquatic nutrients that increase in the river as it grows. This organic stew feeds everything from the smallest invertebrate and clam to the clever raccoon that grasps with prehensile hands for crayfish. Nutrients broken down by bacteria and particles of rotting wood furthermore benefit estuaries where rivers meet the sea, and the wood contributes to the food stores of the ocean even beyond sight of land. Later—perhaps years

later—many oceangoing logs wash back ashore at distant beaches and create whole micro-ecosystems there. All of these relationships are made possible by the rivers.

The forest belt along rivers is called the riparian zone. Biologists consider this a part of the river itself because it is so enmeshed in the workings of the flow. The stream isn't just blue, but blue and green. It doesn't just end at the edge of water, but continues to the outer edge of the river's influence on plant life in the valley. Whenever I photograph rivers, floodplains and trees are almost always part of the scene.

Like cottonwoods and similar riparian trees, salmon are keystone species—many other species depend upon them. These fish have one of the most remarkable life cycles on earth. Salmon are born at the headwaters or upper reaches of streams, sometimes a thousand miles from the ocean, but they spend several years at sea. This dualism of habitat permits young fish to find safety in the shelter of small streams and adults to find more plentiful food in the ocean.

Young salmon adapt to saltwater conditions as they drift down their river and approach the sea. When they later return as impressive adults, two, three, and four feet long, they power upriver, finning through rapids, leaping over waterfalls, and evading predators of all kinds until they reach the very spot in the tributary where they started out as eggs, two to five years before. An unimaginably acute sense of smell serves them well in finding the way upstream to their birthplace, and a mysterious inner compass apparently enables the ocean-roaming fish to read the magnetic poles of the earth. After spawning, the salmon die, their life-purpose accomplished, their bodies fully spent in the effort.

As with other creatures, the individual dies but the system of life goes on. Far more important than the life of any single fish, the salmon play a role that the rest of the ecosystem utterly depends upon. First of all, many animals eat the salmon directly. Wildlife biologists counted twenty-two species devouring salmon on the Elwha River in Washington. Some predators—most sensationally the brown bears of coastal Alaska—skillfully snag the would-be spawners as they dart upriver. Others animals gorge on the orange flesh after the fish spawn and die.

Even more consequential, after each salmon's last gasp, its body becomes a building block at the very foundation of the ecosystem. The fish that are eaten by predators such as bears and eagles and by scavengers such as vultures and ravens get recycled as fertilizer

on the floodplain or even farther away from the stream. The fish are largely made of carbon, which is the critical element for life to flourish, and much of the carbon along streams in the Northwest originates with the salmon. The fish transport this and other vital elements upstream from the ocean and back to the land in a nutrient cycle made possible only by the impulse of these sleek creatures to swim upstream.

When the salmon go extinct, not only do people miss the opportunity to see these wondrous fish and eat their nutritious flesh, but a host of other species decline for lack of food, and the entire cast of life along rivers becomes impoverished. The life cycle of salmon depends on healthy rivers, and likewise the health of certain rivers depends on robust runs of salmon.

Another fascinating river cycle that underpins whole ecosystems is evident in flooding. While many people regard floods as simply nuisance events that cause inconvenience, danger, and damage to homes built in harm's way, high water plays an elemental role in the work rivers do and in river health. The big flows overtop the banks and spread across the floodplains, allowing surplus water to seep into the soil and recharge groundwater, which later reciprocates by seeping slowly back into the river when the river needs water the most. Without periodic floods, the effects of droughts worsen.

Some fishes spawn and reproduce only on floodplains that turn swampy with high water in the springtime. Others, such as the Colorado pikeminnow, must migrate upriver or down, and they can do this only in the big channels that floods provide. Willow trees need fresh sandy beaches, which are deposited by floods. The willows in turn are needed by flycatchers and a host of their insect-eating relatives; even songbirds need floods.

Even more fundamental to a river's health, floods define the shape of the riverbed itself. During the rush of high water, the force of the current scours out pools much as a backyard hose makes a divot in cultivated soil if you hold the nozzle on the same spot too long. The sand, gravel, and rocks that floods excavate from the pools and pluck from the riverbanks then resettle in riffle areas. Pools and riffles are both necessary parts of a river's structure because some creatures need the deep, cool, dark depths of the pools while others need the shallow, swift, sunny light of the riffles, whose bubbling action oxygenates the water.

In these same riffles, invertebrates attach themselves to the undersides of stones. Slightly buried beneath stones that were

deposited by the floods, mussels breathe and feed in the flushing flow, filtering water that circulates past their bodies constantly. Crayfish find shelter amid the flood-delivered rocks. Because floods create the physical features critical for habitat, the entire community of river life depends on the flush of high water.

Floods also carry sand and silt the whole way to the ocean, and there, even beyond the mouths of the streams, lies another relationship of far-reaching importance to ecosystems and to people. The sand on ocean beaches originally came from soil eroded by rivers and brought to sea during floods. These beaches are constantly under siege by the ocean surf, especially during winter when fierce storms batter the coast and suck the sand out into deeper water. New sand, delivered by the rivers, is needed.

This dynamic system of give-and-take suffers in places where too many dams have been built upstream. There, the delivery of the sand is blocked. Instead of washing down to replenish oceanfront beaches, the sand settles uselessly onto the bottoms of reservoirs, eventually making the dams white elephants of public investment. But long before that occurs, the lack of sand being flushed downstream results in erosion on the seashore where homes and roads collapse into the ocean. This problem is evident on the coast of southern California, where comprehensive damming has halted the flow of sand.

A raging, powerful flood causes enormous disruption when it occurs, altering everything in its path. But in the long term, the changes and renewal that floods bring are essential to whole ecosystems and landscapes.

As if to confirm the importance of all this vitality, the riffles, the rapids, the sandbars, the exposed gravel, and the pools of transparent water in a natural river are far more interesting to the eye than the ponded stillness of reservoirs or the constant glides that result downstream from dams that eliminate the peak runoff. Lacking floods, pools eventually fill in with silt and the riffles gradually erode, reducing the variety of habitat.

A river's pulse can be counted in its floods, irregular as they might be, but a steadier pulse is felt in the turning of the seasons. Beauty and function again correspond in concert with the whiteness of snow and ice; the flowery blooms of springtime; the luxuriant green of summer; the dazzle of orange, red, and yellow leaves that flame in autumn. Small nuances as well as dramatic changes brought with the beauty of each season are all necessary parts of the way nature works, and they are all prerequisites for river health.

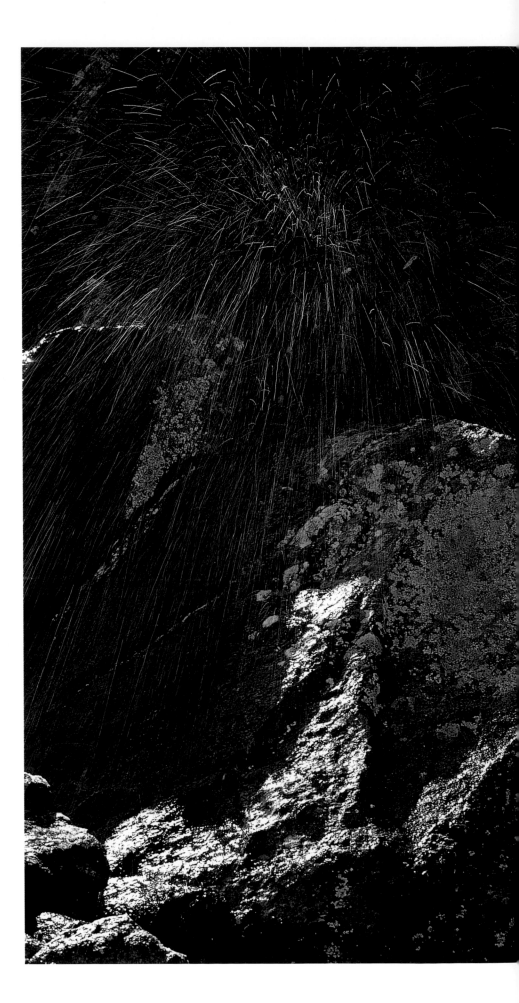

The cold of winter, for example, acts as a trigger telling riparian creatures to rest by temporarily slowing their metabolic rates. Winter also kills pests that can otherwise multiply out of control the way water hyacinth has done in the Southeast, and tamarisk on the floodplains of the Southwest.

Winter means that ice forms on rivers in many parts of the country, and ice is one of the few compounds that does not become denser when it freezes. This fortunate quirk of physics makes all the difference, because ice floats instead of sinks. If it sank, not only would it displace water and force the remaining flow up and out of its banks, ultimately filling whole valleys like an unwelcome reenactment of the Ice Age, but it would also kill the bottom life in the stream during the lean months of winter and thus bankrupt the entire aquatic food chain. Like armor on the surface of the river, ice shelters the water beneath from the harshest cold. When the ice breaks up in the springtime and tumbles downstream, it beneficially scours the bottom of shallow rivers and redistributes silt and mud that can otherwise coat underlying gravel like pavement and prevent its use by insects, invertebrates, and fish.

Many creatures require the warm water of summer, which incubates a nursery of organic life. Creatures of many kinds grow, mature, breed, reproduce, die, and decompose so that others can thrive on the building blocks of the past, which are forever renewed during this productive time of the year.

In autumn, all those fallen leaves—brilliant flashes of color as they spin in eddies—sink and become the fuel of the food chain by providing important nutrients. The community of plants and animals in the river prepares for the colder months to come. At some rivers, especially in California and the Northwest, autumn brings the first heavy rains to arrive in many months and the promise that high winter flows will begin a new cycle of life in the river.

River life needs a mix of heat and cold, flood surges and low flows, nutrient feasts and carbon supplements, all at the correct times in order for creatures to survive in cycles determined by eons of adaptation to the climate and the hydrology of each individual stream. In other words, river life depends on the complexity that's evident in so many beautiful scenes of rivers.

After taking a lot of pictures of rivers, it became evident that I often had to simplify the view in order to make it "read." An intense splay of green or red, a funneling flume of whitewater, a cresting wave breaking in the full light of the sun—these and myriad other phenomena dazzled my eyes and compelled me to take out my camera and focus on another nugget of beauty that I saw. Yet, the complex view caught my attention as well, and sometimes I stared for whole minutes at the ever-changing eyeful of color, shape, and texture confronting me. Now that I knew more about rivers, I knew that every aspect of the scene spoke to the life of the river and of all the creatures that depend on it.

One day, for example, I walked along the Middle Branch of the Westfield River in Massachusetts. Bend after bend took me to riffle after riffle, pool after pool, each adorned with rocks of varying sharpness and shine, each with insects and other invertebrates hiding underneath. Each jet of water spawned crosscurrents where bubbles spun in backwater eddies before being whisked onward to destinations unknown. Tangles of branches hung down over the riverbanks from the trunks of maples, hemlocks, and beech trees, each flaming in autumn color before they dropped their leaves as nutriment to the chain of life resident in the water or streaming past so ephemerally. Each tree would ultimately contribute its entire mass to the river as a fallen snag, as fresh topping on a logjam, and as unseen particles of detritus after the bacteria and bugs had their fill. The lavish complexity of this river, changing by the day and by the minute, was impossible to really capture with a camera. But I caught what I could.

The condition and health of rivers, and their related ability to do the natural work that they intrinsically do, have been compromised in many ways. But rivers still shape the land, pulse with floods and seasonal vigor, support riparian forests and ocean beaches, nurture life of myriad forms, and provide us with water to drink. The more I learned, the more I saw connections between all this beneficial work that rivers do and the beauty that I was drawn to photograph.

47

SALMON RIVER HEADWATERS, IDAHO
Melting from the winter's snowpack, runoff from the Sawtooth Range sparkles in ephemeral waterfalls marking the beginning of a stream that eventually becomes the Salmon River.

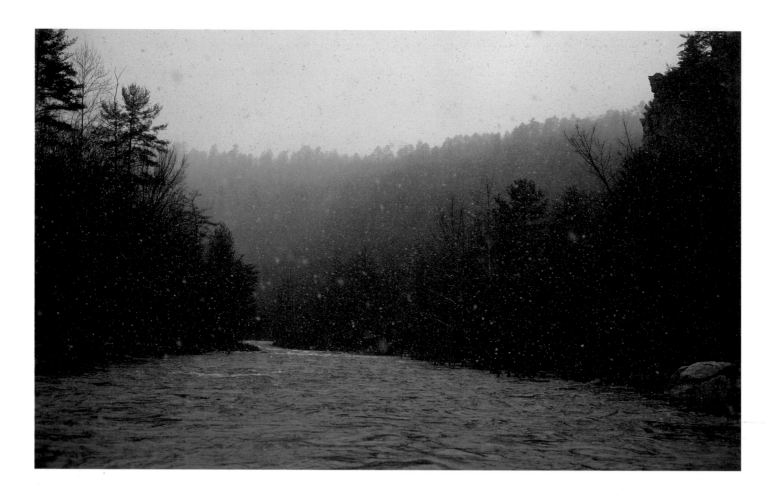

48

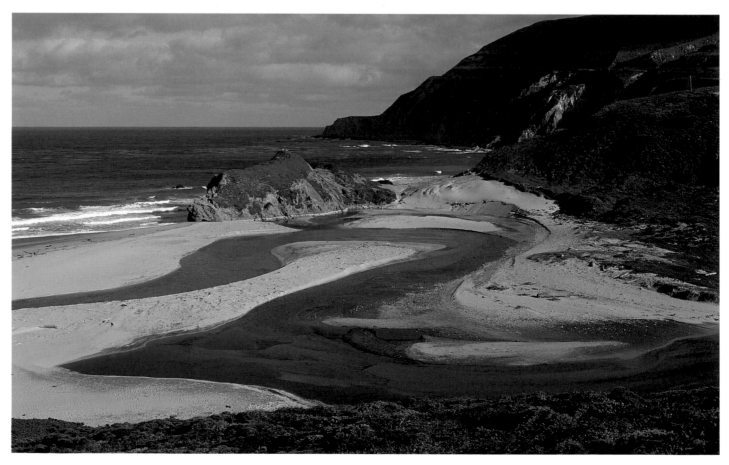

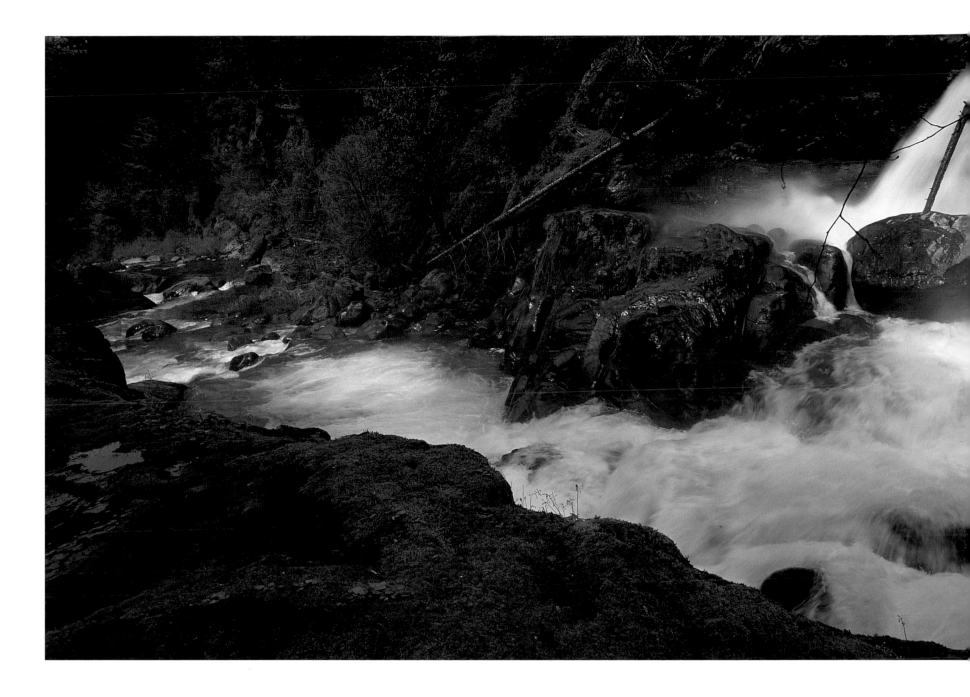

SOUTH FORK COQUILLE RIVER, OREGON
Swelling in size as each tributary contributes its runoff to the larger stream, the South Fork Coquille gains power on its life-giving journey to the sea.

LOST RIVER, WEST VIRGINIA
A winter snowstorm delivers water to the Appalachian Mountains and to the Lost River as it flows toward the Cacapon, which later flows into the Potomac River.

LITTLE SUR RIVER, CALIFORNIA
Completing the hydrologic cycle, the Little Sur River flows from the Santa Lucia Range, meanders across a beach of untracked sand, and ends in the Pacific.

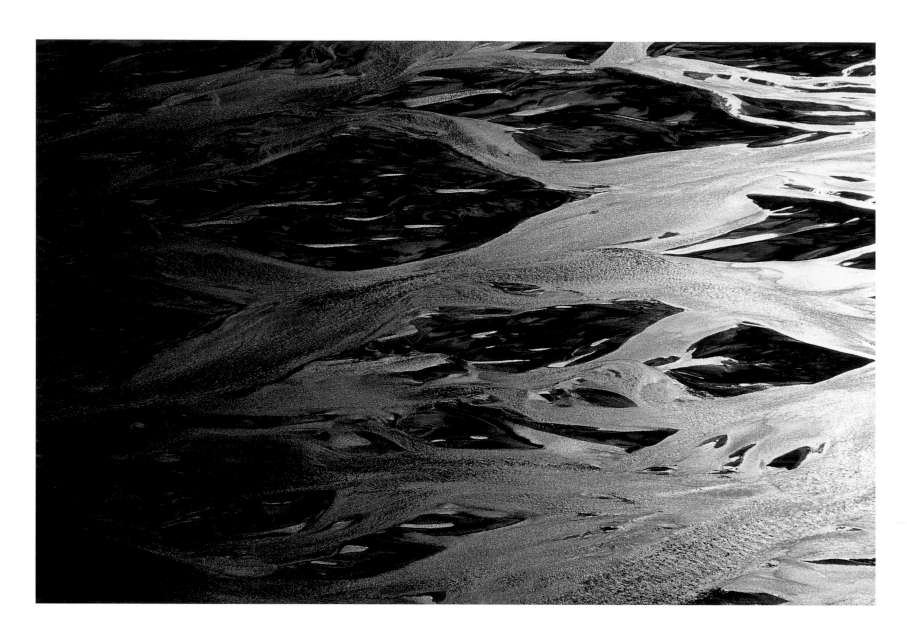

Chilkat River, Alaska
Carrying mountainous quantities of sediment scraped loose by glaciers at its headwaters, the Chilkat River of southeastern
Alaska splits into dozens of braided channels and redeposits the glacial debris of rock, soil, and silt at sea level.

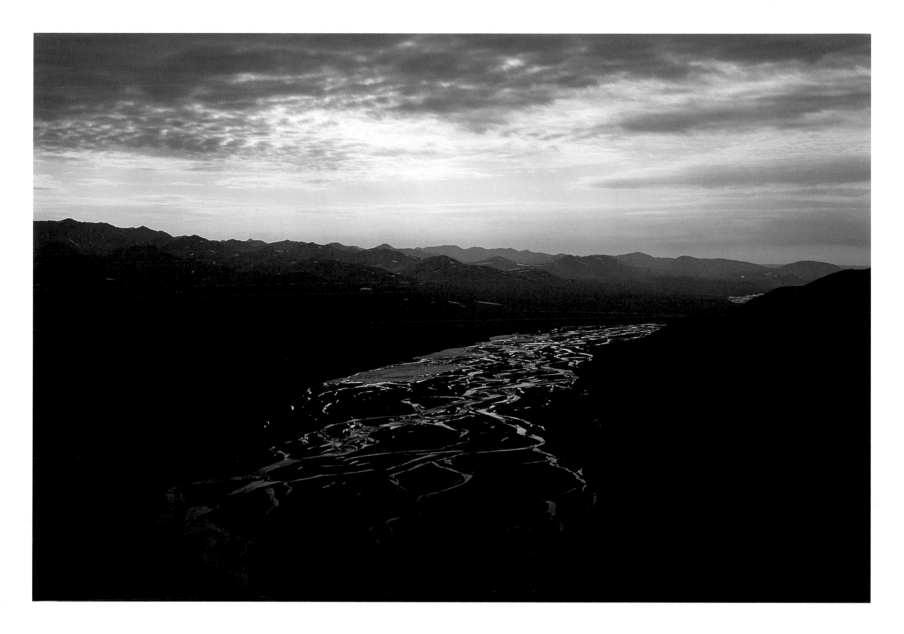

KONGAKUT RIVER, ALASKA

Transporting sediment that comes from erosion upstream, the Kongakut River of northeastern Alaska braids into dozens of
channels and distributes the rock, soil, and silt on the coastal plain in the Arctic National Wildlife Refuge.

Overleaf GREEN RIVER, UTAH

Rivers shape the land by wearing down mountains, molding valleys, sculpting canyons, creating
floodplains, and amassing deltas at the edge of the continent. Here in Dinosaur National
Monument, the Green River has cut through the center of Split Mountain by patiently carving
solid rock while earthquakes slowly lifted the desert massif thousands of feet in height.

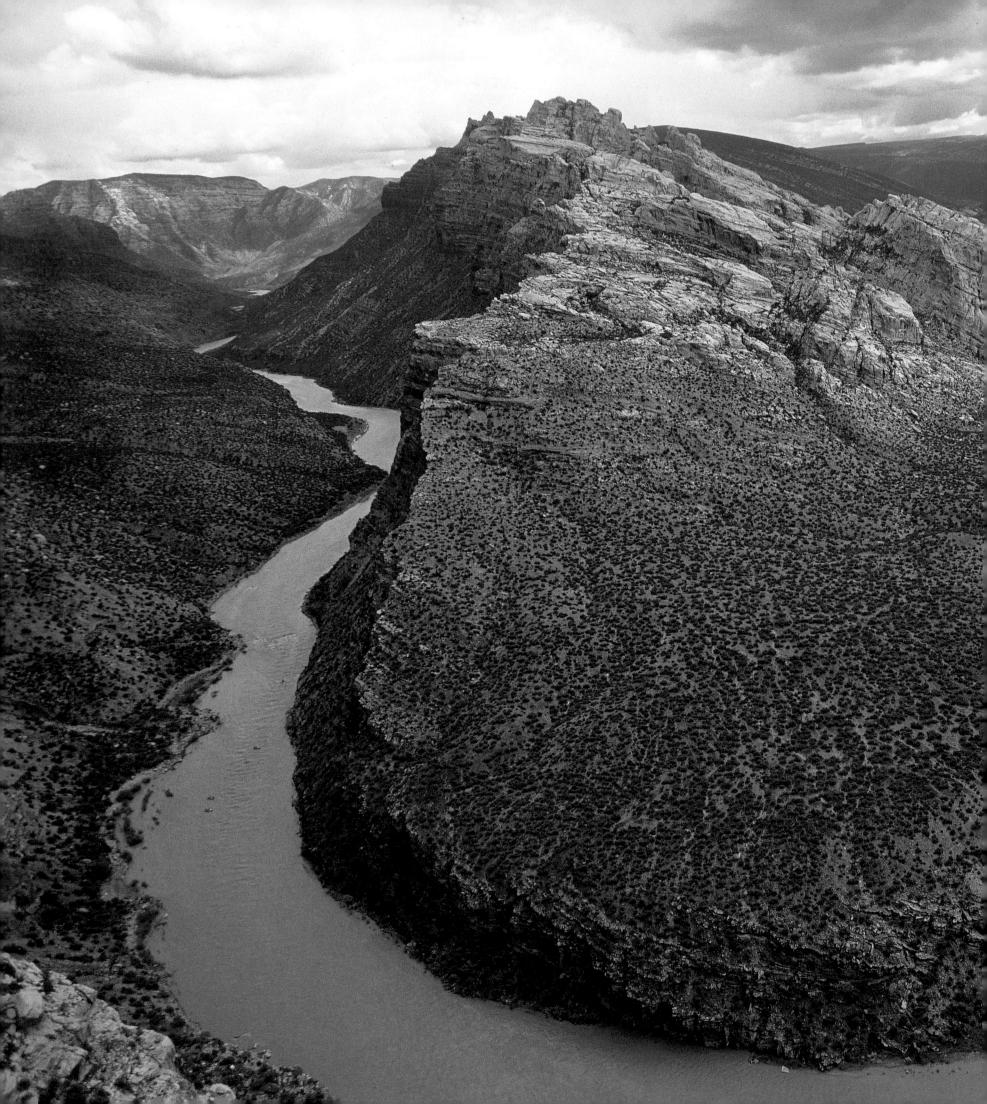

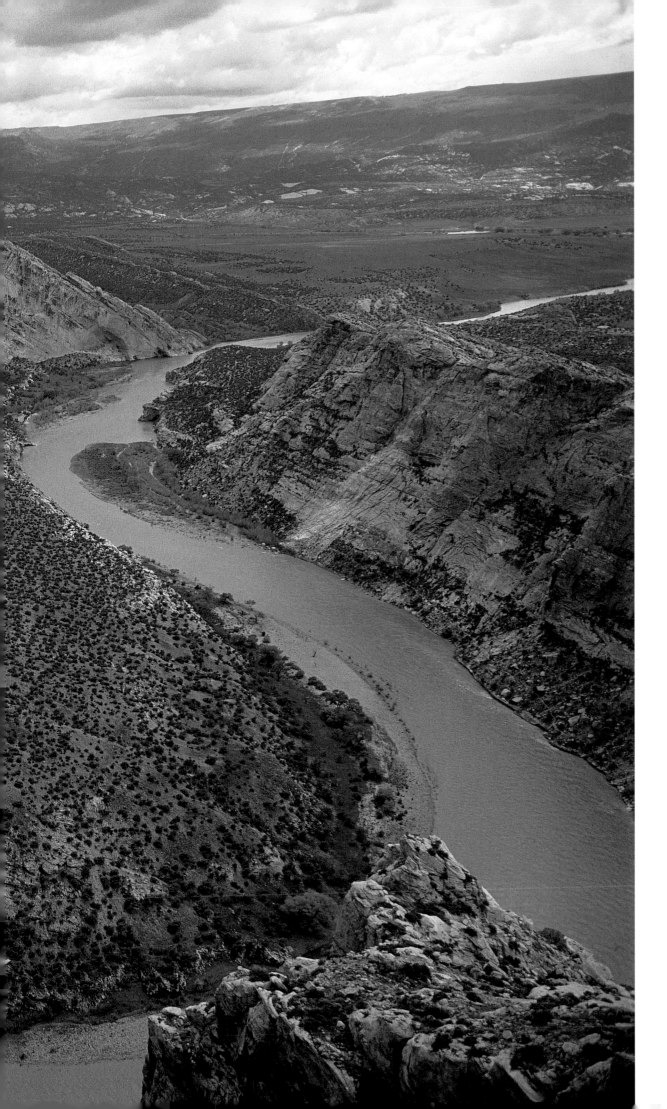

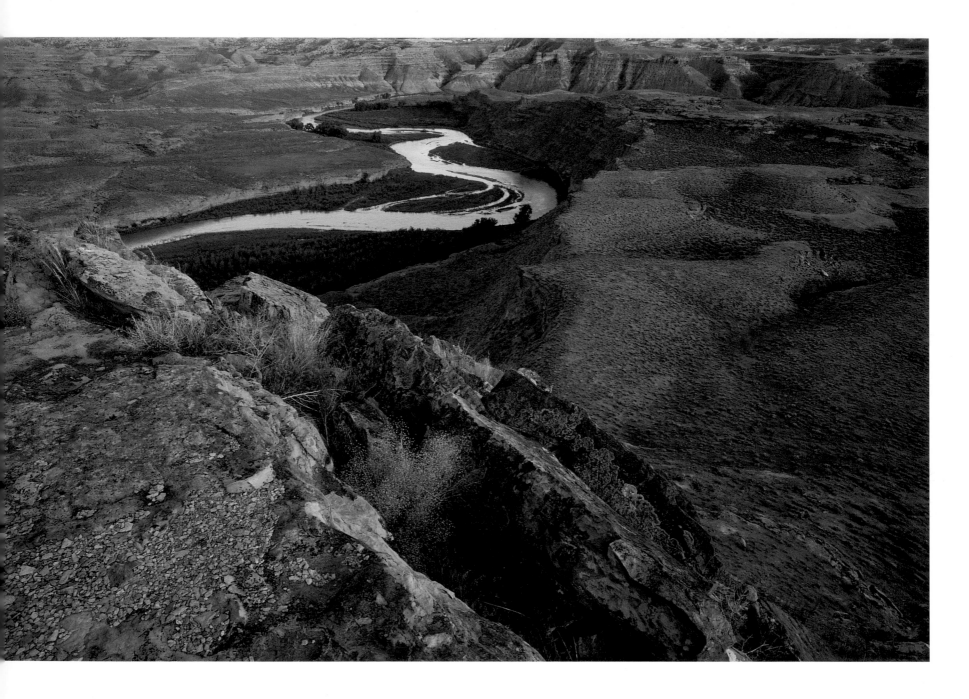

White River, Utah

In the drylands of the West, the water flowing from distant mountain ranges is all the more precious for its scarcity. Along the White River, a thin corridor of riparian greenery—essential to life in the region—is surrounded by the harsh aridity of the desert.

Rogue River, Oregon

Rivers and their riparian corridors vitally support 70 percent of wildlife, including this great blue heron, which hunts for small fish, crayfish, and other prey in the Rogue River.

Alligator, Everglades, Florida

With uncanny stealth, the alligator—the largest American reptile—appears and disappears without a sound or a ripple in the "River of Grass," a twenty-mile-wide flow of shallow water known as the Everglades.

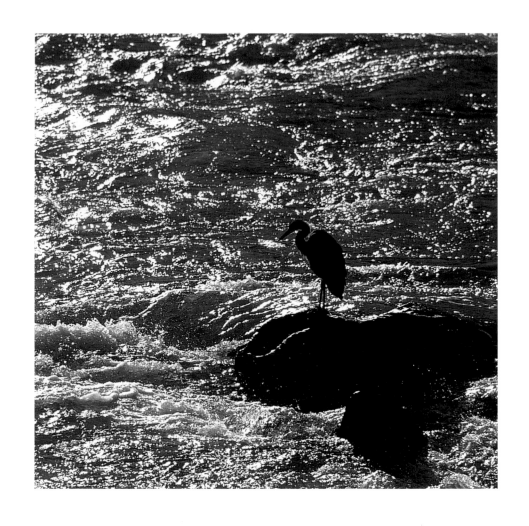

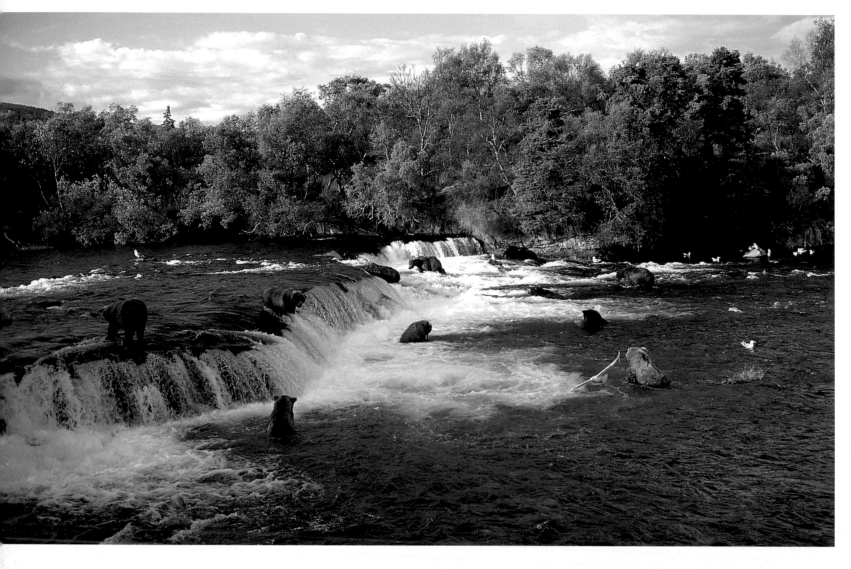

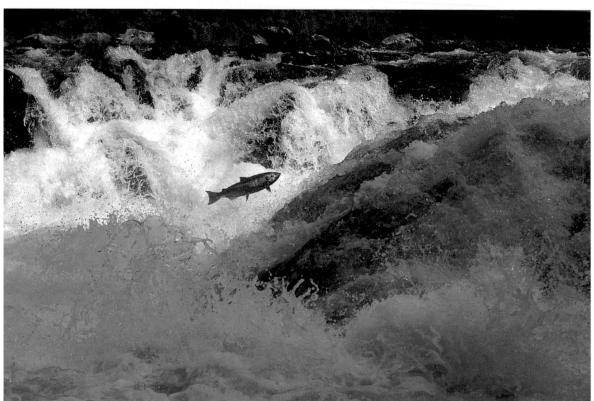

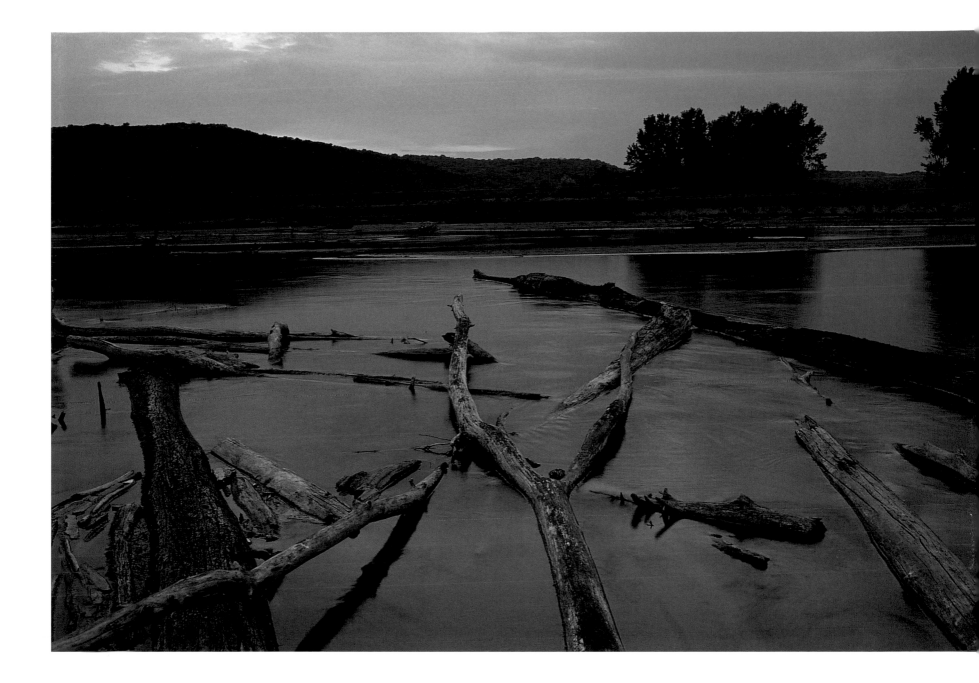

MISSOURI RIVER, NEBRASKA

Cottonwood logs have floated downstream and formed a logjam in the Missouri River at Ponca State Park. Important to the chain of life in the river, the logs provide shelter for invertebrates and other animals that otherwise lack the habitat they need in the broad, muddy, sandy-bottomed river.

BROOKS RIVER, ALASKA

At the Brooks River in southwestern Alaska, brown bears feast on salmon, which thicken the river during their spawning run to upstream lakes. Once a common sight even in San Francisco Bay, great concentrations of bears eating salmon can now be seen only in the wilds of Alaska and western Canada.

ROGUE RIVER, OREGON

Salmon, steelhead, and other anadromous fish are the embodiment of wild rivers; born at the headwaters, they migrate to sea, live in the ocean for several years, then swim all the way back up their natal streams to spawn and die. This chinook salmon in the Rogue River determinedly leaps to the top of Rainie Falls.

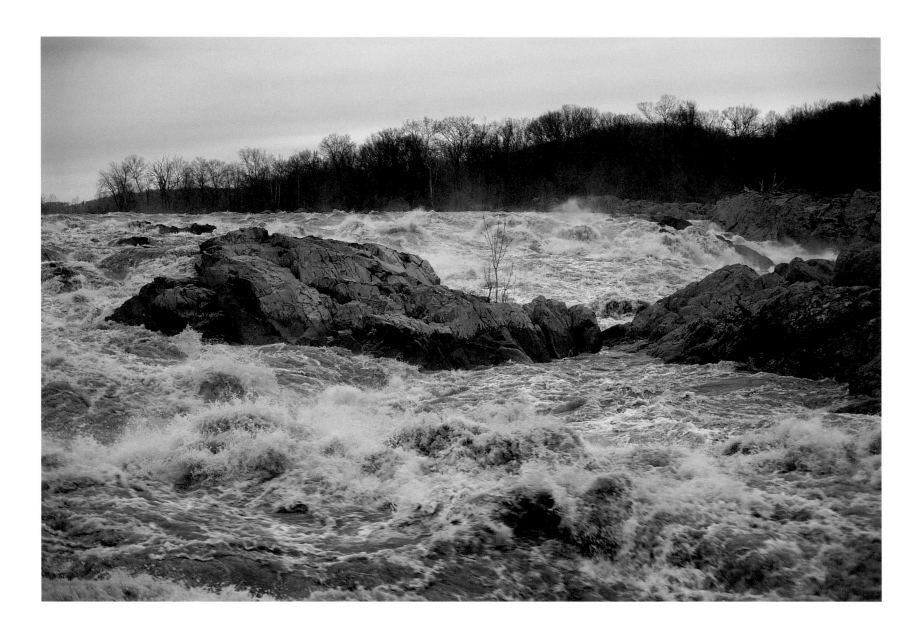

POTOMAC RIVER, VIRGINIA

Floods are critical to the well-being of rivers because they recharge groundwater, scour deep pools, deposit rocks that form aerating riffles, and push fallen trees downriver, where the trunks, limbs, and roots become habitat for many forms of life. Following heavy rains, the Potomac River, just upstream from Washington, DC, thunders at breakneck speed over Great Falls, almost completely obscured by the high water.

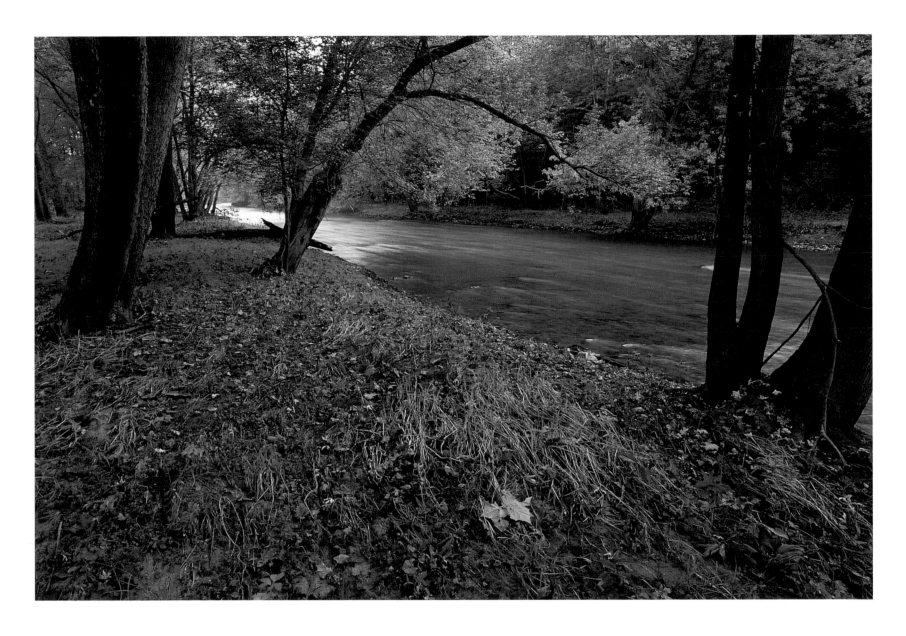

LITTLE BEAVER CREEK, OHIO
Flooding rivers collect silt and soil from upstream lands and then redeposit them when the floods subside—a process
that forms the flat or undulant terrain of floodplains. These are hazardous places to locate buildings and are important
as open space for wildlife. Little Beaver Creek in eastern Ohio recently topped its banks and combed riparian grasses
when it washed across this low floodplain before receding back into its channel.

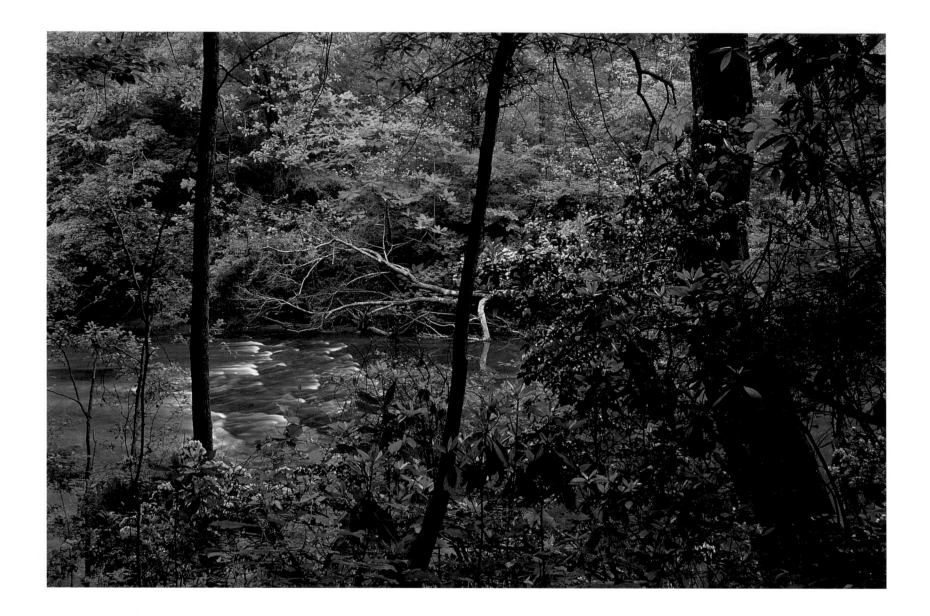

HURRICANE CREEK, ALABAMA
Mountain laurel blooms in late spring along Hurricane Creek, almost within the city of Tuscaloosa. Along most rivers, springtime brings high water that nurtures abundant life both in the streams and along riparian corridors.

60

GOOSE CREEK, VIRGINIA
In summer, morning mist gathers over Goose Creek, alive with bird songs in Virginia's Roanoke River basin.

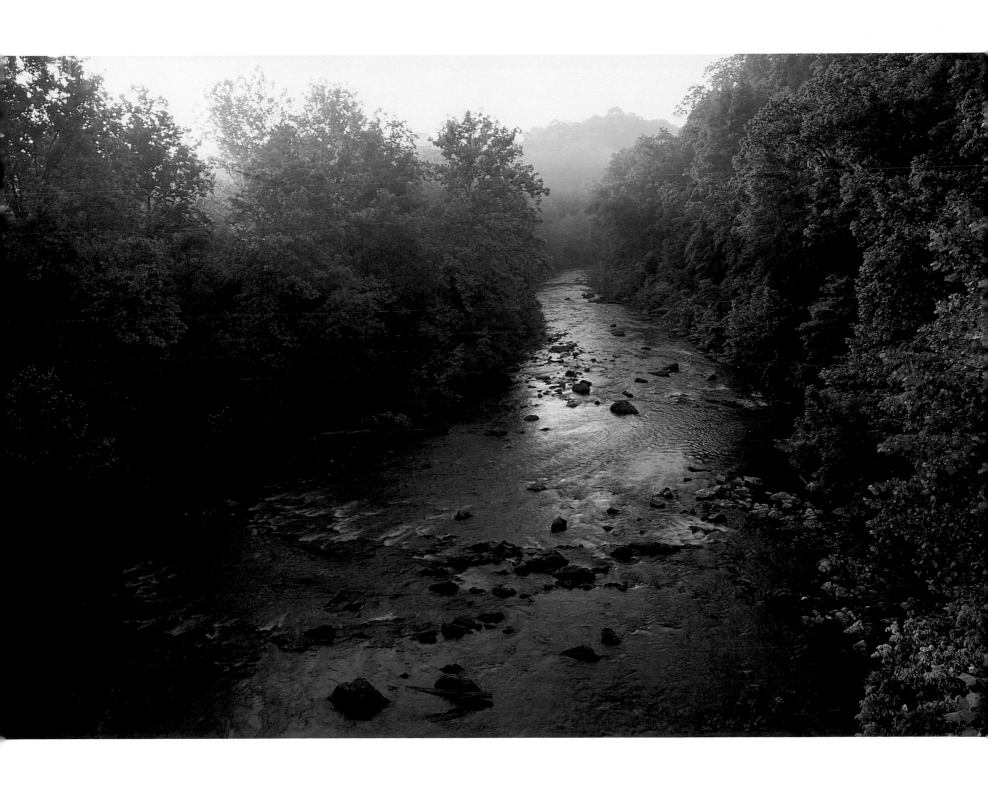

Saco River, New Hampshire

The brilliant red leaves of a sugar maple color backwater pools of the Saco River near its headwaters. In autumn, fallen leaves provide nutrients important to the river's food chain.

Big Darby Creek, Ohio

In winter many rivers slow down when ice covers the quieter water. Wildlife either takes refuge from the cold, hibernates, or migrates south. Even in the deep freeze of January, Big Darby Creek, near Columbus, supports an impressive eighty species of fish and forty species of mussels.

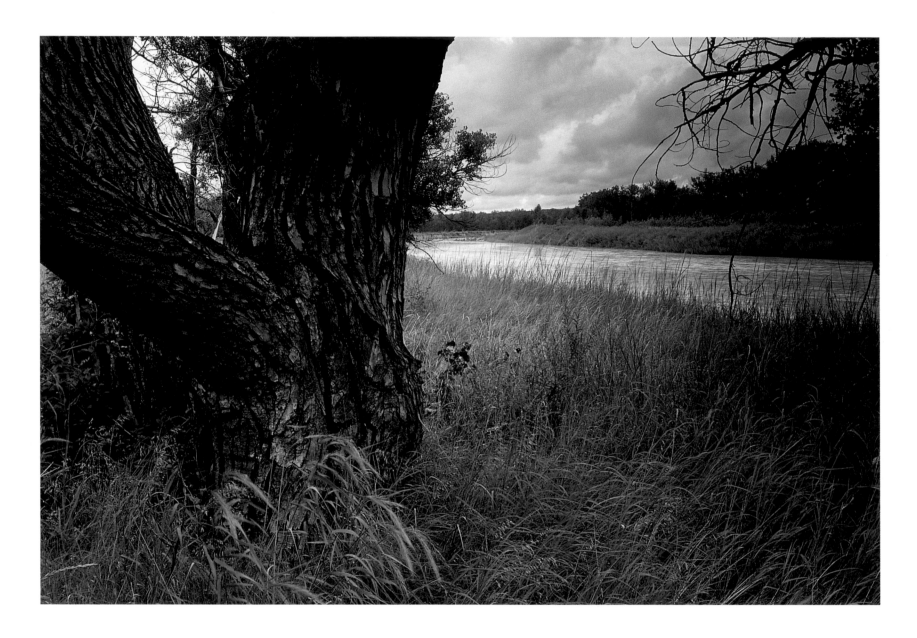

WHITE RIVER, SOUTH DAKOTA

Cottonwood trees are a keystone species; many other plants and animals depend on them. Requiring periodic floods, the trees' seeds germinate on freshly scoured bars or silt deposits. This Plains Cottonwood has survived frequent floods and offers essential habitat to birds and animals along the White River near Badlands National Park in South Dakota.

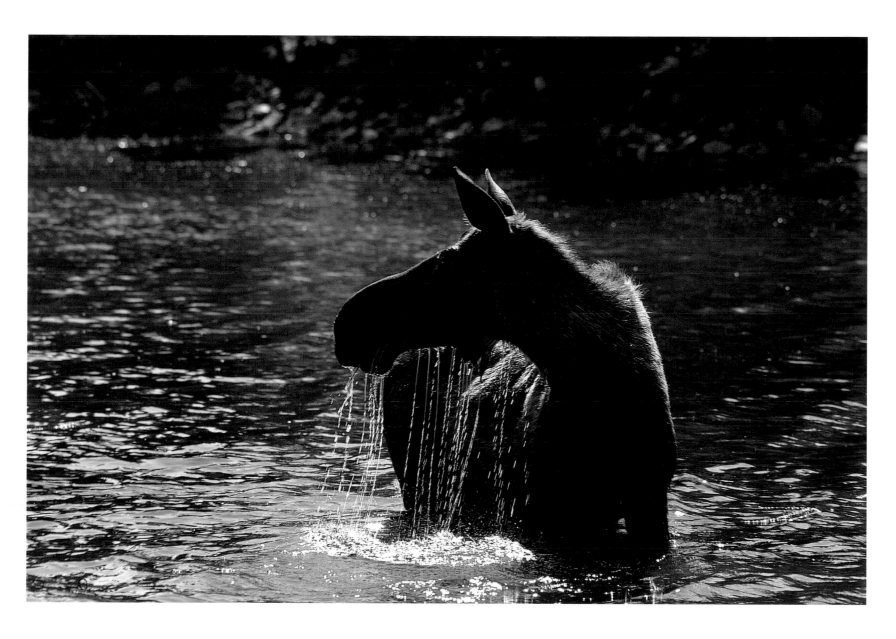

MOOSE, NENANA RIVER, ALASKA
Dependent on riparian or riverfront plants for 70 percent of its diet, this moose feeds on
aquatic vegetation near the Nenana River.

Currents of the Continent

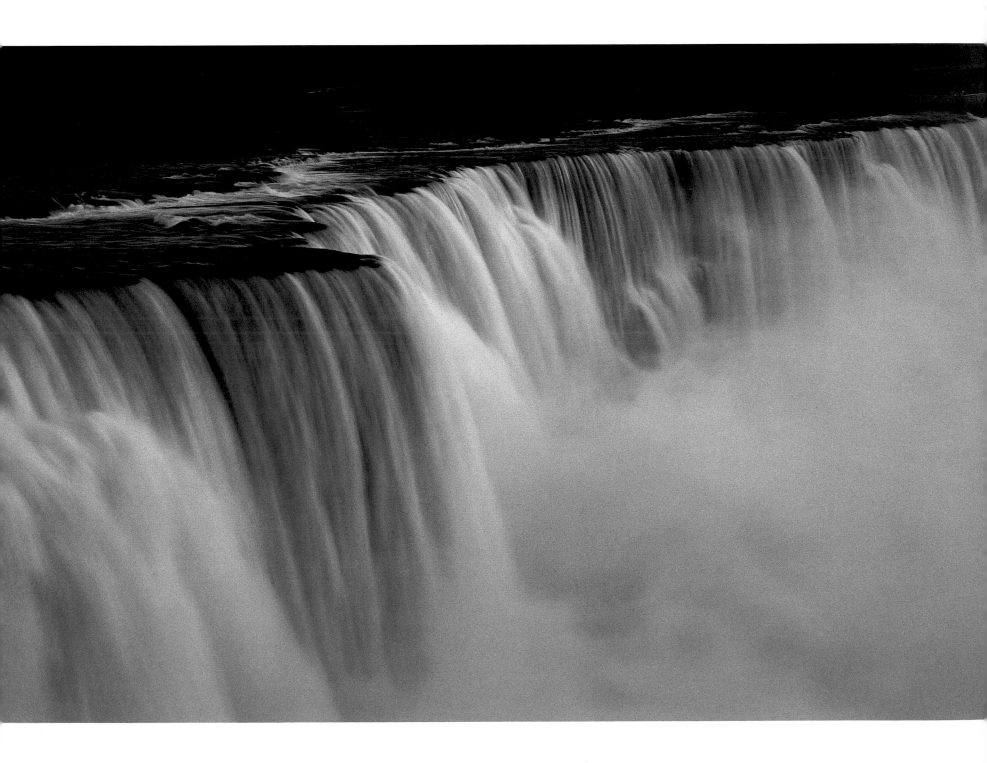

WHEN PEOPLE HEAR that I've had the good fortune to see so many of America's rivers, they often ask if I have a favorite.

I always pause. It would have been easy to chose a favorite when I knew only the Youghiogheny, or later, during a formative summer of my life when I lived in Sawtooth Valley along Idaho's Salmon River. But now I know that each stream has its own specialties flavored by distinct climate, geology, plant life, and animal communities. The more I knew, the harder it became to choose a favorite.

When I set out to photograph rivers all over America, a pageant of scenes awaited me, from the edges of milky-white floods frothing from the mouths of glaciers to the mirrors of blackened swamp waters in semitropical climes. Trying to find the most beautiful scenes from everywhere, I explored our riverscape from the Atlantic to the Pacific, and then on to the Arctic Ocean.

I was dazzled by the flowers and green of springtime along the rivers of the South, the mix of summertime forests at the edge of Appalachian streams, the orange and red of autumn highlighting New England's waterways. I was gratified to see the fine rivers that remain in the Midwest—many are just remnants of what was, but some still have corridors of nature running for miles. I was awed by the open spaces of the Great Plains, the rugged rise of the Rockies, the elegant shapes of desert canyons, the brilliant runoff of the Sierra and all California, the organic richness of the Northwest, and the ultimate wilderness in Alaska. Each of these ten river regions appealed to me in powerful ways.

I started in New England, where rivers flow from rocky, glaciated ground and find fast routes to sea. The mountains there are tall, but the distances to the Atlantic Ocean and the Saint Lawrence Valley are short. Streams plunge over waterfalls that formed when the continental ice sheets forced water to flow in new directions across the land. Rivers also connect many lakes, which are artifacts of the glaciers as well. The most famous link of this kind is formed by the Niagara River, with its breathtaking drop between Lake Erie and Lake Ontario.

For color along rivers, no place can match autumn in the Northeast, when birches, maples, oaks, hornbeams, and other trees turn brilliant at the water's edge. Rivers were dammed in order to power mills at villages and towns, and this legacy remains central to

NIAGARA FALLS, NEW YORK
America's original tourist attraction, Niagara Falls drops over its precipice at twilight.

many urban waterfronts. Other northeastern streams have regained the essence of wildness, if only for a short distance.

Showing both its industrial heritage and a recovering wildness, the Housatonic runs through Massachusetts and Connecticut to Long Island Sound. This river begins in towns where factories once polluted the water with toxins that still make it unsafe to eat too many fish. But downstream it winds through forests, refreshing rapids, and villages of white-frame homes, steeples, and covered bridges. One of America's oldest watershed organizations, the Housatonic Valley Association, has long stewarded this recovering river as it riffles through its valley, both wild and cultured, in classic New England style.

Southwest from there, along the backbone of the Appalachians, I found rivers bubbling and shining everywhere among the tangled green mass of rhododendron, silver maple, and sycamore. Rocky streams tumble out of America's oldest mountains and through forested gorges. Then they flow onto foothill terraces and curve across farmed valleys of the Piedmont. This gently sloping run-out on the Appalachians' eastern slope continues to the Fall Line, where the waters drop over one final set of rapids before spilling onto the Coastal Plain near sea level.

Teeming with life wherever they've been spared dams, heavy development, or acid drainage from coal mines, the Appalachian rivers enliven a temperate and rainy land of endlessly corrugated topography. Calcium embedded as layers of limestone dissolves slowly into the waters and nourishes our greatest abundance of fish species, mussels, and other aquatic life. Perhaps no place is more completely painted in green than the Appalachians in summer, when the transpiration from billions of trees further mists the already humid skies and when valley fog, caused by the rivers, moistens the air in morning.

While most rivers of the Appalachians and other mountain ranges seek the shortest possible routes out of the high country and onto the flatlands, the Greenbrier of West Virginia runs for all its 160 miles sequestered between fortresslike ridgelines. Located east of the coal country, the Greenbrier Valley is only lightly developed, and its emerald vastness indicates a quality of nature once found throughout this leafy, watery land. It reveals what might exist once again throughout the Appalachians if we take better care of our rivers.

On the Coastal Plain, which includes the Deep South and all the lowlands along the Atlantic and Gulf Coasts from New Jersey

Wildflowers brighten the shoreline of the Watauga River at the historic site of Sycamore Shoals in eastern Tennessee.

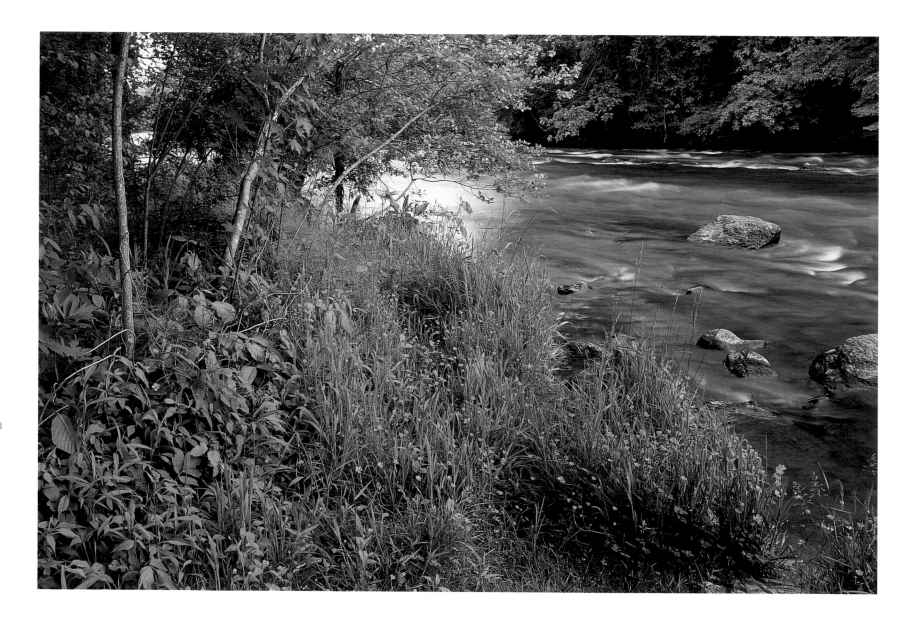

through Texas, rivers run from watersheds hammered by rainstorms that can come any month of the year. Many rivers carry swamp water that's amber when shallow and black when deep, the colors caused by high concentrations of carbon coming from dissolved organic matter coupled with low amounts of sediment. Vines and lichens hang like living tapestries from the branches of sweet gum and tupelo, which rise tall along many of the southern streams. On rivers such as the Black in South Carolina and the Lumber in North Carolina, baldcypress trees stand in the water itself, with fat trunks buttressed for stability and "knees" that help the trees to breathe. Turtles line up to sun themselves on logs, and alligators lurk along the edges where the fanlike branches of palmettos are another sign of the hot, humid, fecund waterways in the Deep South.

Many southern rivers of dark water are edged by white sand and backed by green jungles of plant life. Overflowing annually into swamps that can run for miles back from the banks, southeastern streams have some of the least-developed river frontage in America. The riparian wetlands feed a glut of nutrients to the waterways, which in turn nourish estuaries and productive ocean fisheries. As they near the coast, many streams curve in big elliptical bends through yellow-green marsh grasses swaying in the tides.

A quintessential river here, the Suwannee overflows from its source in Georgia's Okefenokee Swamp and winds for two hundred low-country miles over limestone bedrock, where submerged caves abound, through sandy plains that remain from an ancient seashore, and into a placid Gulf of Mexico, where palm trees rustle in semitropical breezes and occasionally bend low in hurricanes.

The Midwest's gridwork of farms drain into rivers with pushy brown flows that swell into giants such as the Ohio, Wabash, Minnesota, White, and Mississippi. The larger rivers of the Corn Belt flow with enough dirt-brown silt to fill a dump truck every few minutes. Yet not all of the Midwest is dominated by the plow. The north woods and wetlands of Minnesota, Wisconsin, and Michigan spawn hundreds of clearwater and blackwater streams riffling through recovering forests. The Ozark Mountains feed a whole suite of Appalachian-like streams in Missouri and Arkansas.

A primary lifeline of this region, the upper Mississippi flows as smooth as honey through its headwaters in Minnesota. Its moisture infuses the morning air in autumn, when the maples turn orange and scarlet, all reflected in glassy pools. Deeply iced in winter, the river later thaws, rises, and overflows its banks in springtime, soaking into broad floodplains. It fingers down through islands that isolate intimate currents, separating them from the main channel and from the farmland that lies beyond the banks. The ultimate accumulator of water, the Mississippi is joined by one tributary after another until it becomes America's largest river.

The Great Plains tilt down from the Rockies to the Midwest, and their rivers strike parallel eastbound routes across the alluvium that water has delivered for eons from the Rocky Mountains' eastern face. Drier than the Midwest, this adjacent region features lightly developed streams through grasslands edged in ribbons of cottonwoods and willows. Though heavily diverted and dried-up for pasture and forage, several Great Plains streams have some of the longest undammed mileage in America.

One of the finest rivers of the Plains, the Niobrara riffles across the Sand Hills of northern Nebraska where thousands of springflows nourish the stream as it cuts through sandstone ledges and slides gently eastward to the Missouri. Cottonwoods guard banks topped by waist-high grasses, all lying beneath the big sky of prairie open space.

Deep snows of the Rocky Mountains melt into an extraordinary set of rivers from the Flathead, whose source lies in Canada, to the Rio Grande, with its headwaters in Colorado. Seven major rivers drain this region and flow like radial spokes from the enormity of the Rockies, their snowmelt a welcome gift to the plains and deserts beyond. The mix of mountains and water blends perfectly where the Snake River curves in front of the Grand Teton and adjacent skyscraping peaks. Along many riparian corridors in the Rockies, wildlife still thrives: otters, beavers, moose, and elk. America's largest herd of bison grazes along the Yellowstone River in our first national park.

The signature river of the Rockies is the Salmon, which flows nearly undammed for its entire 406 miles. After beginning with jewellike sprays of snowmelt in the Sawtooth Mountains, the river churns down through pine forests, into sage-scented drylands, and across the forested center of Idaho to the severe basaltic walls of Hells Canyon, where it meets the larger flow of the Snake River.

Lying west and south of the Rockies, the dryland and desert rivers extend from the steppes of eastern Washington to the Rio Grande's border with Mexico, and they bring water to a whole region that lies parched in the rain shadow of big mountains rising to the west. Many of these streams surge with silty brown runoff from faraway

69

peaks. The thin strips of riparian plant life on the floodplains are the principal source of life in a lean but austerely scenic land.

The Colorado in the Grand Canyon may be the most impressive desert river, but for free-flowing length, nothing compares to its tributary, the Green, which is longer than the Colorado where the two meet. Unchecked for more than 400 miles between dams, this river carves sheer-walled canyons with smooth sandstone rising straight from the water's edge, glowing like gold at sunset and stretching the imagination about what a riverfront can be.

In California, the Sierra Nevada rivers foam down from exquisite high country, boil through granite canyons, flow past conifer forests, and finally ease across a foothills belt of oaks to a grassland savanna and Central Valley farmland. No other region rivals the Sierra as a showcase of crystal-clear water tumbling through rapids. Farther west, Coast Range streams make short but splendid drops to the ocean, and rivers in the northern third of the state flow with uncommon wildness from deeply forested mountains to booming surf.

California holds a stunning diversity of river types and river scenes; waterways flow from our highest mountains to sea level, from our driest deserts and from rain forests. This region's rivers also provide the water for America's most intensive agriculture and for cities where a state population of thirty-seven million is slated to double in less than forty years.

I think of the Tuolumne as the king of Sierra rivers, waterfalling out of Yosemite National Park and through a canyon that survives below the dammed Hetch Hetchy Valley. Smaller but irresistible in its own way, the South Yuba River forms where the snow piles up ten, twelve, and fourteen feet in Donner Pass, lasts until summer, and makes the Sierra's already-brilliant whitewater and white granite almost unbearably bright. In northern California, the Klamath River is a vital but troubled artery in an empire of forested wildness. Its salmon and steelhead once ranked among the most robust fisheries on the continent, but are now plagued by the largest fish kills in the West, owing to diversions of water for agriculture.

Northwestern rivers course down from green mountains pummeled by rain and snow that sometimes continue all winter long. The larger rivers begin on the snowcapped volcanoes of the Cascade Range and accumulate springflows from the porous igneous rock. Others begin when massive Pacific storms dump up to two hundred inches of rain a year on the coastal mountains. Closer to sea level,

lotic gems of clear water curve through ancient forests that still have a hauntingly primitive feel.

Northwestern salmon and steelhead once supported whole cultures of American Indians and commercial fleets of thousands of boats, but owing to dams and watershed disturbance, the fish are now gone or reduced to endangered status in many streams. The survival of these fish depends on what Northwesterners do to eliminate the most troublesome dams and to restore their rivers. Through much of the region, timber companies have clear-cut the forests, and the rivers show heavy losses as a result, but the beginnings of recovery can also be seen in protected areas and where trees are now cut by a few progressive logging companies in ways that minimize watershed damage.

Disclosing all the features of the Northwest, the Rogue of southern Oregon begins with springflows seeping from the blue caldera of Crater Lake. The river flows through the lava-land of the Cascade Mountains and then completely transects the Coast Range. Chinook salmon still leap over the eight-foot pitch of Rainie Falls and muscle their way up to the concrete face of Savage Rapids Dam, which will someday be blasted away so that the fish can reclaim the middle reaches of this fine river.

In Alaska, one-third of America's fresh water flows across one-fifth of the nation's land. The wildest rivers remaining in America include the massive Yukon—nearly as undeveloped as the Mississippi was in 1700. Rivers issue from rain forests, volcanoes, ice fields, and tundra, all twisting and shining across what natives still call the Great Land. Brown bears, caribou, moose, and wolves can be seen along the rivers, and nowhere else do clearwater streams still run thick with salmon.

Superlative by any measure, Alaska's Copper River cuts through the Wrangell Mountains, which rise to sixteen thousand feet. It rasps against glaciers that push directly into the river along a two-mile length of shoreline—not really a shoreline at all, but rather a listing wall of perilous and transitory ice. A mile or more wide and flowing fast, the river tears through the snowcapped Chugach Mountains all the way to sea level. Finally it branches out in a delta that supports seven million breeding Pacific shorebirds, each dependent on the health of that great northern waterway. In summer, to travel on the Copper is to visit wildness in an extravagant landscape. In winter, when snowstorms can deliver thirty feet of snow at a time to surrounding peaks, going to the Copper River is like going back to the Ice Age.

SEARCHING FOR BEAUTIFUL RIVERS everywhere across America, I found headwater streams that I could step across and mainstem arteries five miles wide; whitewater blizzards over rock gardens and blue-green pools so deep I couldn't begin to fathom how far down the bottom lay. Some rivers were showcases of autumn color; others were stark monochromes of snow and ice where, underneath, I could hear the quiet murmur of flowing water even in the depths of winter.

After spending time in all these river regions, I had trouble paring down to a short portfolio of photos that celebrate each. I wanted to include two or three times the number of rivers that space allowed in this book. These choices were difficult enough, yet I couldn't help but wonder again, was it possible to choose a single favorite stream?

When I think about the Kings as it winds out of the Sierra and through its foothills belt of oak savanna, green and flowery in the warm breeze of springtime, that's my favorite. When I'm immersed in a thirty-day trip on Idaho's Salmon River, it's the only stream I would choose. When I return to the Youghiogheny, the sounds, the sights, and the scents of the past pull so hard on my heartstrings that I can think of no other place I'd rather be. But when I drift back through memories of all the scenes I've admired on all the rivers, I can't even pick a favorite region let alone a favorite stream. I realize that, like the rest of life, where I am at the moment is what counts the most.

Setting out to record the nature of America's rivers, I knew that an astonishing variety of watery views awaited me, but all along the way I found that the universe of rivers was far more intricate, far more engaging, and far more beautiful than I had ever imagined it could be.

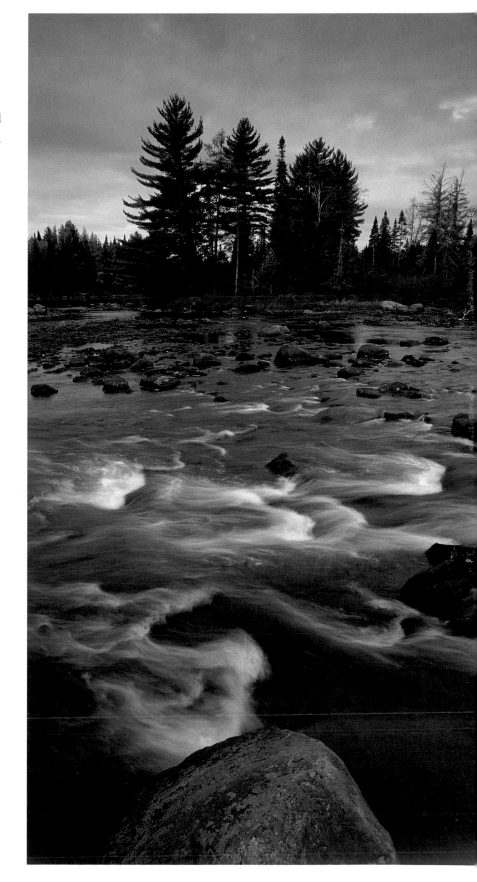

RAQUETTE RIVER, NEW YORK
The Raquette River begins in the lake country of the Adirondack Mountains and then creates boulder-riddled rapids on its way north to the Saint Lawrence River.

Northeastern Rivers

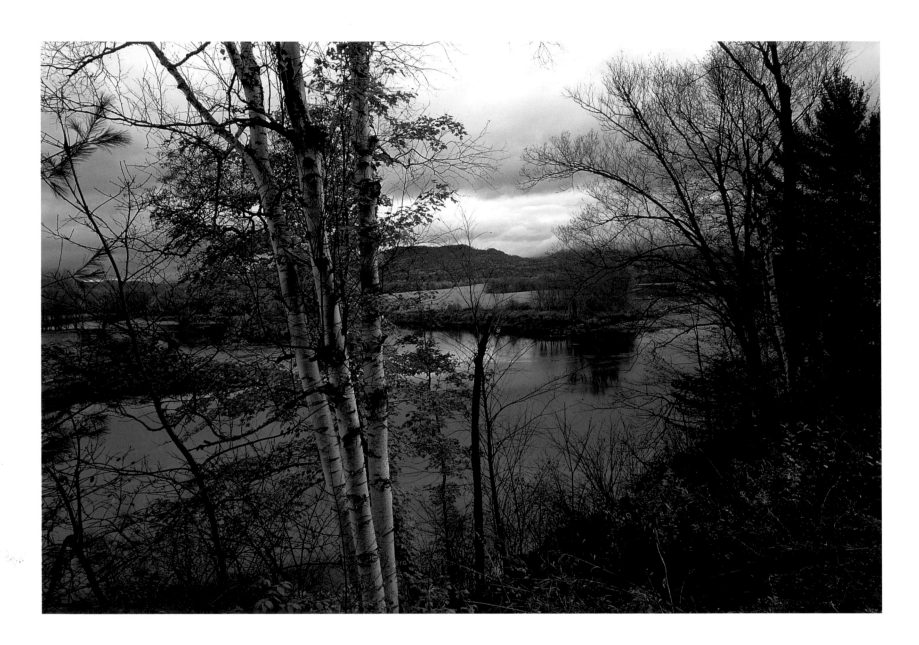

CONNECTICUT RIVER, VERMONT

Centerpiece river of New England, the Connecticut begins near Canada, defines the border between Vermont and New Hampshire, then crosses the width of Massachusetts and Connecticut. Though dammed for hydropower through many of its miles, outstanding free-flowing sections remain in upper reaches including this site near Bloomfield.

SAINT JOHN RIVER, MAINE

One of the wildest large rivers in the East, the Saint John begins in the green north woods of Maine and then scribes the border between the United States and Canada before flowing entirely into New Brunswick. A plan to dam the river at this site above the mouth of the Allagash River was defeated in one of the pathbreaking river conservation battles of the 1970s.

LAMOILLE RIVER, VERMONT

As it transects the Green Mountains, the Lamoille River curves in classic New England style through dairy land. Here the rising sun burns through fog near the town of Hyde Park.

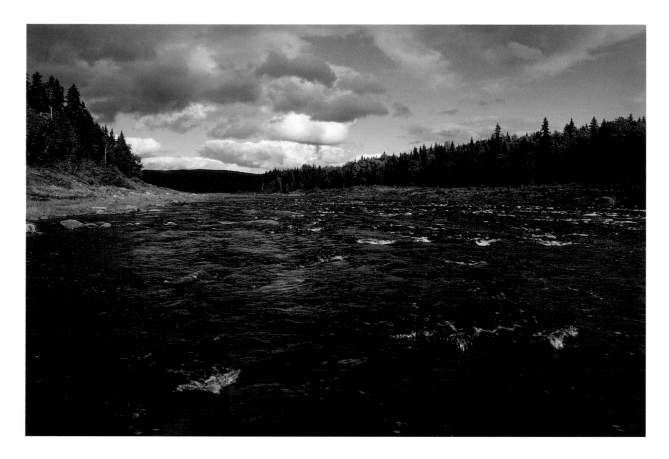

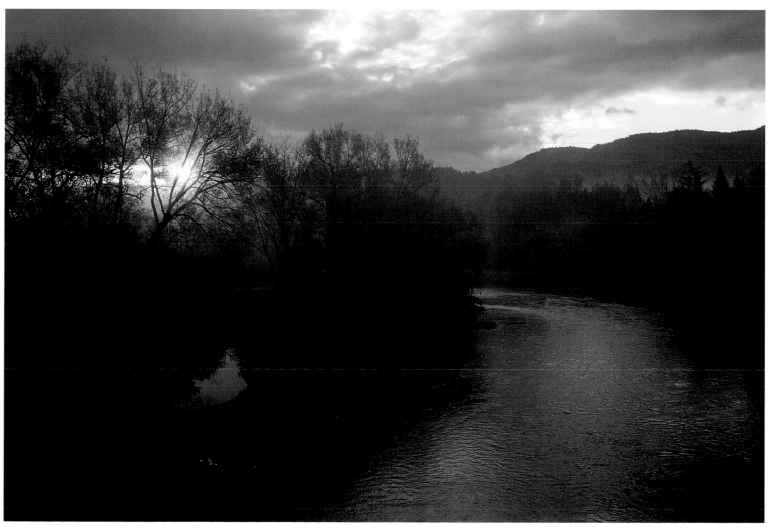

73

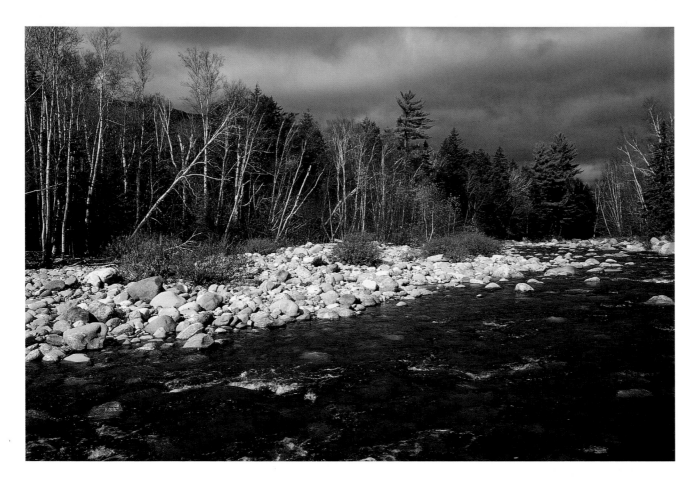

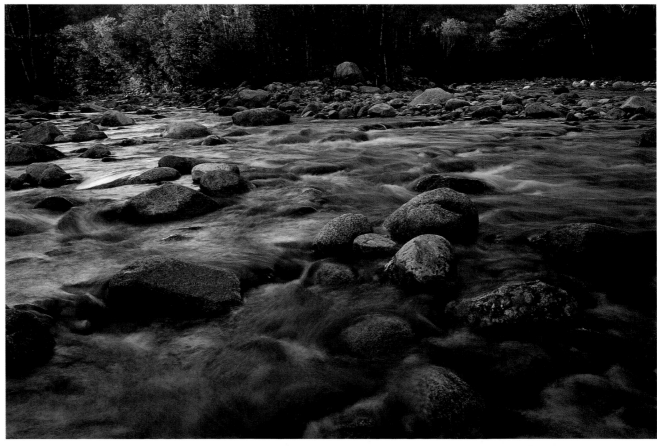

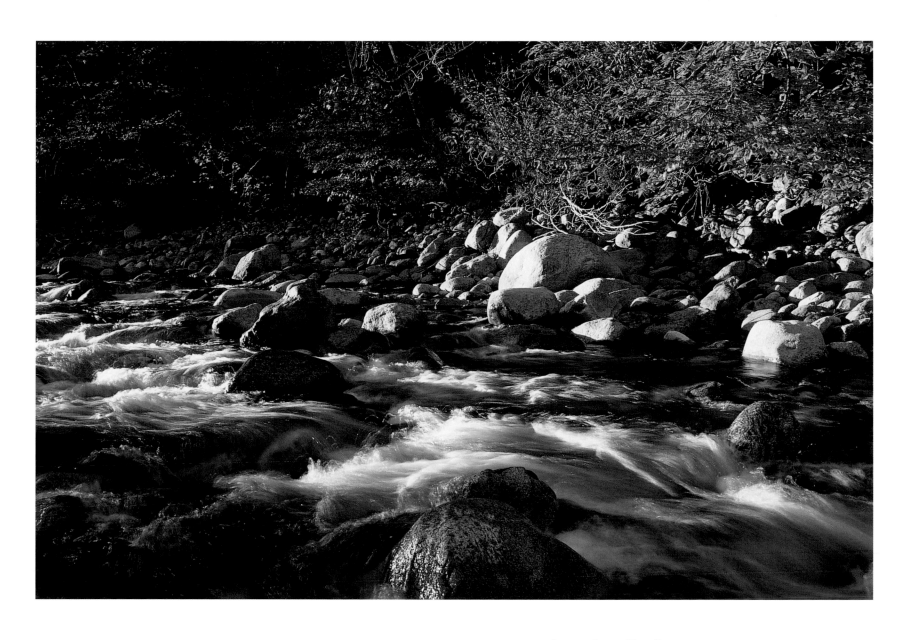

SAWYER RIVER, NEW HAMPSHIRE
American beech trees brighten an autumn afternoon along the Sawyer River.

PEABODY RIVER, NEW HAMPSHIRE
Crystal clear beneath a threatening autumn sky, the Peabody River rushes toward its confluence with the Androscoggin.

SACO RIVER, NEW HAMPSHIRE
The confluence of the Saco River on the right, and the Sawyer River on the left, is covered with cobbles delivered by glaciers, which once filled the valleys of New Hampshire's White Mountains. Downstream the Saco becomes one of Maine's major rivers before emptying into the Atlantic.

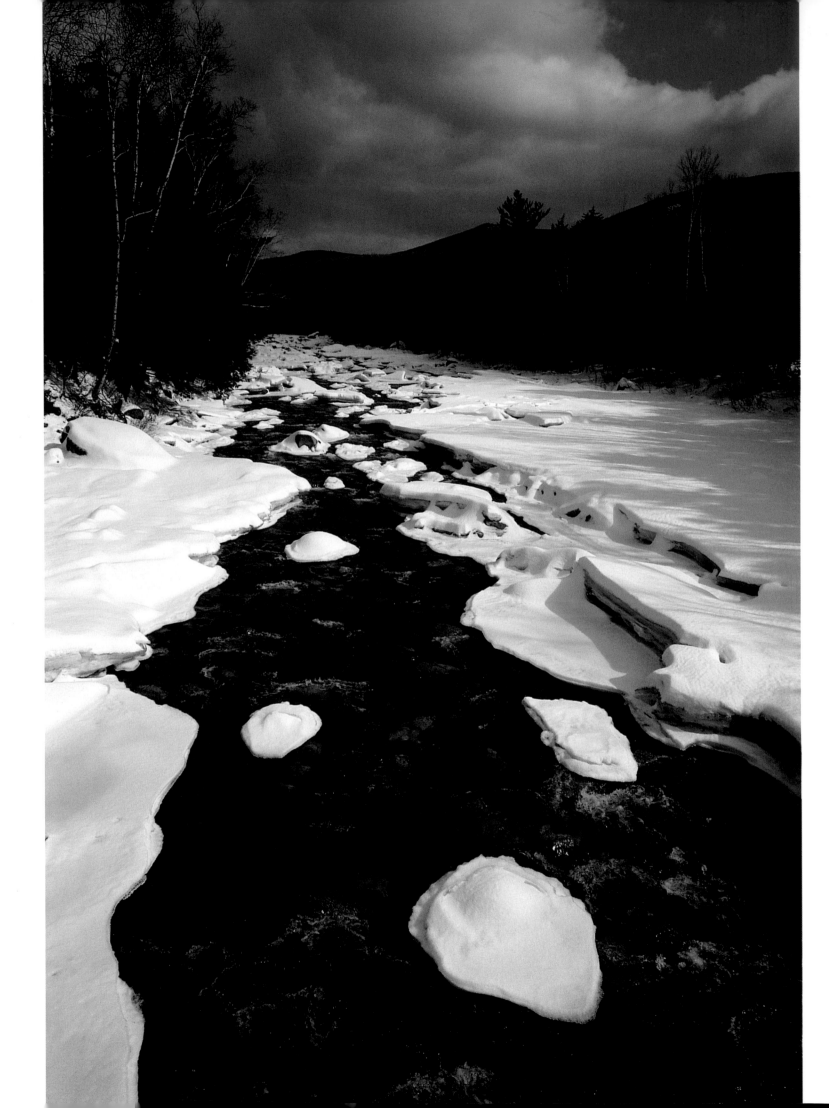

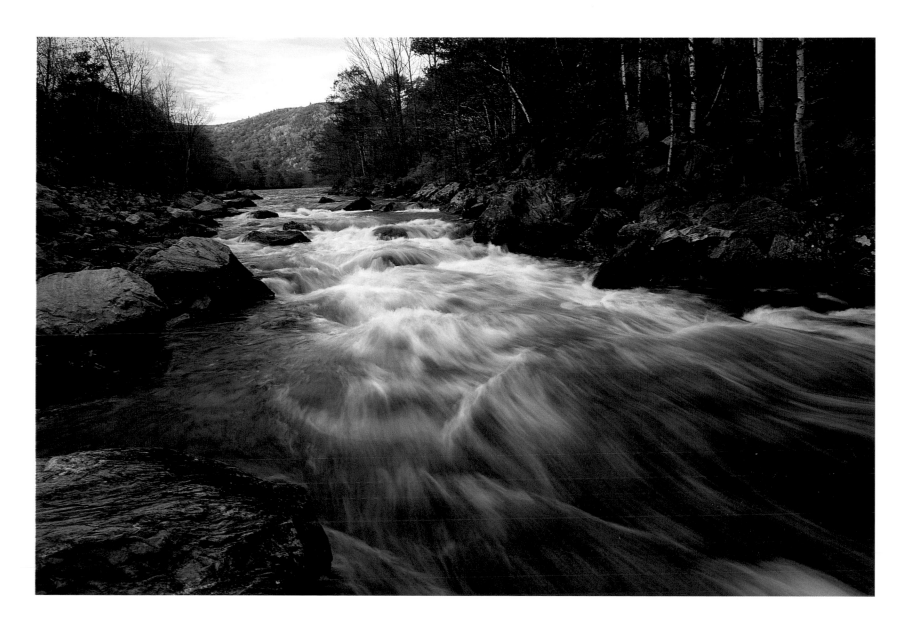

DEERFIELD RIVER, MASSACHUSETTS
In an idyllic valley of northern Massachusetts, the Deerfield River speeds through swift rapids.

EAST BRANCH PEMIGEWASSET RIVER, NEW HAMPSHIRE
The East Branch of the Pemigewasset is gripped in the ice of midwinter as it flows out of
a large wilderness in the White Mountains.

Overleaf NORTH BRANCH WESTFIELD RIVER, MASSACHUSETTS
The North Branch Westfield River has created the strikingly beautiful
Chesterfield Gorge in western Massachusetts.

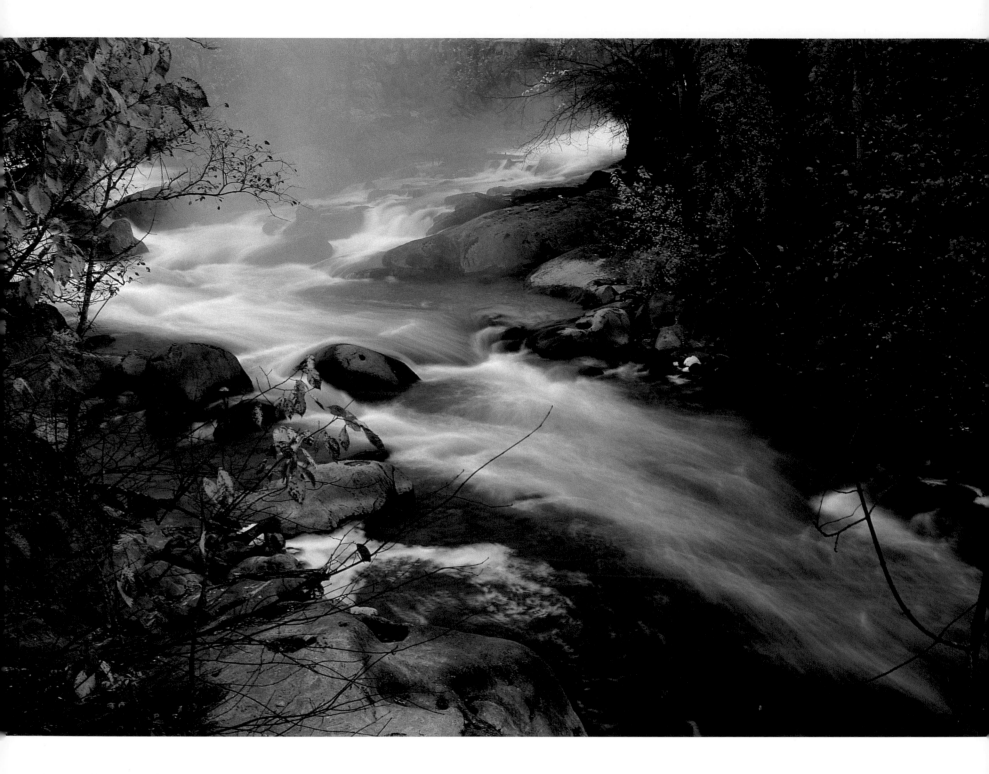

80 HOUSATONIC RIVER, CONNECTICUT
Though its course is interrupted by several hydroelectric dams, the Housatonic River drops gracefully
over ledges at Bulls Bridge.

POMPERAUG RIVER, CONNECTICUT
Sugar maple leaves swirl in an eddy of the Pomperaug River above its confluence with the Housatonic.
Local residents in this small Connecticut basin have formed the Pomperaug River Watershed Coalition with
concerns about further diversions for urban growth and stormwater runoff from urbanizing land.

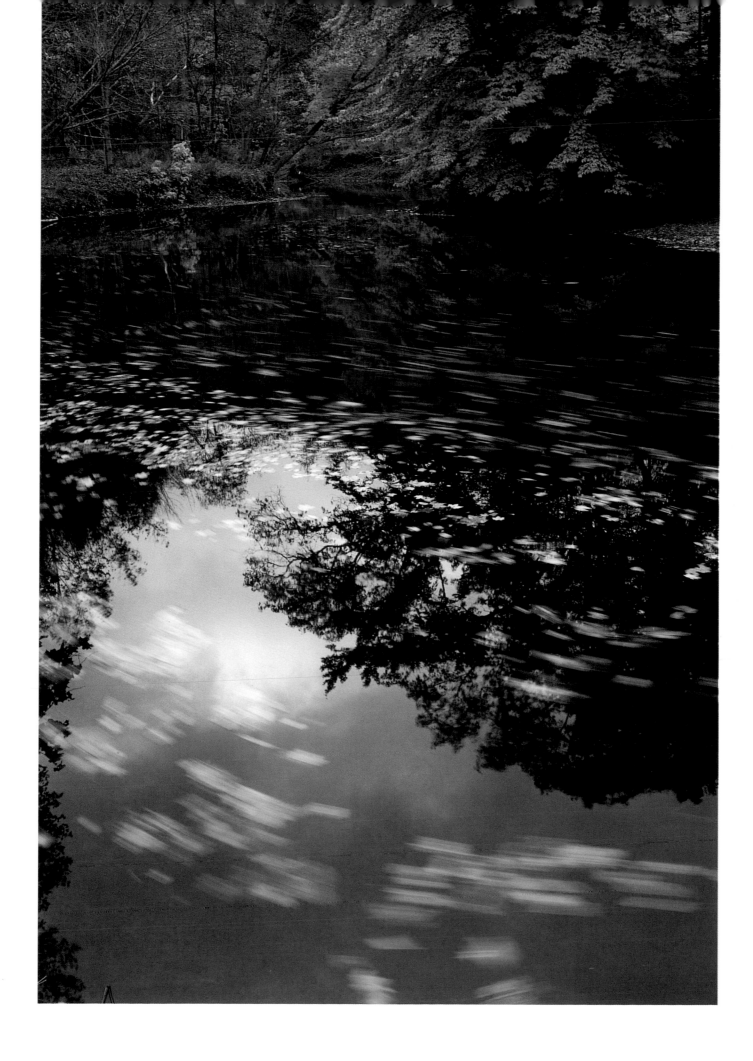

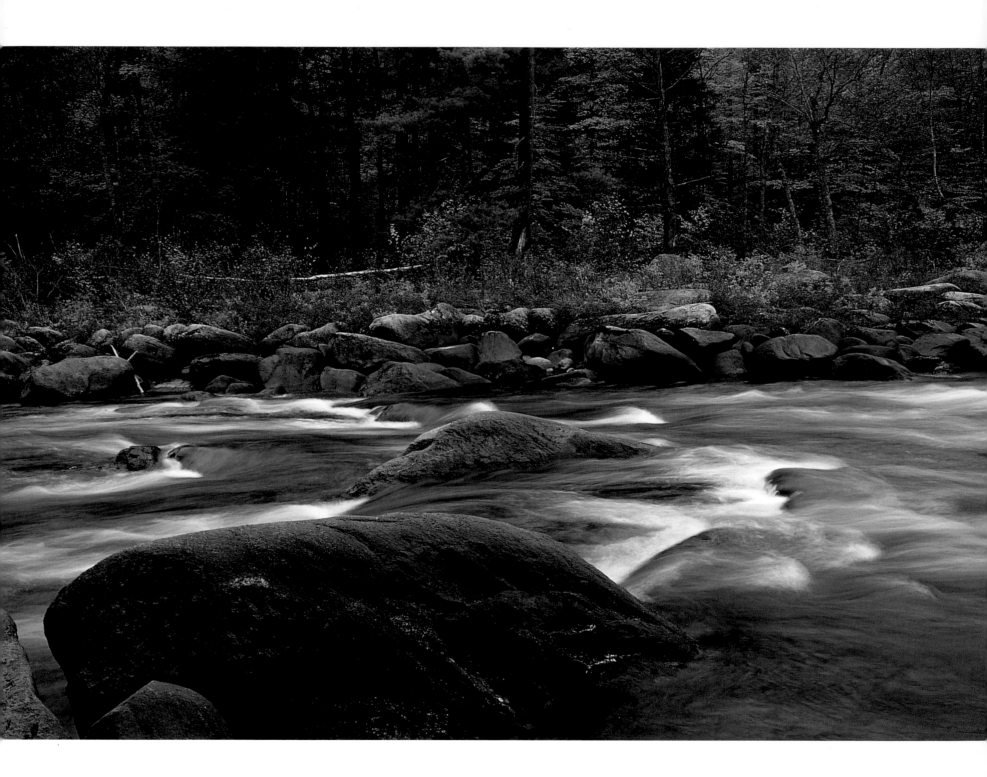

HUDSON RIVER, NEW YORK

The upper Hudson offers exciting whitewater below Blue Ledges in Adirondack State Park. In its lower reaches, the river eases toward New York City within a massive tidewater channel.

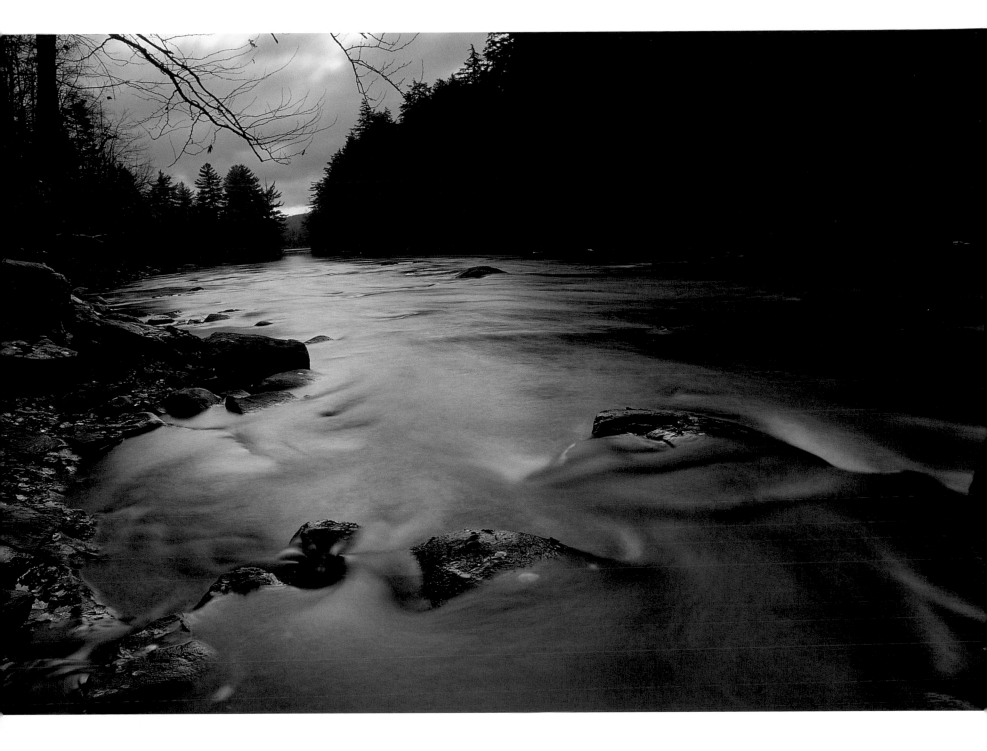

SARANAC RIVER, NEW YORK
The Saranac River shimmers in the first light of dawn below Saranac Lake, in the Adirondack Mountains.

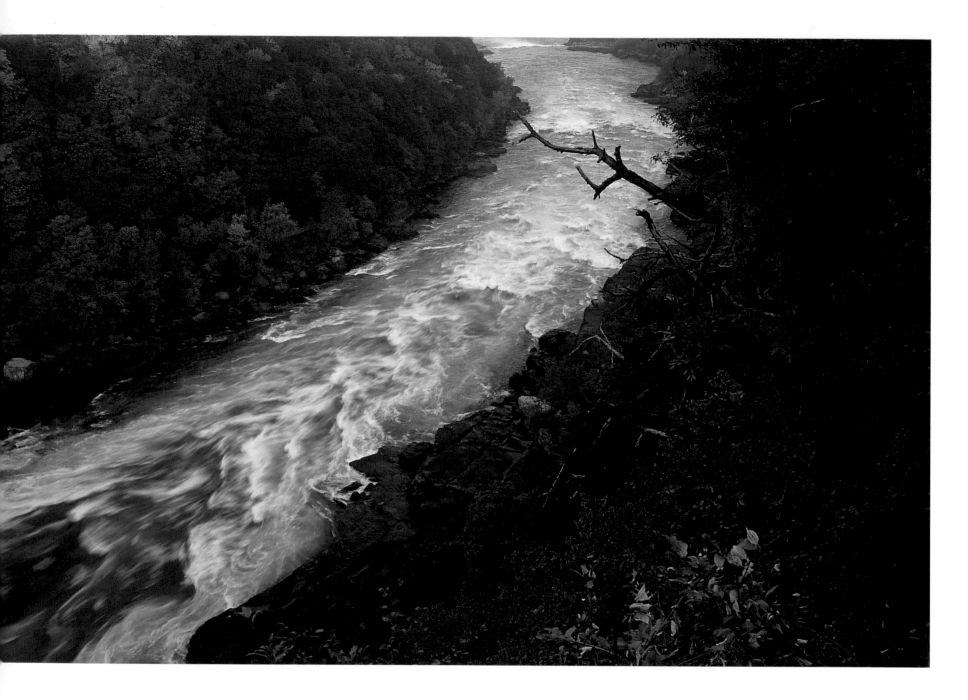

NIAGARA GORGE, NEW YORK
With nonstop whitewater, the Niagara River speeds toward Lake Ontario after dropping over
its landmark falls at the border of the United States and Canada.

NIAGARA FALLS, NEW YORK
Niagara Falls foams under the arc of an afternoon rainbow formed by the river's mist.

NIAGARA RIVER, NEW YORK
Below its famous waterfall, the Niagara River rages with enormous volume through
a gorge with steep gradient, creating rapids of incomparable power.

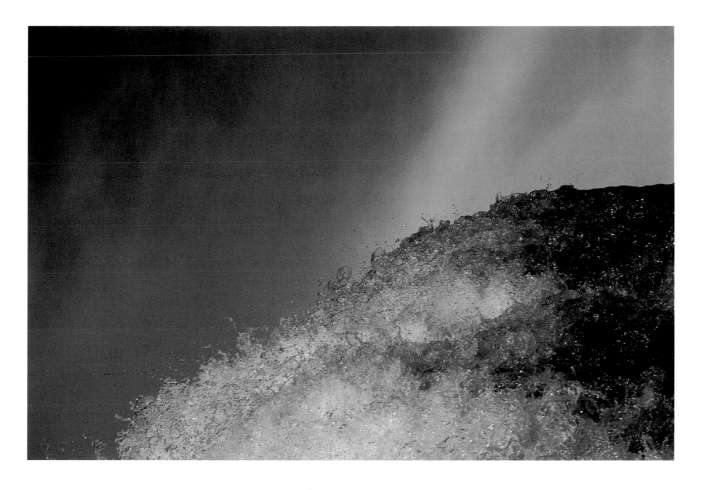

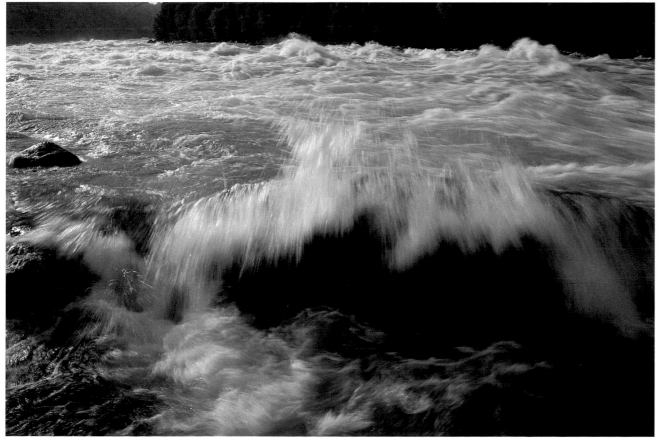

Appalachian Rivers

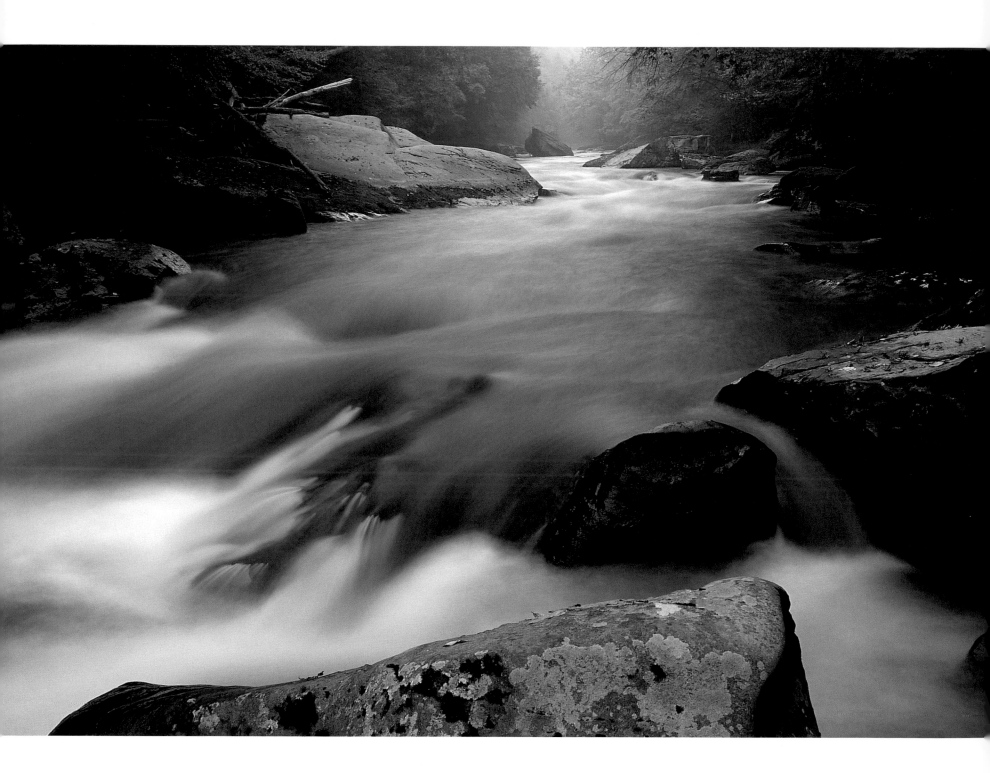

SLIPPERY ROCK CREEK, PENNSYLVANIA
The exquisite gorge formed by Slippery Rock Creek makes a refuge for nature
in the coal-mining country of western Pennsylvania.

SHOHOLA CREEK, PENNSYLVANIA
With its source in blackwater bogs of the Pocono Plateau, Shohola Creek
stairsteps down toward the Delaware River.

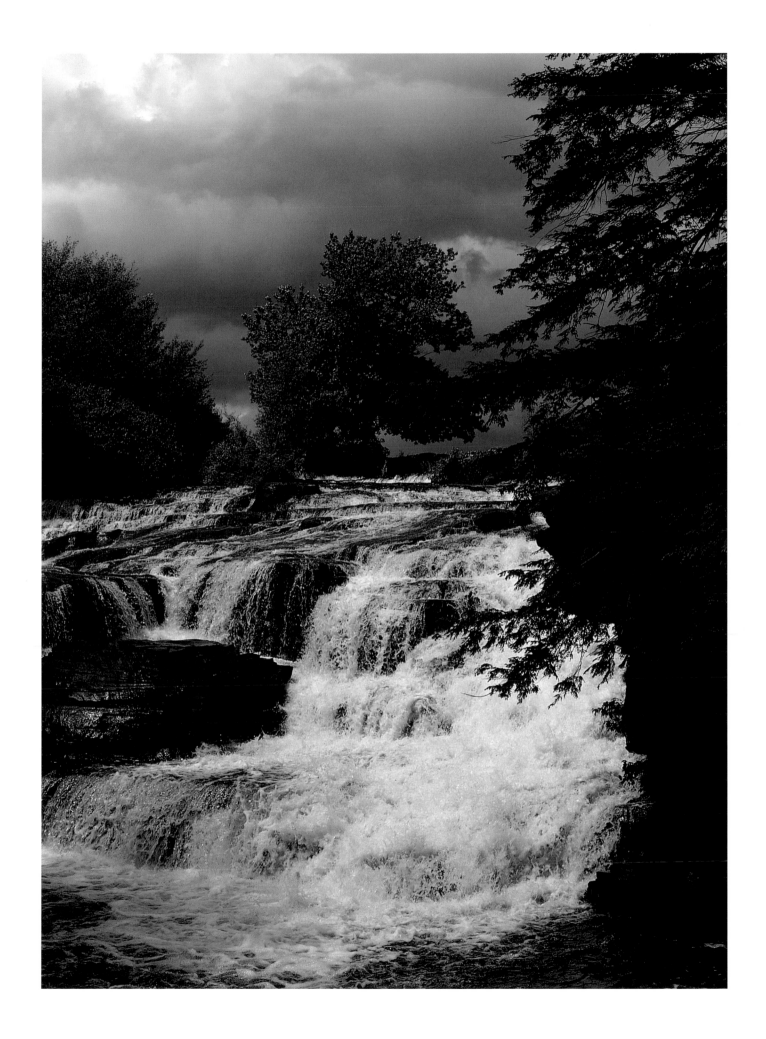

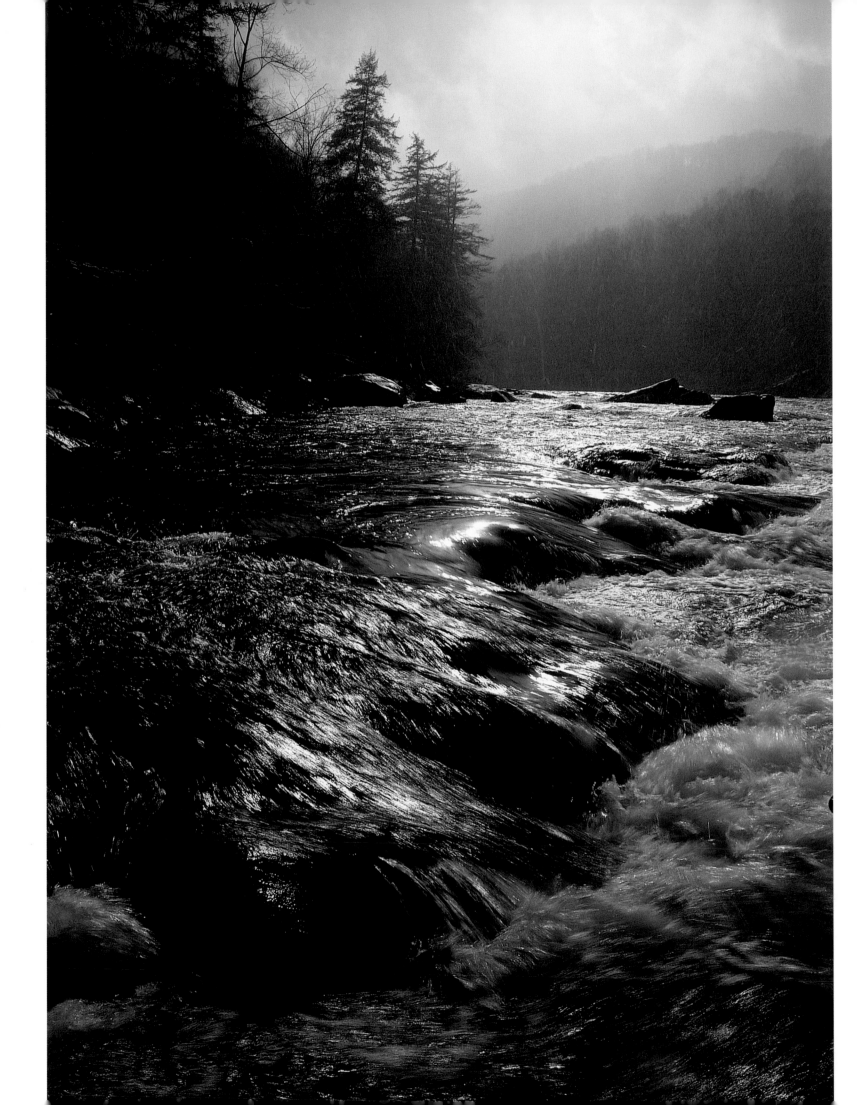

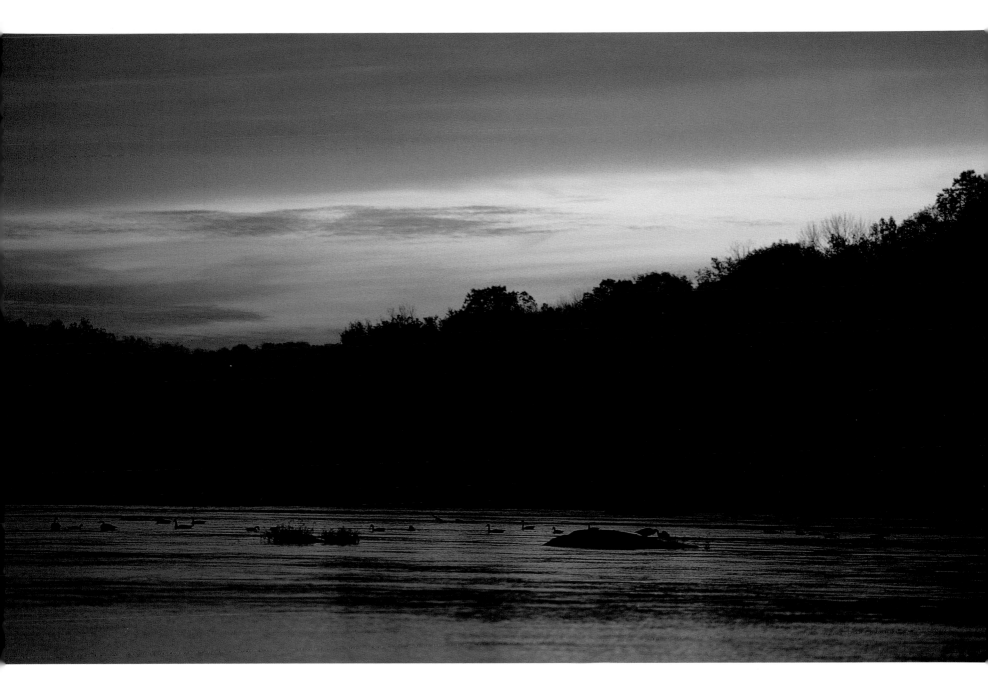

POTOMAC RIVER, VIRGINIA
Canada geese flock together during a golden sunrise on the Potomac River, which forms the
border between Maryland and Virginia, just downstream from Harper's Ferry.

89

YOUGHIOGHENY RIVER, PENNSYLVANIA
Sunshine interrupts a winter snowstorm at Railroad Rapid, just below Ohiopyle on the Youghiogheny River.

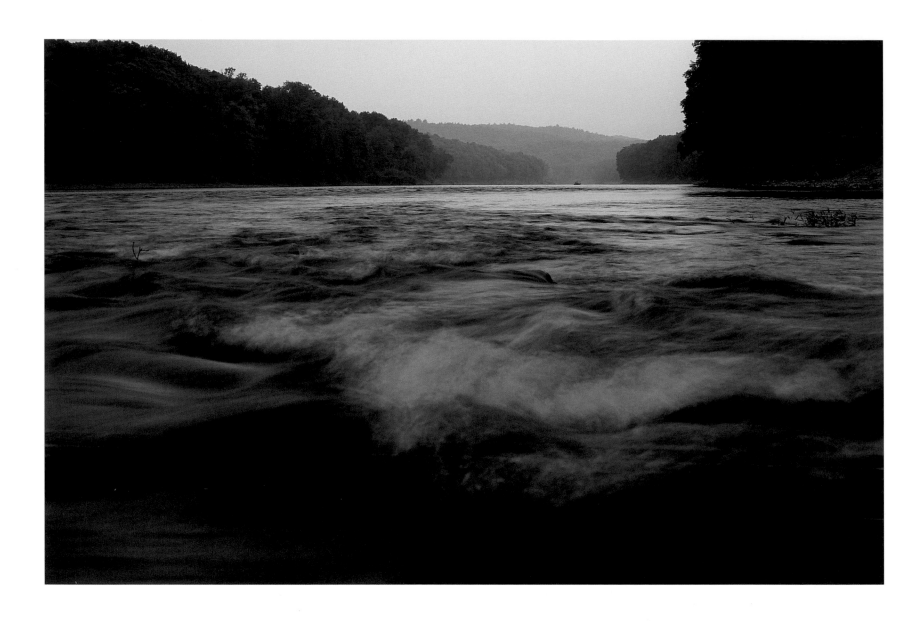

DELAWARE RIVER, PENNSYLVANIA

As the only sizable main-stem river on the East Coast without a dam, the Delaware marks the boundary

between Pennsylvania and New Jersey near Dingman's Ferry.

SOUTH FORK SHENANDOAH, VIRGINIA

Rippling with runoff from the Blue Ridge Mountains, the South Fork Shenandoah mists the air at sunrise near Newport.

Overleaf CLINCH RIVER, VIRGINIA

With one of the longest free-flowing reaches in the Appalachians, the Clinch River angles for 130 miles across southwestern Virginia before hitting the backwaters of dams built by the Tennessee Valley Authority. Shaded by eastern woodlands and reflecting the green of its riparian edge, this reach near Cleveland is known as the center of endemism for native mussels.

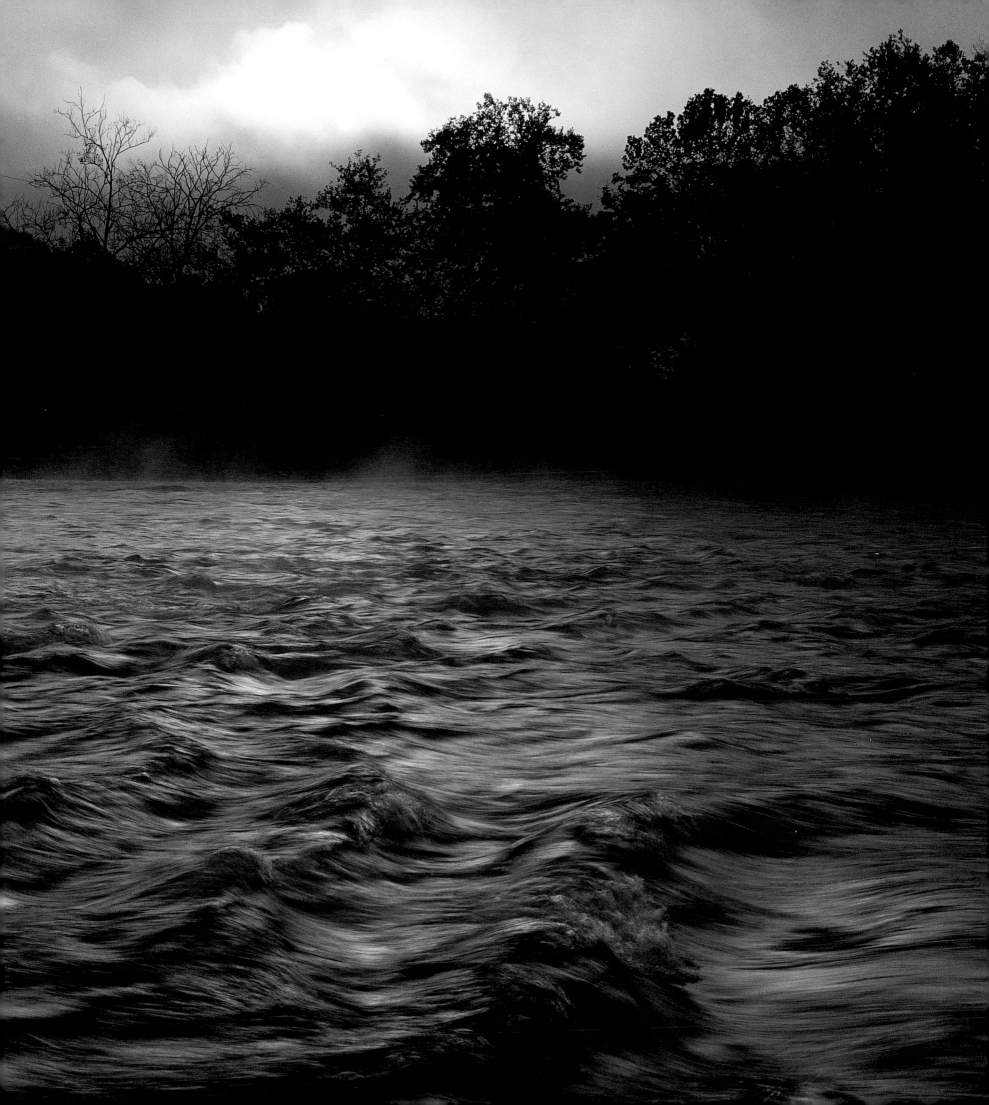

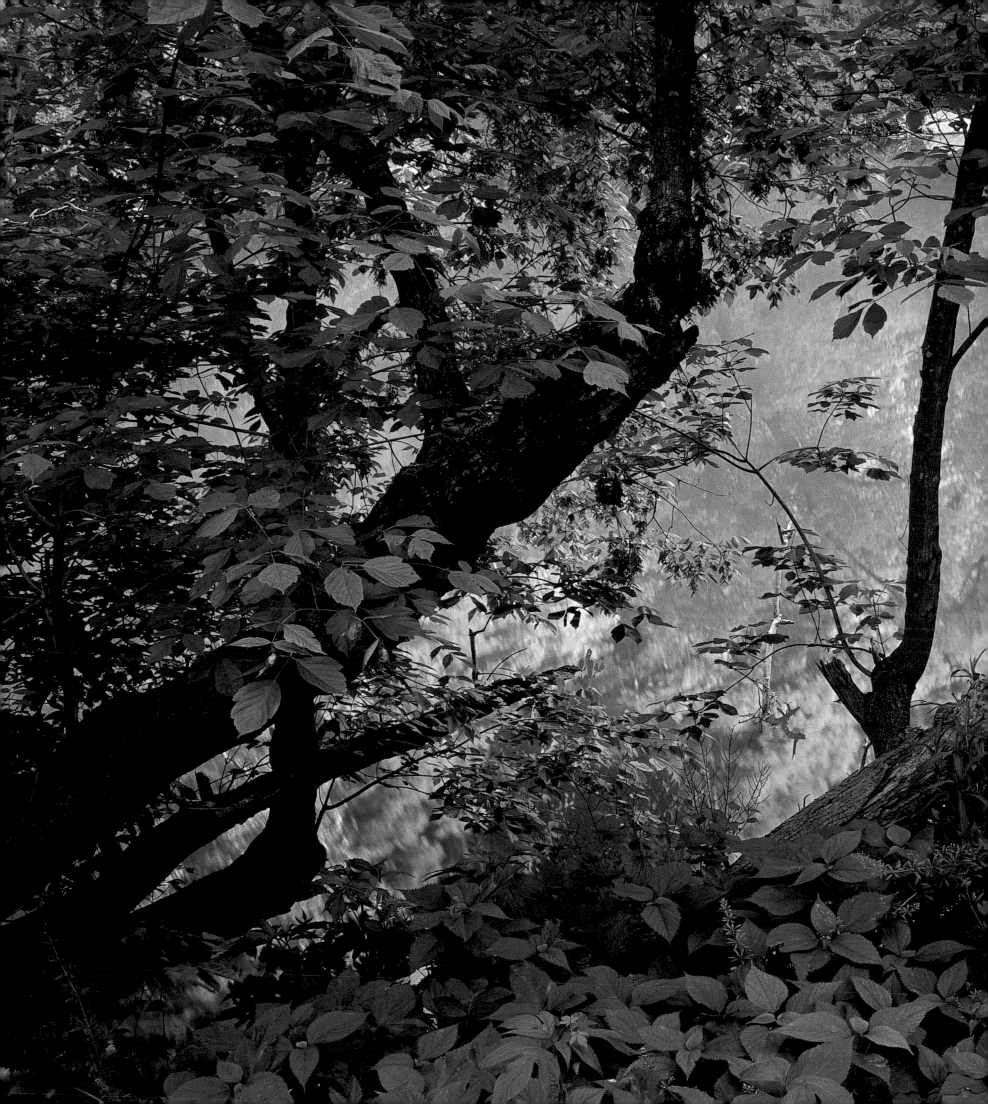

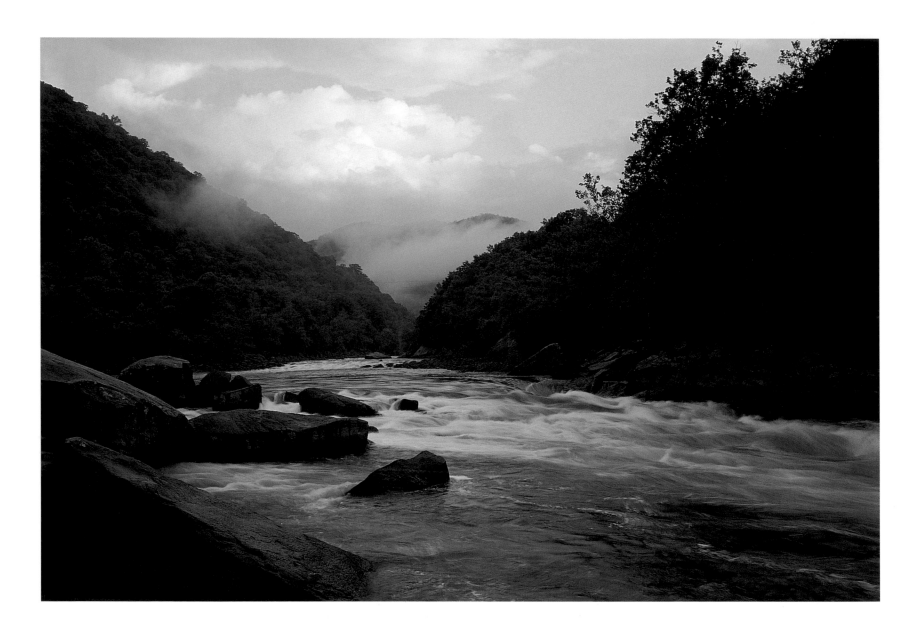

New River, West Virginia

The New River begins in North Carolina, crosses Virginia, and then in West Virginia roars through one of the most dramatic gorges of the Appalachians. Perhaps the oldest river in America, it predated the mountains' uplift 300 million years ago, but it is still riddled with rapids that create the paramount big-water paddling trip of the East.

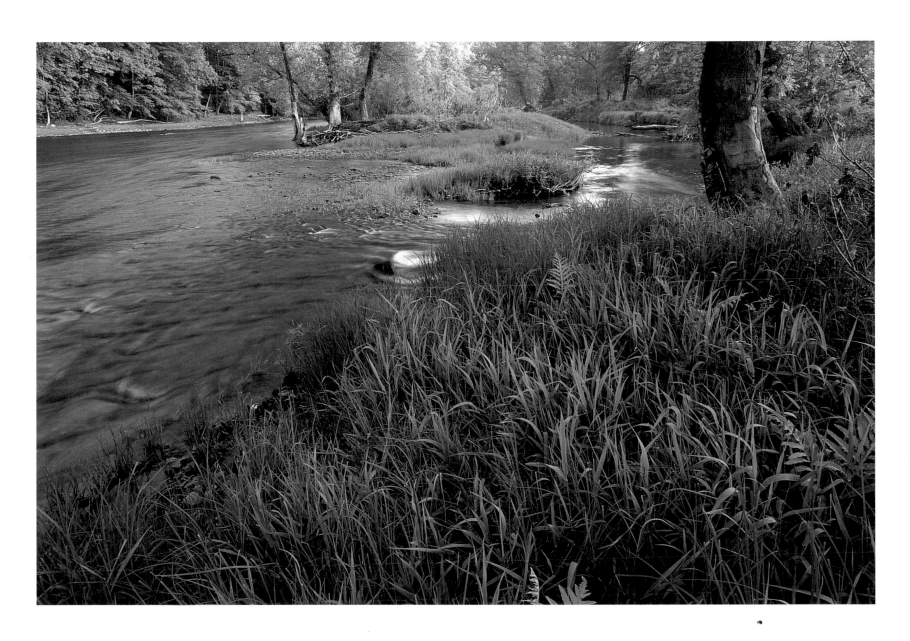

GREENBRIER RIVER, WEST VIRGINIA
With shorelines bursting in the juicy green growth of May, the Greenbrier River flows through
the heart of the Appalachians on its way to the New River.

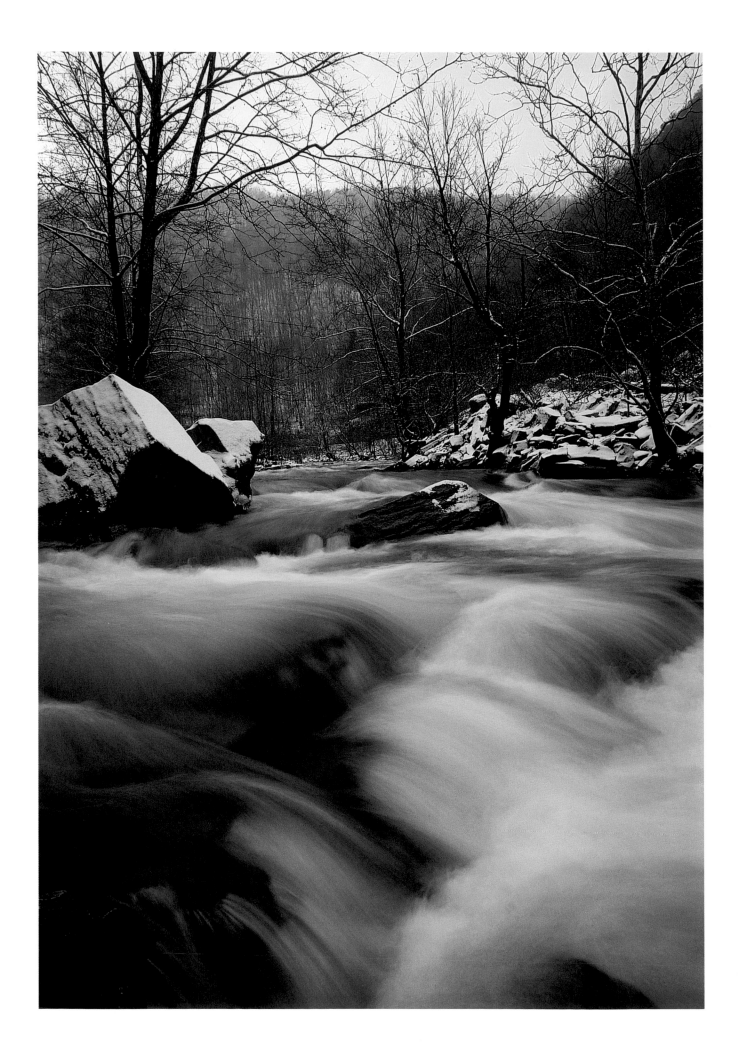

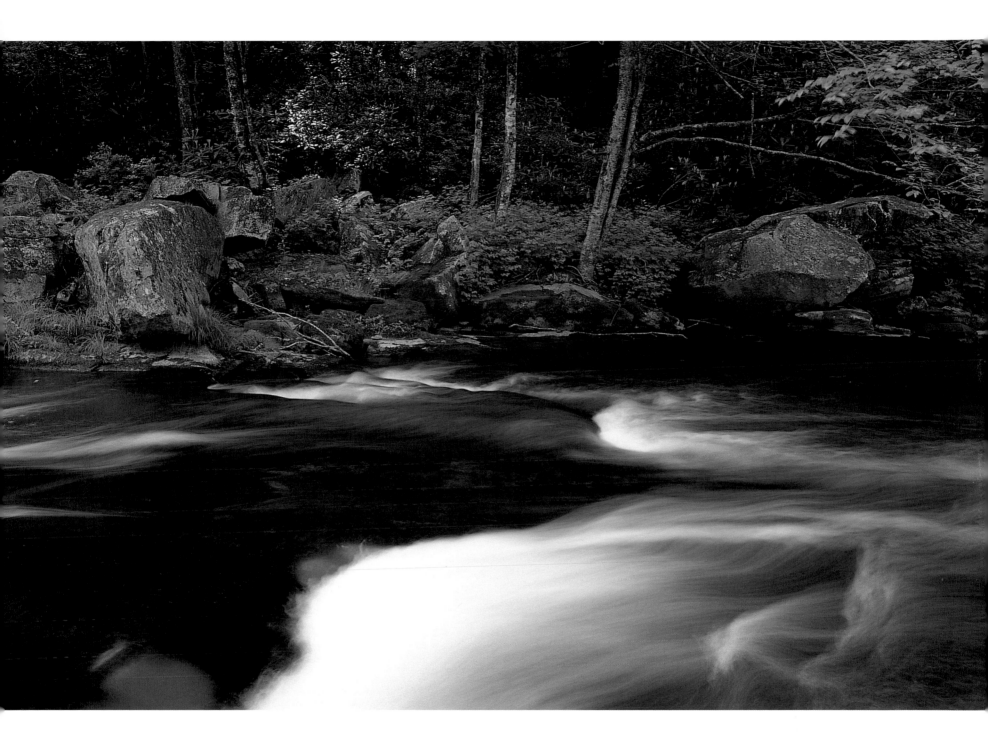

LINVILLE RIVER, NORTH CAROLINA
Enchanting in a deep and shaded gorge, the Linville River follows one of the most extreme gradients in the
Appalachians as it descends toward the Catawba River from the high peaks of the southern mountains.

NANTAHALA RIVER, NORTH CAROLINA
A fresh snowfall whitens the shores of the Nantahala River, a tributary to the
Little Tennessee and a popular paddling stream.

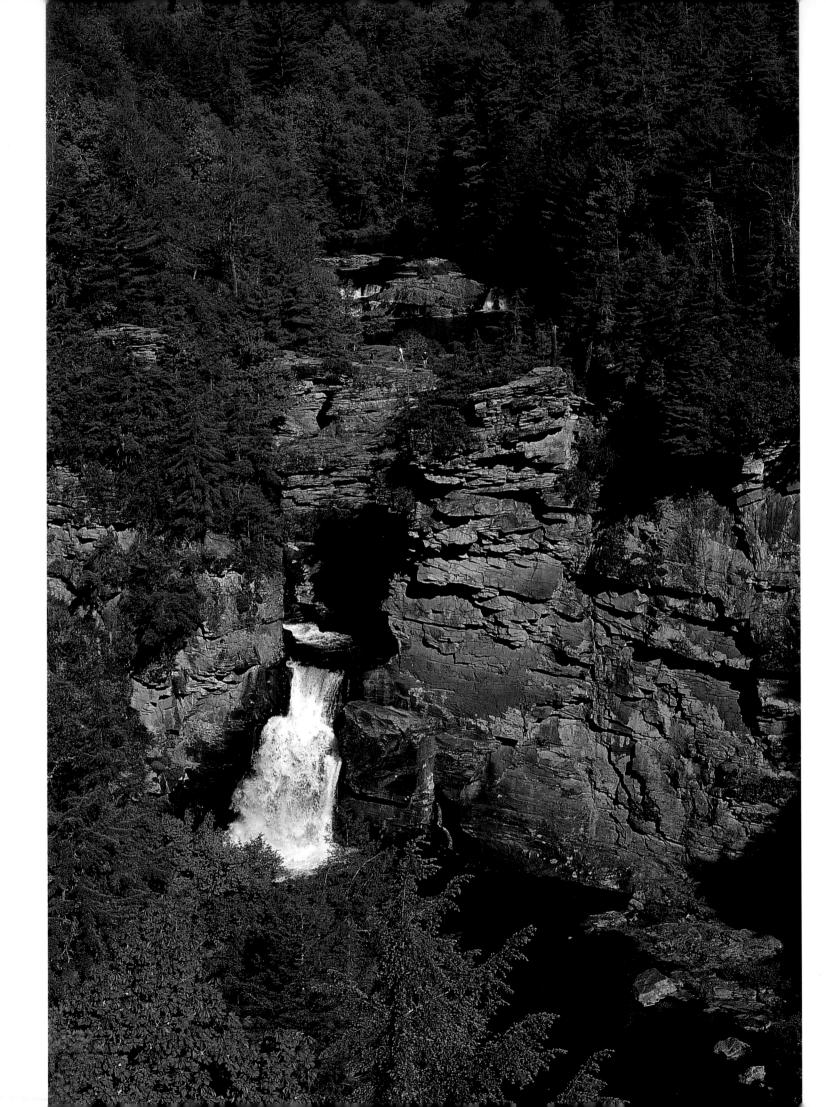

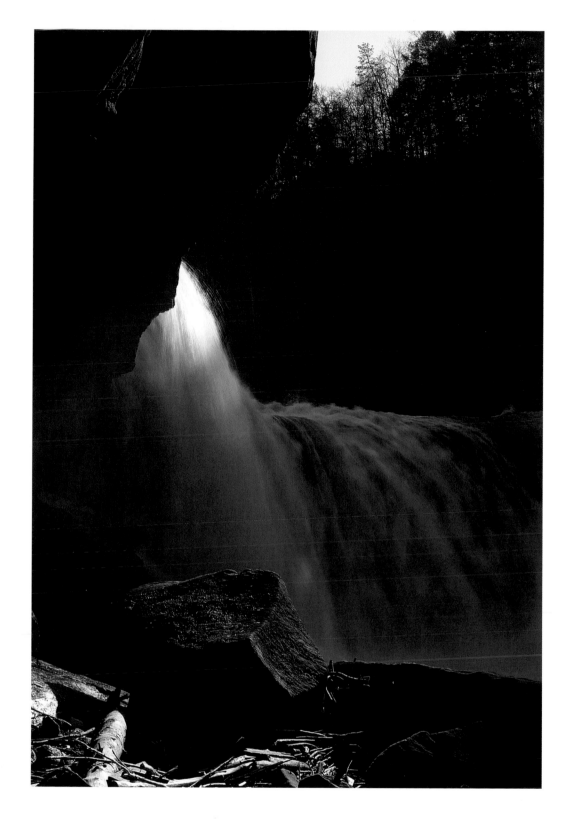

CUMBERLAND RIVER, KENTUCKY
The Cumberland River drops over the second-largest waterfall in the eastern United States.

LINVILLE RIVER, NORTH CAROLINA
Downstream from this ninety-foot waterfall, the Linville River offers the ultimate in Appalachian whitewater as it
flows through a canyon of unmatched rugged wildness. Green summits rise 2,000 feet above the stream.

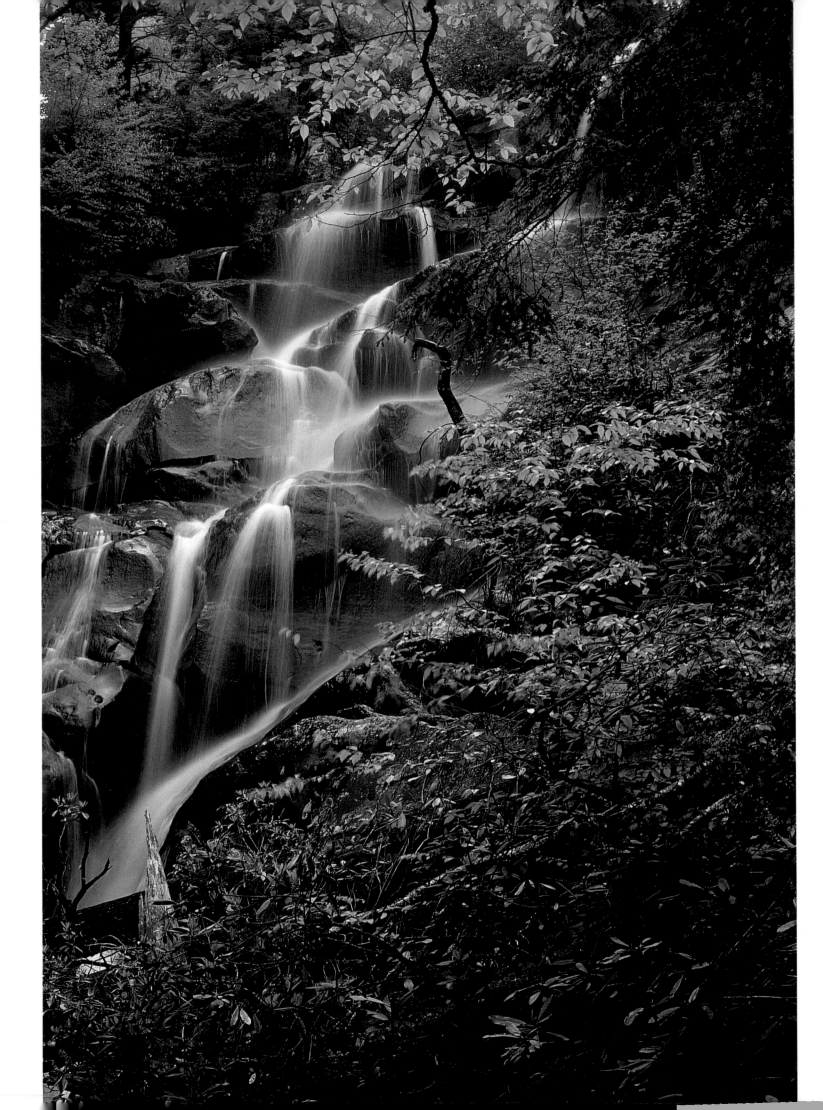

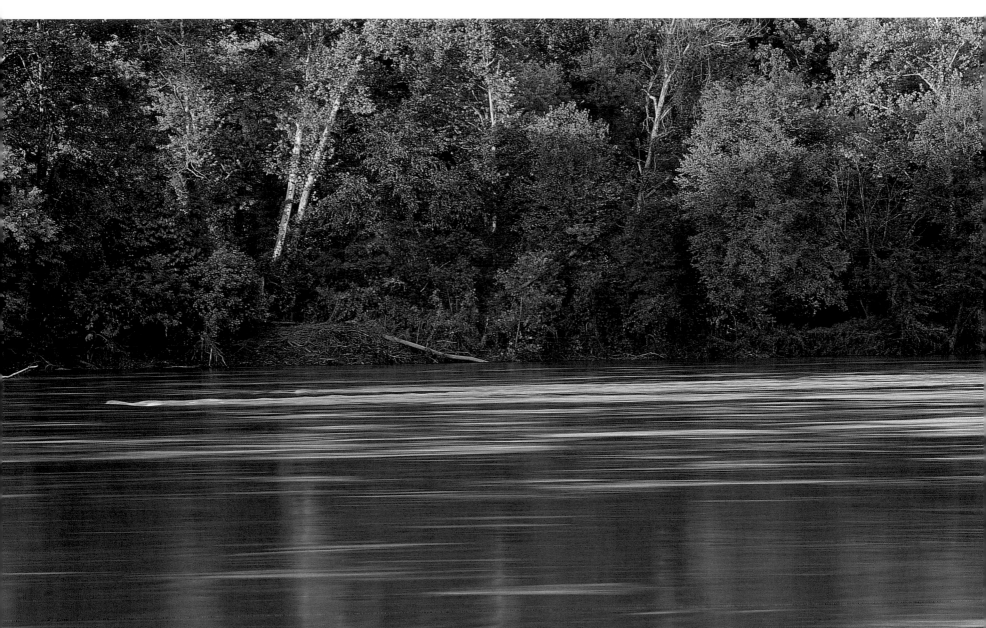

JAMES RIVER, VIRGINIA
Smooth waters of the James shimmer through rolling terrain near Scottsville. Farther downstream the river plunges over the Fall Line in Richmond and enters the Chesapeake Bay at Jamestown, where the first successful English settlement in America was built.

RAMSAY PRONG, TENNESSEE
Birches and alders frame this waterfall of Ramsay Prong, a tributary to the Little Pigeon River in the Great Smoky Mountains.

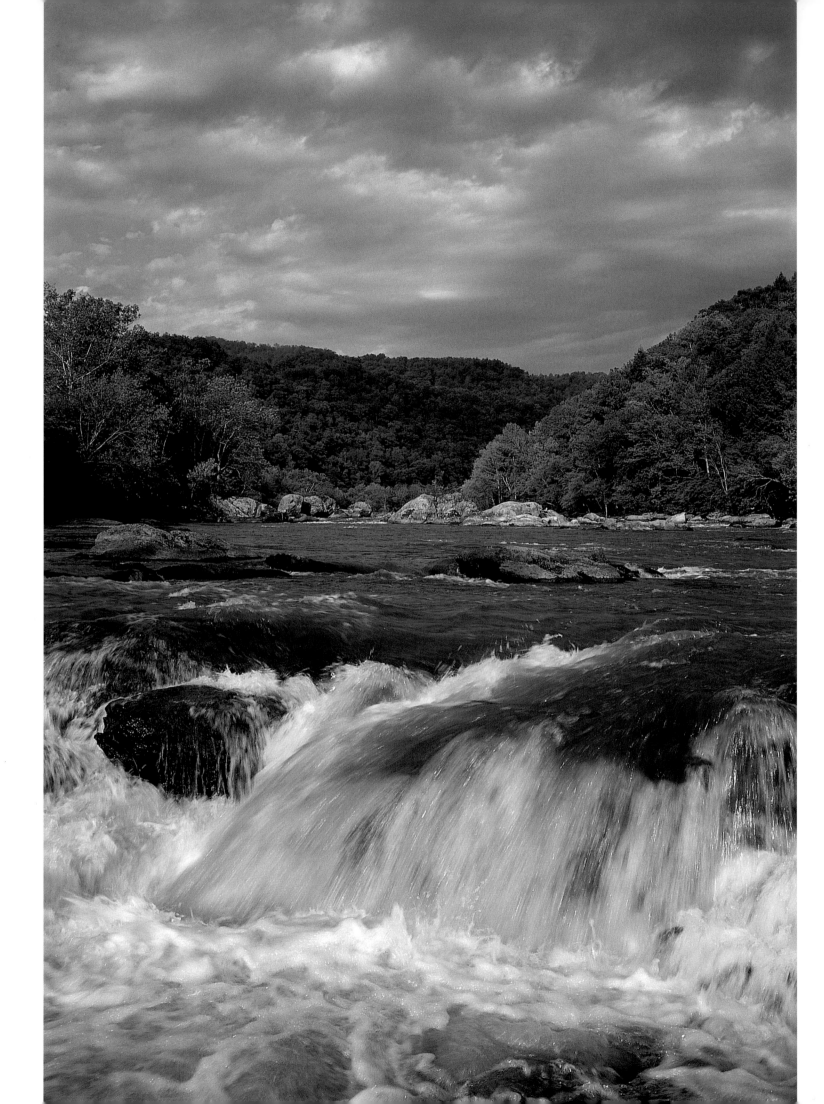

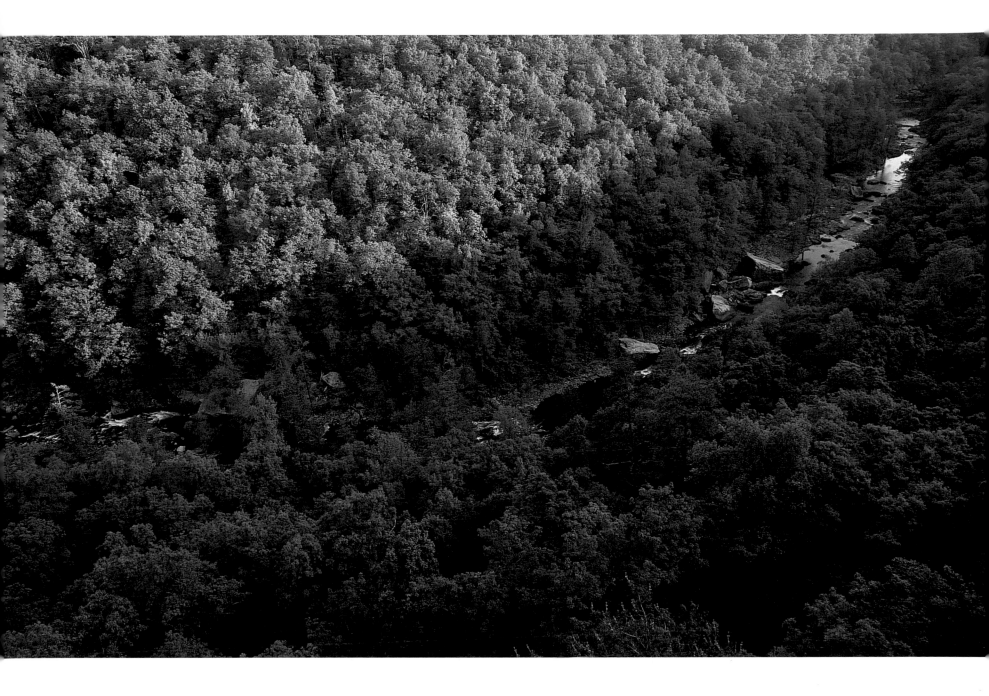

LITTLE RIVER, ALABAMA
The Little River carves an unexpected gorge in the southernmost reaches of the Appalachians.
With a fascinating diversity of plant species, this section of the river is protected as the Little
River Canyon National Preserve.

FRENCH BROAD RIVER, NORTH CAROLINA
One of the larger whitewater rivers in the Appalachians, the French Broad below Barnard boils through
rock gardens and over steep pitches popular among canoeists, kayakers, and rafters.

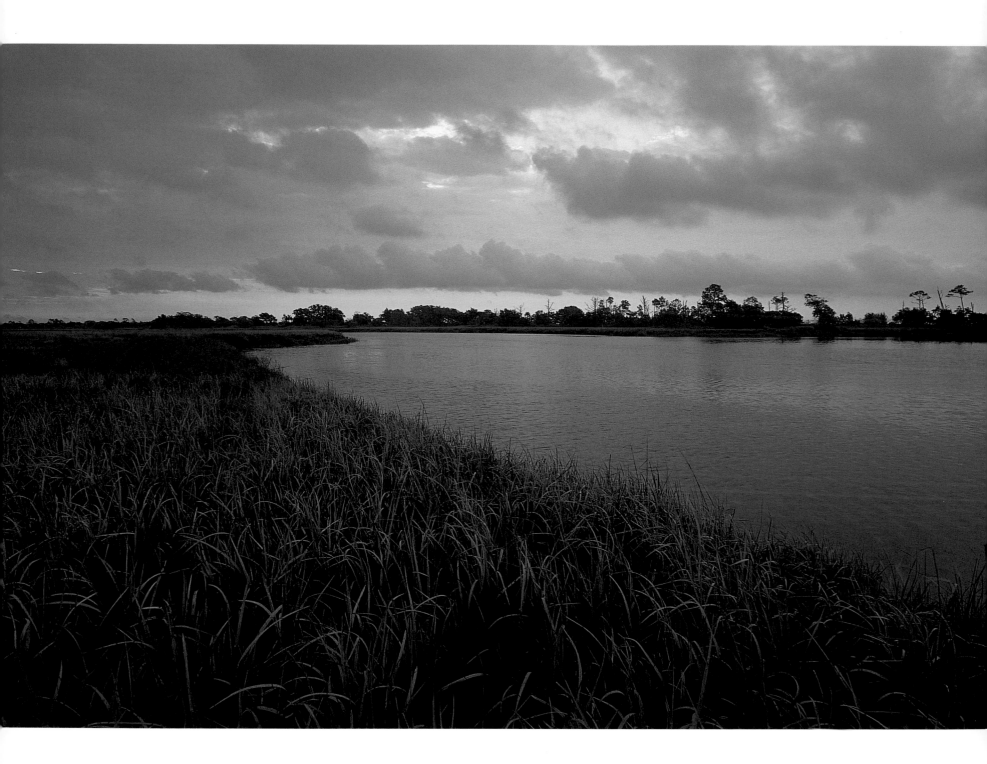

ASHEPOO RIVER, SOUTH CAROLINA
After draining the lowlands of South Carolina, the Ashepoo River winds through salt marshes when it nears
sea level on the Atlantic Coast. Ocean fisheries offshore depend on the quality of rivers feeding the estuaries.

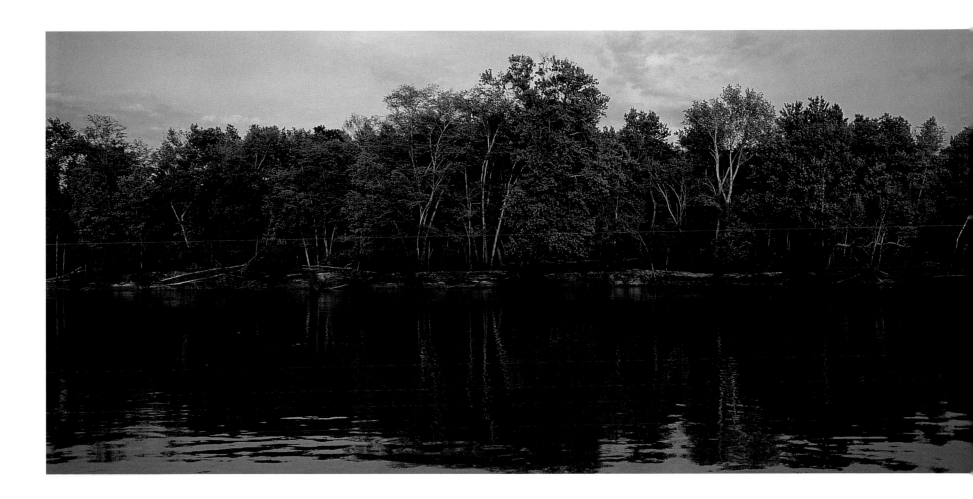

ALTAMAHA RIVER, GEORGIA

With the second-largest volume of river water on the Atlantic Coast south of Canada, the Altamaha begins at the confluence of the Ocmulgee and Oconee Rivers and ends in an intricate maze of islands on the coast of Georgia. In some places forested wetlands reach back miles from the riverfront.

Overleaf BLACK RIVER, SOUTH CAROLINA
Willow trees grow from sandbars along the Black River of South Carolina.

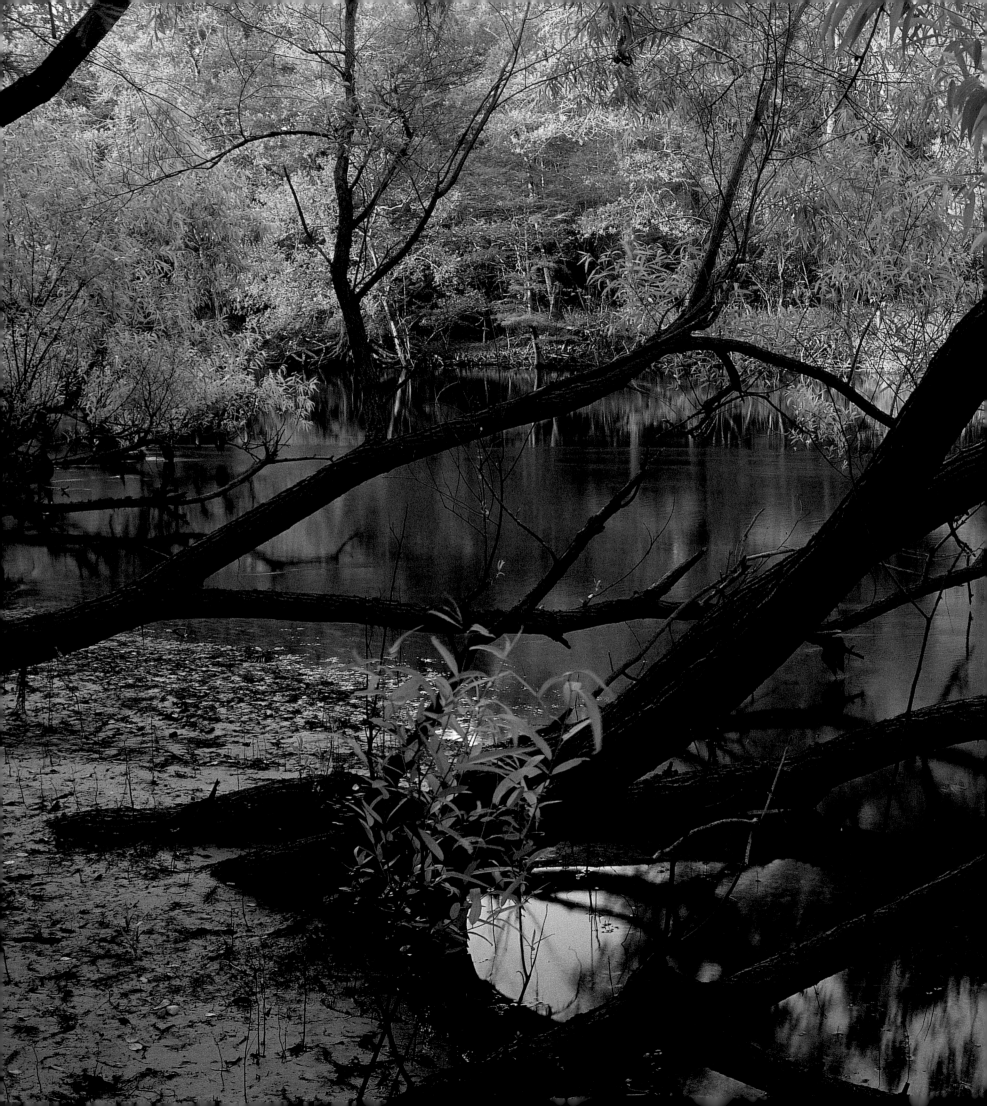

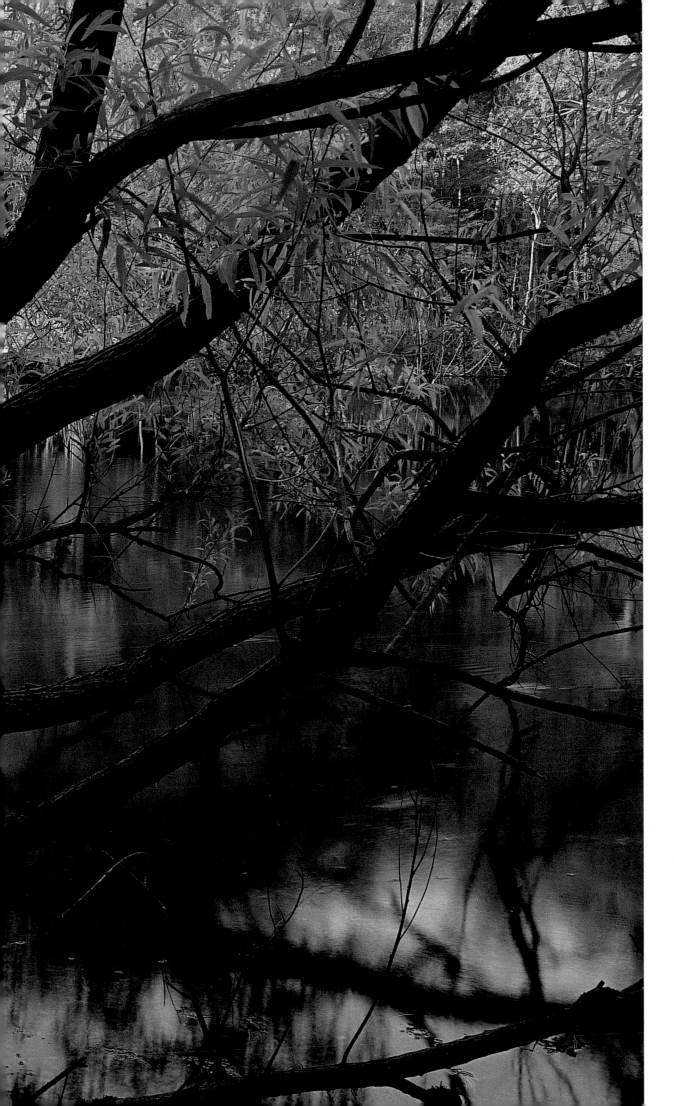

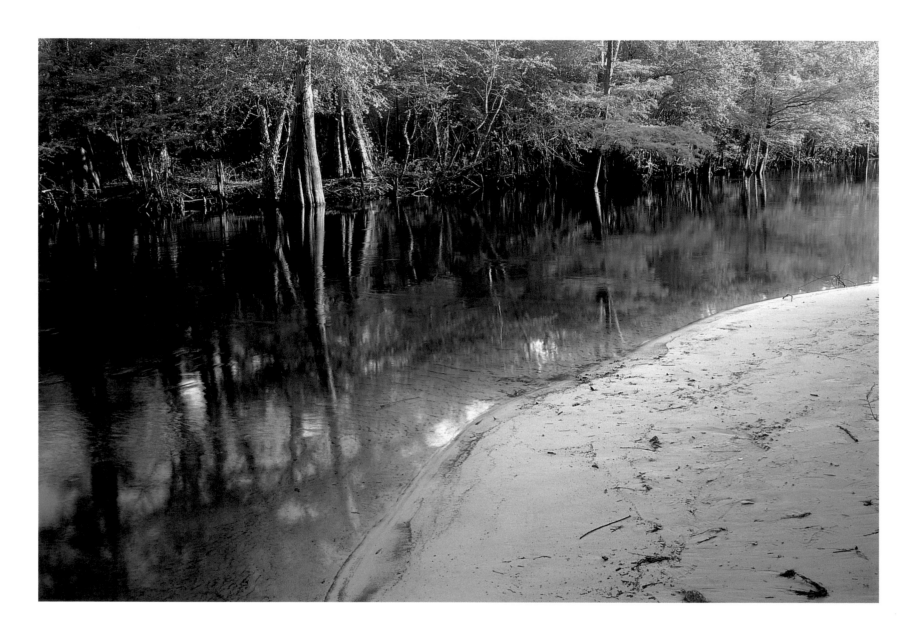

Waccamaw River, South Carolina
Draining wide expanses of wetlands that adjoin southeastern waterways, streams such as the Waccamaw River here near Conway carry heavy loads of dissolved organic matter, which colors the water amber in the shallows and black in deeper channels.

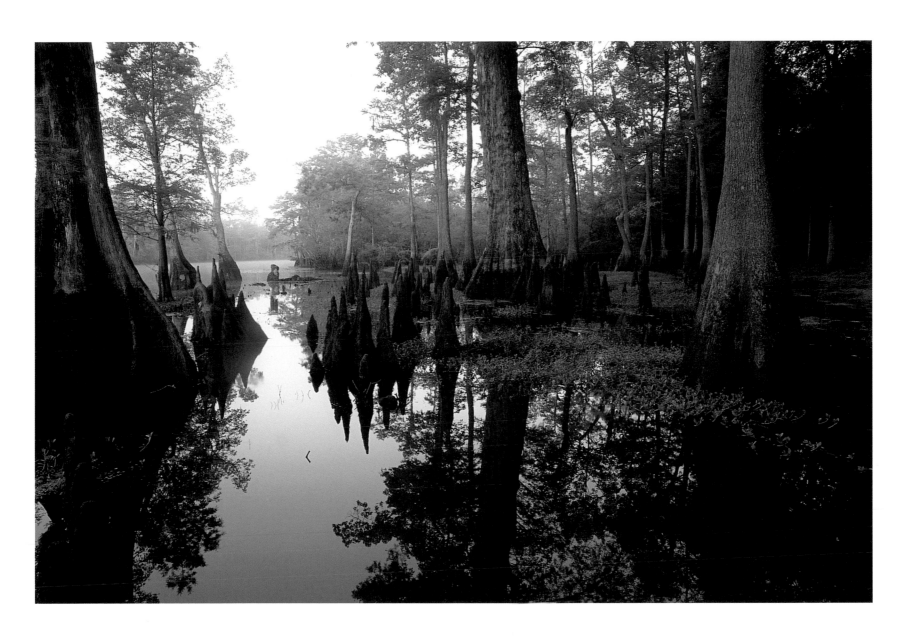

BLACK RIVER, SOUTH CAROLINA

Baldcypress trees grow along the edges of the Black River, a tributary to the lower Pee Dee. With trunks
buttressed for stability and "knees" that help the flooded roots to breathe, some of these magnificent
conifers have been alive for 1,700 years—the oldest trees east of the Rocky Mountains.

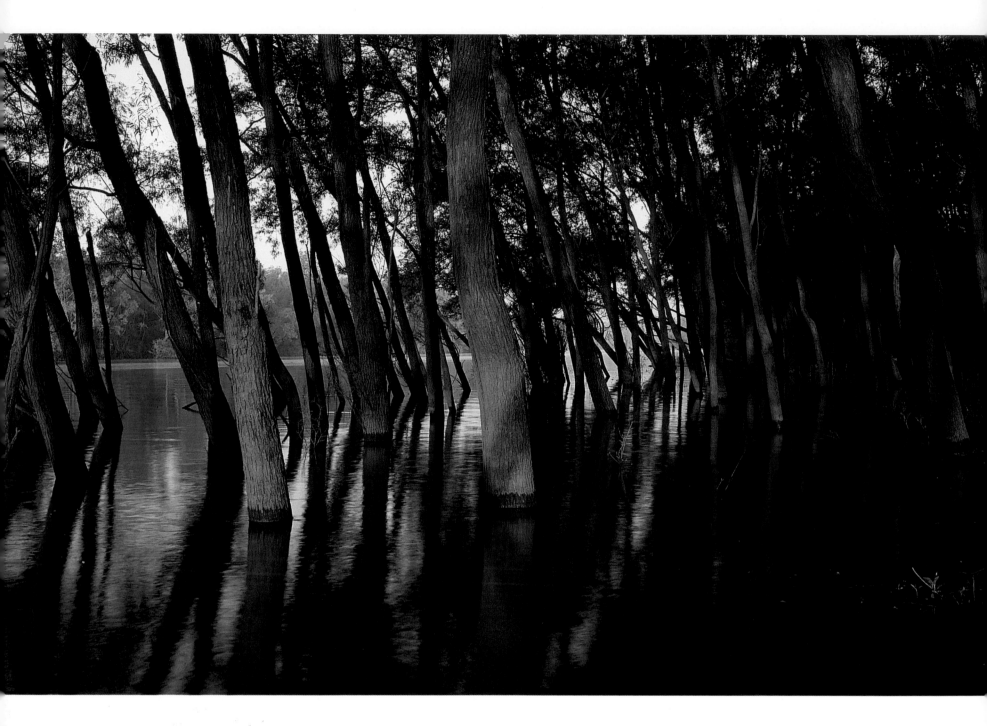

SAINT FRANCIS RIVER, ARKANSAS

Willow trees are flooded where the Saint Francis River meets the prodigious runoff of the Mississippi. Forested wetlands such as this are integral to rivers, absorbing floodwaters, filtering pollutants, and providing habitat for birds, fish, and other wildlife.

SUWANNEE RIVER, FLORIDA

Shores of the semi-tropical Suwannee River are tangled with palmettos and oaks. The floodplains along much of the river's 200-mile route to the Gulf of Mexico have been protected through public acquisition.

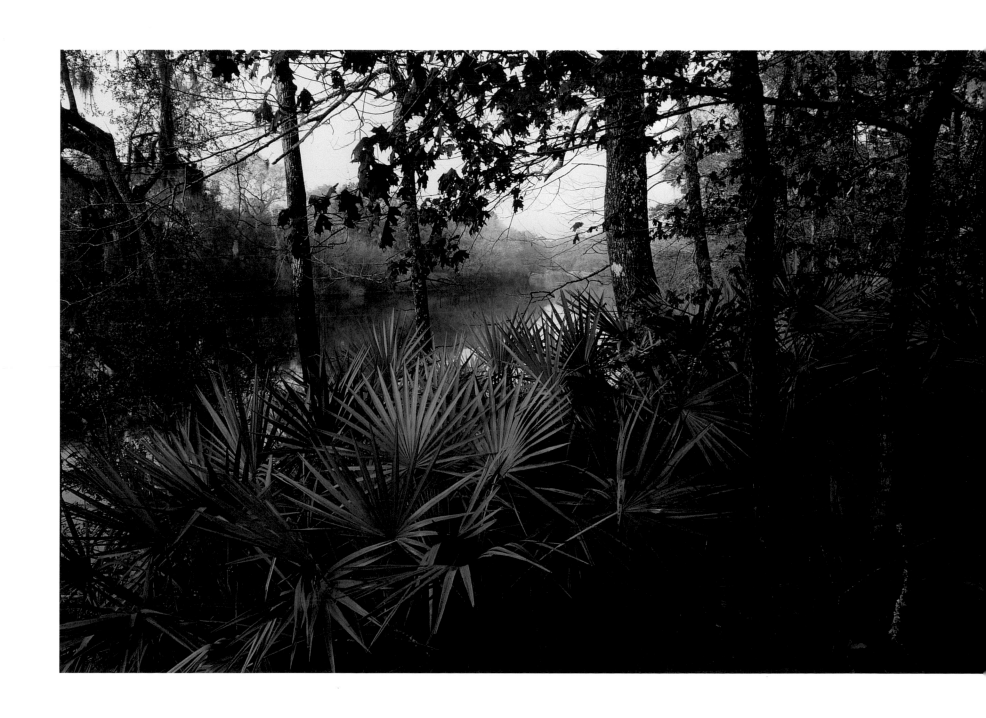

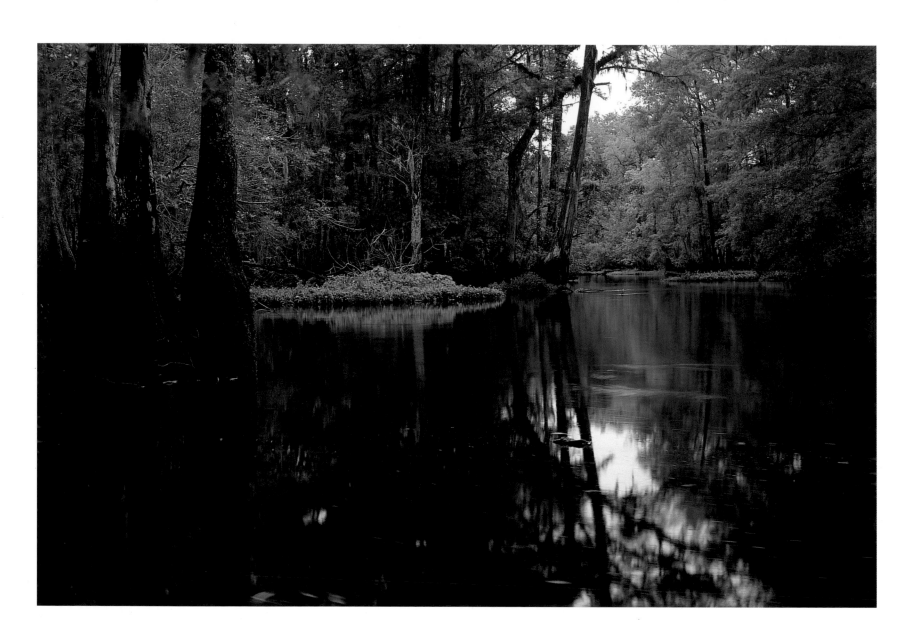

LUMBER RIVER, NORTH CAROLINA

The Lumber River filters through a deep forest of baldcypress on its way to the Pee Dee River and the Atlantic shore.

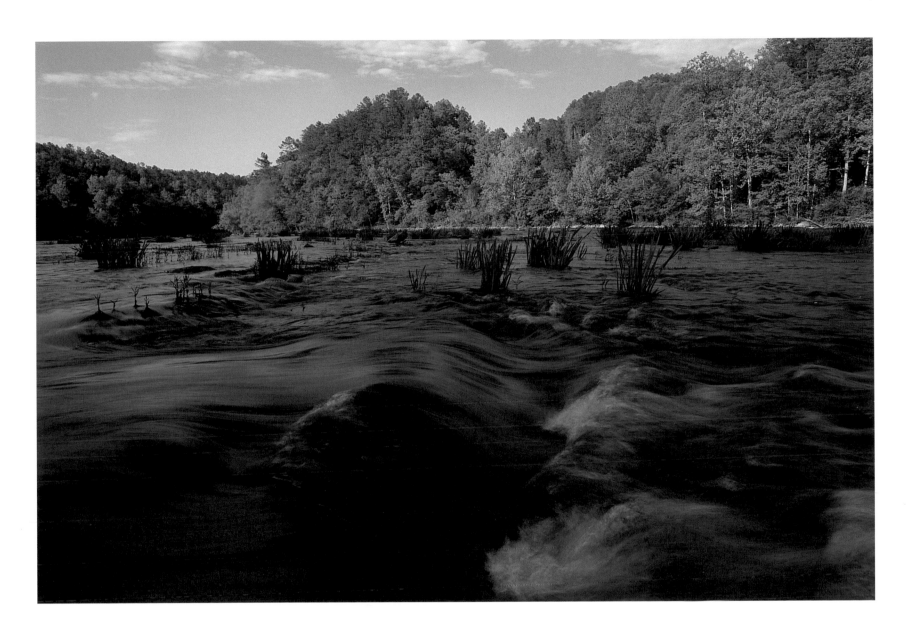

CAHABA RIVER, ALABAMA

The Cahaba River hosts a fascinating mix of life as it connects the southernmost foothills of the Appalachians with the
Coastal Plain, which extends with almost no gradient to the Gulf of Mexico. One of the most active river groups in
the South, the Cahaba River Society works to stop pollution in the river's upper reaches, which include Birmingham.

Midwestern Rivers

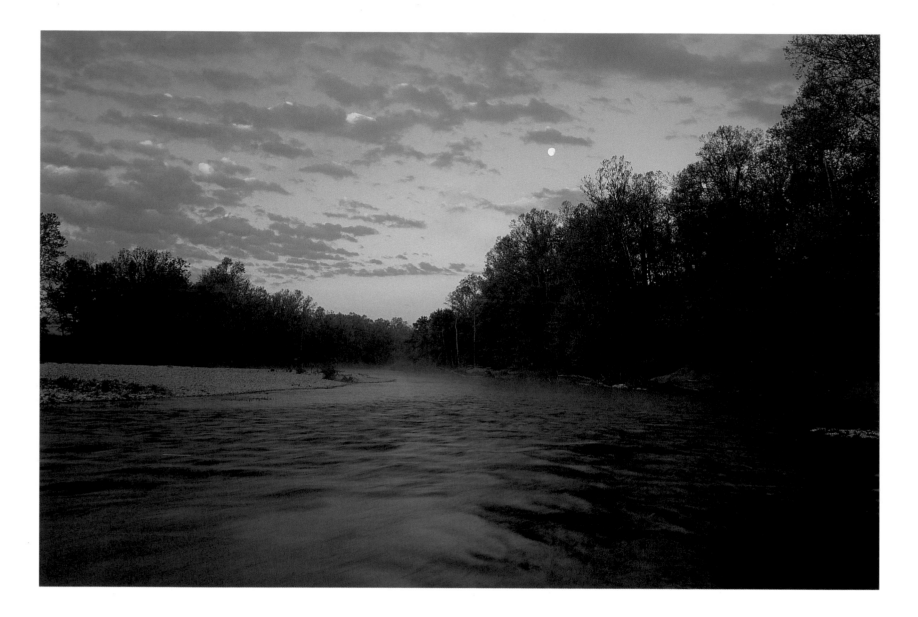

ILLINOIS RIVER, OKLAHOMA
Just after dawn, a nearly full moon sets over the Illinois, an Arkansas River tributary north of
Tahlequah. This river provides habitat for a wide variety of birds and other wildlife and is also used
by crowds of people canoeing and inner-tubing on weekends.

SKUNK RIVER, IOWA
At sunrise the Skunk River slides lazily across southeastern Iowa on its way to the Mississippi. Owing to channelization
and comprehensive drainage of headwater reaches, extreme loads of silt rinse from corn and soybean fields, yet a
refuge of riparian habitat survives along the shores.

MISSISSIPPI RIVER, MINNESOTA
The Mississippi River fingers through hidden channels in an intriguing complex of
islands downstream from the Crow Wing River.

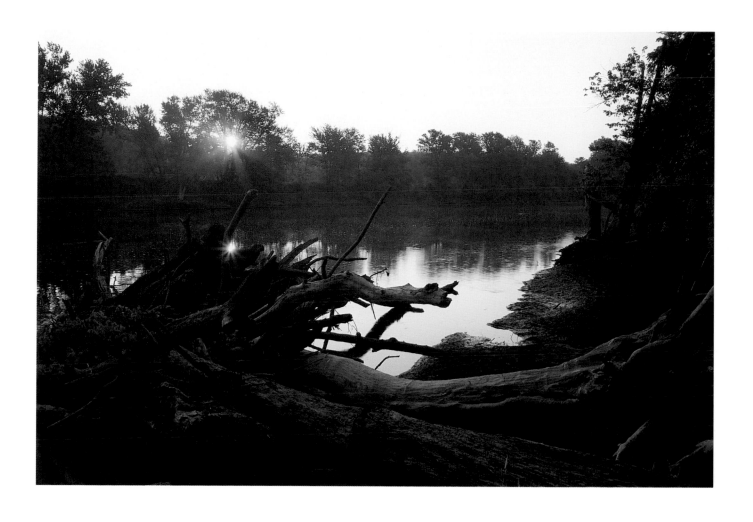

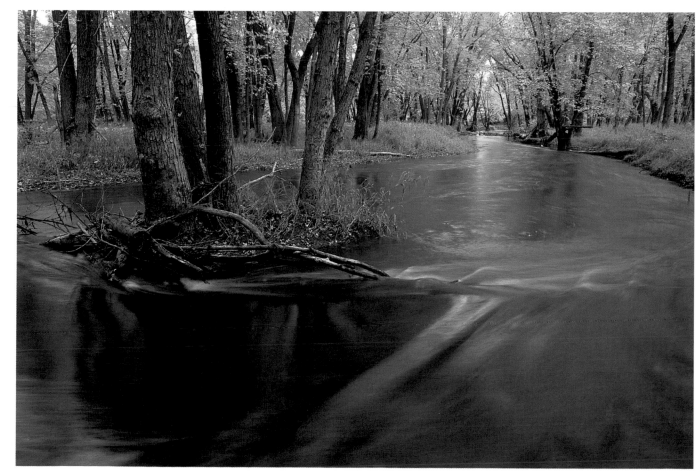

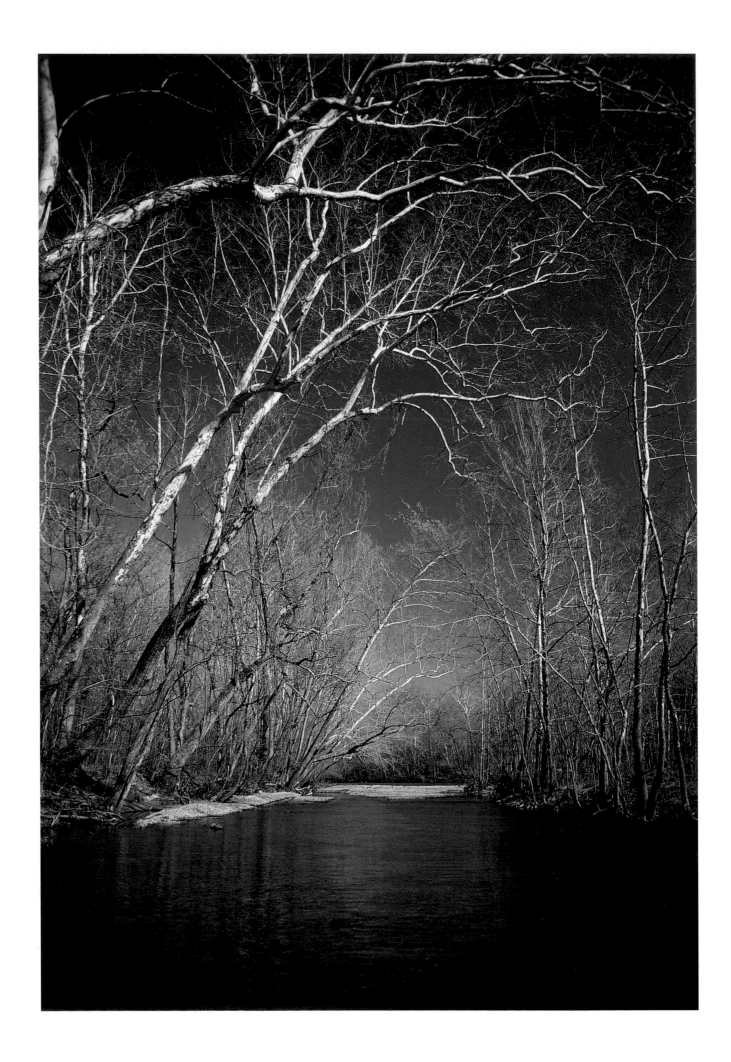

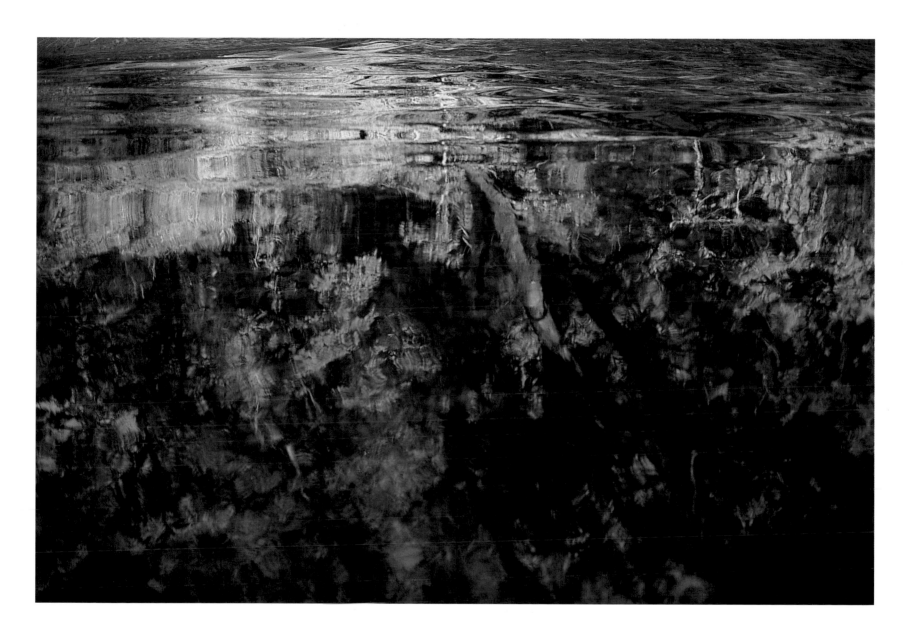

BUFFALO RIVER, ARKANSAS
Quiet waters of the Buffalo River reflect the green of silver maples and other streamside plant life.

ELEVEN POINT RIVER, MISSOURI
White-branched sycamores line the banks of the Eleven Point River south of Bardley. This was one of the original dozen National Wild and Scenic Rivers designated by Congress for protection in 1968.

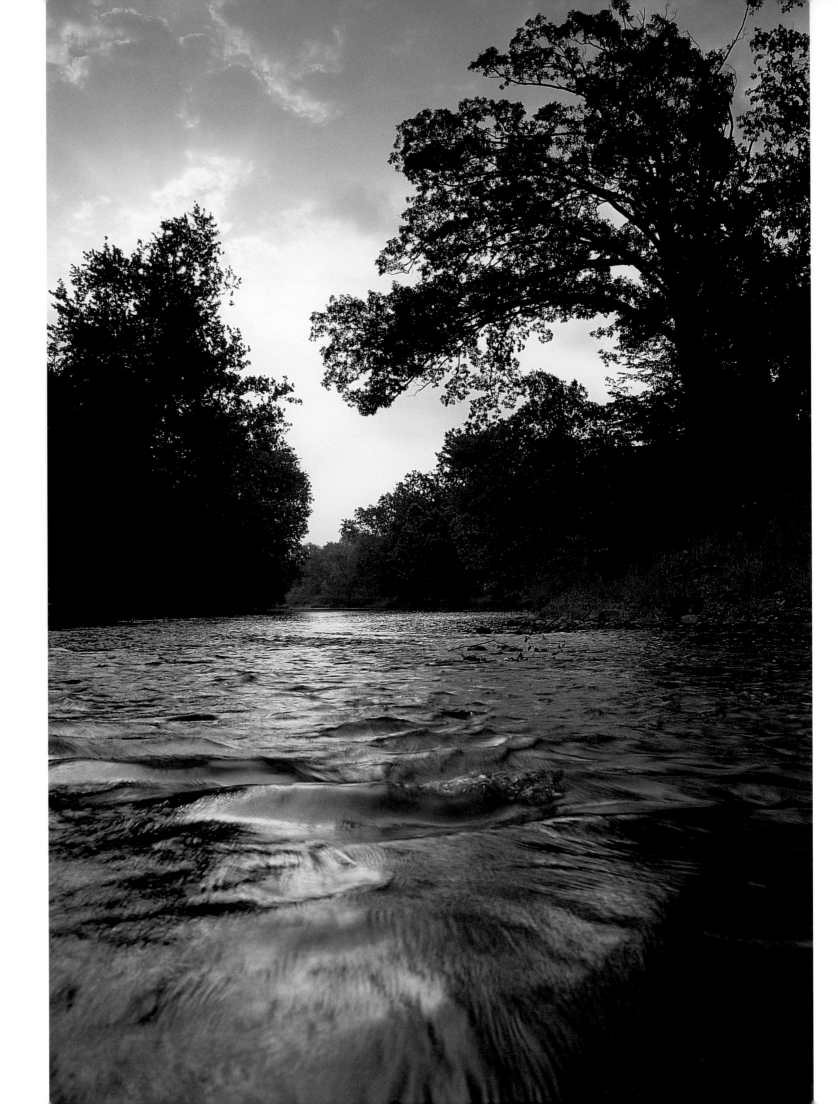

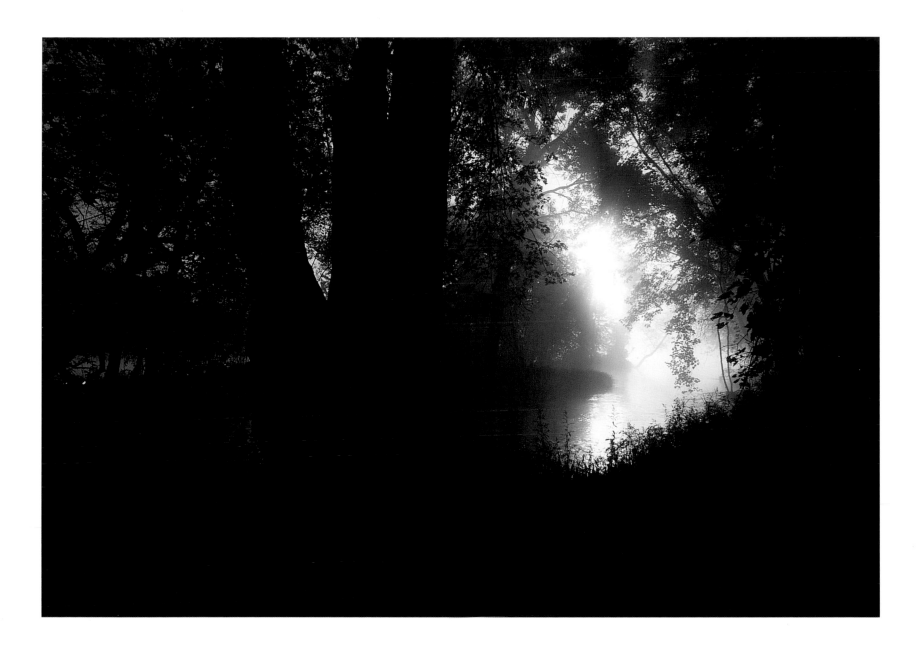

MISSISSIPPI RIVER, MINNESOTA
Intimate backwaters of the upper Mississippi emerge from the shade of
silver maples and drift into the brightness of morning light.

MIDDLE FORK VERMILION RIVER, ILLINOIS
The only National Wild and Scenic River in Illinois, the Middle Fork of the Vermilion slips through a narrow belt
of forest upstream from Kickapoo State Park before the small river joins the Wabash.

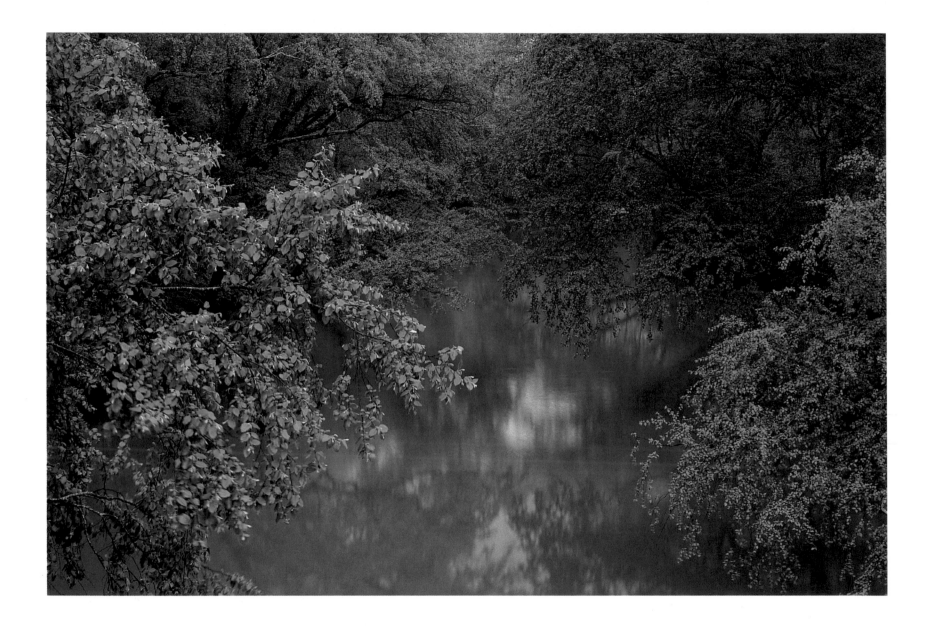

MULBERRY RIVER, ARKANSAS
Flowing from plentiful springs in the Ozark Mountains, the Mulberry River shows the
milky-blue tint of streams where limestone predominates.

WABASH RIVER, INDIANA
One of the central rivers of the midwestern Corn Belt, the Wabash lumbers southward through
Indiana to the Ohio River. Sunset glows golden over the wide, muddy river.

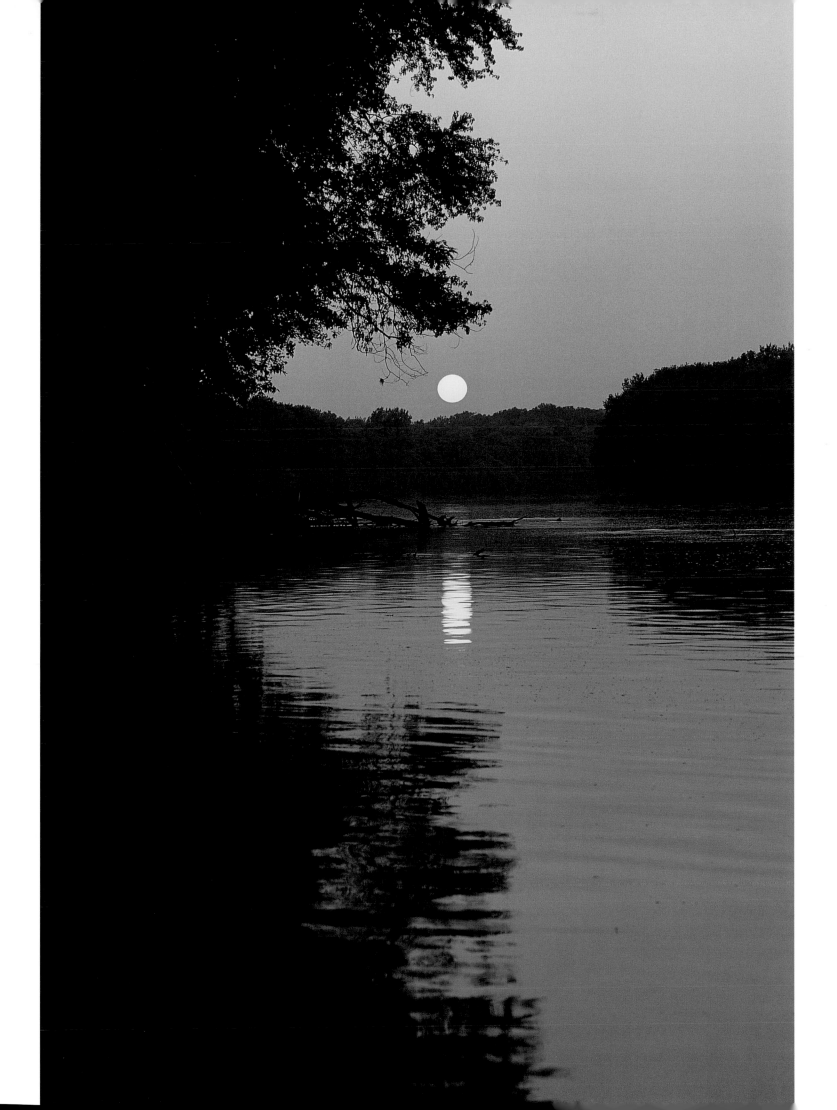

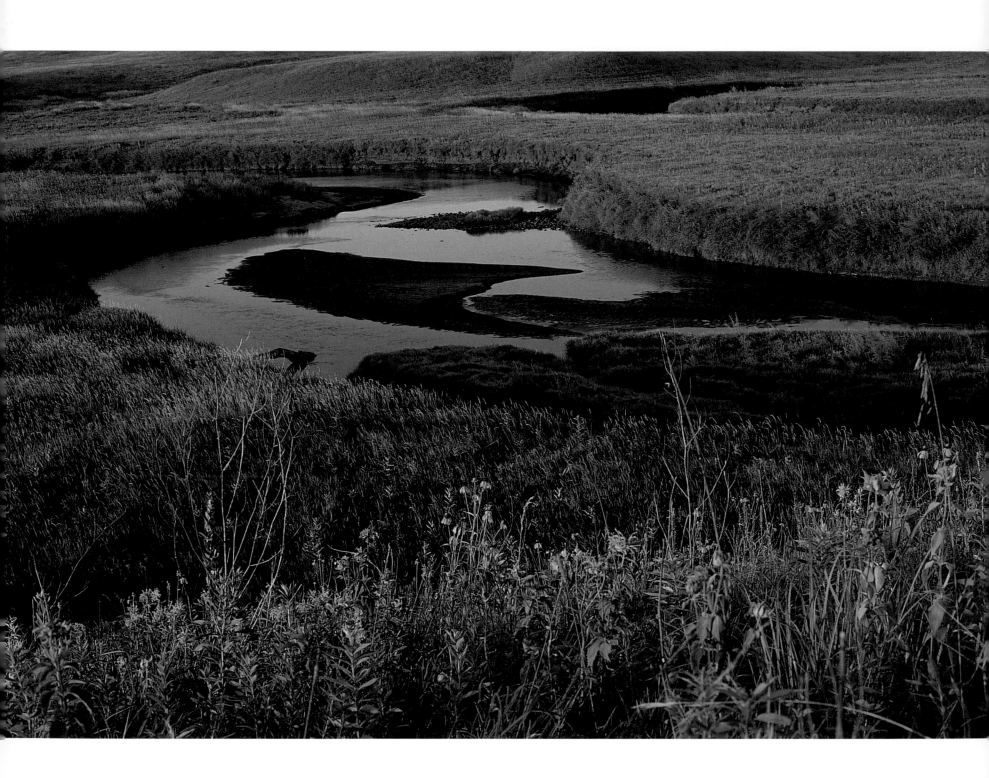

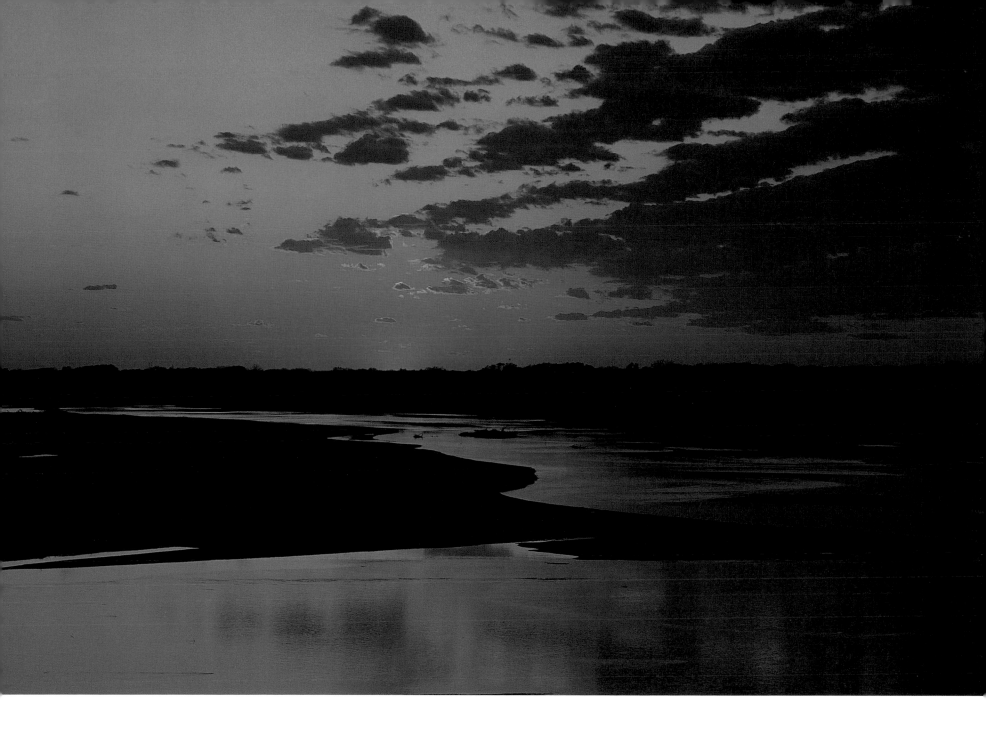

CIMARRON RIVER, OKLAHOMA
The Cimarron sweeps across hundreds of miles of Oklahoma before joining the Arkansas River. Though dammed, heavily diverted, and suffering from groundwater withdrawals, the river near Guthrie still supports a corridor of cottonwoods and reflects the spectacular sunsets of the Great Plains.

123

LITTLE SIOUX RIVER, IOWA
Few traces of the native tall-grass prairie remain, but west of Spirit Lake, Iowa, the Little Sioux River bisects the Cayler Prairie State Preserve with its abundance of native grasses, forbs, and wildflowers.

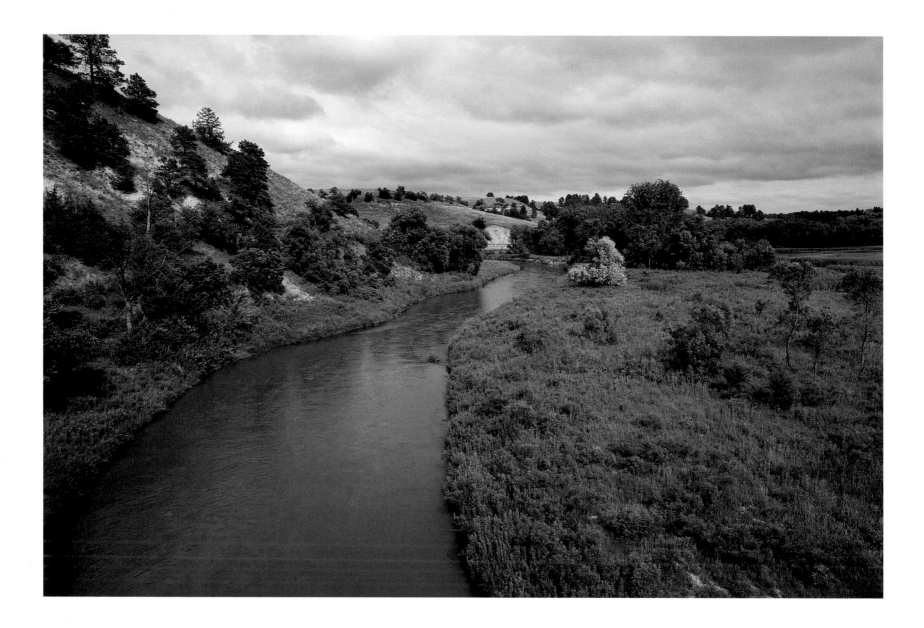

NIOBRARA RIVER, NEBRASKA
One of the finest streams remaining on the Great Plains, the Niobrara begins in the Sand Hills of Nebraska and continues for hundreds of winding miles to the Missouri River. Though still small here near the Merriman Bridge, the river offers an excellent canoeing route through grasslands and riparian forests of the Plains.

LITTLE MISSOURI RIVER, NORTH DAKOTA
The short-grass prairie along the Little Missouri River in Theodore Roosevelt National Park supports one of the largest herds of free-ranging bison in America.

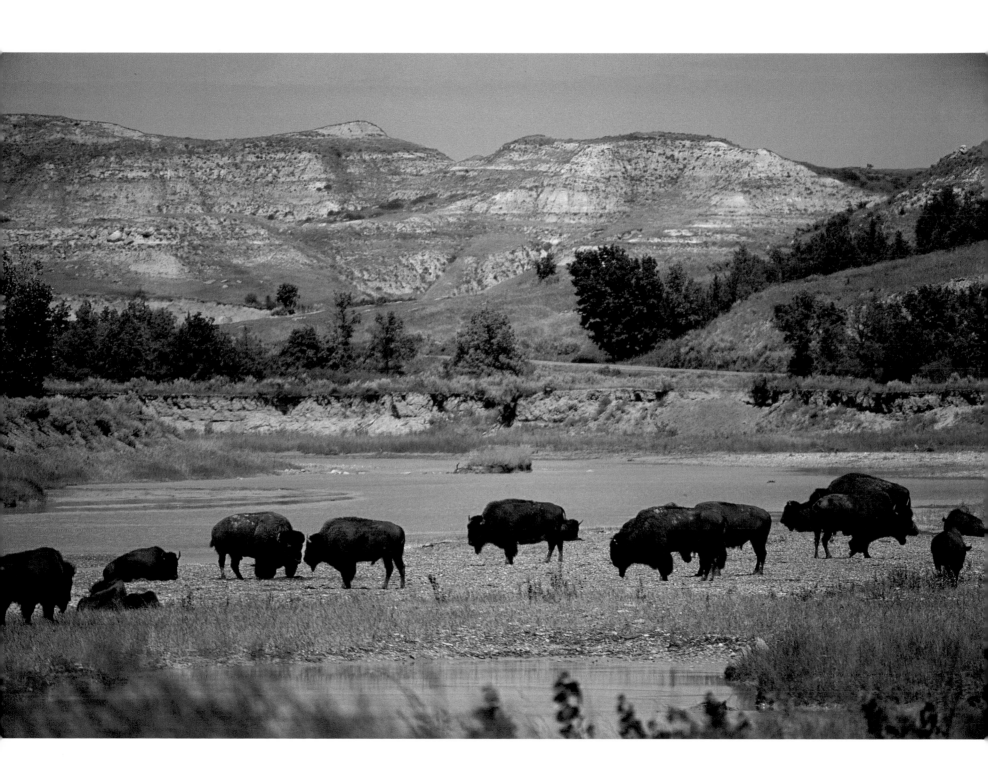

MISSOURI RIVER, NEBRASKA AND SOUTH DAKOTA
The Missouri River—the longest in America at 2,540 miles, counting headwaters—winds for most of its length through the Great Plains, where American Rivers and other groups have waged a ten-year battle for better management of federal dams that stifle the river's flow. The sun rises here at Ponca State Park in Nebraska.

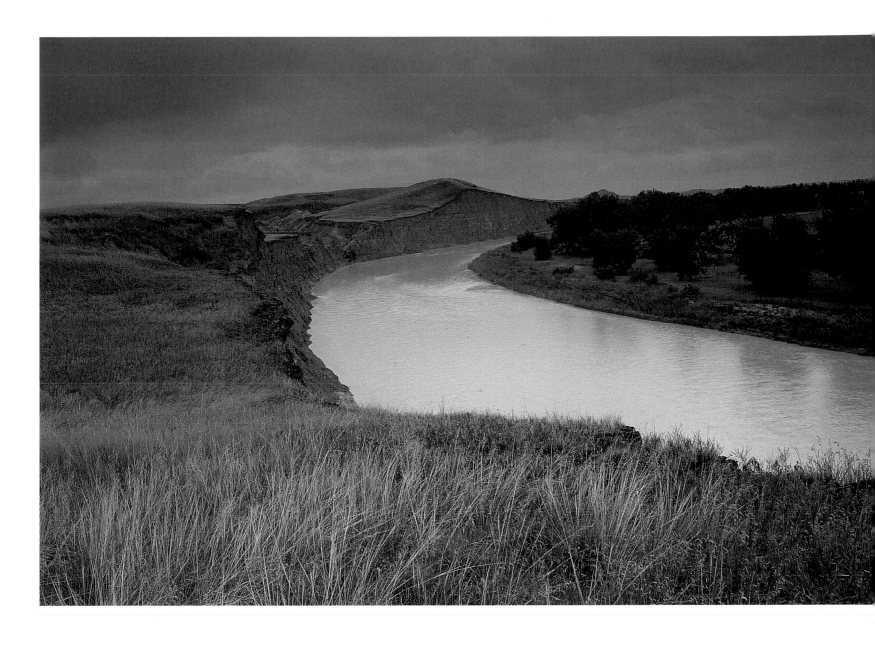

WHITE RIVER, SOUTH DAKOTA
Bunch grasses of the prairie's mixed-grass zone grow thickly along an eroding bluff above the White River, just south of Badlands National Park.

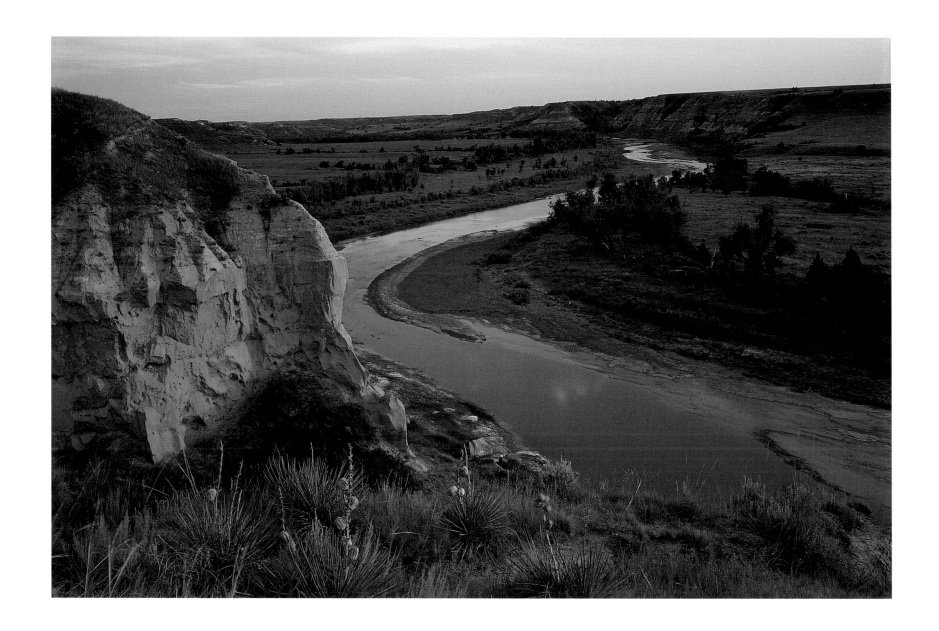

LITTLE MISSOURI RIVER, NORTH DAKOTA

The Little Missouri River traverses the northern Great Plains for 560 miles with almost no dams. Here at the south unit of Theodore Roosevelt National Park, the dwindling waters of midsummer curve through small canyons surrounded by gentle slopes alive with native bunchgrasses.

LITTLE MISSOURI RIVER, NORTH DAKOTA

The Little Missouri evokes the wildness that once stretched across the entire Great Plains.

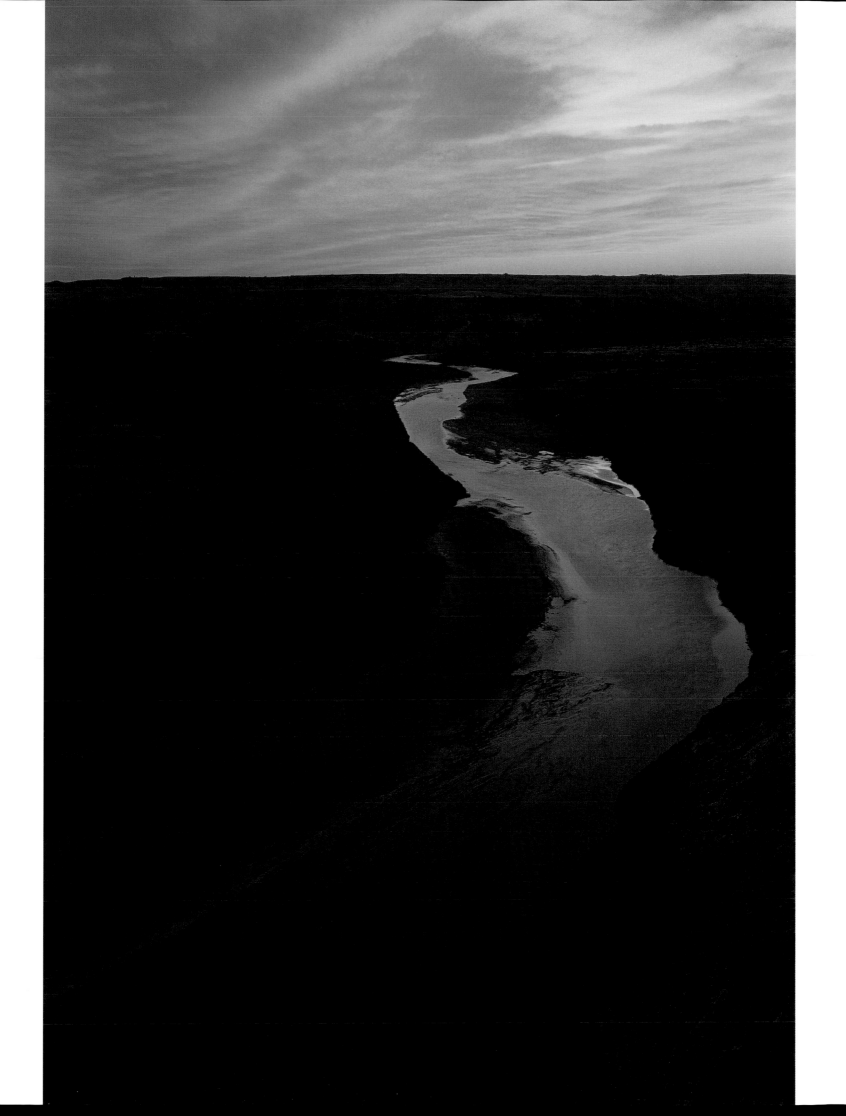

129

Rocky Mountain Rivers

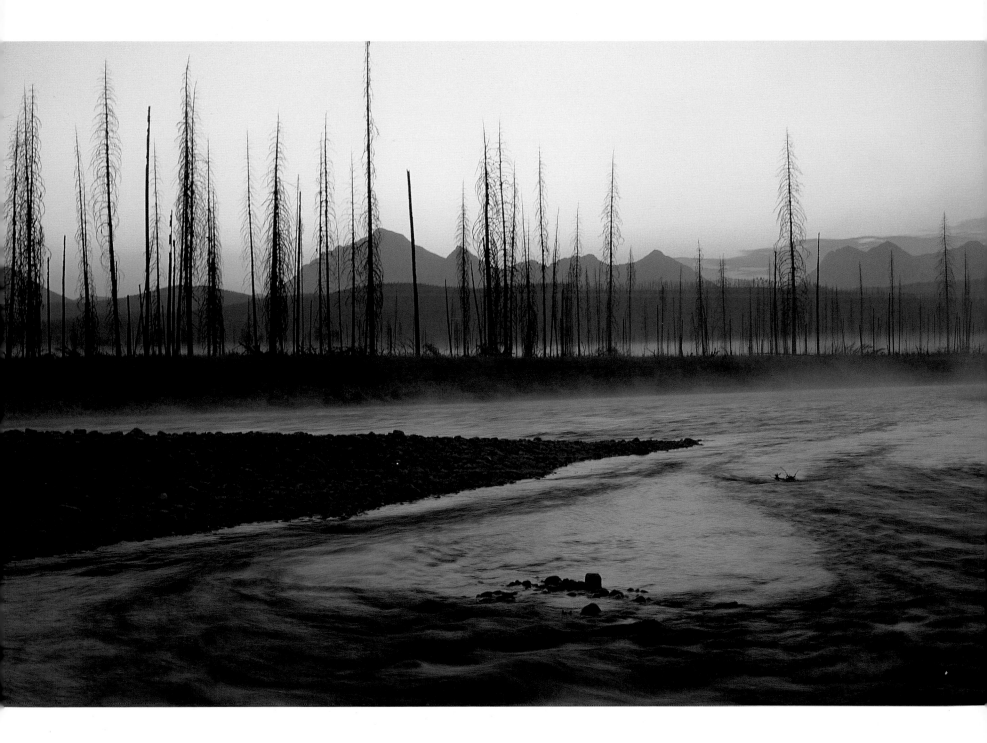

NORTH FORK FLATHEAD RIVER, MONTANA
The North Fork of the Flathead flows past the Livingston Range, where forest fires have left a stark and ever-changing beauty in their wake at the edge of Glacier National Park.

ST. JOE RIVER, IDAHO
Though its lower basin has been heavily logged, headwaters of the St. Joe, upstream from Coeur d'Alene Lake in northern Idaho, remain wild and clear.

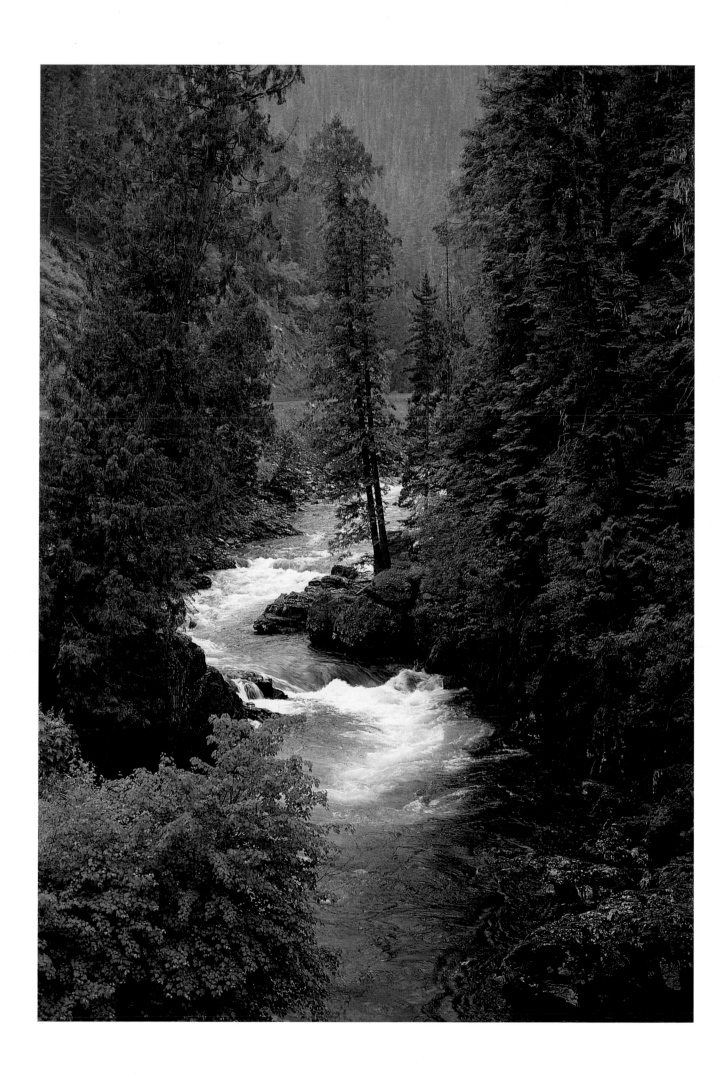

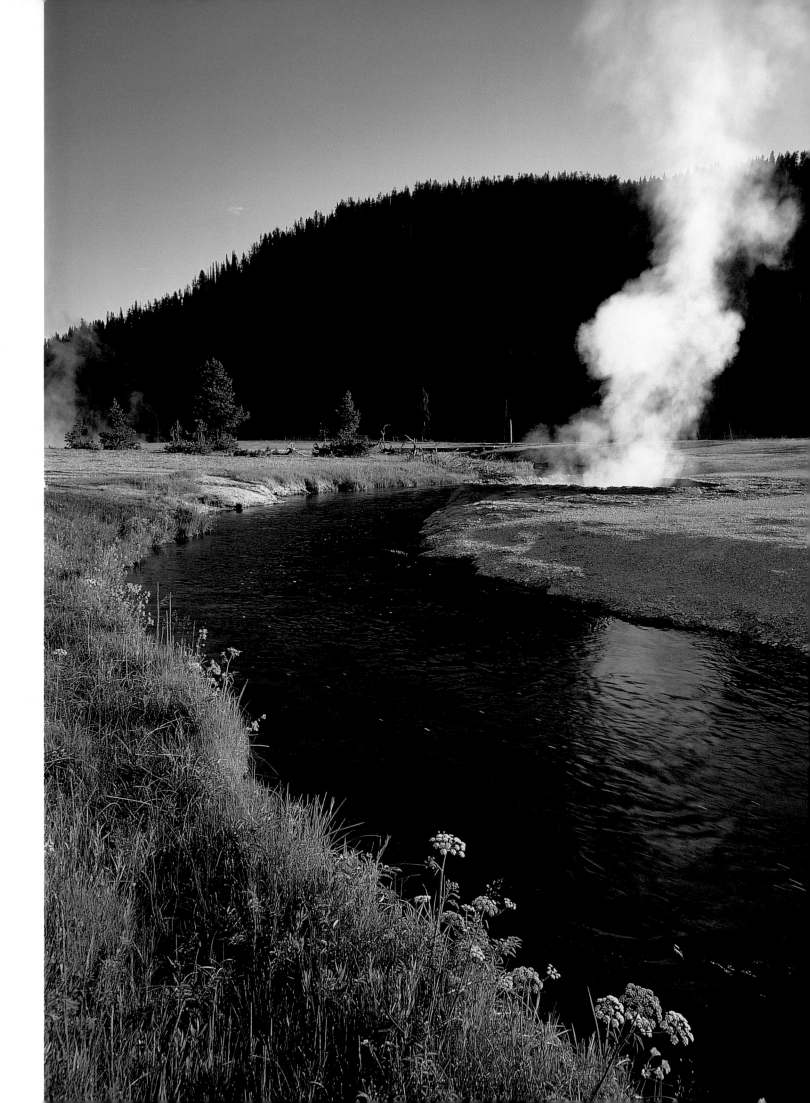

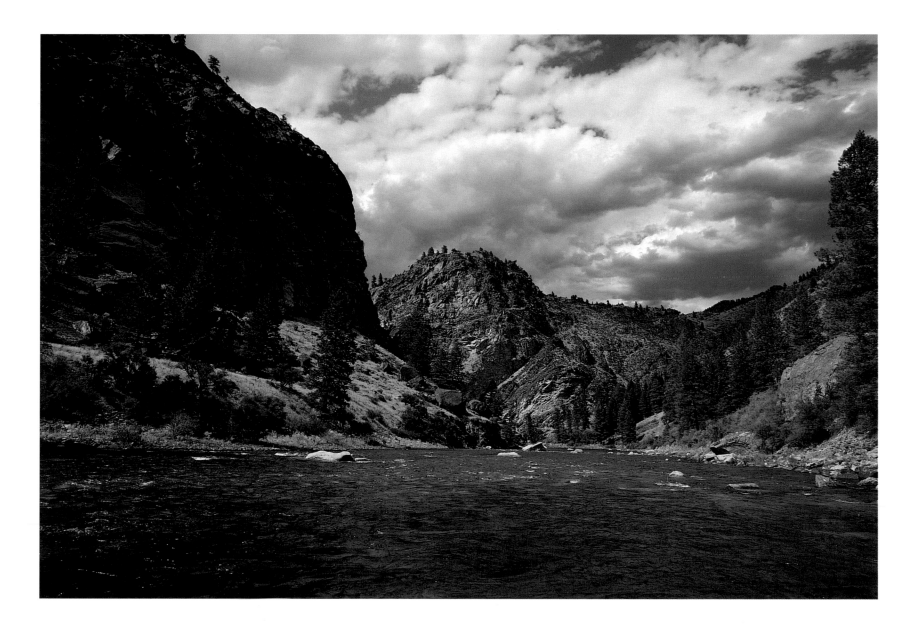

MIDDLE FORK SALMON RIVER, IDAHO
A classic among the wild rivers of America, the Middle Fork of the Salmon offers wilderness, whitewater, and rugged scenery.

FIREHOLE RIVER, WYOMING
Geysers, fumaroles, and hot springs warm the otherwise chilled trout waters of the Firehole,
a Madison River tributary in Yellowstone National Park.

Overleaf SNAKE RIVER, WYOMING
Quintessential river of the Rockies, the upper Snake flows past the Grand Teton
and other peaks while a summer thunderstorm brews to the west.

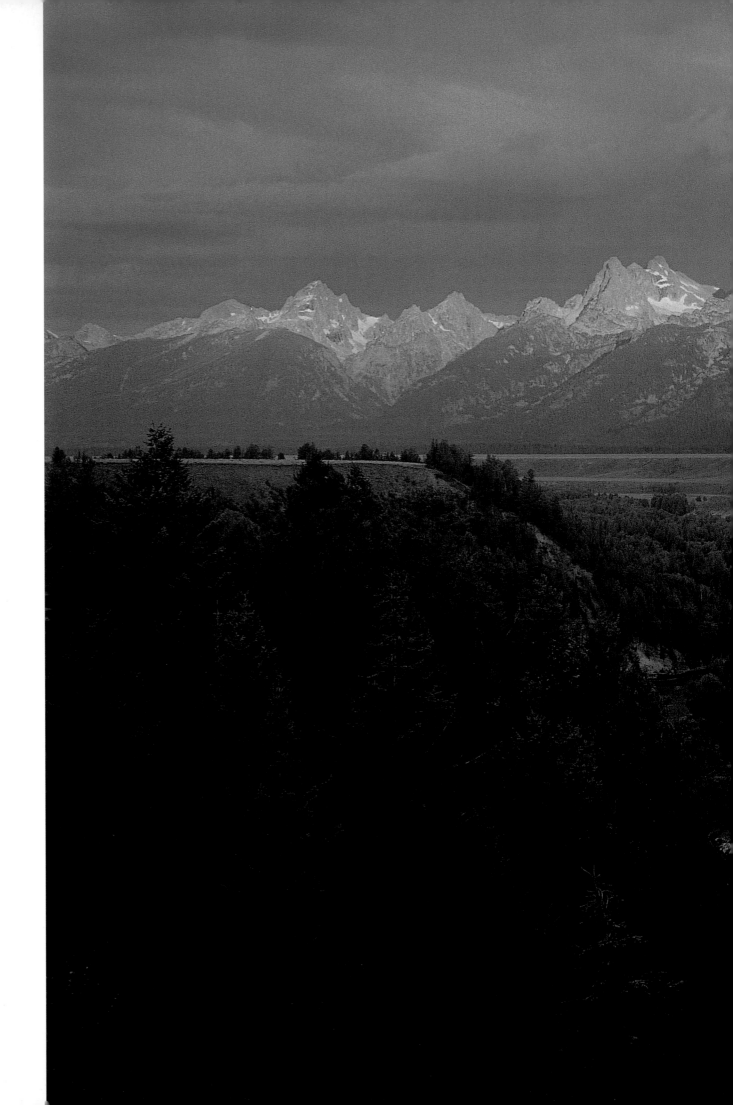

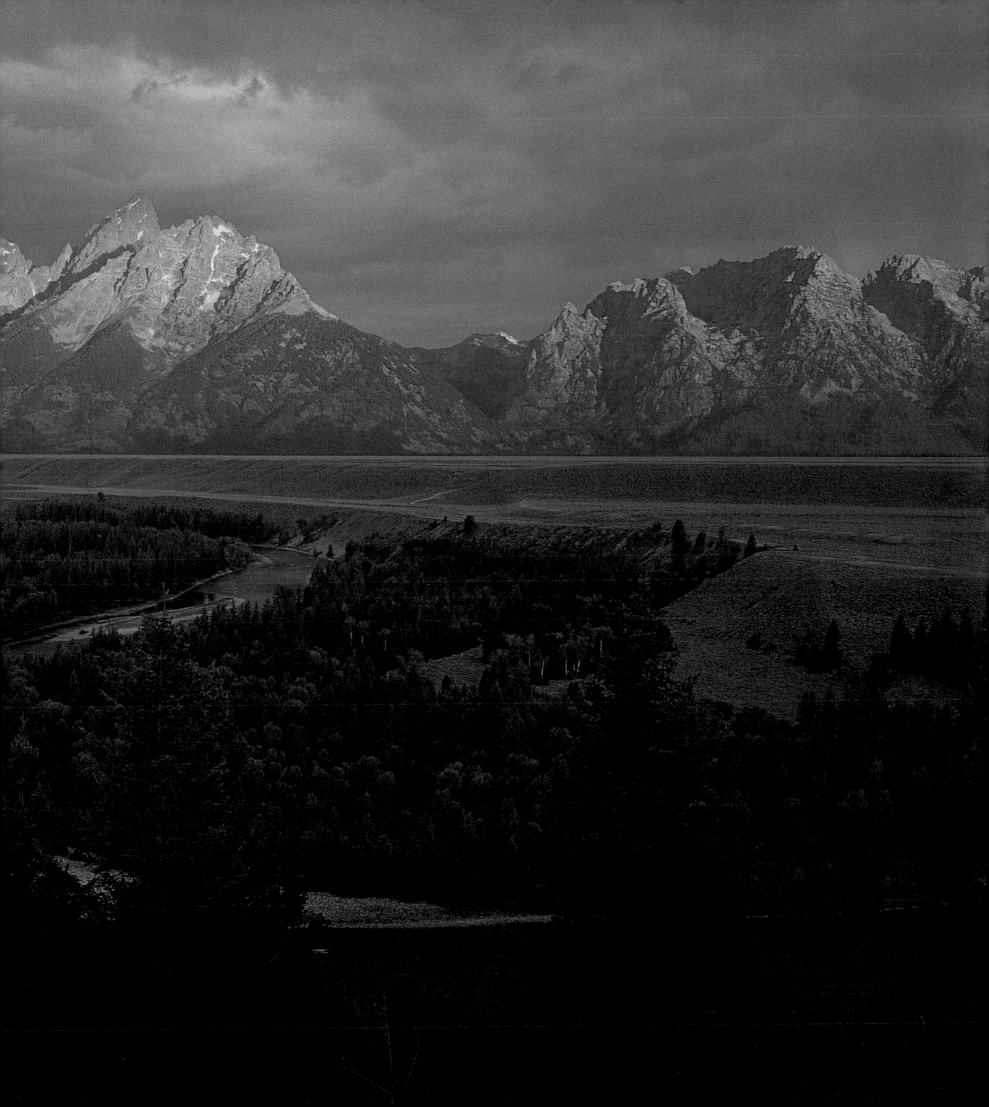

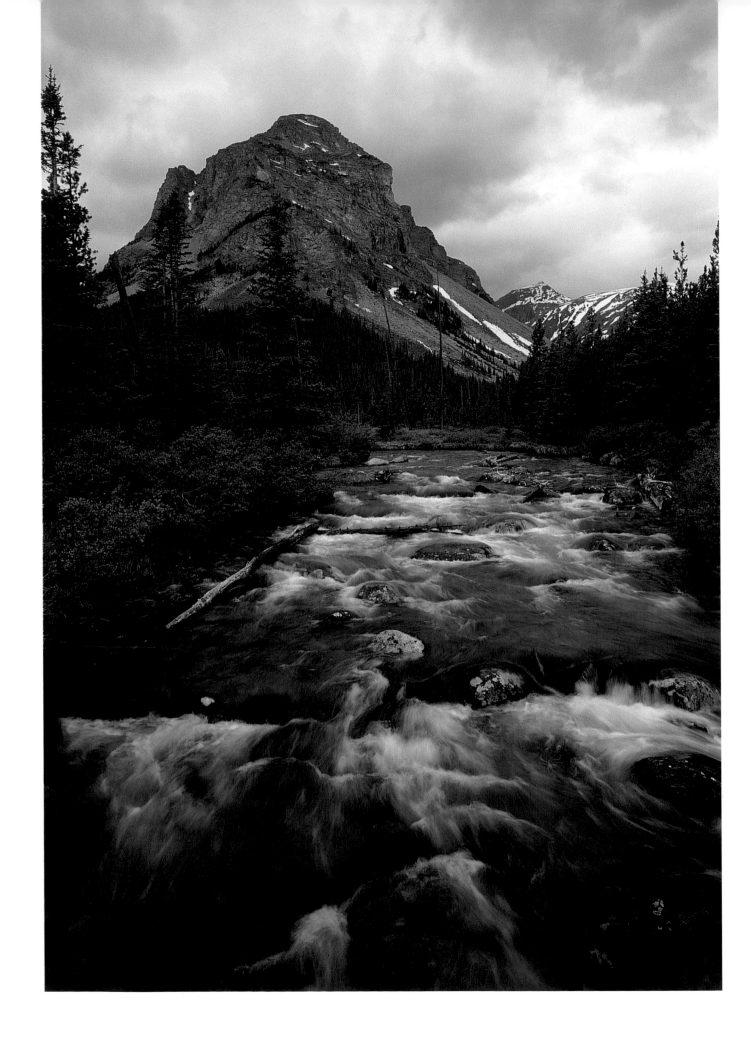

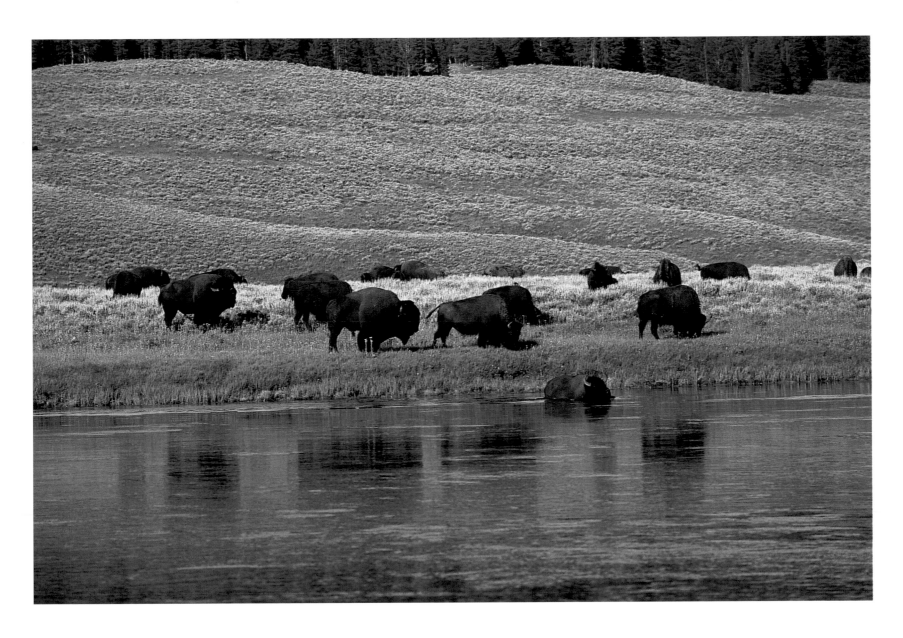

YELLOWSTONE RIVER, WYOMING
In Hayden Valley of Yellowstone National Park, America's largest herd of free-ranging bison congregate along the Yellowstone River during the mating season in July.

LAKE FORK, ROCK CREEK, MONTANA
The Lake Fork of Rock Creek tumbles down toward the Yellowstone River from towering summits and the formidable granite plateau of the Beartooth Mountains.

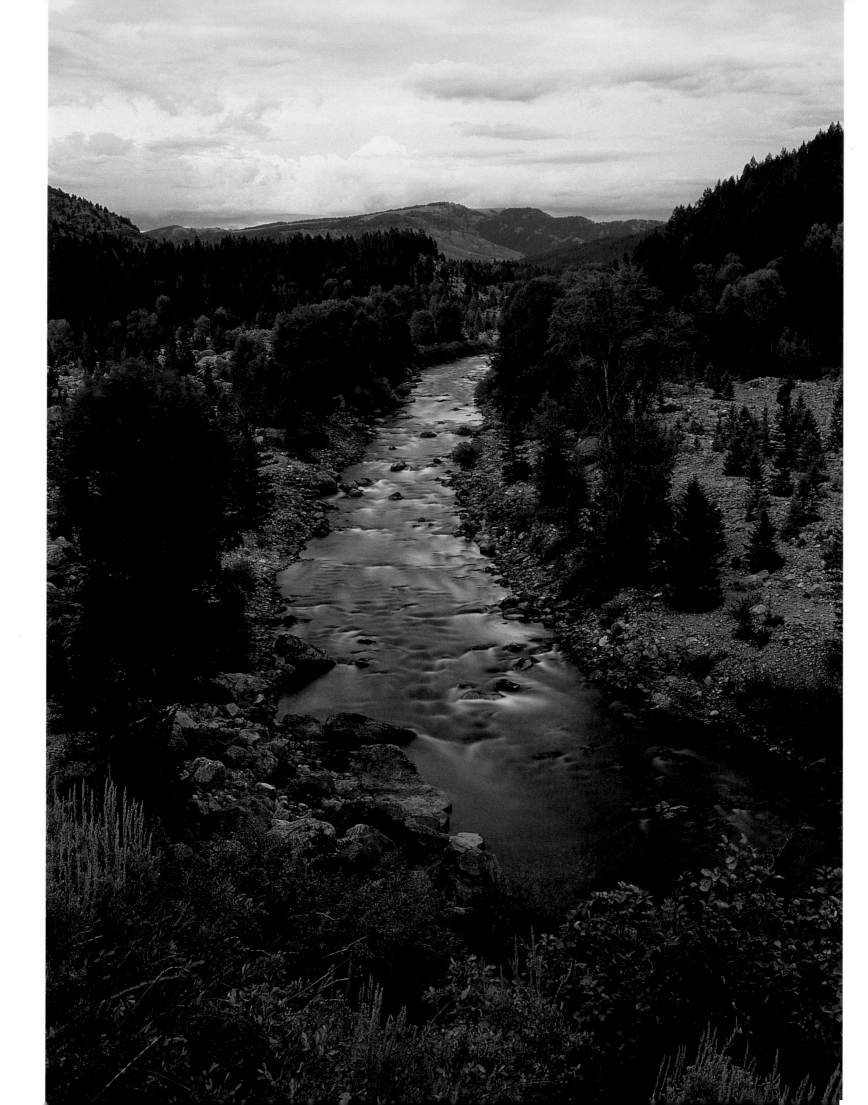

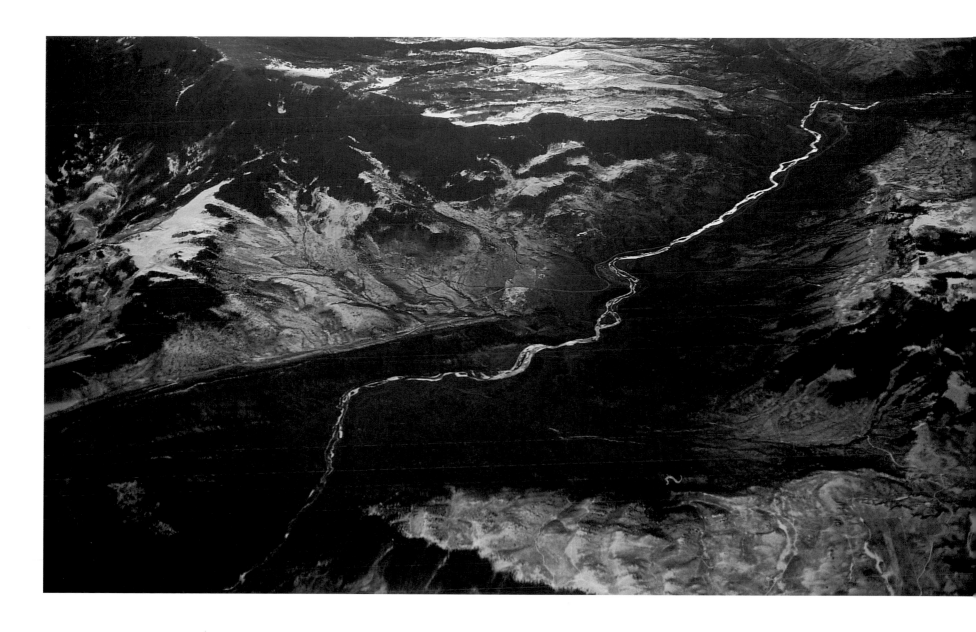

COLORADO RIVER, COLORADO
The Colorado River begins its 1,430-mile route to the Gulf of California by winding through the mountains of northern Colorado.

GROS VENTRE RIVER, WYOMING
Twilight shines on the Gros Ventre River, where a massive landslide once blocked the river upstream from Grand Teton National Park and created a mile-long rapid.

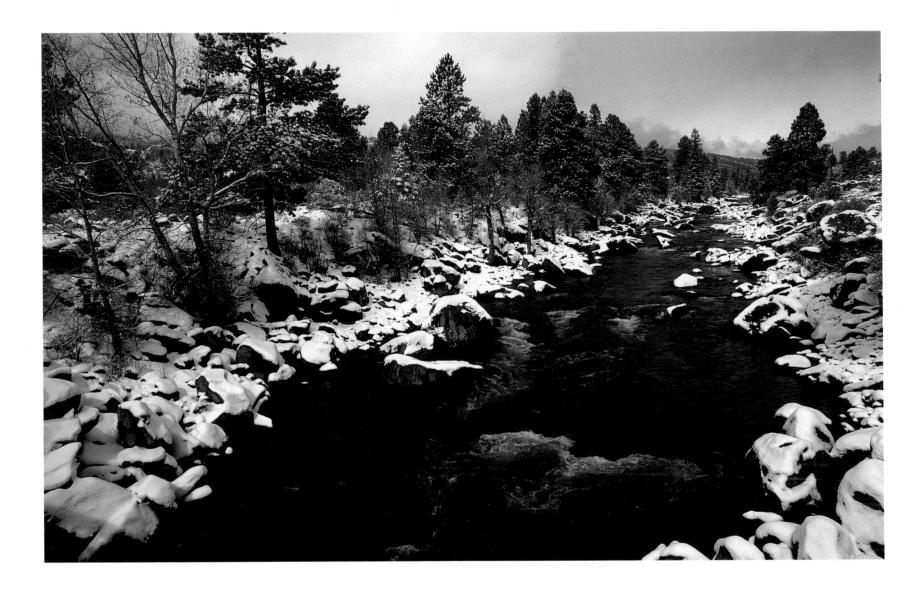

ARKANSAS RIVER, COLORADO
Snow covers the recently thawed Arkansas River above Buena Vista. In the summer the Arkansas
is one of the most-floated whitewater rivers in the West.

SELWAY RIVER, IDAHO
One of America's premier wild rivers, the Selway issues from Idaho's Bitterroot Mountains and later
joins with the Lochsa River to form the Middle Fork Clearwater. While other rivers are heavily used for
recreation, only one raft trip per day is allowed on the wild section of the Selway.

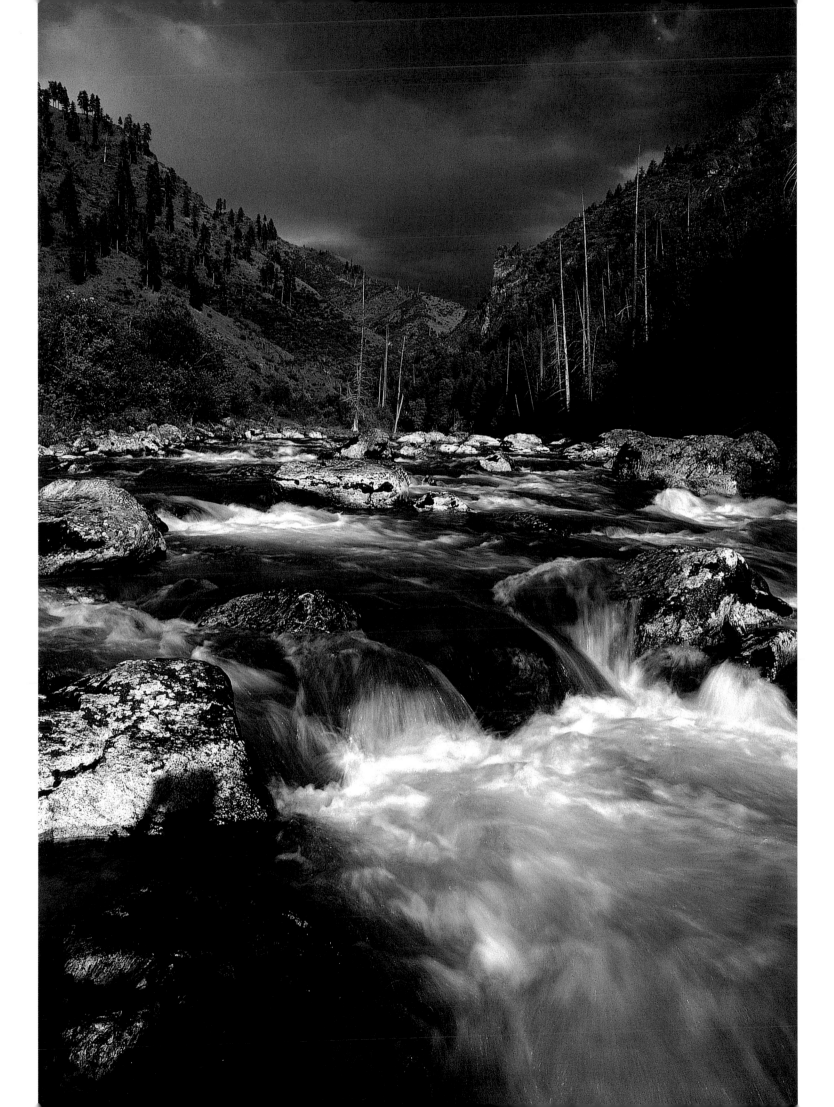

Desert and Dryland Rivers

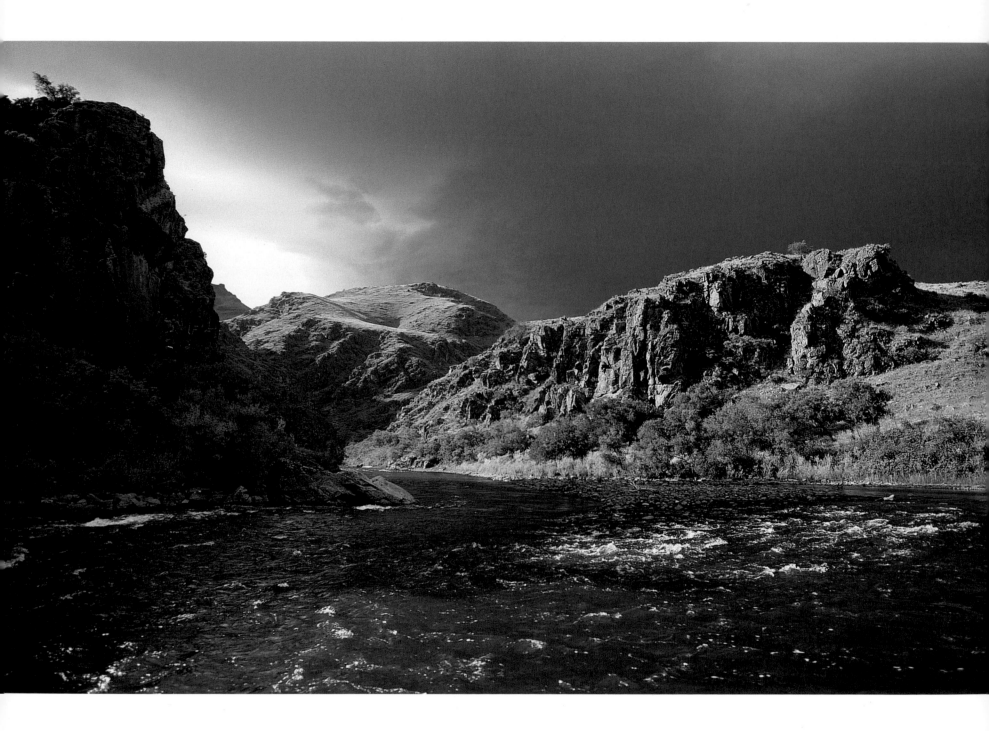

IMNAHA RIVER, OREGON

In the dry rain shadow of the Cascade Mountains, a steppe of grassland extends across eastern Washington and Oregon.
Here the Imnaha River aims toward its confluence with the Snake River in the depths of Hells Canyon.

YAMPA RIVER, COLORADO

The Yampa River in northwestern Colorado approaches the fury of Warm Springs Rapid,
where high cliffs shade the river from early morning light.

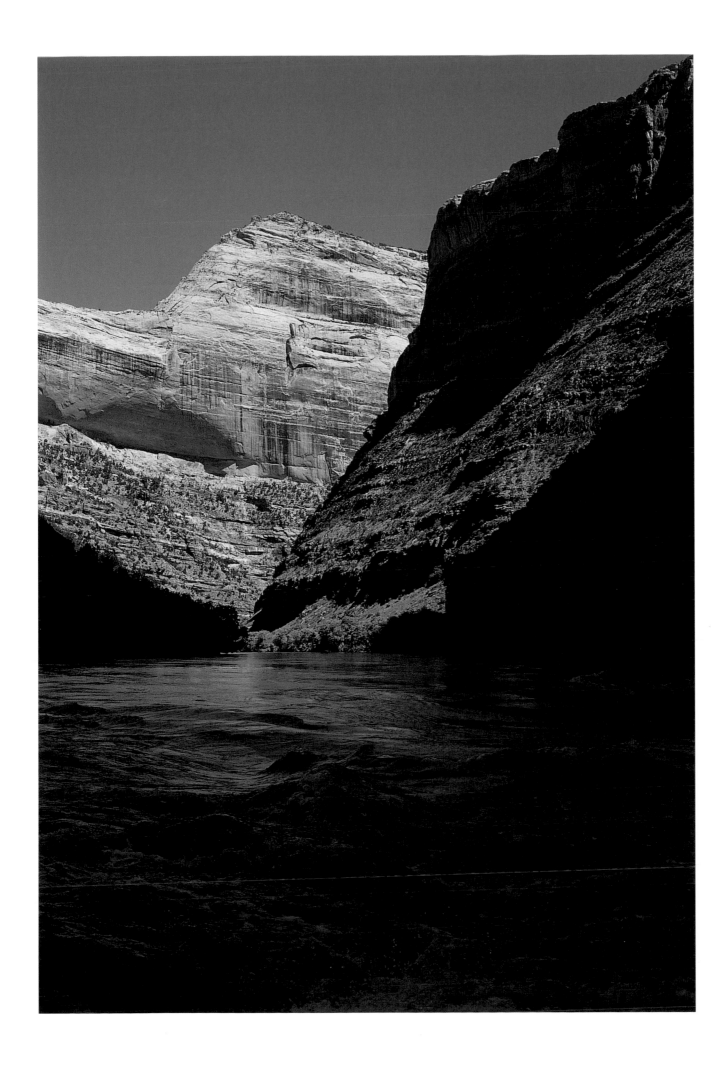

BRUNEAU RIVER, IDAHO
Cutting sharply through once-molten volcanic basalt, the Bruneau River has created an exceptional
gorge in the drylands of southwestern Idaho.

GREEN RIVER, UTAH
The Green River sorts out a tortuous course through Desolation Canyon, seen here
from 30,000 feet above. For 407 miles this river winds from Flaming Gorge Dam to
Powell Reservoir—one of the longest reachs of free-flowing river in the West.

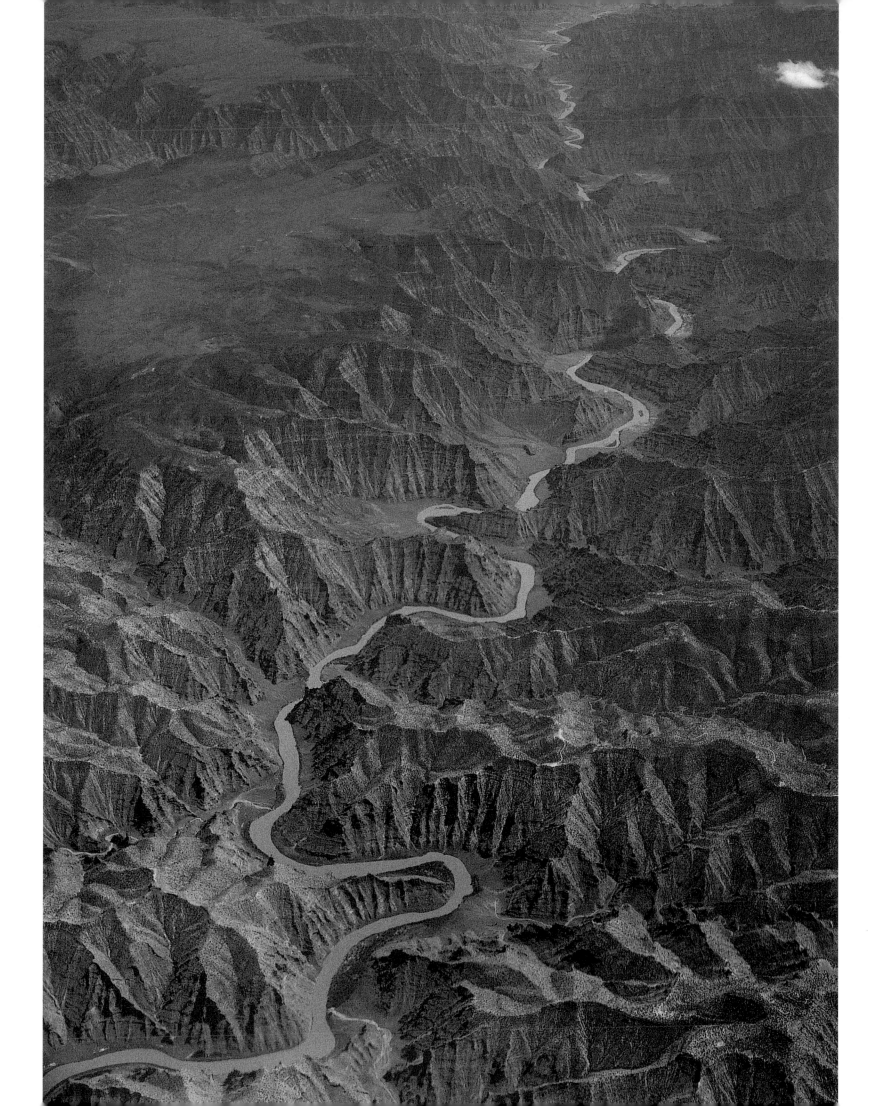

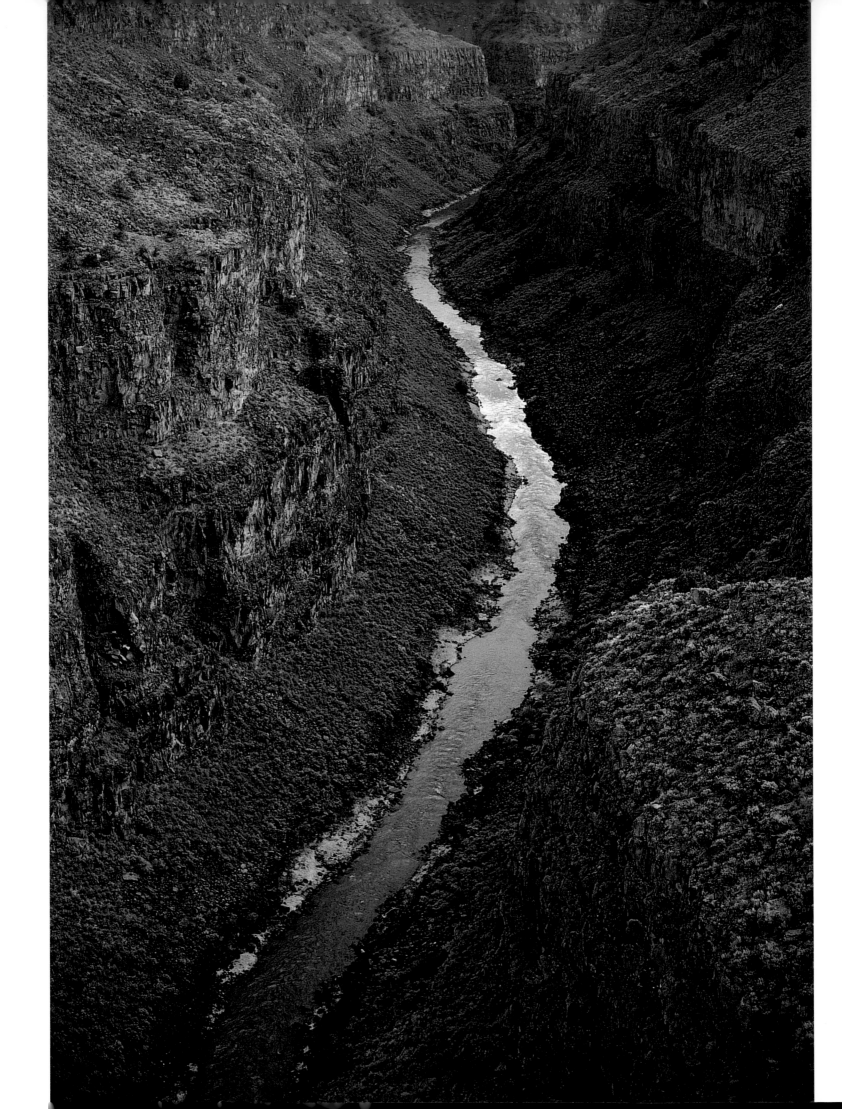

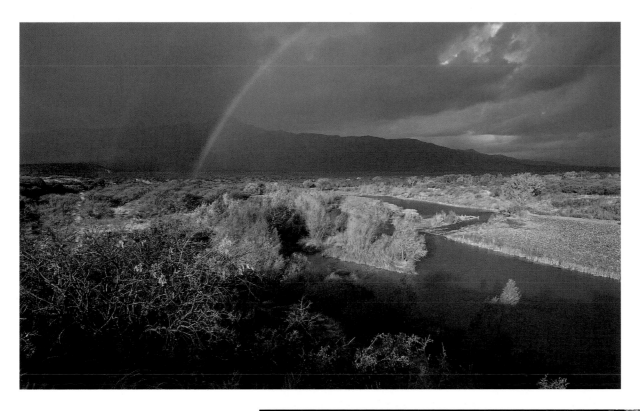

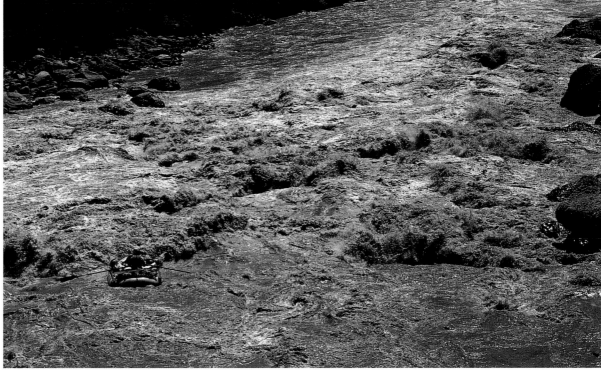

VERDE RIVER, ARIZONA
Creating a green corridor through cactus-studded drylands, the Verde River is refreshed by an autumn storm and brightened by a rainbow.

COLORADO RIVER, LAVA FALLS, ARIZONA
A maelstrom of waves, holes, and silty-brown foam, Lava Falls in the Grand Canyon of the Colorado River challenges boaters with its big breaking water and deafening roar.

RIO GRANDE, NEW MEXICO
Multiple layers of basalt laid down by volcanic eruptions over the millennia have been incised by the Rio Grande in a deep canyon known as the Taos Box.

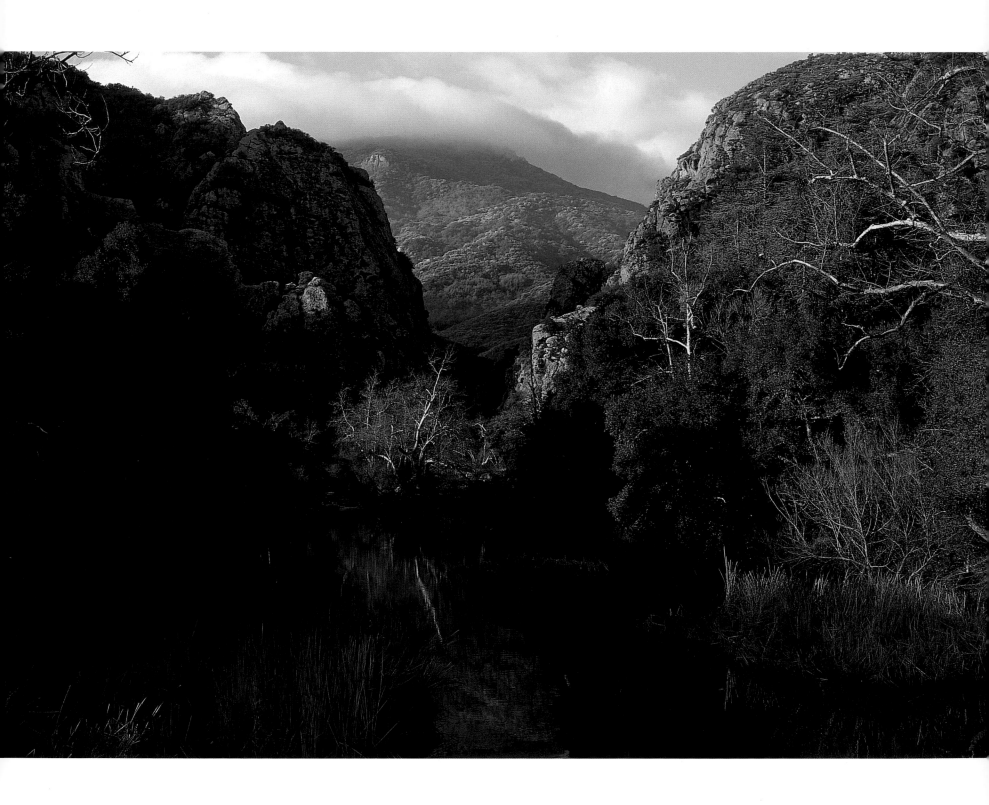

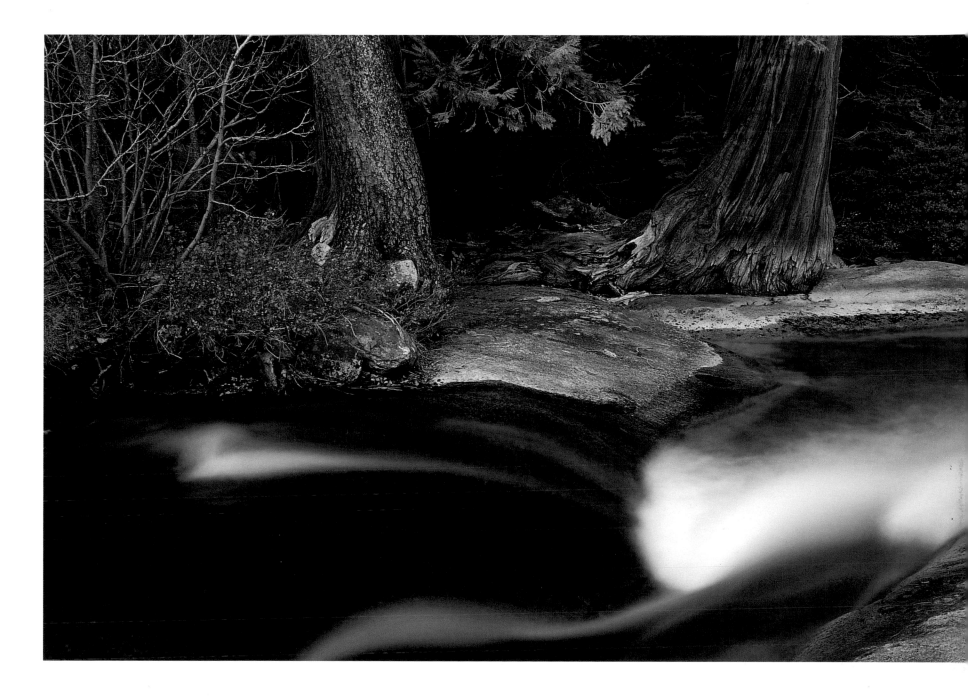

PYRAMID CREEK, CALIFORNIA
Lodgepole pines and incense cedars tap the shoreline moisture of Pyramid Creek at the headwaters of the
South Fork American River—one of America's most popular whitewater streams in lower reaches.

MALIBU CREEK, CALIFORNIA
A wild stream at the western edge of Los Angeles, Malibu Creek offers a delightful oasis of sycamore trees,
live oaks, and willows in a region of chaparral and near-desert.

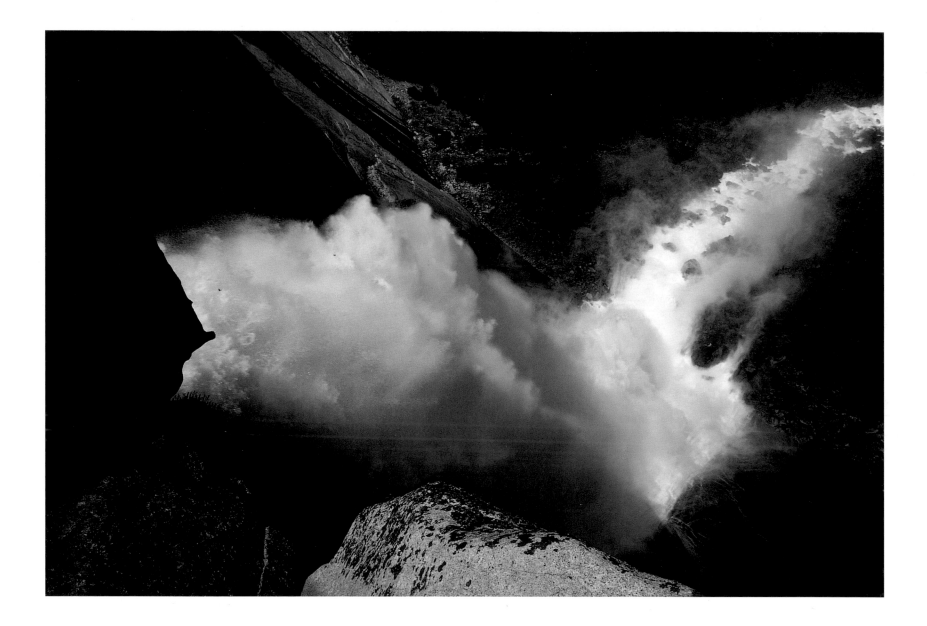

MERCED RIVER, CALIFORNIA

After its sheer drop over Nevada Falls, the Merced River splays onto granite bedrock in Yosemite National Park.

YOSEMITE CREEK, CALIFORNIA

Big flakes of an April snowstorm fill the sky at Yosemite Falls, where Yosemite Creek swells with meltwater of early spring before joining the Merced River.

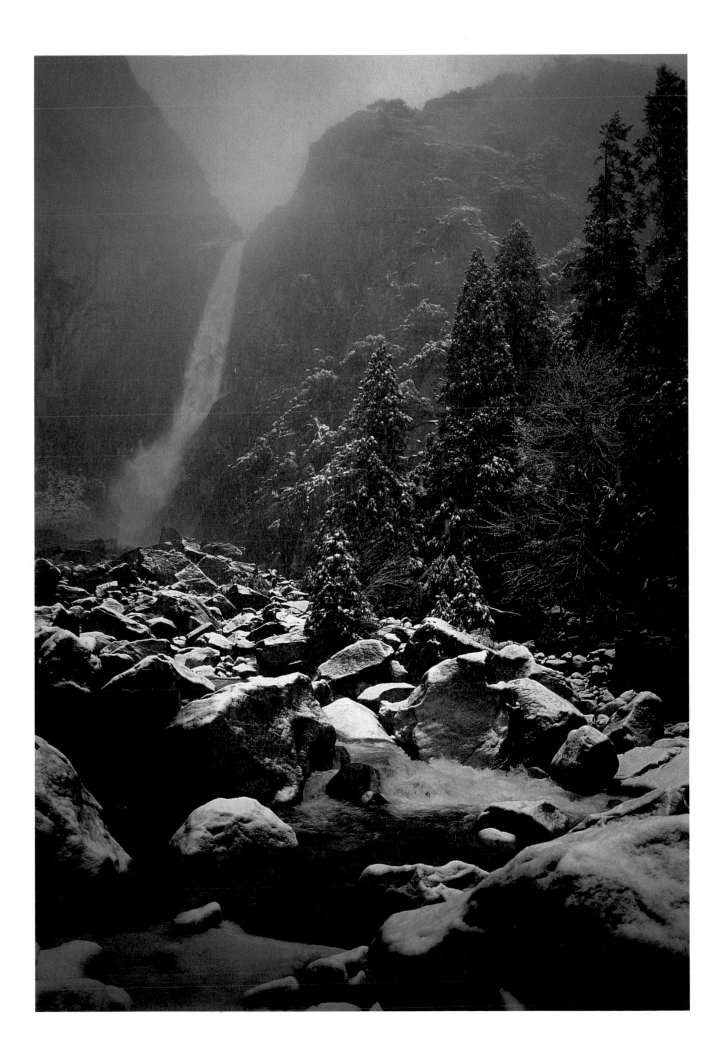

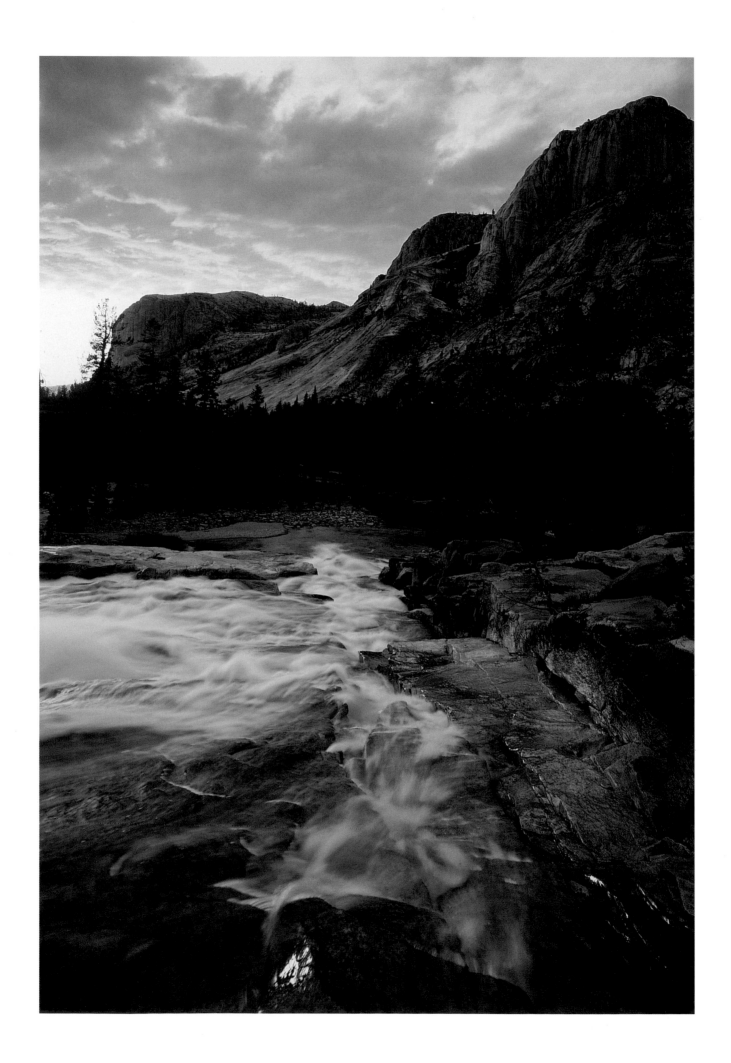

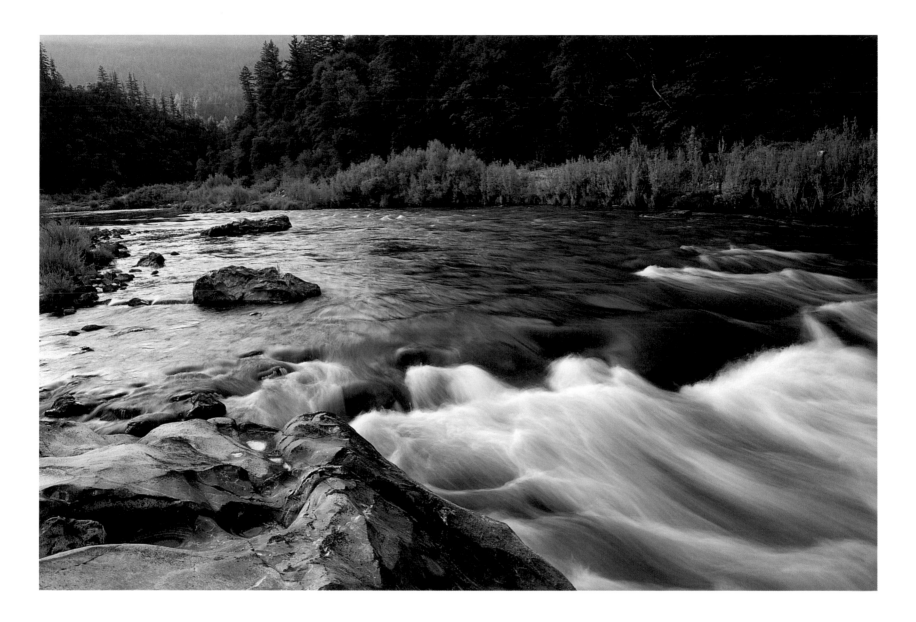

KLAMATH RIVER, CALIFORNIA

Extraordinary for its remaining wildness and deep forests, the Klamath runs dam-free for 189 miles from its lowest reservoir to the ocean. Once among the finest of steelhead and salmon streams, this river is acutely stressed by irrigation withdrawals at its upper reaches and by diversions from its largest tributary, the Trinity River. Indian tribes, conservationists, and commercial fishermen strive to reclaim water that could restore much of the greatness of this river.

153

TUOLUMNE RIVER, CALIFORNIA

The Tuolumne River begins in the high country of Yosemite National Park and then plunges spectacularly through the Grand Canyon of the Tuolumne, pictured here near Glen Aulin.

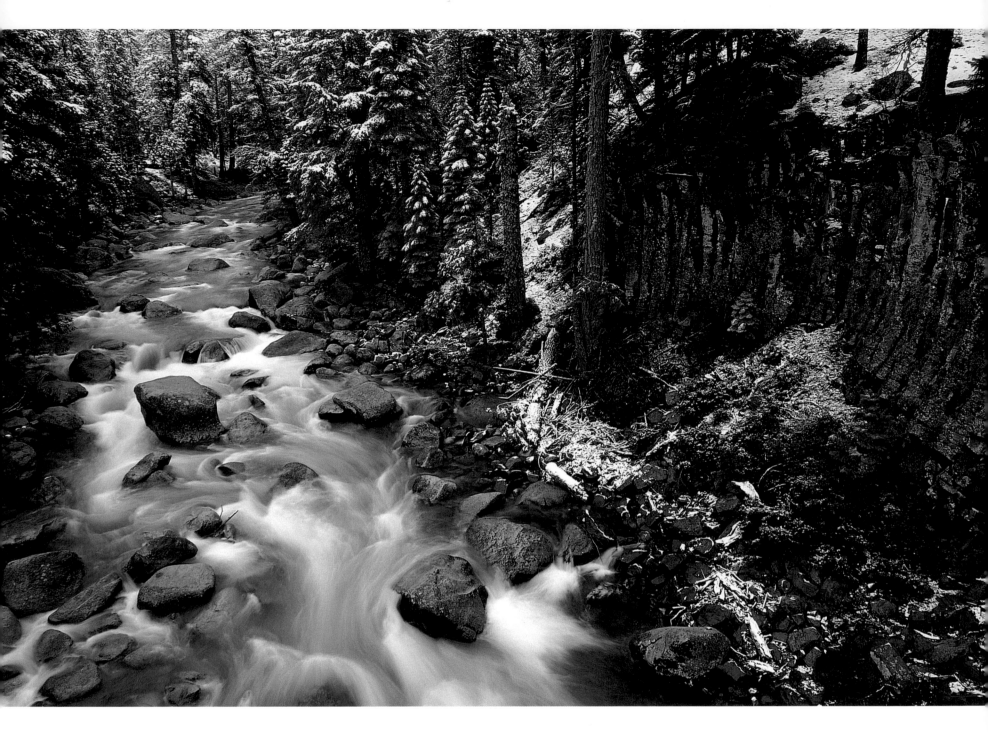

MIDDLE FORK STANISLAUS, CALIFORNIA
The Middle Fork Stanislaus enlivens the wintry wildness of the Sierra Nevada, where fresh snow
dusts upended layers of volcanic basalt and a dark forest of fir and cedar.

NORTH FORK STANISLAUS, CALIFORNIA
The North Fork of the Stanislaus pours over one steep rapid after another near Sourgrass Bridge before penetrating a
parkland of giant conifers at the Sierra's middle elevations and then disappearing into rocky lower canyons.

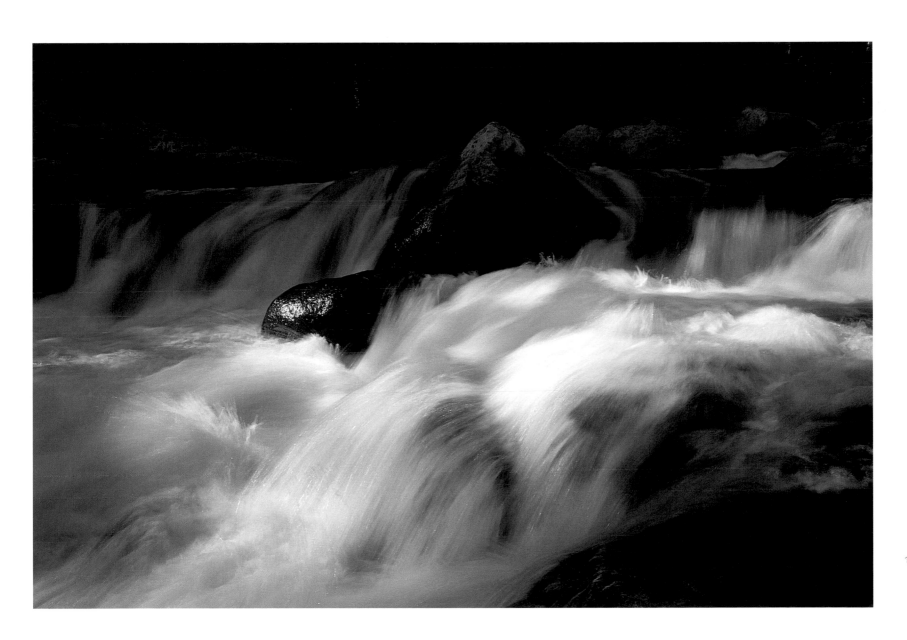

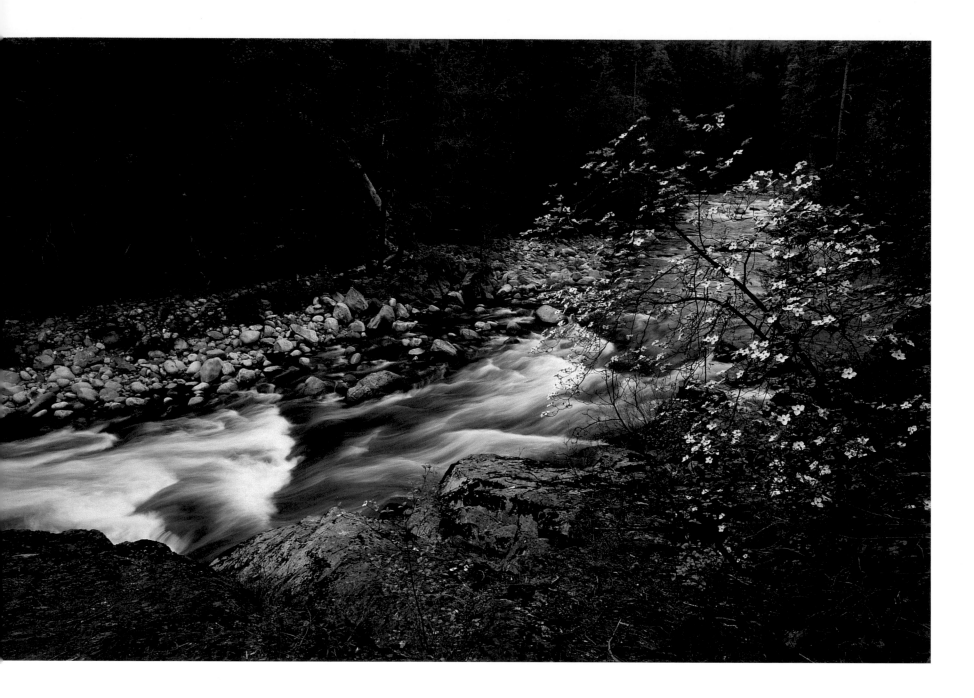

NORTH FORK STANISLAUS, CALIFORNIA
From Sierra Nevada high country, the North Fork Stanislaus carries snowmelt to deep forests at middle elevations where Pacific dogwood blooms in early springtime.

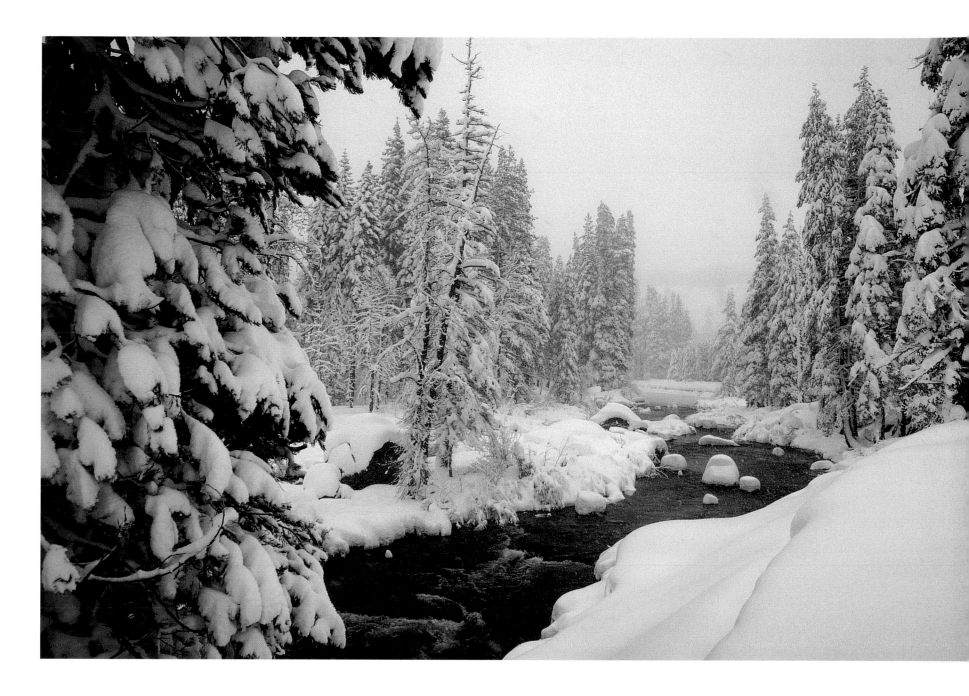

SOUTH YUBA RIVER, CALIFORNIA

Running persistently even in winter, the South Yuba River in Donner Pass is muffled beneath some of America's heaviest snowfalls in the Sierra Nevada. Downstream from here, the river is dammed and diverted for hydropower, but exquisite wild reaches remain.

157

Overleaf **HAT CREEK, CALIFORNIA**

With springflows constantly replenished by snowmelt from Mount Lassen, the fine trout waters of Hat Creek swish through a darkened forest of live oak as the stream rushes toward the Pit and Sacramento Rivers.

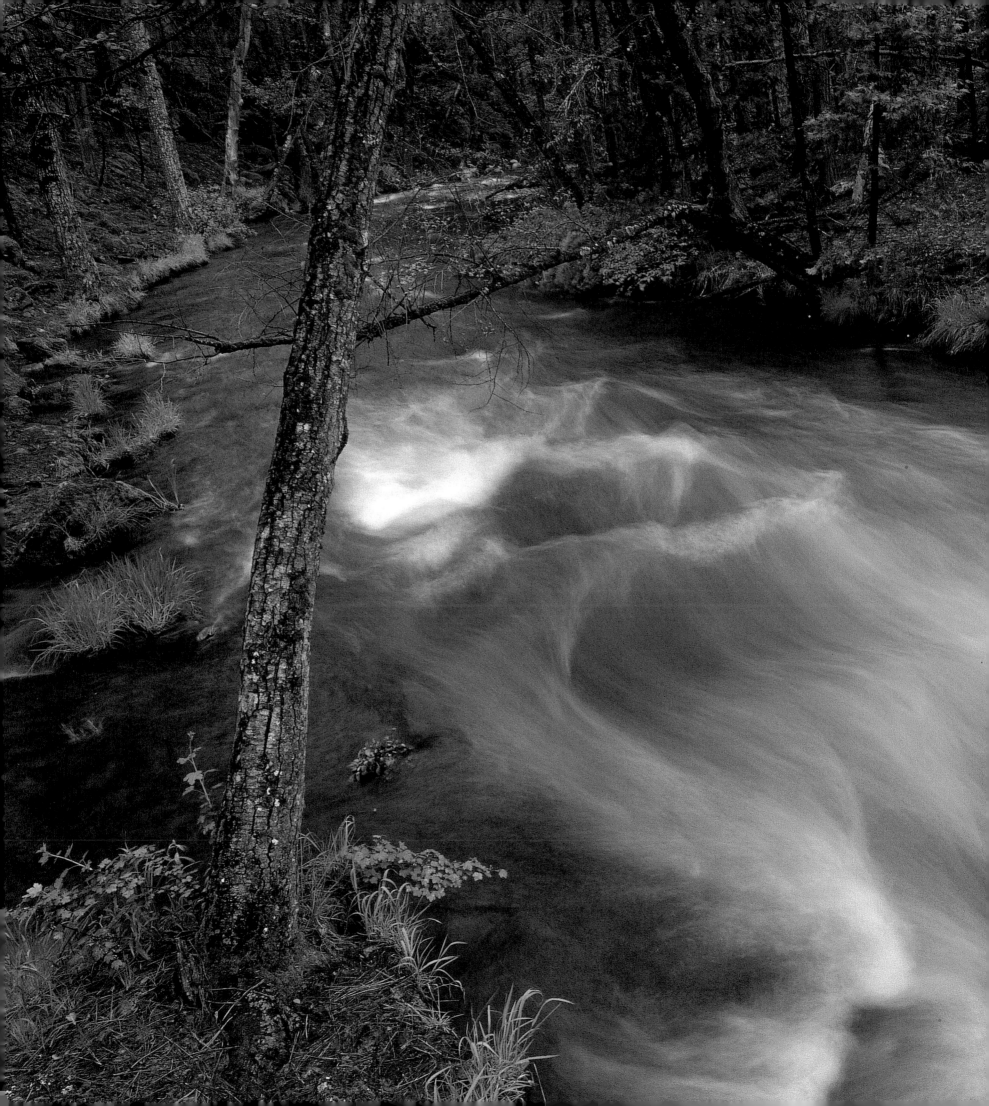

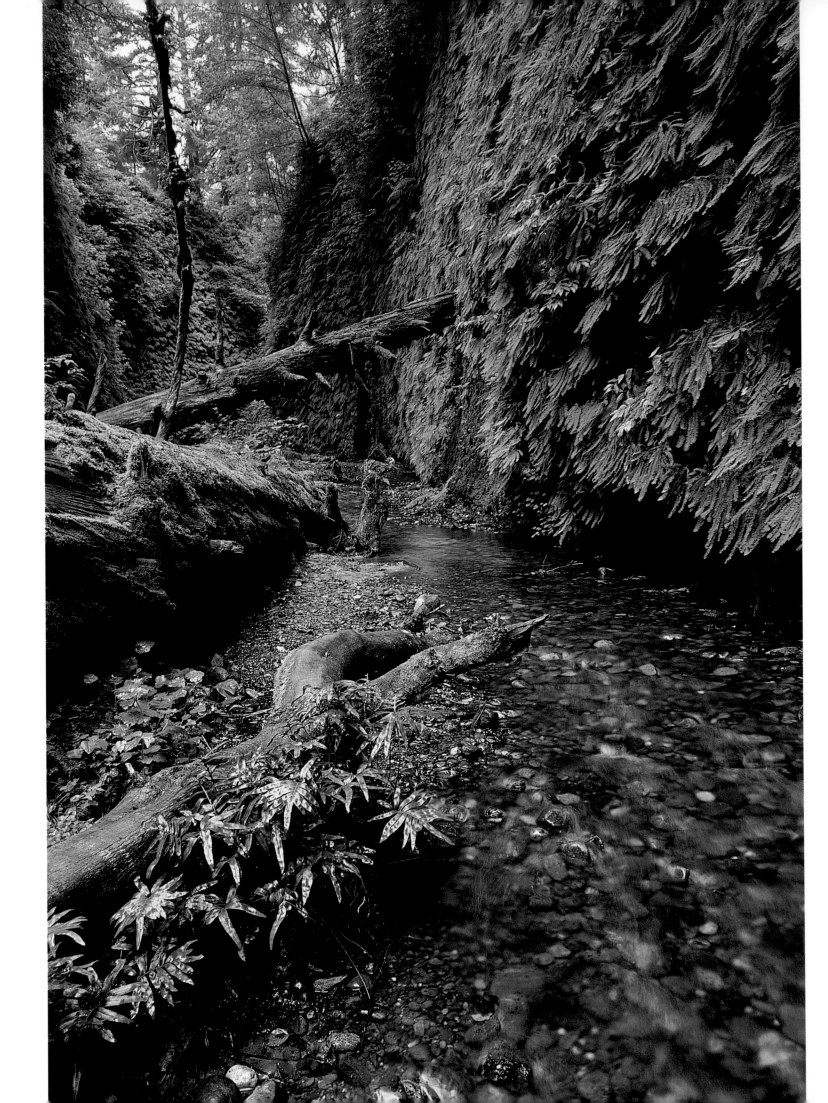

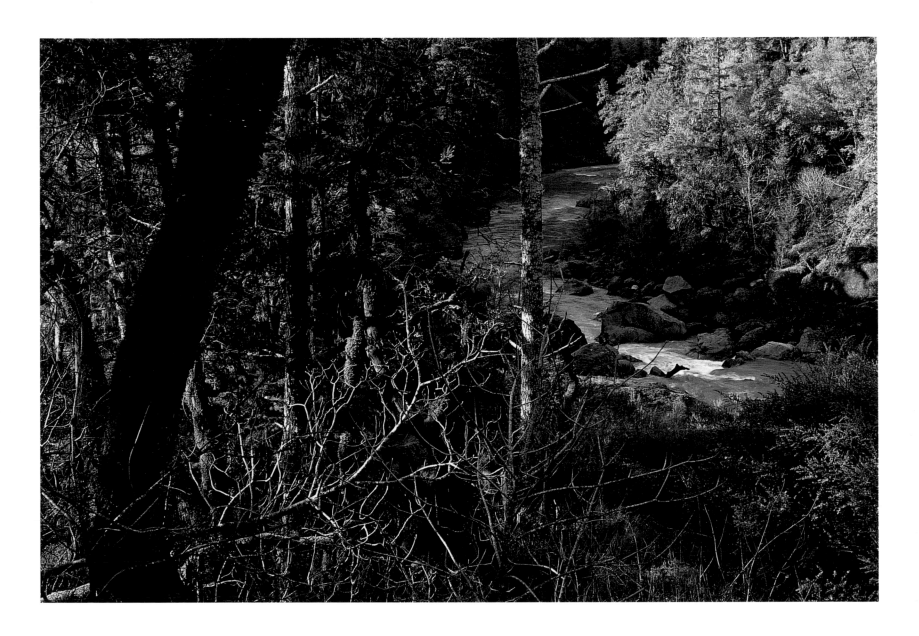

VAN DUZEN RIVER, CALIFORNIA
California's North Coast is unexcelled as a region of wild rivers. Here the Van Duzen disappears into forested canyons, eventually joining the Eel River.

HOME CREEK, CALIFORNIA
Home Creek is watered by heavy rains in the winter and by fog-drip in the summer as it nears the ocean in Fern Canyon at Prairie Creek Redwoods State Park.

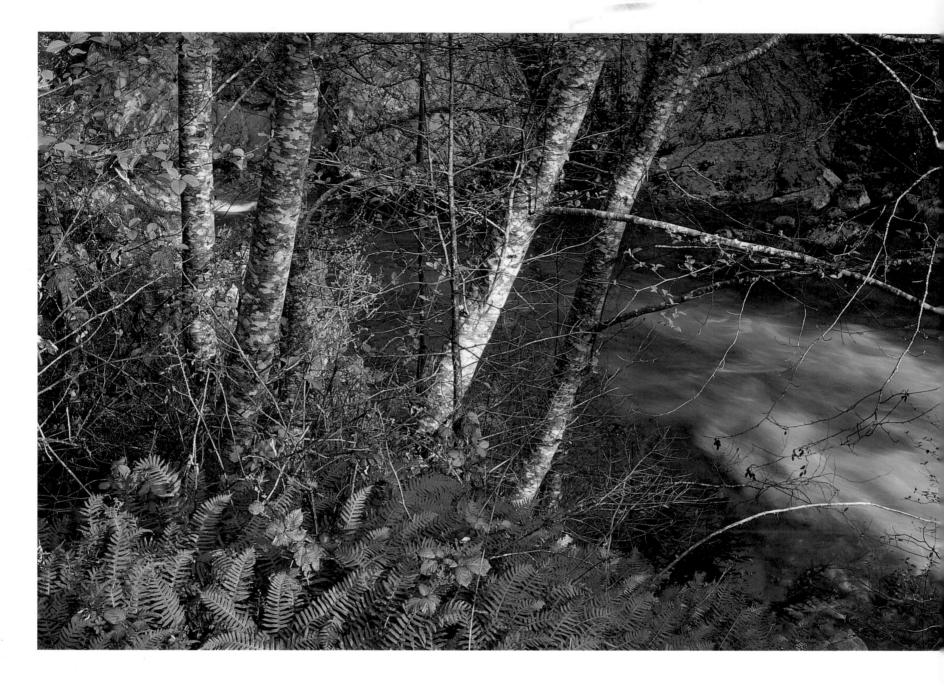

SOUTH FORK SMITH RIVER, CALIFORNIA

The South Fork of the Smith rushes toward the river's main stem, which is the largest undammed stream in
California. With much of its watershed safeguarded as a National Wild and Scenic River and as a National Recreation

Area, the Smith is among the best-protected streams on the West Coast.

MILL CREEK, CALIFORNIA

Flowing within one of the finest groves of coast redwoods, Mill Creek nears
its confluence with the Smith River in Jedediah Smith Redwoods State Park.

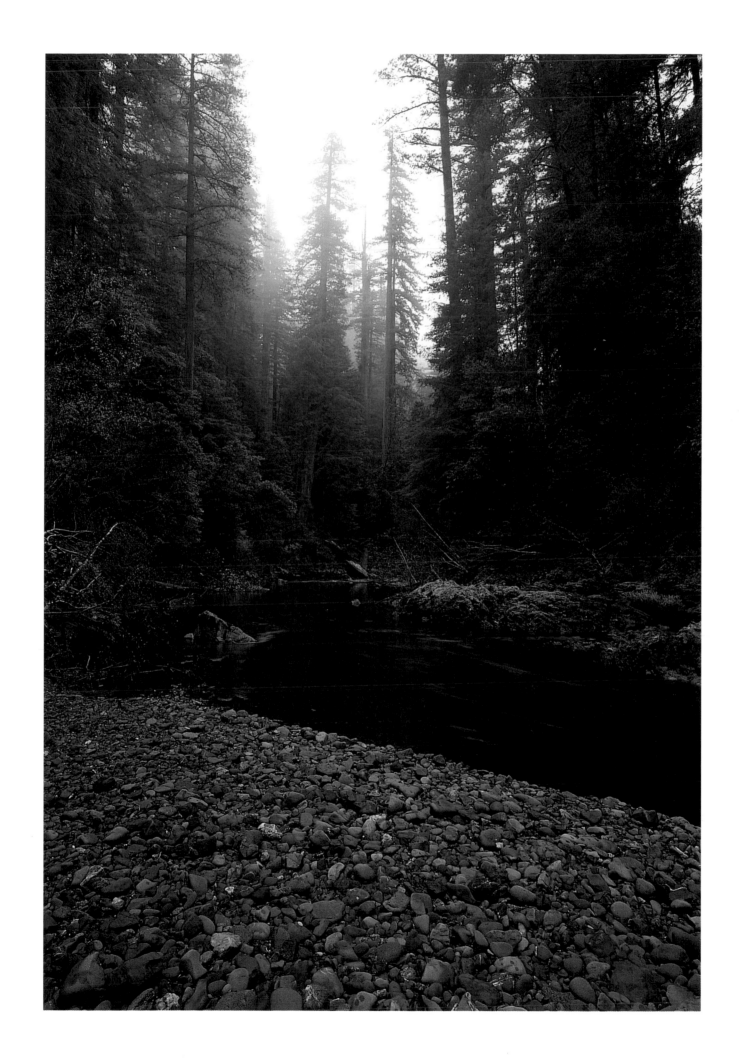

Northwestern Rivers

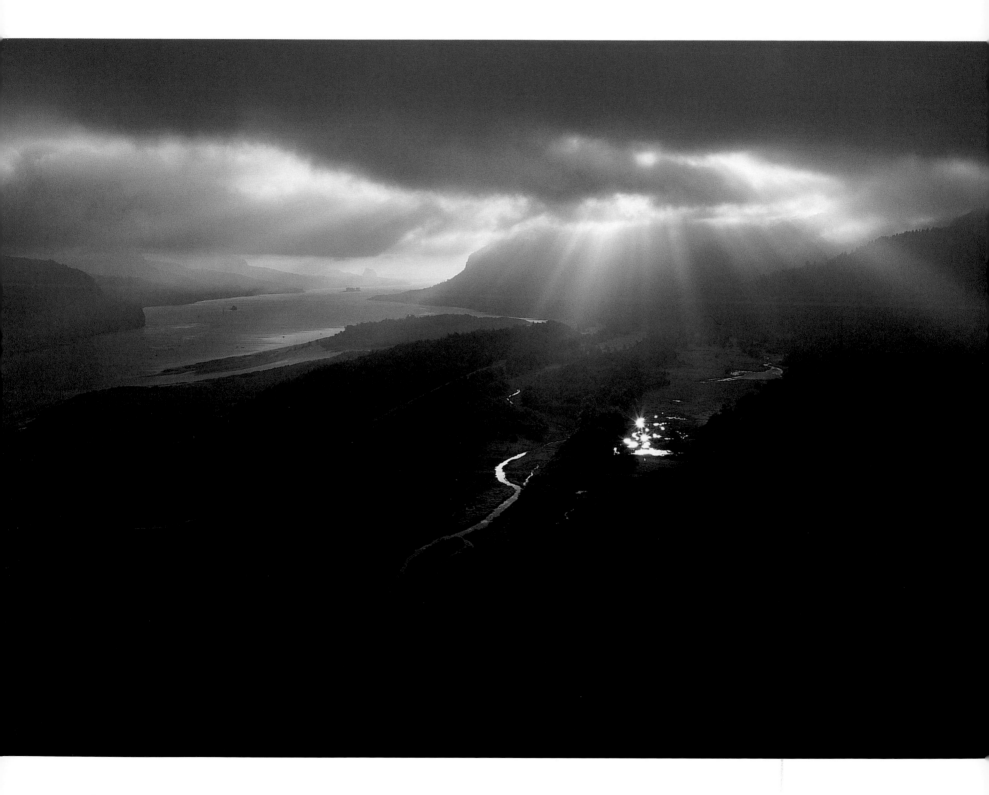

COLUMBIA RIVER, OREGON AND WASHINGTON
Largest river in the West and fourth largest in America, the Columbia carries its massive volume through a spacious gorge upstream
from Portland. Here the waters of seven states and one Canadian province meet tidewater after a journey of 1,240 miles.

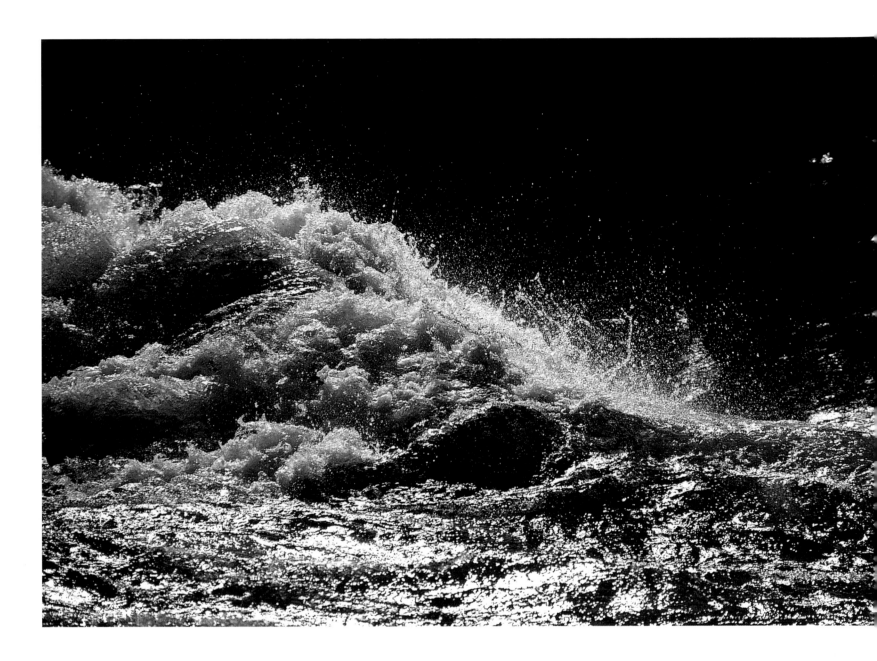

DESCHUTES RIVER, OREGON
Collecting snowmelt and springwater from the eastern face of the Cascade Mountains, the Deschutes River
speeds downward in a precipitous rapid south of Bend.

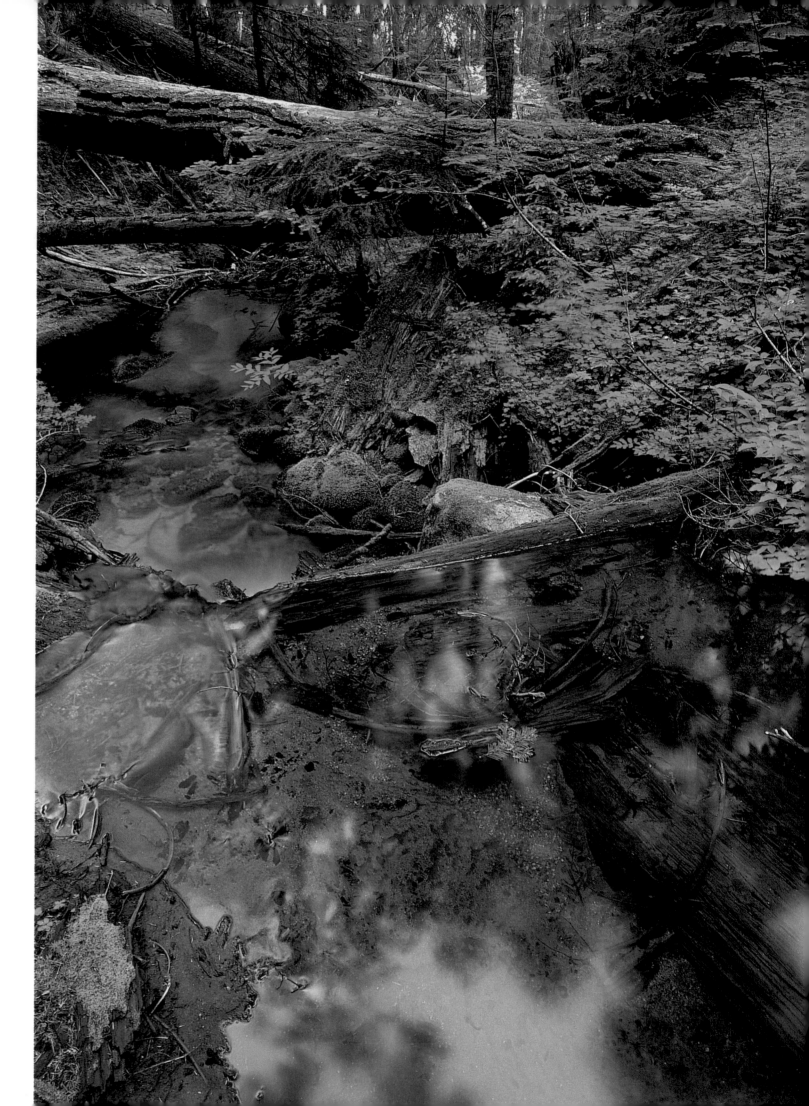

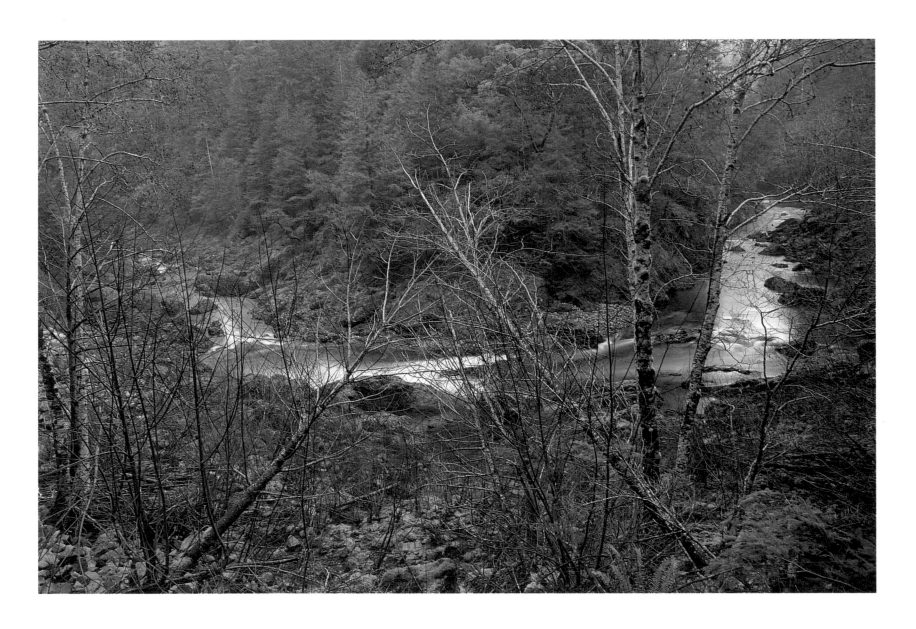

ELK RIVER, OREGON

At the Elk River in southern Oregon, a hundred inches of rain saturate the ground in winter. Designation of headwater reaches as the Copper-Salmon Wilderness Area is critical if the Elk is to remain the finest salmon and steelhead stream of its size south of Canada.

SUIATTLE TRIBUTARY, WASHINGTON

Deep in the Glacier Peak Wilderness, a tributary to the Suiattle and Skagit Rivers pauses in glassy pools amid old-growth hemlock and grand fir.

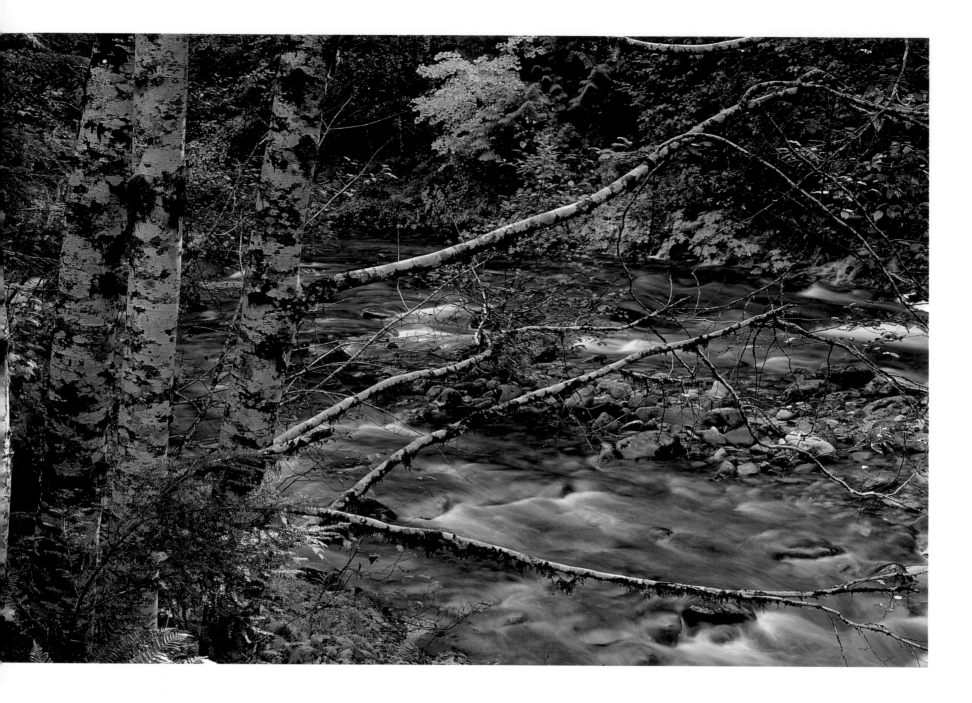

LITTLE NORTH SANTIAM RIVER, OREGON
The Little North Santiam River riffles from the protected forest of Opal Creek in the Cascade Mountains east of Salem.

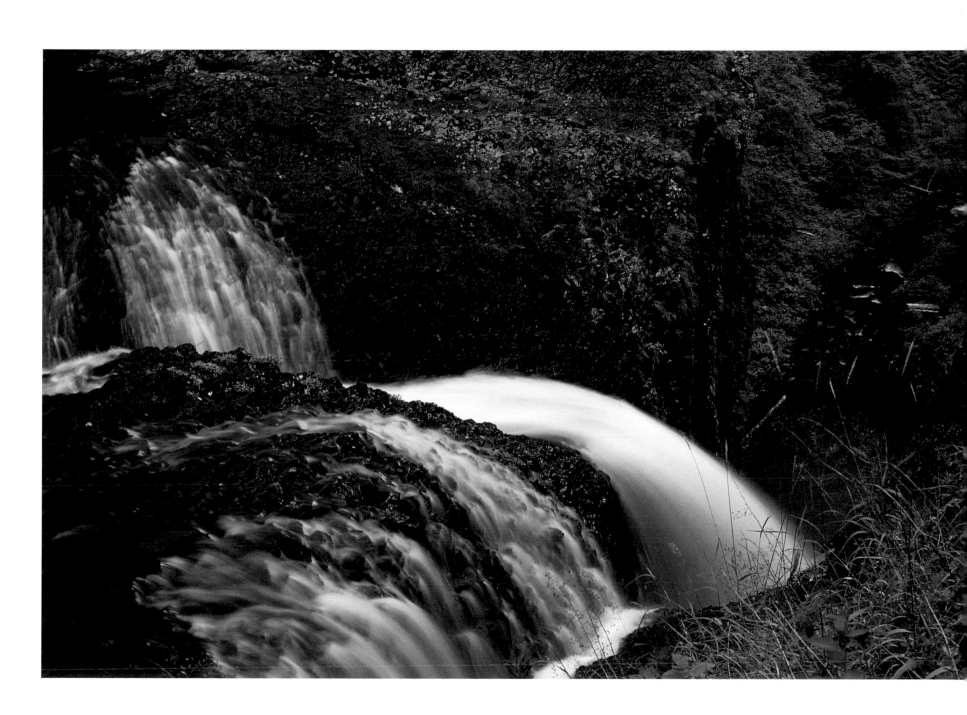

EAGLE CREEK, OREGON

Eagle Creek takes the plunge east of Portland. Hundreds of cascades on this and dozens of nearby streams pour from cliff faces in the Columbia River Gorge, which features the greatest concentration of waterfalls in America.

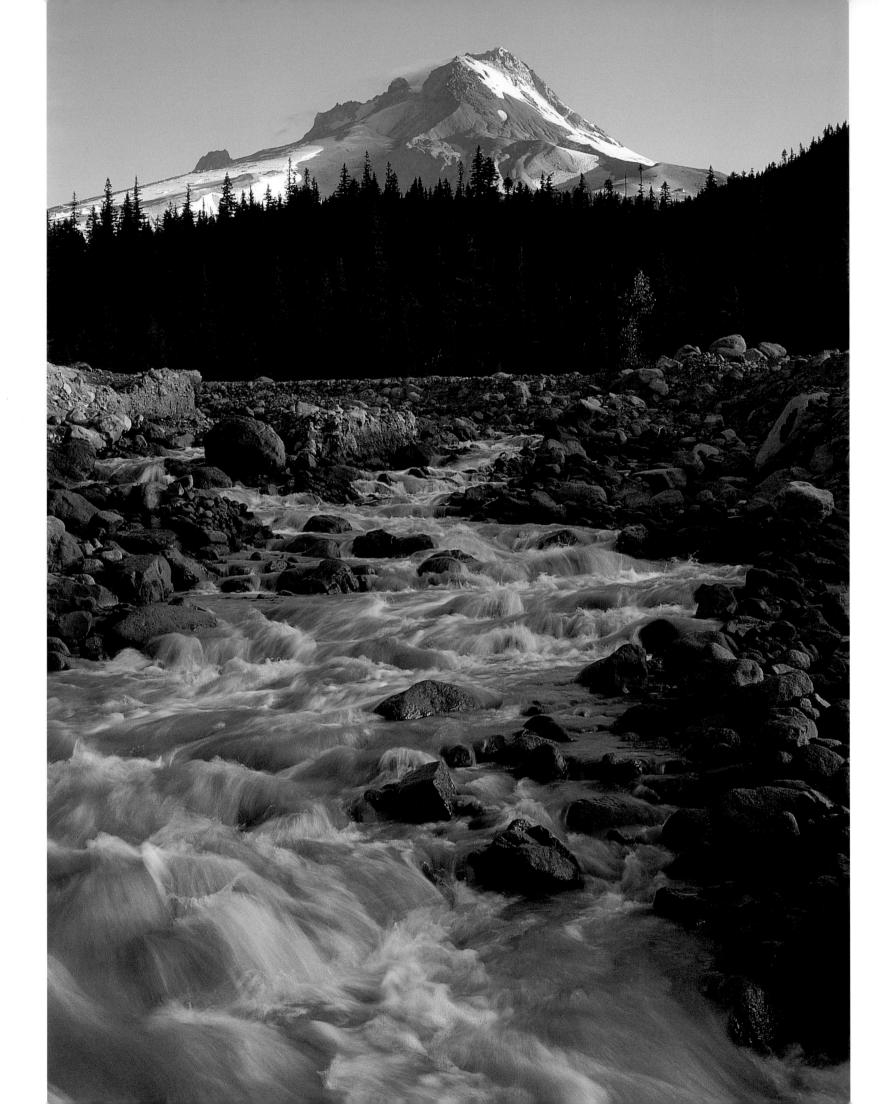

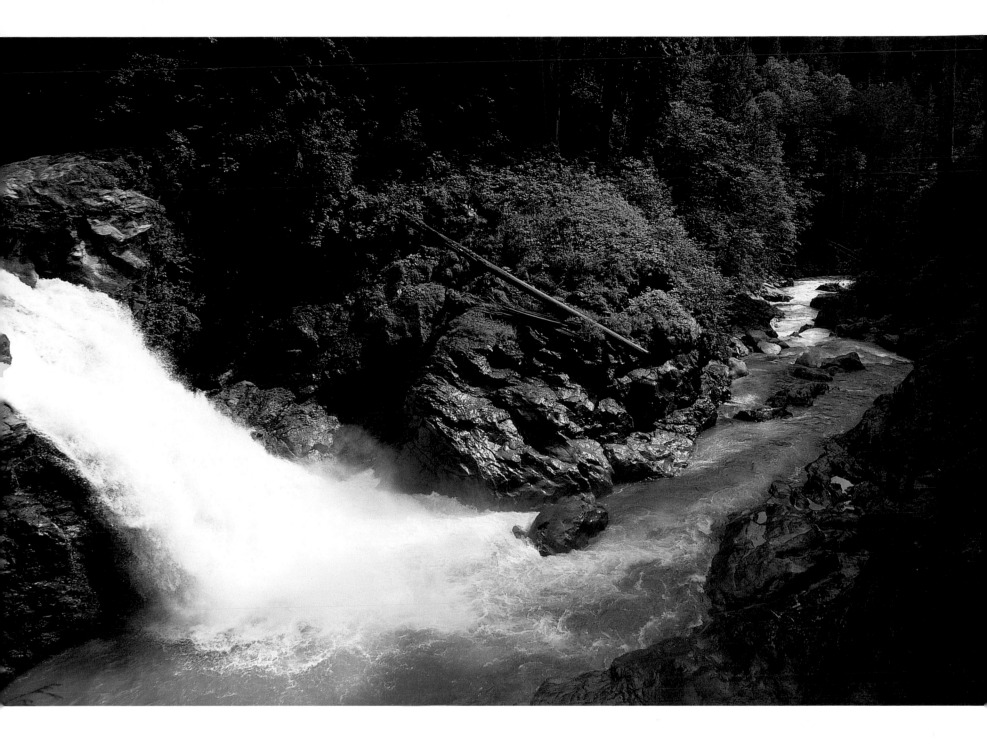

North Fork Sauk River, Washington
A wild tributary to the Skagit River, the North Fork of the Sauk churns through a temperate rain forest, where logging pressures remain intense but where some riverfront groves have been protected.

White River, Oregon
Constantly reworking its bed through loose cobbles and gravel, the White River, on the eastern flanks of Mount Hood, is named for the glacial rock dust that colors the water.

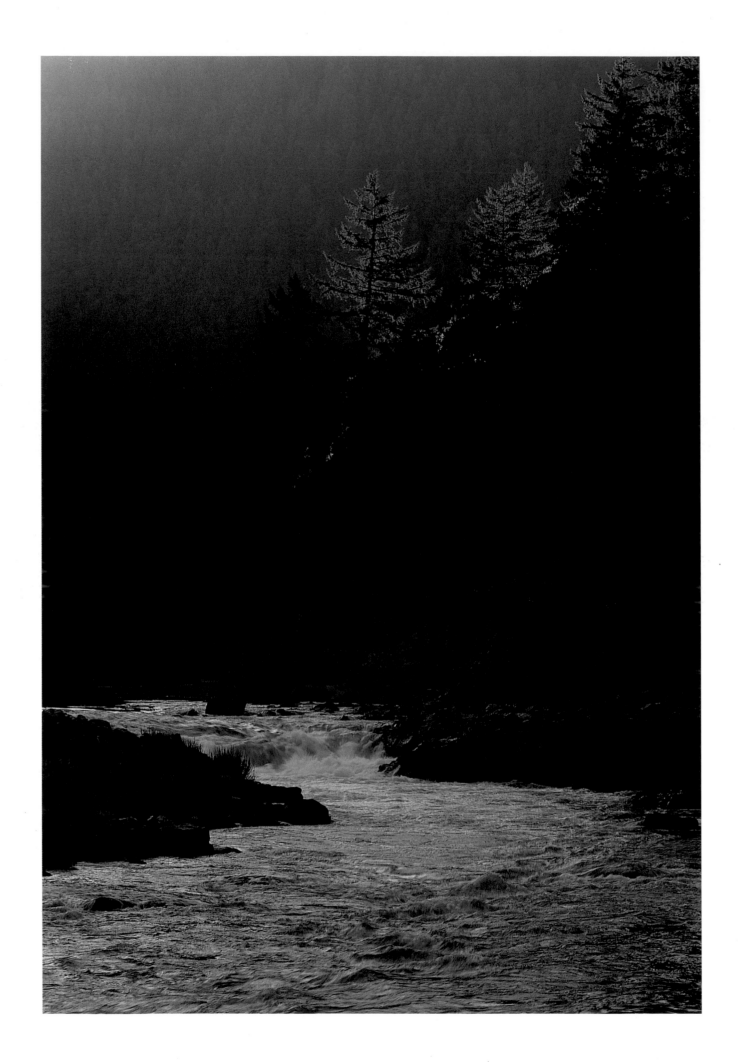

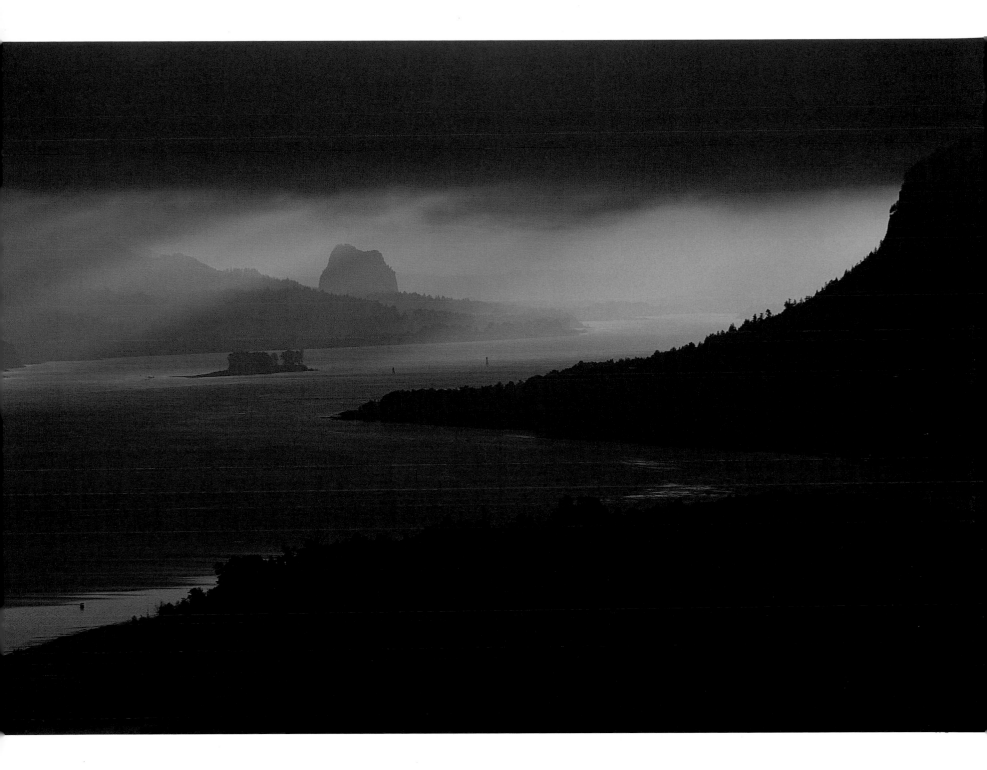

COLUMBIA RIVER, OREGON AND WASHINGTON
The sun burns through morning fog in the Columbia River Gorge east of Portland. Beacon Rock rises in the background.

ROGUE RIVER, OREGON
One of few rivers that transect the entire width of the Pacific Coast Range, the Rogue of southern Oregon flows through a
forested canyon. Rainie Falls, in the background, presents a challenging obstacle to whitewater boaters and migrating salmon alike.

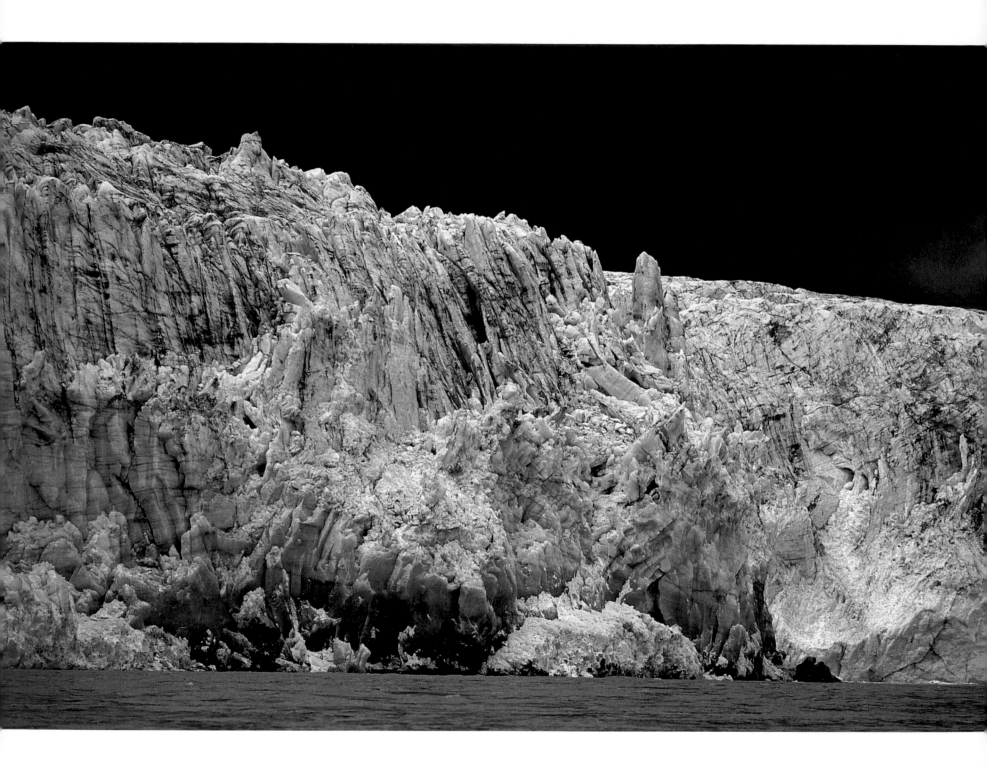

COPPER RIVER, ALASKA

For two miles the Childs Glacier encroaches directly on the channel of the Copper River, sometimes dropping house-sized icebergs into the deep current. A behemoth of the north, the Copper can carry half the volume of the Mississippi, even though it's less than 300 miles long.

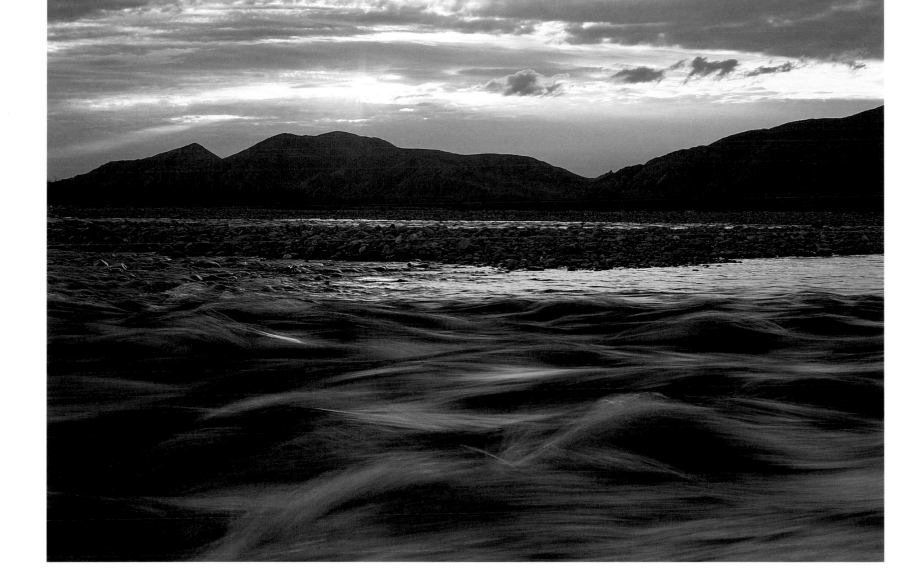

KONGAKUT RIVER, ALASKA
The Kongakut River flows north from the highest parts of the Brooks Range to the Arctic Ocean near the U.S.–Canada border.
With some of the wildest land remaining on earth, this river and its watershed are prime habitat for caribou, grizzly bears, and
musk oxen within the Arctic National Wildlife Refuge.

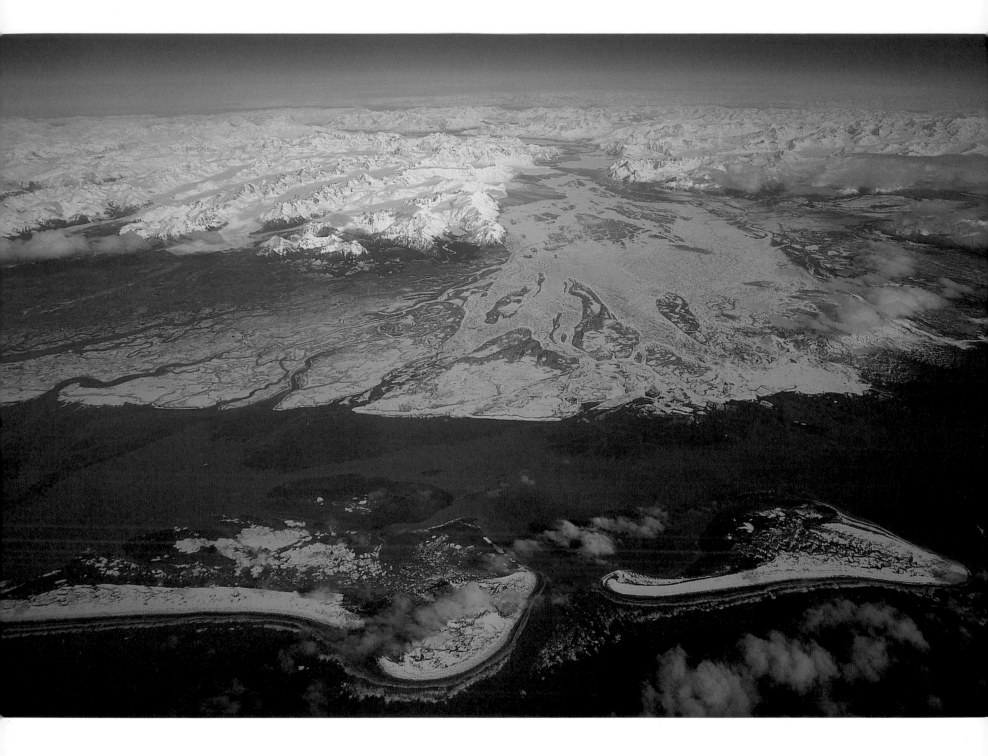

COPPER RIVER, ALASKA

The mouth of the Copper River spans ten miles and fans out in a seventy-mile-wide delta along the Gulf of Alaska.
All this, and much of the river's Ice-Age watershed, are seen here from 35,000 feet in the middle of winter.

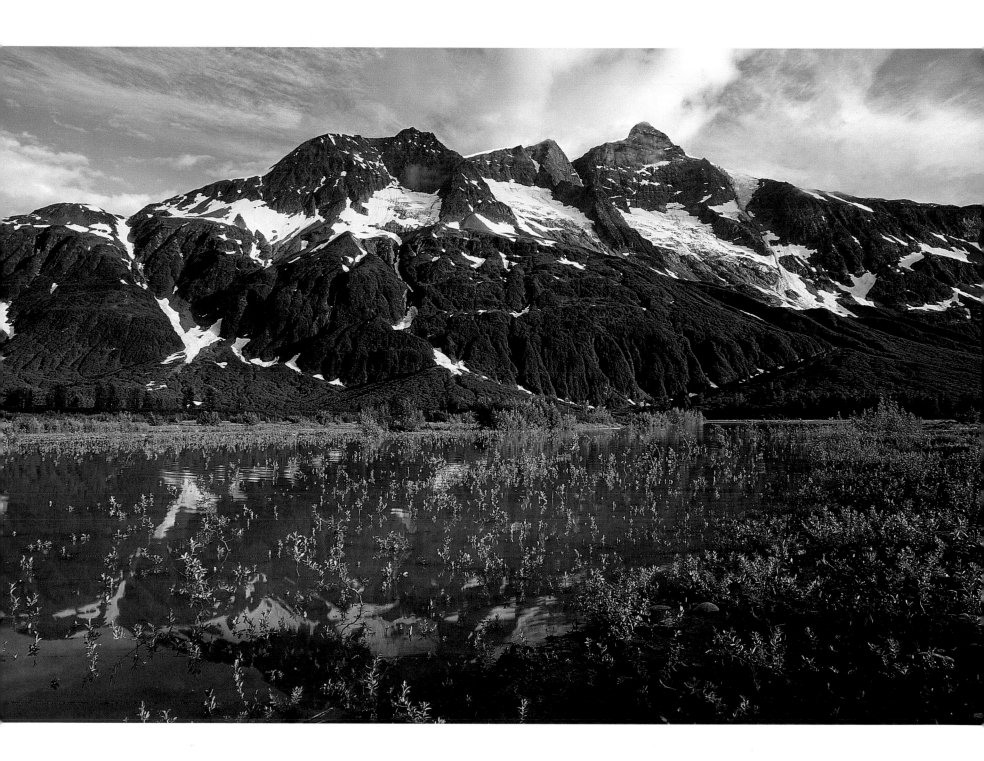

ALSEK RIVER, ALASKA

Young willow trees and broad-leaved willow herbs take hold in a quiet backwater of the Alsek River. This high-volume artery of the
north courses seaward beneath skyscraping peaks of the Saint Elias Mountains on the border of British Columbia and Alaska.

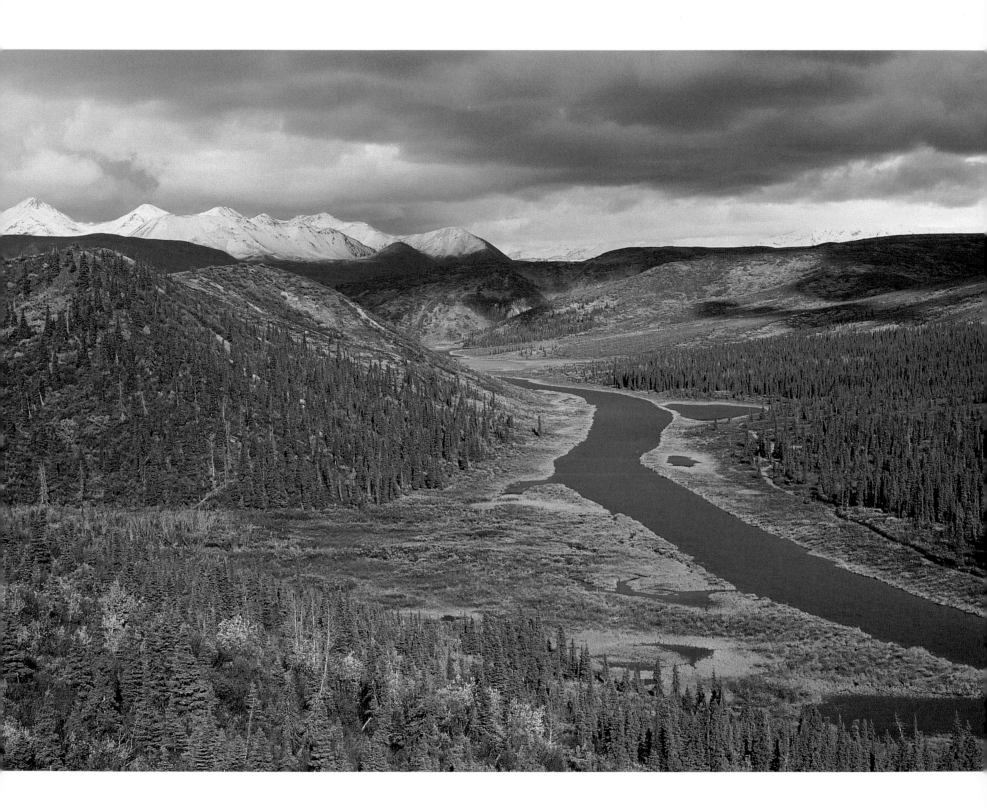

DELTA RIVER, ALASKA

With autumn coloring the tundra and mountainsides while a cool autumn storm approaches, the Delta River crosses a low gap in
the Alaska Range on its way to the Tanana River.

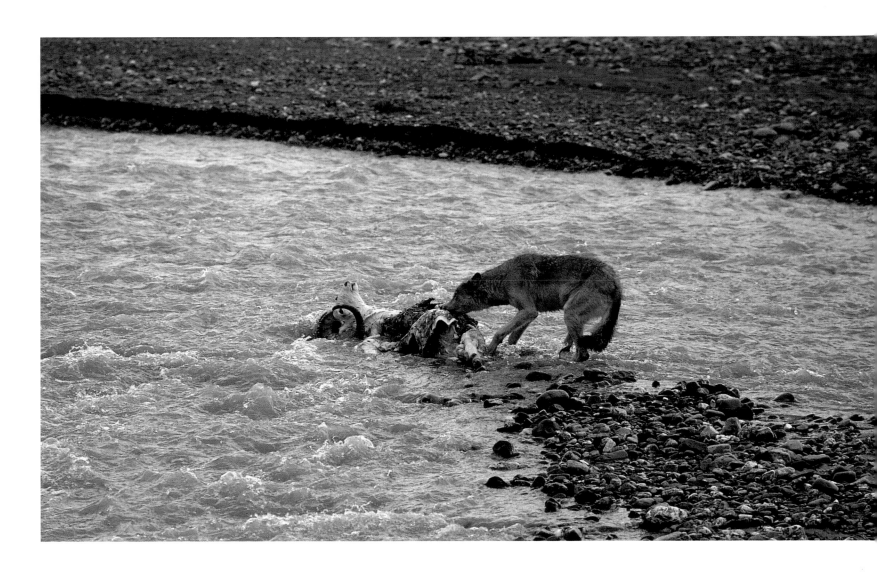

TOKLAT RIVER, ALASKA
A young gray wolf feasts on the flesh of a Dall sheep, recently killed in the Toklat River of Denali National Park.

179

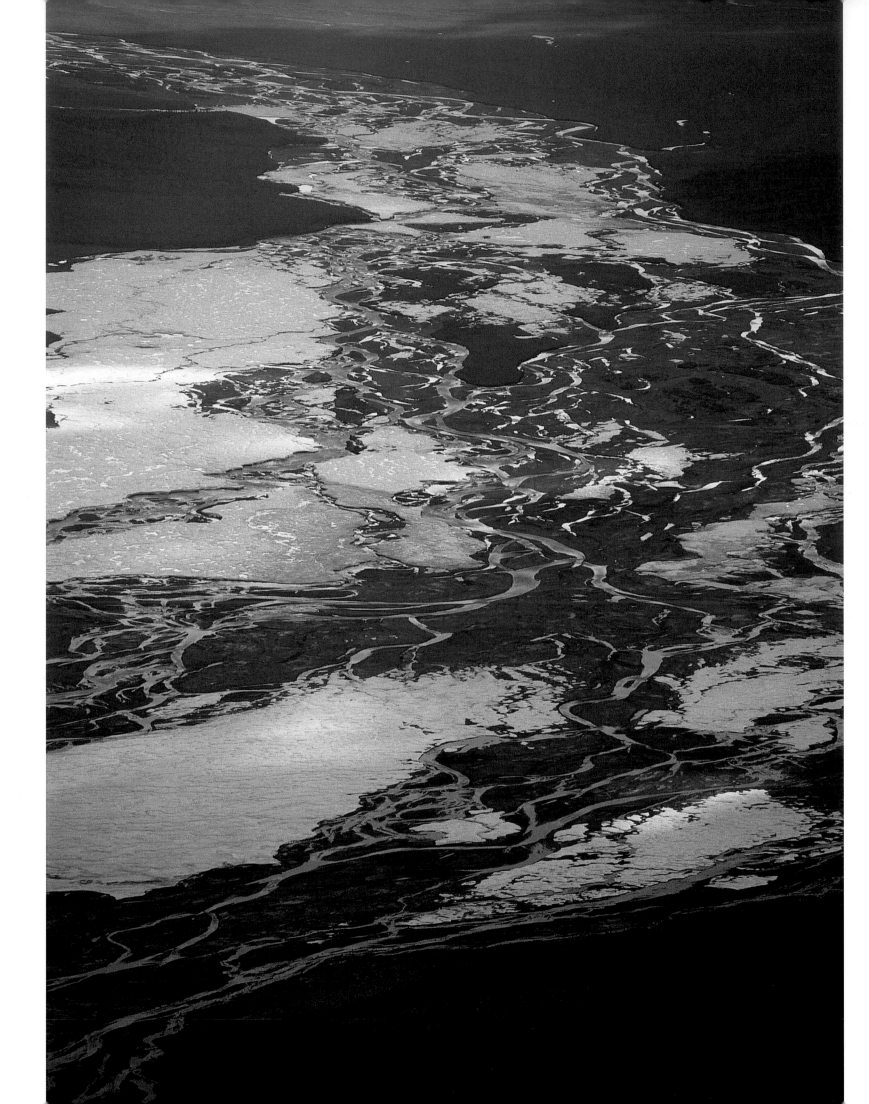

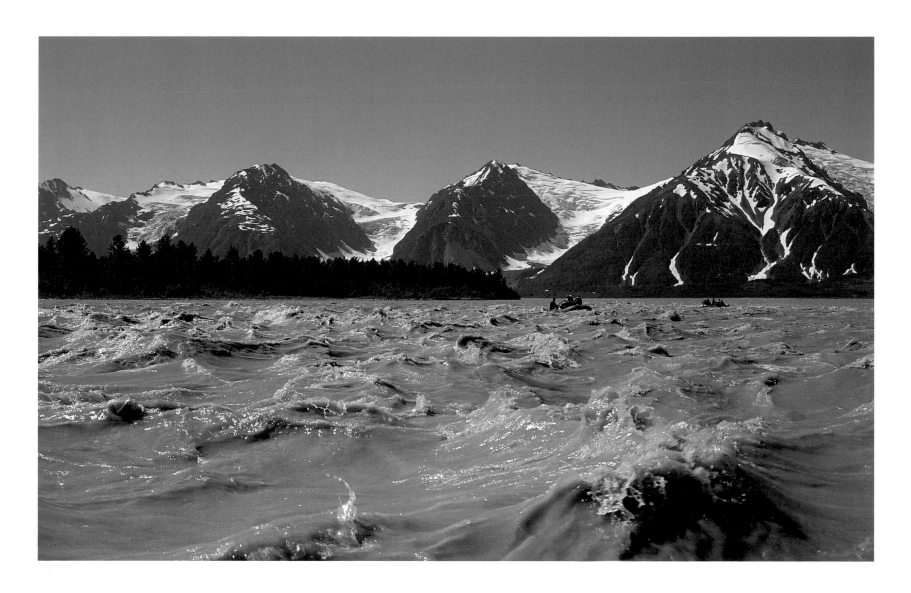

ALSEK RIVER, ALASKA
Two miles wide and carrying frigid water from the largest non-polar icefield on the continent,
the Alsek River breaks like ocean surf as it pushes out toward the Gulf of Alaska.

SHEENJEK RIVER, ALASKA
At Double Mountain, the Sheenjek River accumulates *aufeis*—ice that freezes to the bottom of the river and forces incoming water to spill over
the top, spread out, and freeze further, ultimately icing over the entire valley floor. Even in August the river's main channel can remain blocked.
With its entire length wild, the Sheenjek runs south for 300 miles from the heights of the Brooks Range to the Porcupine River.

The Fate of Rivers Everywhere

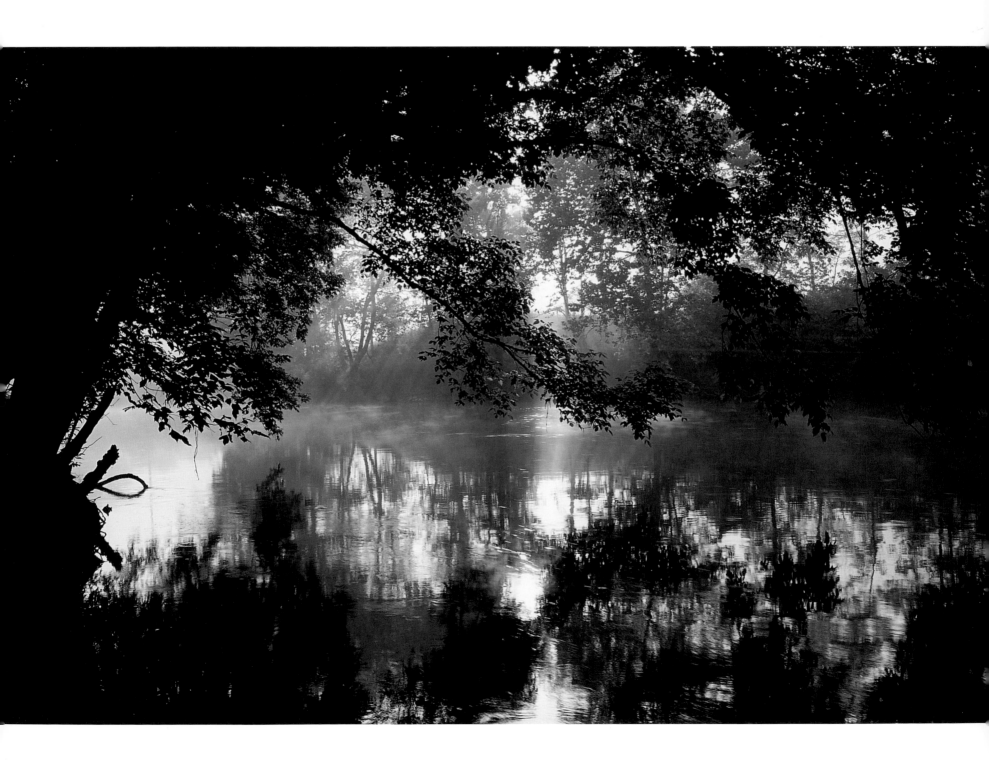

As I searched for the scenes that appear in this book, I visited rivers in all regions, seeking out places that I knew would be beautiful. This pilgrimage often took me to the wildest remaining waterfronts, to state and national parks, to preserves owned by land trusts, to national forests, and to other public land. But on the way—connecting the dots, so to speak—I stopped at rivers everywhere. I paused at each bridge crossing. When nighttime rolled around, I sought out places to park my van and sleep near a stream, any stream.

Many of these everyday rivers thrilled me with striking views that can appear wherever water flows—familiar reaches through dairy land along the Lamoille River in Vermont, common cottonwood groves along the Willamette in Oregon, one of a thousand palmetto thickets along the Suwannee. Yet, many of these rivers also suffered from misuse, evident even at a glance.

I often arrived at scarred banks, stream fronts cluttered with the backsides of development, oil seeps of industry, cutbanks engineered for railroad tracks, or the deathly quiet flatwater of dammed-up rivers. I found a lot of streams that had been ruined the way the Ohio River of my youth had been ruined. I took pictures of these rivers as well as photos of the natural ones, and a portfolio of the troubled waterways would be entirely different from the book in your hands. Yet those pictures, too, show the rivers of America.

A lot of the damage was evident and stark, but much of it was more subtle. The water may not have had the odor of disgusting waste, but streams that should have been clear were clouded with the diffuse fallout of pollution from poorly graded dirt roads or green with algae caused by overdoses of nutrients coming from farms. The layers of silt melting off plowed acreage or excavation for new development coated otherwise colorful rocks in brown—sometimes a deep sticky sludge, but sometimes just a light film. I had learned to read the telltale signs of long-term damming even below the obvious flatwater of the dams: downstream currents lacked a pool-and-riffle sequence, and they showed a sharpening erosion of their banks.

CLINCH RIVER, VIRGINIA

Though most of the river runs through private land, the Clinch still has some of the finest undeveloped riverfront in the Appalachians, and it also has the greatest concentrations of rare mussels. The Nature Conservancy works to protect habitat by establishing reserves and working with landowners. Box elder trees catch early morning light here in the far western reaches of Virginia.

With the help of biologists and hydrologists, I had learned to identify streams that were heavily diverted for irrigation, power generation, or city use. Not only were their flows anemic, but the lack of regular flushing action had led to riverbeds choked full of vegetation instead of the exposed rocks, sand, or gravel I would normally see during dry-season conditions. I clearly saw the incised paths of waterways where too much pavement, land clearing, or soil compaction had caused extreme surges of runoff followed by mere trickles. In short, I had begun to read the condition of watersheds, and of rivers, by noticing the nuances of the waters, the flows, and the shorelines.

In many parts of the country, otherwise-scenic views of rivers were ruined for me after I learned about exotic species. These plants or animals from other parts of the world have found their way to North American rivers like rats in a ship—literally including rats in ships—and exploded in populations here because they lack the predators or other limiting forces that elsewhere may have kept their numbers in check. As a result, exotics have taken over whole habitats, whole rivers, whole ecosystems. Purple loosestrife has commandeered many riverfront wetlands across the northern states, completely displacing native plants. Tamarisk has encroached on 90 percent of the floodplains in the Southwest, ousting willows and cottonwoods. Spotted knapweed has transformed the Northern Rockies, kudzu the Southeast. Star thistle now completely blankets steep hillsides above Idaho's lower Salmon River, where only twenty years before I saw none of this hideous, pinpricking invader. You can't even walk there anymore. Zebra mussels multiply by the billions in eastern rivers, suffocating the world's most varied assortment of native mussels. Without the native plants and animals that are displaced by the exotics, larger native wildlife lacks the food and shelter it needs.

Unfortunately, the more aware I became, the more problems I saw. The sad truth, with rivers as in other aspects of life, is that knowledge can lead to discouragement. My goal here was to create a book that shows the beauty that can still be found in rivers—to celebrate rivers by photographing the natural scenes that remain. But completely undamaged streams were hard to find. Even at some of the parks and other safeguarded sites, I had to crop out the riprapped banks of roads, the sag of power lines, and the clutter of buildings located on the floodplains when they could have been sited elsewhere.

183

I noted the problems with disappointment but also with interest and one eye toward analysis, comparing river to river and noticing changes over time. Again and again I was struck by the same realization that flashed into my mind when, as a boy, I emerged from Sixmile Run at the polluted flatwater of the Ohio and saw the extent of what could go wrong for a river, and when a few years later I sat mesmerized at the summertime Youghiogheny and realized that what I saw was perfect. My intuition back then and knowledge gained in the following years all indicated that we can be well-informed by our aesthetic sensibilities—by our sense of beauty. If it *looks* good, it probably *is* good. And the inverse is also mostly true.

Completely unspoiled rivers are rare, though what is now scarce was once plentiful. Three centuries ago, when my ancestors pioneered the Appalachian frontier at Ohiopyle along the Youghiogheny, natural rivers could be found everywhere. Imagine North America National Park, each valley, in its own way, a Merced in Yosemite, a Snake River beneath the Grand Teton, a bubbling Ramsey Branch lush in the rainstorms of the Great Smoky Mountains. What we now see in the wildness of the upper Hudson or in the canyon of Idaho's Middle Fork Salmon once described the state of rivers all across America.

Though it became oil-swirled, the Ohio once flowed as the biologically richest river in our country, its enormous basin encompassing thousands of rivers and tributaries, all untouched by pollution, dams, or channelization. Its continental flow riffled freely, its edges a haven of sandbars and shadowy Appalachian woodlands musically alive with bird songs including the incomparable northern oriole. The valley was animated with life from orange-bellied newts in quiet pools of side streams to black bears foraging for berries and wild grapes on flood-swept banks. The Ohio had to have been the most productive of all American rivers, not only because it was big and unspoiled at that time, but also because it was mild in climate and plush with rainfall. Furthermore, it drew from limestone basins rich in the elements needed by life. Its watershed was patterned by myriad streams connected by water yet separated by chaotic topography, enabling plants and animals to evolve in isolated and distinct forms. Except for the upper Allegheny, its basin remained mostly unglaciated and so represented millions of years of life's uninterrupted triumph and evolution. There was nothing else like it. John James Audubon raved about the birds and wild nature of this eastern artery as he journeyed through its valley in the 1830s.

The Ohio River of preindustrial America will never be seen again. I avoid getting bogged down in nostalgia, though any sensible person seeks to learn from the past, and in that regard I find it helpful to know what once existed. Some qualities of the old Ohio can be brought back, and dedicated people have had great success in cleaning up the most noticeable pollution, but the primary lesson that I take from this big river is to protect what still remains unruined before it's too late—especially when what remains unruined is rare.

Only 2 percent of our total mileage of rivers and streams flow in a pristine, completely natural condition according to a Nationwide Rivers Inventory compiled by the Department of the Interior in 1982. Rivers, of course, flow from landscapes—from whole watersheds—and we have set aside only about 12 percent of our land in parks, wilderness areas, or national wildlife refuges. Twelve acres out of one hundred is not a large share of the land. Eminent biologists including Reed Noss, editor of the scientific journal *Conservation Biology*, estimate that half of all our land must be protected in order for natural systems to work as they should and for the whole range of native species to survive. Many rivers outside the parks and refuges are still in good shape, but many are not. Indicative of the problems, one-third of all freshwater fish species are imperiled, as are 20 percent of the shellfish and invertebrates.

The problems of rivers fall into six categories: pollution, dams, diversions, altered channels, riverfront development, and the invasion of exotic species.

According to data from state officials and the Environmental Protection Agency, 40 percent of our rivers and streams are so polluted that they fail to meet the minimum water quality standards for swimming, not to mention drinking. These standards are based on chemical criteria alone. If we applied biological criteria, such as a requirement that water quality support the full range of native wildlife, more than half the mileage would fail the test. Though some rivers have improved in recent decades, the overall situation grows worse by the day. Pollution problems include sewage from cities as well as individual malfunctioning septic tanks, industrial wastes, toxins from the mind-boggling 73,000 chemicals used in commerce each year, and polluted runoff from farms, city streets, and sites that are bulldozed for new development.

Across America, 75,000 sizable dams six feet or greater in height have been built, blocking virtually every major river outside Alaska. Even the famed Yellowstone of Montana pools up behind six low

ROGUE RIVER, OREGON

A favorite among river runners and salmon anglers, the Rogue flows toward the Pacific with rapids, riffles, and waterfalls. Unlike most wild rivers, this one lies downstream from a valley that is booming with population growth, which threatens water quality important to the health of fisheries and recreational use.

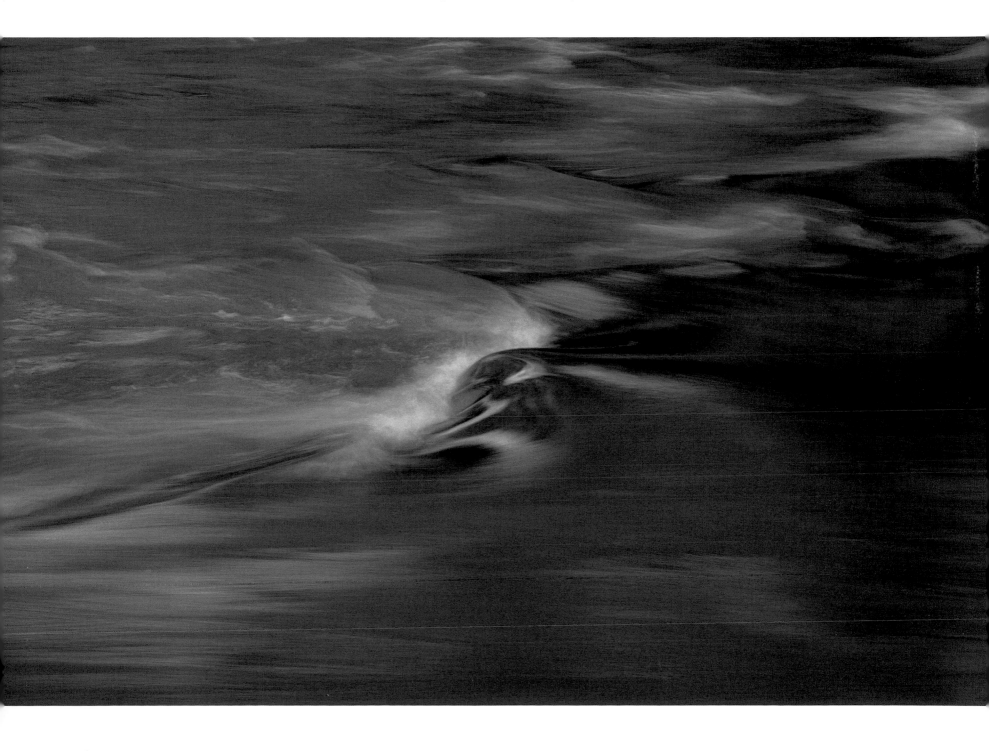

dams that shunt water into irrigation ditches; even the Salmon of Idaho has one low dam serving a fish hatchery in Sawtooth Valley. Most rivers are dammed more than once, and the Ohio is not the only freshwater artery impounded back-to-back for its entire length. The Columbia—the largest river in the West—is dammed fourteen times, impounded in all but fifty-two of its nontidal miles in the United States. Most of its mileage in Canada is also blocked by dams—built with U.S. dollars.

Dams form reservoirs that permanently flood rivers and streams, burying everything that was there. Beyond that obvious effect, dams block the passage of fish up and down rivers; species such as salmon, steelhead, and shad are eliminated or their runs crippled. Furthermore, dams result in drastically altered flow regimes downstream, and the effects sometimes extend hundreds of miles. Water is withdrawn and not returned, or not returned until much later, or much dirtier, or much warmer. Flood flows are stopped, seasonal rhythms turned on end, temperatures inverted, chemistry rearranged, silt balances upset—zombie rivers the result.

Diversions that remove water from rivers are problems at dam sites and elsewhere; the withdrawals are often taken in ways that diminish or eliminate the natural values of the rivers. Water has been ditched out of streams for irrigation, water supply, and hydropower at thousands of places, leaving rivers as large as Idaho's Snake nearly dry in a channel that would otherwise carry the volume of a whole Delaware River. The Gila in Arizona has become the stuff of dust storms, as has the Owens in California and the Humboldt in Nevada. This is not just a problem of the arid West. The artful Shepaug River in Connecticut is robbed of its modest flows for city water use. In Virginia, the biologically endowed Roanoke is diverted for hydropower, and larger diversions are proposed to serve urban development far away from the river itself.

Beyond the pollution, the dams, and the diversions, many rivers suffer from direct trauma to their channels. More than 200,000 miles of waterways outside Alaska have been channelized for barge traffic or for speeding the drainage of floodplains. Untold additional mileage has been ditched to accelerate runoff or cemented into sluiceways, aggravating flooding problems downstream and, in the process, reaming out the life-support system that each stream had provided.

Even more widespread, riparian or riverfront corridors are damaged by mile after mile of land development on floodplains,

poorly managed cattle grazing, clearcut logging, and farming right up to the banks of the streams. According to the U.S. Fish and Wildlife Service, 60 to 80 percent of riparian corridors are degraded. In addition to all these problems, exotic species run rampant along many rivers. Taking up the space that had been occupied by native plants and animals, the exotics have become one of the most dire threats to the flora and fauna that evolved and lived on the continent for millennia.

America has a long and colorful record of people taking action to reverse this alarming record of loss and destruction. The rich history of river conservation has in many ways defined conservation in America. For example, typhoid outbreaks in New York and Chicago in the nineteeth century led to some of the first reforms for cleaning up pollution of any kind. In 1900 the pioneering preservationist John Muir struggled to save his beloved Hetch Hetchy Valley—a twin to the famed Yosemite—from being buried behind the backwater of a dam on the Tuolumne River in California. He lost that heartbreaking fight in the final battle of his lifetime, but it marked the start of a movement to save parklands, wild places, and rivers. Advocates who were inspired by that aging but spirited defender of nature stepped up to protect other streams.

While efforts to stop pollution date to the late 1800s, the most effective push for reform came with the federal Clean Water Act of 1972, which set a goal to meet swimming standards on every stream by 1985. Vested interests, such as the owners of large feedlots, benefit from having the general public absorb the costs of keeping water clean, and because of their political influence we've come nowhere close to the 1985 goal. However, tremendous gains were made, especially in treating sewage. This was accomplished with federal programs in the 1970s that helped local communities pay for treatment facilities (most of those programs have been discontinued).

Early efforts for clean water were almost entirely oriented toward protecting water supply rather than rivers, a subtle but important distinction. Under the water-supply model, human hygiene was the main issue, and simple laboratory tests revealed whether or not the water was considered clean. In contrast, fights against dams, which more dramatically defined the first eighty years of river conservation in America from 1900 to 1980, were rooted in a greater sense of river wholeness. A river and its entire valley were eliminated when dammed—not just temporarily degraded by pollution, but

permanently flooded. A complex set of human values were lost when a river was dammed; so too was the river's function as centerpiece of the ecosystem.

Many of the fights against dams became classic battles in the environmental history of America. Citizens fought plans to impound the Colorado River in the Grand Canyon, the Flathead in Glacier National Park, the Delaware in Pennsylvania, the Saint John in Maine, the Sangamon in Illinois, and others. Eventually, all these individual campaigns against unnecessary dams coalesced into a movement to protect rivers. With enthusiasm based on urgency, people came together with keen awareness and with great visions about what natural rivers really are. They became more informed and more impassioned to protect their streams for both altruistic and personal reasons. With increasing traction in the political system, this movement succeeded in halting the big-dam building era in America, marking one of the greatest environmental successes our country has known.

The demise of the big-dam era and the control of the most noticeable pollution by the 1980s opened the way for what I call a second generation of river conservation. People recognized that even without dam threats or the stink of sewage, rivers still faced problems, many of them even more ubiquitous and insidious than the dam threats and gross dumping of waste had been.

Foremost, water quality experts recognized a growing epidemic of toxic wastes. Modern toxins are more difficult to see and to treat than traditional pollution, yet many pose greater dangers to people and to all life. Most of the chemicals released into the environment have been inadequately tested according to the Environmental Working Group and other organizations that track this issue. Many of these frightening neurohazards and hormone disrupters can cause cancer or other physiological damage. Consider for example, 600,000 babies born in the United States each year are exposed to dangerous levels of mercury while still in the womb. The mothers ingest this mercury by eating fish, which absorb it from the water, which is contaminated by fallout coming from power-plant smokestacks that escape federal regulation. Mercury is just one of many toxins that seep into water supplies and food chains everywhere.

To address these formidable problems, a federal "superfund" was established for cleanup of the worst sites, a program now crippled by budget cuts. Analysts have long claimed that source reduction—

not producing such hazardous chemicals in the first place—is the most effective means to reduce toxins in the environment. Alternatives exist. But this approach confronts the influential lobby of chemical commerce and has met with limited success. Most of the problems of toxins and their dark legacy for future generations remain to be solved.

Just as troublesome in many respects, runoff from farms and pastures pollutes rural streams and major waterways. With no resemblance to the old barnyards and pigpens of the American family farm, feedlots of up to 100,000 cows and even more hogs now cause appalling and uncontrolled contamination of streams, groundwater, and air. A compliant federal administration in 2005 waived antipollution requirements on the oversized feedlots if the owners simply agreed to "self-monitor" their levels of waste. Industrial animal factories foul streams to degrees unimagined by the most hardened livestock growers just a decade or two ago.

For example, one consequence of industrial-scale pig farming was a *Pfiesteria* outbreak along North Carolina coastal rivers in the 1990s. This microscopic dinoflagellate multiplied beyond control when pig factories released excess nutrients into the water from mountains of manure and dead, diseased animals. Floods destroyed holding ponds of concentrated animal waste that had been improperly stored on the floodplains. *Pfiesteria* produces toxins that caused massive fish kills and also nerve damage to people who didn't even eat the fish but simply breathed the air near the river. Biologists studying the issue were some of the first to succumb—public servants never intending to be canaries in the coal mine. Trying to get a grip on feedlot problems that the federal government ignores, a few states have enacted laws limiting new industrial-scale animal operations and requiring nominal improvements, such as the diversion of stormwater around the feedlots.

The second generation of river conservation has also tried to address the problem of adequate flow in the rivers—the issue of water quantity rather than just quality. Some of the worst diversions cause rivers such as the San Joaquin of California to virtually dry up. In the same valley, less than a hundred years ago a riparian garden stretched as far as the eye could see and salmon swam upriver by the tens of thousands.

Owing to legal protection under a western-states doctrine that gives farmers and ranchers license to take water from streams even until the streams are bone-dry, damaging irrigation diversions have

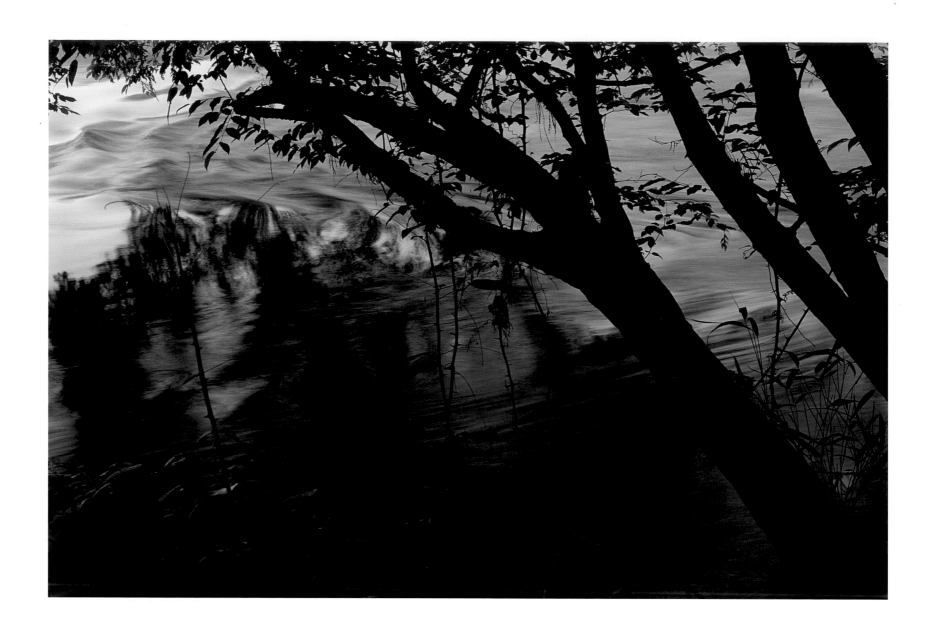

rarely been corrected. However, some progress has been made to restore natural flows in two other respects.

First, hydroelectric permits issued under the Federal Power Act periodically come up for review, and since 1986 these reviews have been required to address environmental standards. Though meaningful reform has rarely occurred without lawsuits or appeals every step of the way, many of the hydro dams are now less destructive. For example, instead of holding back most of the water and then releasing it all at oncc to make electricity, utility companies are now required to moderate their operations and release water more evenly, which is less damaging to fish and other life in the river.

Progress has also been made in restoring the flow of rivers by improving the management of federal dams. Each of these taxpayer-funded facilities governs the downstream flow of its river through the daily turn of a dial that either releases water or holds it back.

Control of these public dams has for decades been wholly in the hands of irrigators, water companies, and power producers. For one example of reform, consider the Reclamation Project Act of 1992, aimed at the massive Central Valley Project (CVP) in California—a network of twenty dams and related diversions, canals, and pumps. The dams and diversions of the CVP had taken nine-tenths of the flow from the Trinity River—the Klamath River's largest tributary and once a stellar salmon and steelhead stream.

Taxpayers typically pay for about 90 percent of the costs of the federal dams and diversions as if they were matters of national security, yet up to a third of the water from the intensively subsidized projects in the West goes to grow crops that are in chronic surplus—cotton and wheat, for example. Other farmers are actually paid to not grow the same crop in one field that taxpayers generously subsidize in other fields, needlessly destroying rivers in the process.

CHATTAHOOCHEE RIVER, GEORGIA
The Chattahoochee River graces northern Georgia before joining the Apalachicola River and
eventually flowing to the Gulf of Mexico. Here within the city of Atlanta, the Upper Chattahoochee
Riverkeeper works to reduce pollution generated by the South's fastest-growing urban area.

The beneficiaries of all this taxpayer money are not family farmers, whose well-being was the intent of America's original reclamation laws, but rather the largest corporations in American agriculture, which register profits in the billions.

The overdue reforms of the 1992 Reclamation Project Act required that 15 percent of the water stored behind the dams be used for fish, wildlife, and the environment—not much, but real progress nonetheless. The Trinity River's share of this 15 percent was urgently needed by salmon, which supplied several Indian tribes, thousands of sport anglers, and an entire commercial fishing industry that was rapidly going out of business along the coasts of California and Oregon because of diversions from the rivers where the fish needed to spawn. But countering this effort to protect and restore the endangered salmon, Bush administration officials in 2005 ruled that agribusinesses receiving the water need not follow the laws. No surprise, these recipients of government largesse had been dumping money into political campaigns with every gallon of water that the government dumped into their ditches. As a further outrage, the Bush administration flatly gave the agribusiness giants $16 million to compensate them for having to partially comply with the law for several years. Such was the state of American politics and its effect on rivers in the first decade of the twenty-first century. The hard-earned reforms of the previous forty years were in serious jeopardy.

But in spite of the political climate, there were bright spots as well. When I first started photographing rivers in the 1970s, the era of big-dam construction was still in full swing. I spent a year traveling the country taking pictures of streams that were about to be dammed and never seen again: the Stanislaus in California, the Savannah in Georgia, the Applegate in Oregon, and dozens of others. But by 2006, I could photograph a different set of rivers—ones where dams had blocked the flow for decades or centuries but have recently been removed, the channels restored, the natural flows reinstated. River conservation groups now promote the elimination of obsolete, useless, and unsafe dams in every region, with publicity given to rivers such as the Kennebec in Maine, Rappahannock in Virginia, Ventura in California, and Elwha in Washington. These are mostly small dams, but even so, I find it remarkable to go to some of these places now and see a flowing river, alive with fish migrating upstream after decades of absence, and to realize that we can fix some of the damage of the past.

As I watched what was happening to rivers all over the country, one additional approach of the second generation of river conservation caught my eye: the protection of floodplains and large riverfront corridors as open space. Biologists have reminded us that rivers are not just water in channels, but rather whole ecosystems, including water, shorelines, and related land. Protecting rivers means safeguarding riverfronts from pavement and development that are otherwise irreversible and permanent. This mode of river saving depends on two strategies: buying land or easements along rivers and zoning the floodplain.

Several large organizations—including the Nature Conservancy, the Trust for Public Land, and the Conservation Fund—buy land or easements to protect open space along hundreds of rivers nationwide, and 2,000 smaller land trusts protect river frontage wherever they can. Local conservancies are especially active in the Northeast, where sites as small as a few acres can make a difference to the health of a stream. Large segments of rivers are also being saved, especially in the West. The Western Rivers Conservancy, for example, has made remarkable progress on the Hoh River in Washington and the Sandy in Oregon.

For the great bulk of the land remaining in private ownership, floodplain zoning can protect riparian corridors by limiting what may be built next to the rivers. Based on principles of public safety and economic liability, zoning has been upheld by the courts since 1923 but has not been used much by river conservationists.

Improved floodplain management could do more for rivers than any other strategy in the toolbox of river conservation. Zoning, for example, can be applied to virtually every mile of water frontage in America. One county floodplain ordinance can protect thousands of miles of riverfront in a single public action. Most municipalities already have flood zones established as part of the Federal Flood Insurance Program, which mandates nominal land-use controls for approval of federally backed mortgages. The federal standards fail to adequately safeguard river corridors, but they are a start, and improvement beyond the minimum standards could sharply reduce

damage from floods, save billions in tax dollars, and preserve open space for farming, recreation, and wildlife.

Formidable problems still confront rivers all across America, but practical and feasible solutions exist, and people in thousands of conservation and watershed groups now work for the good of their streams. The key organization for nationwide efforts, American Rivers, lobbies in Washington, D.C. This group was started in 1973 to support the National Wild and Scenic Rivers system but now fights for clean water reforms, encourages removal of obsolete dams, and launches campaigns to protect endangered streams and to restore national landmarks such as the Missouri and Columbia Rivers.

Most river conservation is local conservation, and so River Network was founded in 1988 to support local and statewide groups in protecting their streams. This organization has helped people in hundreds of communities and continues to expand its reach through events such as the National River Rally, which every year draws legions of river supporters from all over the country.

Also operating nationwide, the Waterkeeper Alliance encourages the formation of local organizations that take bold action to stop polluters in river basins from the Hudson, where the riverkeeper movement began, to the Columbia. Another effective group, Trout Unlimited, has united anglers for decades with the recognition that fish need clean water and undisturbed streams. The Izaak Walton League, National Wildlife Federation, Natural Resources Defense Council, Clean Water Action Coalition, Sierra Club, Wilderness Society, and other groups also work to conserve rivers.

Thirty-two states now have statewide river groups, each a catalyst for efforts in its region. The largest and one of the oldest of these, Friends of the River, was formed to save the Stanislaus and has gone on to protect dozens of other streams in California. Beyond statewide groups, local activism has exploded. In 1990 River Network conducted a nationwide survey and found 500 river and watershed groups; in 2004 it counted 3,600. The small state of Connecticut alone has 243 river organizations. Massachusetts and the other northeastern states have similar levels of activity. Hundreds of groups now work in the upper Midwest and along the West Coast. River conservation efforts are also growing in the South and even in the long-ignored Great Plains. Each group represents a core of citizen activists who care about their river and who work to clean it up, safeguard its flow, restore its channel, eradicate exotic species, or protect the riparian edge as open space.

Growing from John Muir's lonely but heroic struggle to protect the Tuolumne River in 1900, river conservation has now provided us with hundreds of heroes. With her two children still at home, Sally Bethea launched the Upper Chattahoochee Riverkeeper and challenged Atlanta in a battle to reclaim the centerpiece river of that fastest growing city in the South. A timber cruiser, Jerry Becker helped organize Friends of the Elk River in Oregon and stopped the Forest Service from clearcutting in his spectacular basin, rich with salmon and old-growth forests that the salmon need almost as much as they need water. Then he went on to acquire steep-sloped riverfront properties through a local land trust. A beef buyer at Midwest cattle auctions, Del Wehrspann saw the deterioration of the Minnesota River while fishing on his days off and began a movement for restoration, eventually convincing the leaders of Corn Belt communities that the river should be cleaned up. Bill Sedivy directed Idaho Rivers United, where some of the finest wild rivers in America flow through a state where the political leadership has failed to support protection.

River conservation efforts such as these are being repeated by hundreds of people along rivers all across America. The citizen volunteers, organizers, scientists, activists, educators, communicators, fund-raisers, and soulful leaders of river conservation groups are creating no less than a new democracy in America—one that has people taking real responsibility for their own places, along rivers, from one ocean shore to the other.

If history offers any indication of what we might expect, the people and groups working to protect their rivers have a difficult task ahead of them, but one that can be accomplished. This optimism, however, assumes that the resistance to protection does not radically increase. In fact, the resistance is growing because the most fundamental force behind the threats to rivers are people's need for water and land, and those needs are increasing as the population increases. The Census Bureau expects the current population of 297 million to reach 420 million by 2050, and to more than double by the year 2100 according to a "middle series" projection. The Bureau has typically underestimated the forecast; if the rate of growth in the year 2005 simply continues, our population will double in only fifty-six years. Continuation of today's actual trends will result in a U.S. population of more than a billion people by 2100—nearly the size of today's China. California is slated to double in thirty-seven years, adding the equivalent of a new Los Angeles every decade.

The effects of a population doubling will be felt on every river. One might expect double the need for sewage treatment, double the acid rain, double the development of floodplains, double the volume of stormwater rinsing off sprawling suburbs, double the damming for power and for water supplies that will be needed to slake the thirst of all the new people.

Even if conservationists and efficiency reformers succeed beyond their wildest hopes in efforts to reform the way water is managed, and they somehow reduce the amount of water we use by half, this hard-earned gain that may take a lifetime to achieve would be completely canceled out by simple population growth in less than the same lifetime.

Owing to efficiency improvements, the problems of rivers may not all double when the population doubles, but they will certainly increase. Then, as if this were not enough, the population will likely double again unless federal policies are changed regarding immigration, which accounts for about two-thirds of the projected growth between 2000 and 2050 according to Census Bureau data. This sensitive and complicated issue is one that most people chose to avoid, though the consequences of not even discussing it are enormous.

Facing a future of ever-continuing growth, many of the finest efforts to save rivers would eventually prove futile. The ultimate health of our streams depends on the recognition that unlimited demands cannot be met by a limited amount of water and land.

People working for a sustainable future and for the health of their streams have never been faced with challenges as great as they are now, but never before have so many people been involved and committed to the protection of their rivers.

NORTH FORK FLATHEAD, MONTANA
At this site on the North Fork Flathead, the Smoky Range Dam was proposed in 1956. The National Parks and Conservation Association and Sierra Club stopped the plan in a landmark case protecting national parks.

192 NORTH BRANCH WESTFIELD RIVER, MASSACHUSETTS
Local land trusts have protected many riverfronts across America, including this intimate scene at the North Branch Westfield in
Chesterfield Gorge, a Connecticut River tributary in Massachusetts.

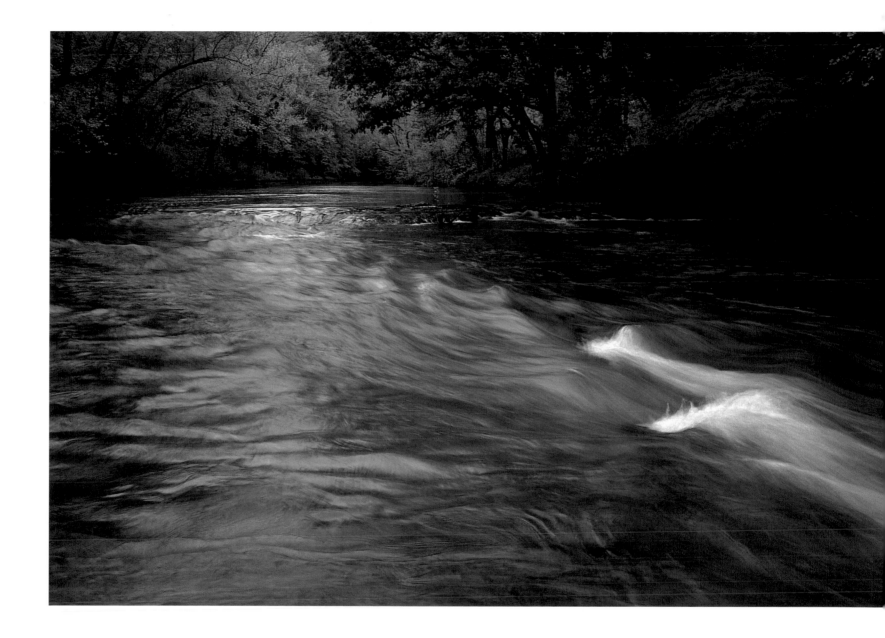

BUFFALO RIVER, ARKANSAS

In 1972 Congress designated nearly the entire length of the Buffalo as a National River, stopping a dam proposal in the Ozark Mountains. All the private land along the riverfront was subsequently bought by the National Park Service. This remarkable river now runs wild with almost no development except for occasional park facilities and bridge crossings.

Overleaf WEST BRANCH FARMINGTON RIVER, MASSACHUSETTS

Proposals to divert water from the Farmington River for urban water supplies prompted rural residents to seek protection for their stream in the National Wild and Scenic Rivers system, and a portion of the river was designated. Autumn leaves are at their peak here along the West Branch.

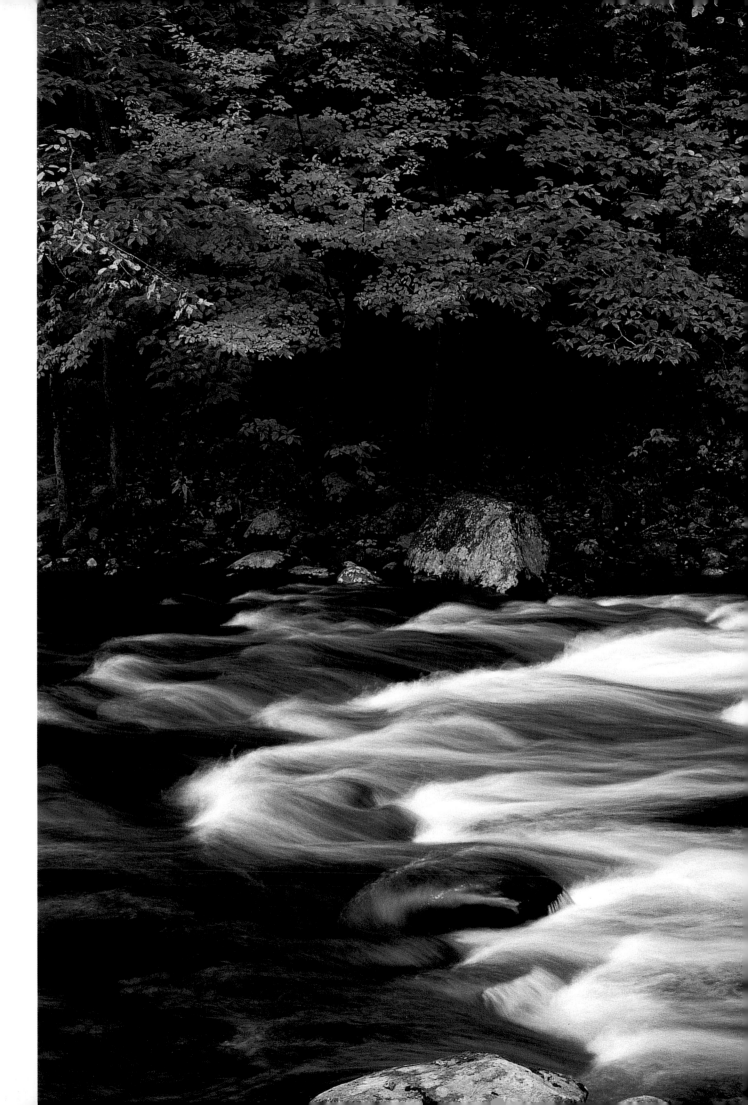

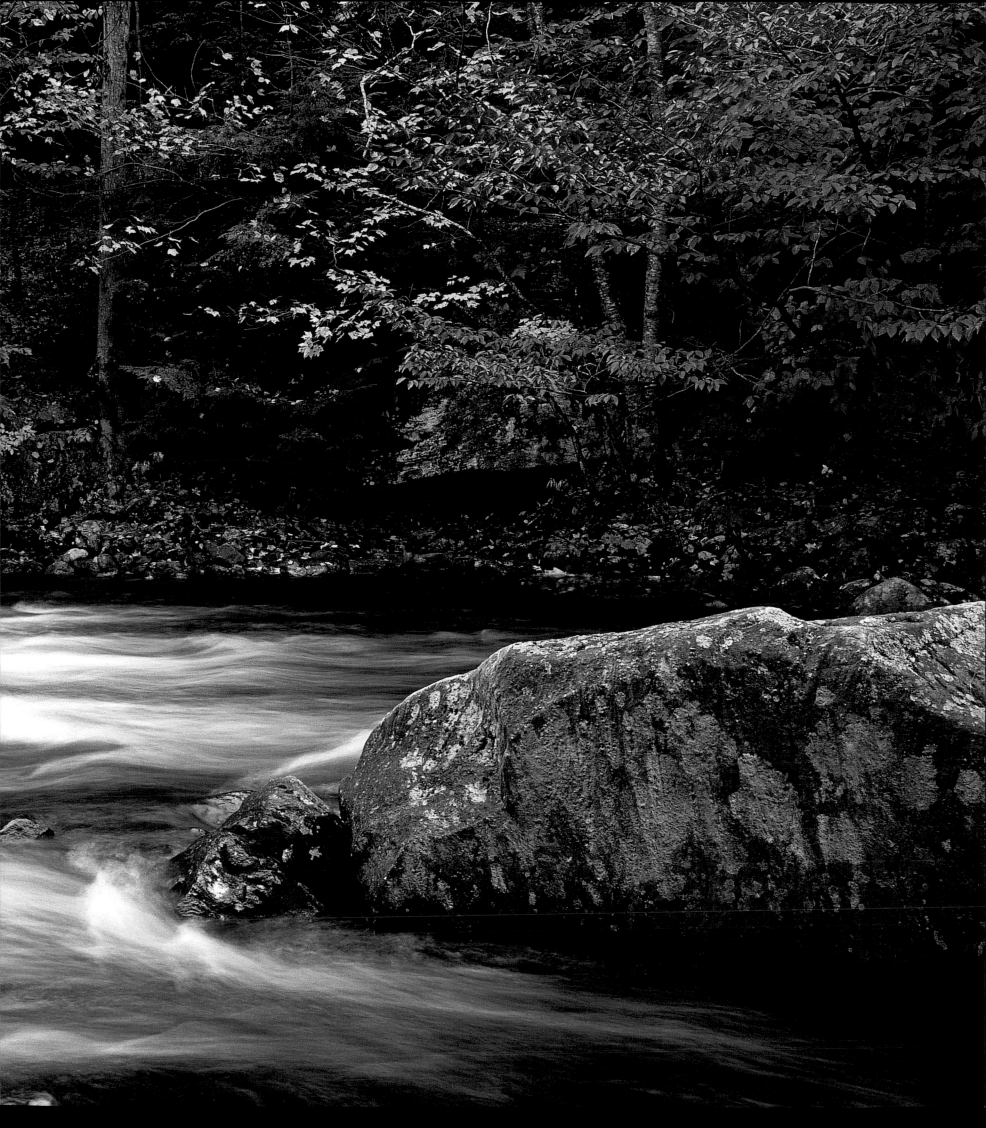

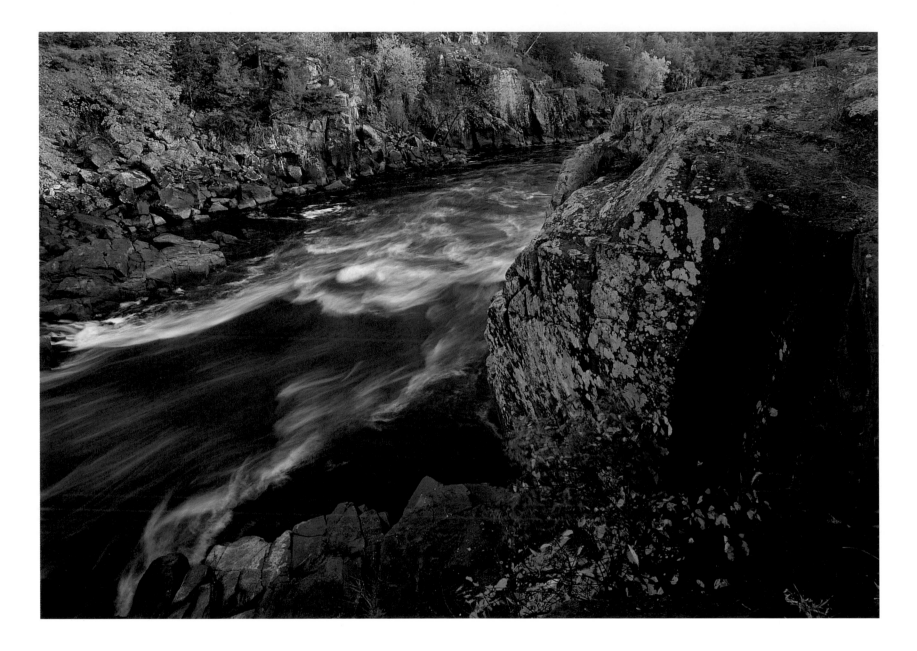

SAINT CROIX RIVER, WISCONSIN AND MINNESOTA
Owing to the support of Senator Gaylord Nelson, Congress included the Saint Croix River of Wisconsin and
Minnesota as the only river east of the Mississippi in the original National Wild and Scenic Rivers Act. The river
cuts through bedrock here at Saint Croix Falls.

NIOBRARA RIVER, NEBRASKA
At the Niobrara River, a dam was proposed for irrigation in the 1970s, though it would have taken more land out of
agricultural production than it would have served. Ranchers organized to stop the project here near Norden.

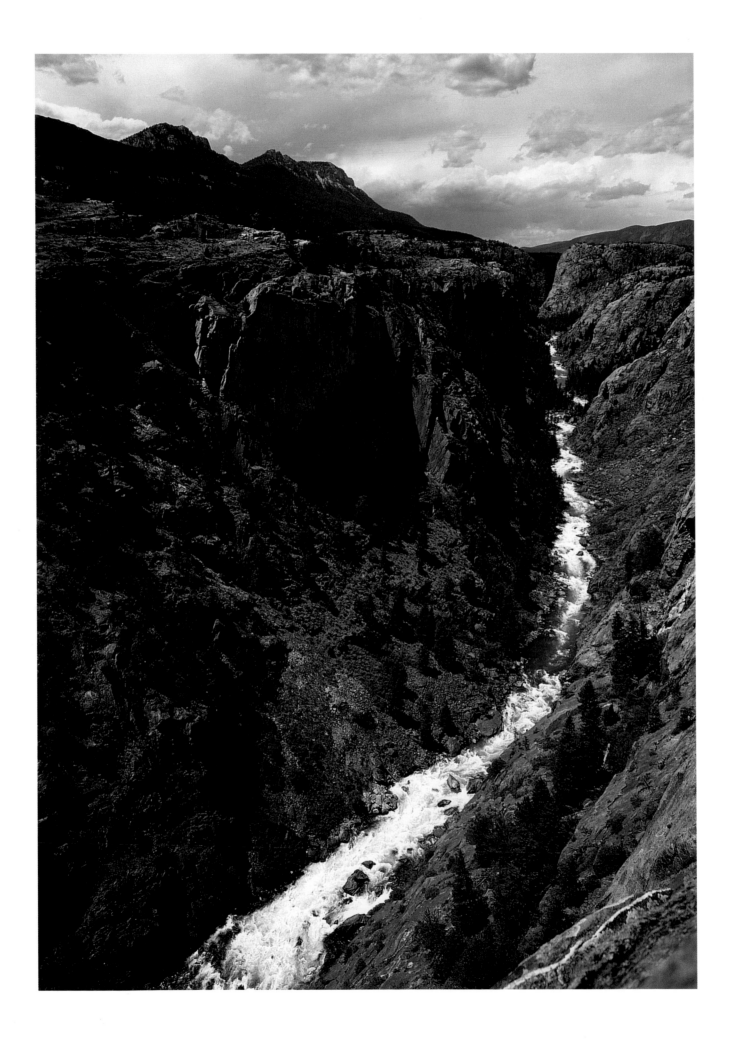

TROUT CREEK, WYOMING

Protected in Yellowstone National Park, Trout Creek meanders across Hayden Valley before joining the Yellowstone River. Bison herds graze safely here in the summer, but in the winter they must migrate to lower country where some are killed when they cross the park boundary or enter private ranch land.

CLARKS FORK YELLOWSTONE RIVER, WYOMING

In some ways the wildest river in America outside Alaska, the Clarks Fork of the Yellowstone disappears into a deep, inaccessible canyon as it pours from the Beartooth Mountains. It was added to the National Wild and Scenic Rivers system in 1990, banning an irrigation dam that was once proposed.

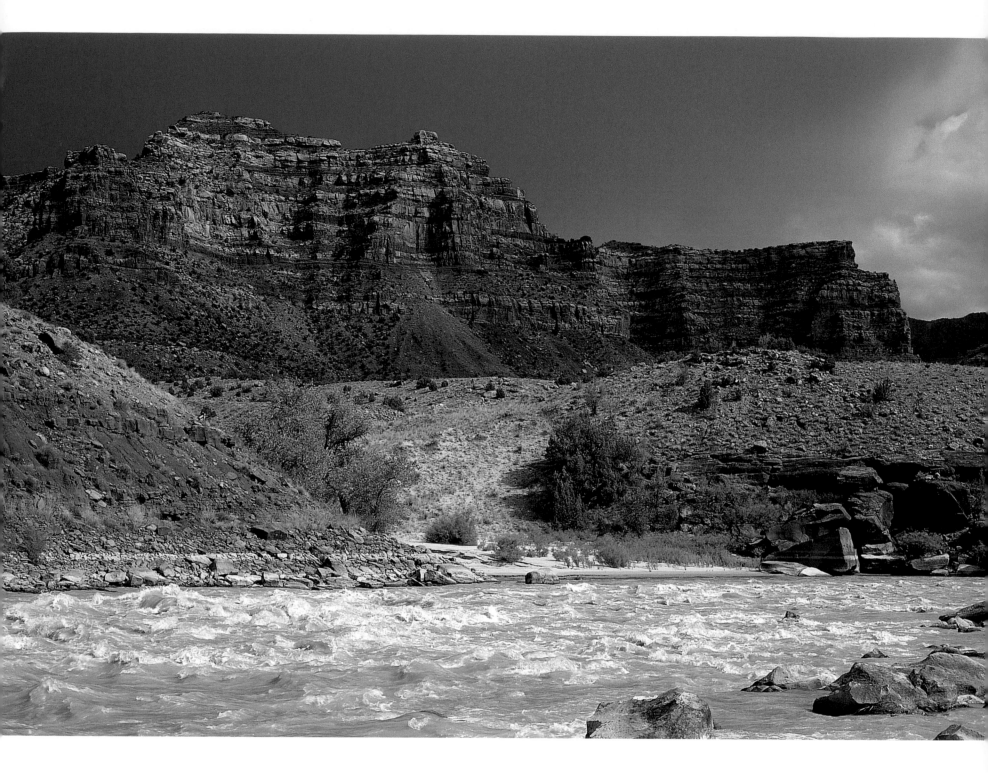

GREEN RIVER, UTAH
The Rivers Council of Utah strives to gain permanent protection for remaining wild sections of the Green River between Flaming Gorge Dam and the river's confluence with the Colorado. This rapid is in the lower reaches of Desolation Canyon, north of the town of Green River, Utah.

COLORADO RIVER, ARIZONA
The Colorado River in the Grand Canyon appeared to be doomed by proposals for two dams in the 1960s, but in a landmark controversy over rivers, the dams were halted and the Grand Canyon was saved. An August rainstorm begins to clear here at Unkar Creek.

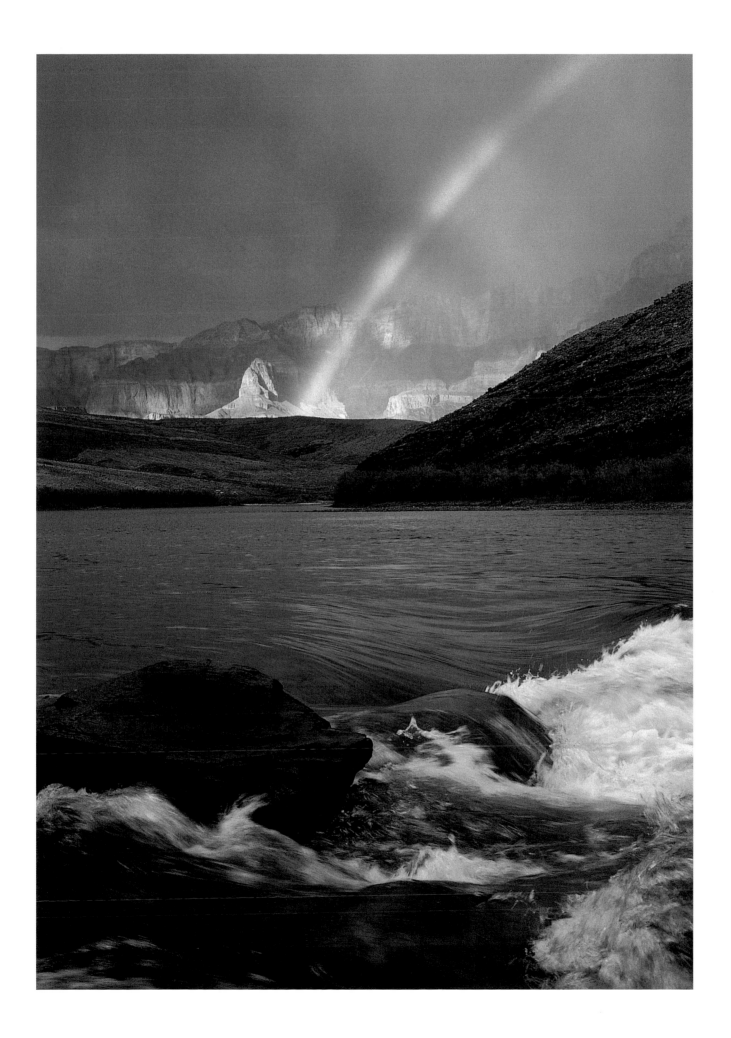

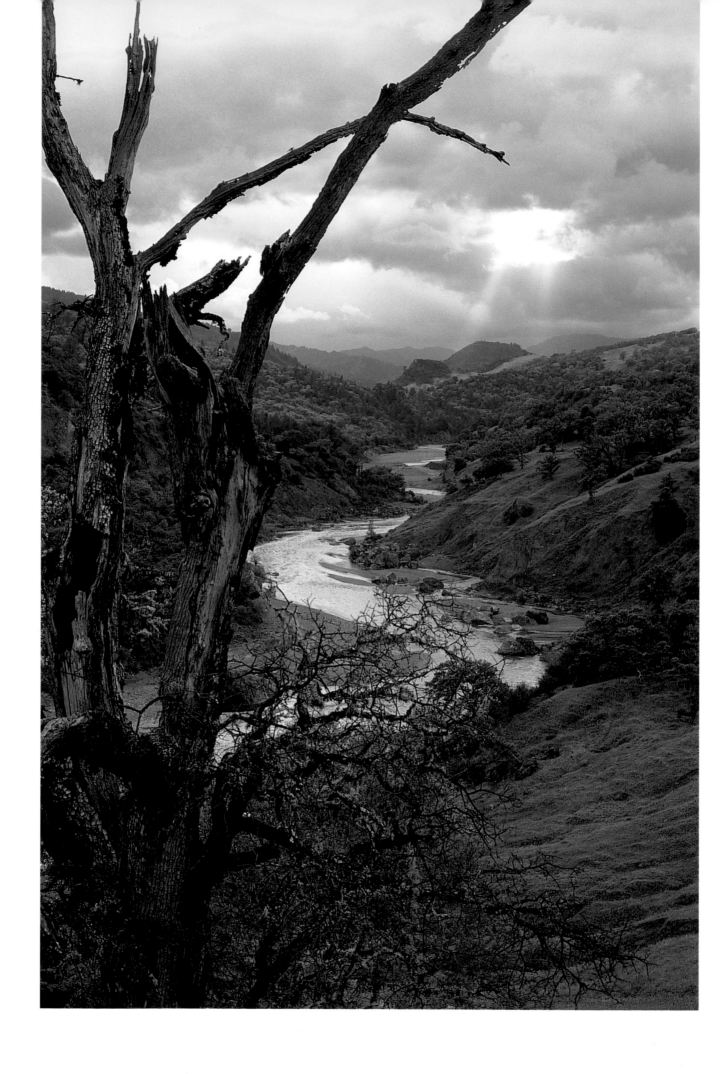

WILLAMETTE RIVER, OREGON
A lifeline of Oregon, the Willamette bisects the state's primary urban and agricultural region. A greenway proposal by Governor Tom McCall resulted in the protection of some open space along the river in the 1970s, and the Western Rivers Conservancy now works to acquire additional parcels for riparian and wetlands restoration. Here the sun rises near Corvallis.

MIDDLE FORK EEL RIVER, CALIFORNIA
The state of California planned to build Dos Rios Dam at this site but was stopped by a coalition of wild river supporters in the 1960s. Governor Jerry Brown later requested wild and scenic designation for this and dozens of other northern California rivers. Interior Secretary Cecil Andrus granted protection only hours before leaving office in 1981.

BROOKS RIVER, ALASKA

Among the most magnificent fish on the continent, five species of Pacific salmon have been eliminated or diminished in most of the rivers they once inhabited. Today the abundance of sockeye and chinook salmon surviving in the Brooks and other rivers of Alaska are a reminder of how rich this fishery once was throughout much of the Northwest.

MIDDLE FORK FEATHER RIVER, CALIFORNIA

The lucid green water of the Middle Fork Feather River belies the chaotic rapids to come downstream in Baldrock Canyon. The Middle Fork later empties into Oroville Reservoir and its water is diverted toward southern California.

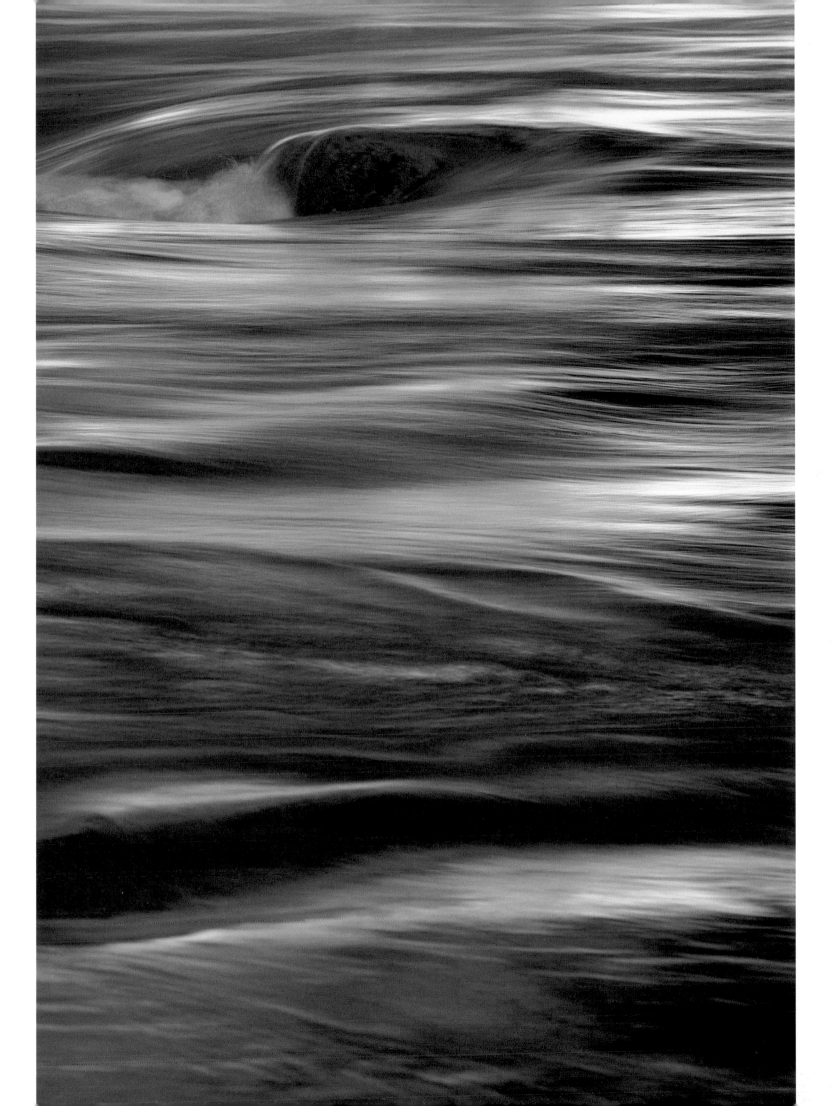

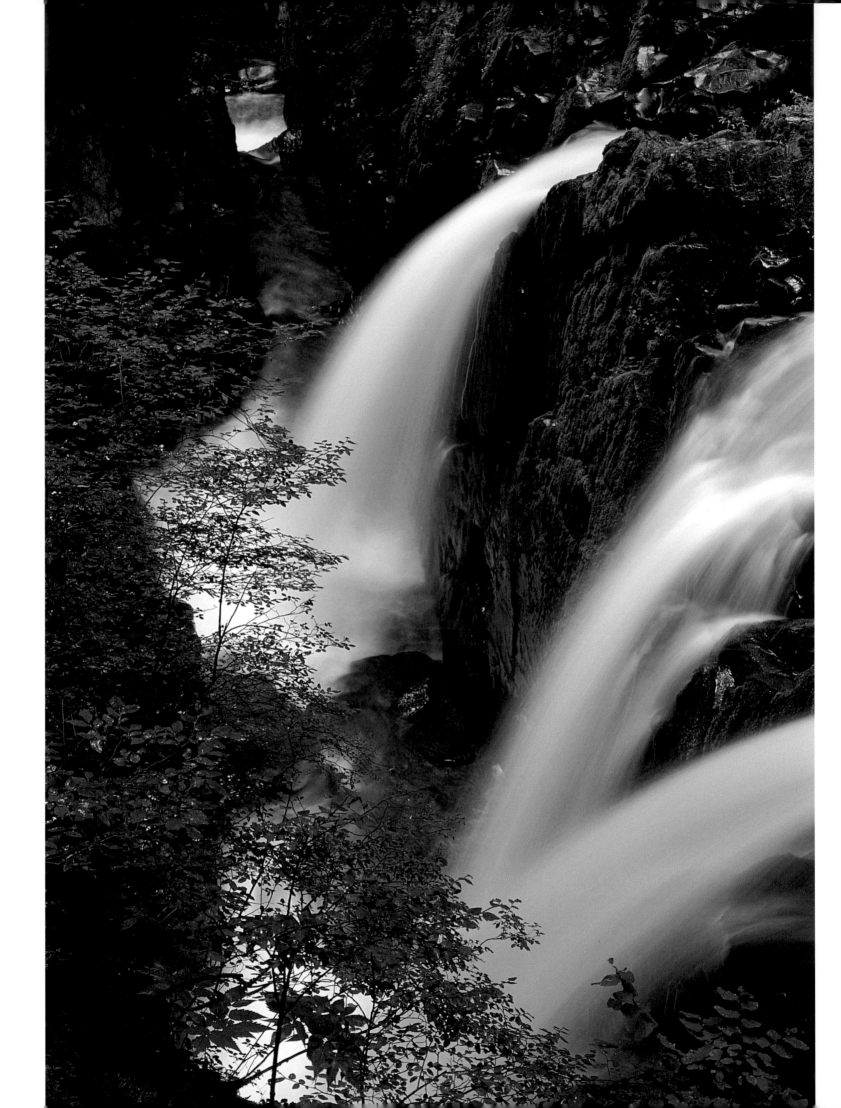

COPPER RIVER, ALASKA
The tenth-largest river in America, the Copper is threatened by logging and mining proposals near the river's mouth—one of the largest and most critical estuaries on the continent for migrating shorebirds. Here the upper river grows in size beneath billowing clouds at Slana.

SOL DUC RIVER, WASHINGTON
Dropping steeply out of the Olympic Mountains, the Sol Duc River and its ancient forests of spruce, fir, and hemlock have been protected on the west side of Olympic National Park.

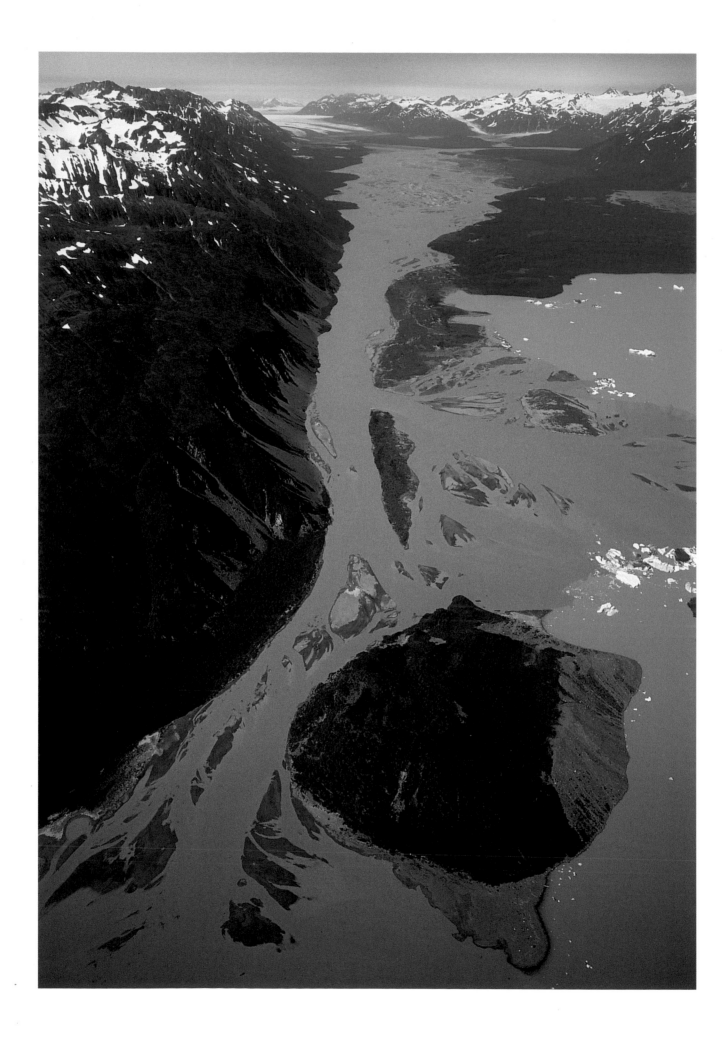

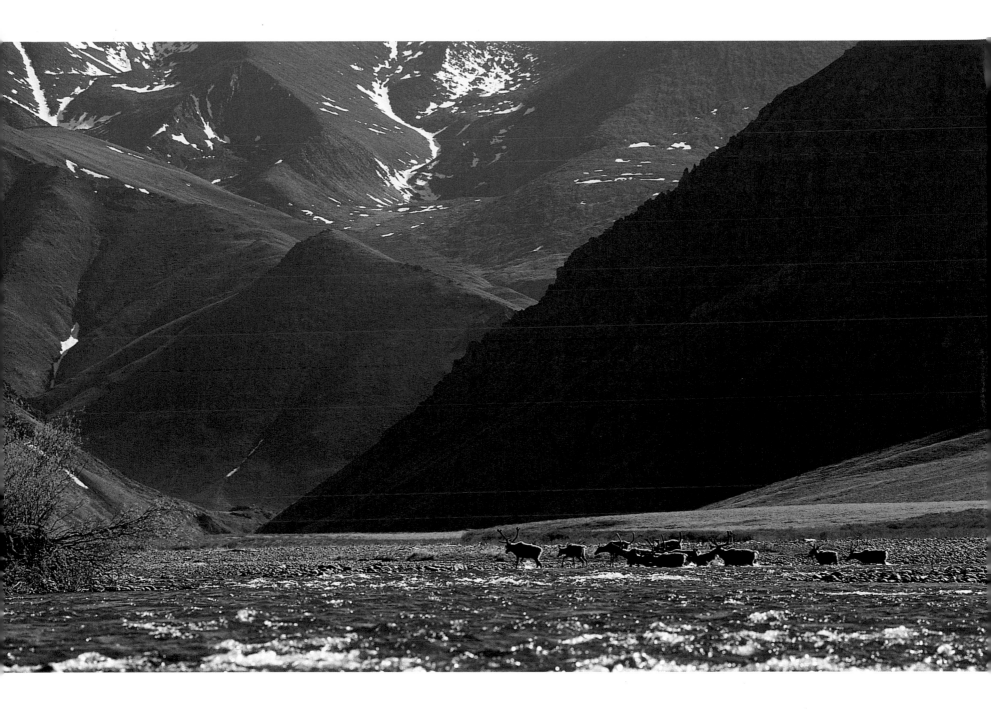

Kongakut River, Alaska

From the northeastern end of Alaska's Brooks Range, the Kongakut River drops toward the Arctic Ocean through the Arctic National Wildlife Refuge—a sanctuary that has been the center of intense political debate for several decades. Caribou annually migrate along the river and give birth to their calves on the Arctic Coastal Plain, which is threatened by plans to drill for oil.

209

Alsek River, Alaska

The Alsek River passes an iceberg-studded lake as it nears the ocean. The river's major tributary, the Tatshenshini, was slated for an open-pit copper mine that would have fated the area to road building and acid mine drainage. In 1993 Premier Michael Harcourt of British Columbia designated the Tatshenshini–Alsek Wilderness Provincial Park, halting the mine. With other adjacent preserves in Alaska and the Yukon, this is the largest protected complex of parkland in the world.

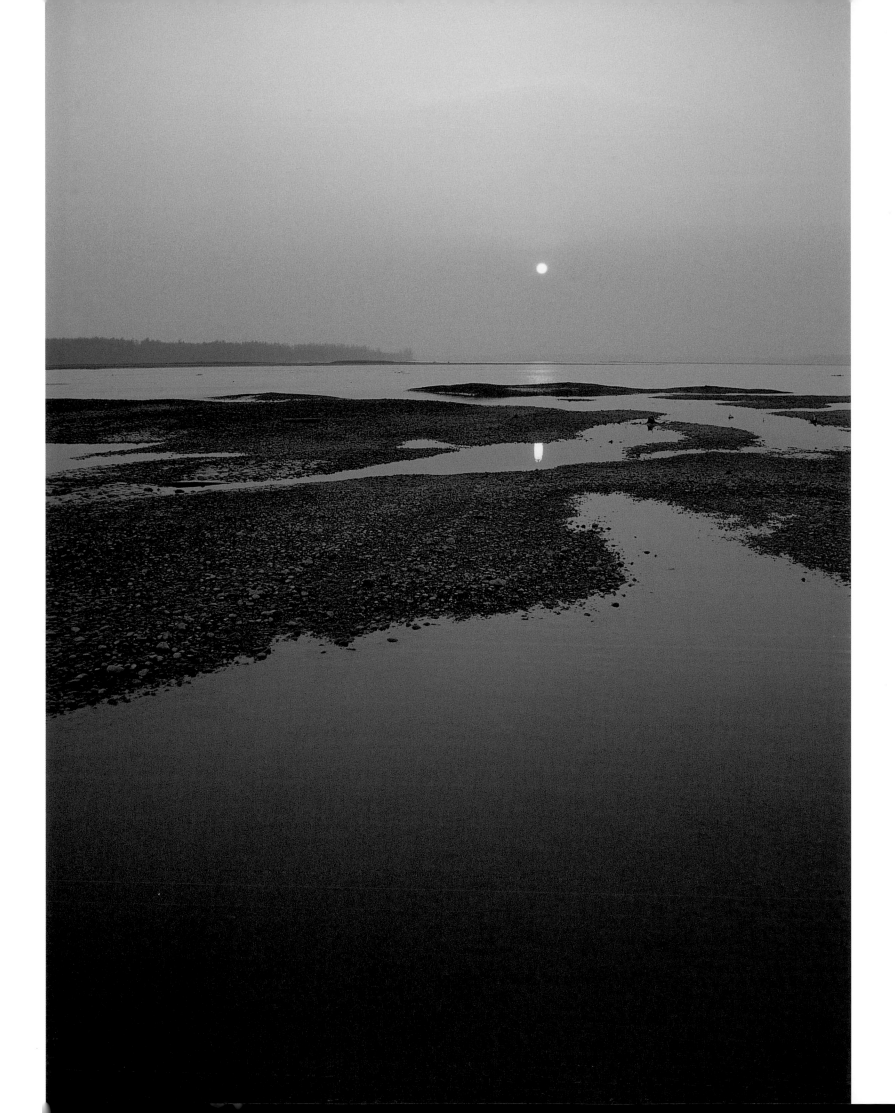

YUKON RIVER, ALASKA

The Yukon River is nearly as undeveloped as the Mississippi was in 1700. It begins in Canada and then crosses the entire width of Alaska, and its shores and waters are home to native peoples and to salmon that swim up the 1,980-mile artery from the sea. This lifeline of the north is the only American river of massive size that remains essentially wild.

The Image of Flowing Water

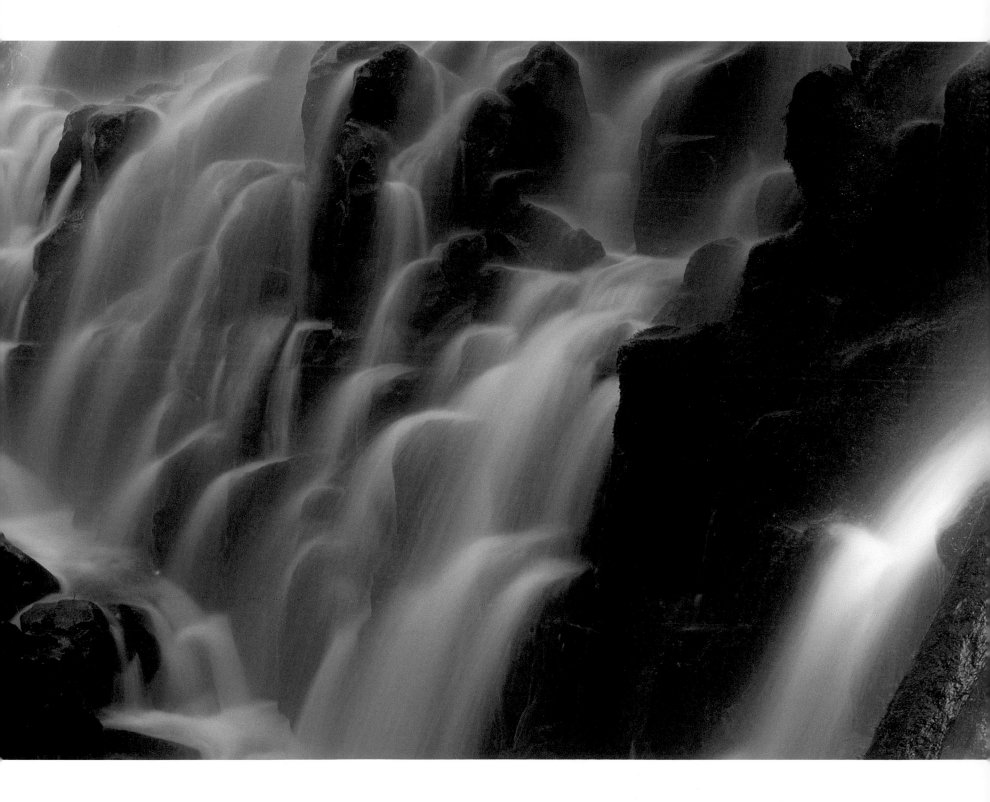

When I first saw Sixmile Run disappear with one final breath of current into the Ohio River, and when I later sat alongside the brilliant rapids of the Youghiogheny, the sight of flowing water made a lasting and indelible impression on me. The images of those streams affected me deeply and in ways that have informed my outlook about rivers ever since. The images lingering in my mind's eye formed my expectations about what a river should be.

The sights that I saw on those rivers of my youth eventually led me to take pictures of rivers everywhere. Knowing personally about the power of images from real life, I was motivated to capture the beauty, to catch the mood, to seize the most precious moment in a picture along each stream.

That is how this book came about, but the important point here is that images can become powerful forces in our minds. To properly care for our rivers, we need to regard them as truly valuable, and this means that the image of a healthy and beautiful river must become a potent force in our collective imagination.

The image of a natural river—sometimes a ribbon of blue flanked by green edges, sometimes a bubbling excitement of whitewater, sometimes a smooth silvery sheen in evening light—is a symbol of nature, of health, of communities that work well, of life itself. It reminds us that we are connected, not just to the water, but to everywhere the water has been and everywhere it is going. Beyond that, we are connected not only to one river, but to all of them. We are part of the hydrologic cycle. The rivers, after all, flow in our veins.

The images imprinted in our minds at some point become expectations, and expectations are essential catalysts for any important shift in our outlook and our culture. Are the rivers seen simply as supply lines for industry and waste lines for cities, or are they lifelines of the land and symbols of all that's beautiful and wild? When we go to the river, do we expect to find a waterfront that's trashed, polluted, and dammed? If this is all we've ever seen, it probably is what we would expect. But if we've stood by the edge of a stream that's alive with nature, or even if we've simply admired pictures that show rivers flowing with the spirit of wildness, then perhaps we will expect to find rivers that nurture all creatures, streams enlivened with fish and bird songs, waterways reflecting the beauty of the world around them.

How we regard the image of a river—how we imagine it—will determine how we regard the rivers themselves, and that will make all the difference, not only to the streams but to all the creatures in them and around them, to new generations of people, and to the quality of our communities.

When I go to the Elk River, not far from my home, and stand next to the water with morning mist rising from the surface, I'm reminded of the work that rivers do for us. Standing there at the edge of my own river, I can feel all of the currents and crosscurrents at once—the movement, the light, the life, the history of change, my ancestors' presence, my own past and future. I feel all this, but mainly I'm overcome by a simple and indefinable beauty that I've tried to capture in the pictures I have taken.

That beauty lies in the rapids and pools, the rocks and trees, the leap of the salmon and the rising of the sun, the changing of seasons, the crest of roaring floods followed by the translucent flow at quieter times—peaceful moments when I could just lie down in the water and float blissfully away.

I like to think that we each have our own river—one that reflects light in a way that catches our eyes, one that constantly moves in a way that makes us notice the flow, one that causes us to breathe deeply and smile with pleasure. It's there, down in the valley, waiting to be discovered again each time we step slowly to the rippling edge or when we round the next bend and watch a new view unfold. The river connects the storms overhead with the ocean far away, and it flows always as the source of water and of life.

RAMONA FALLS, OREGON
A tributary to the Sandy River, Ramona Falls graces the deeply forested flanks of Mount Hood.

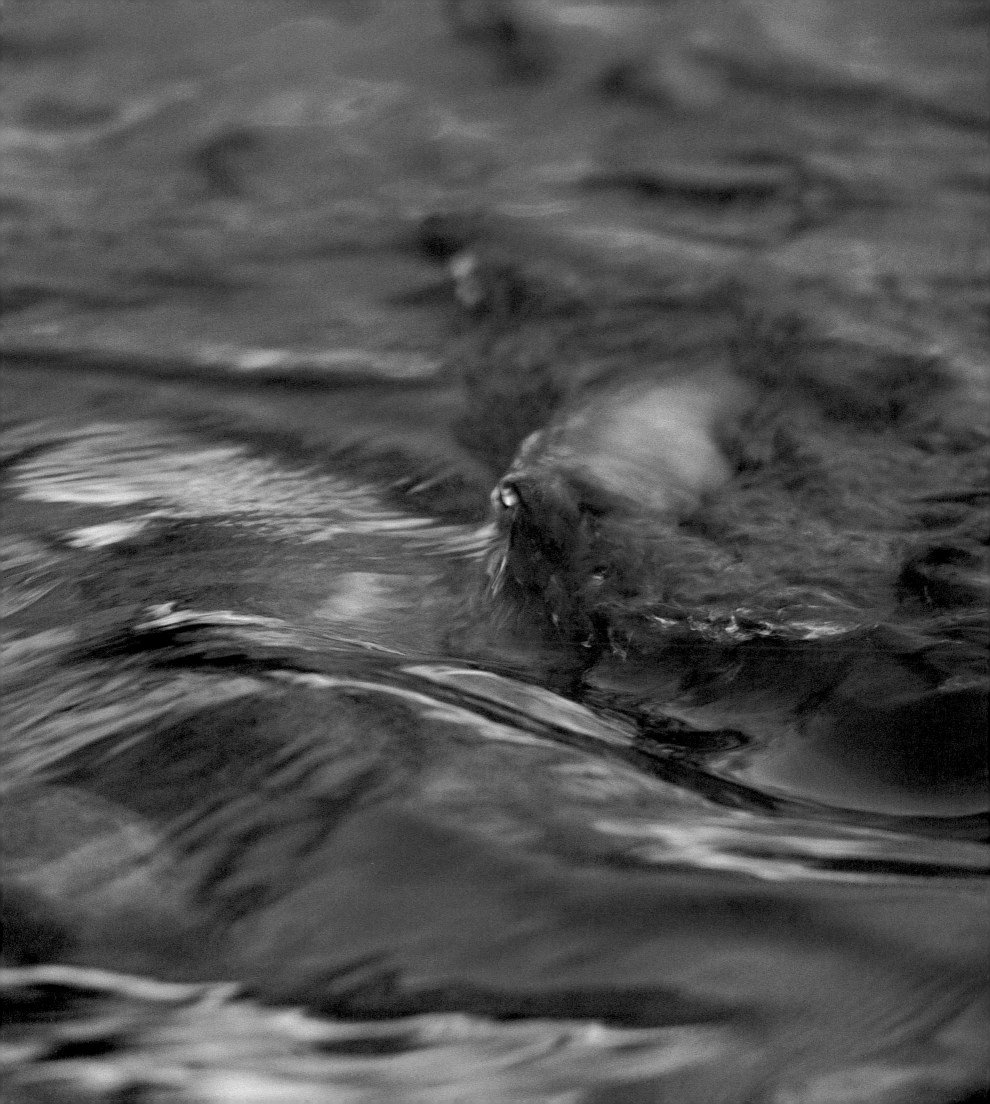